"I HAVE ONLY ONE LIFE TO LIVE. I MIGHT NOT BE HERE TOMORROW, SO I'M DOING WHAT I'M DOING NOW."

BY JANIE HENDRIX

CHRONICLE
CHROMA

& JOHN MCDERMOTT

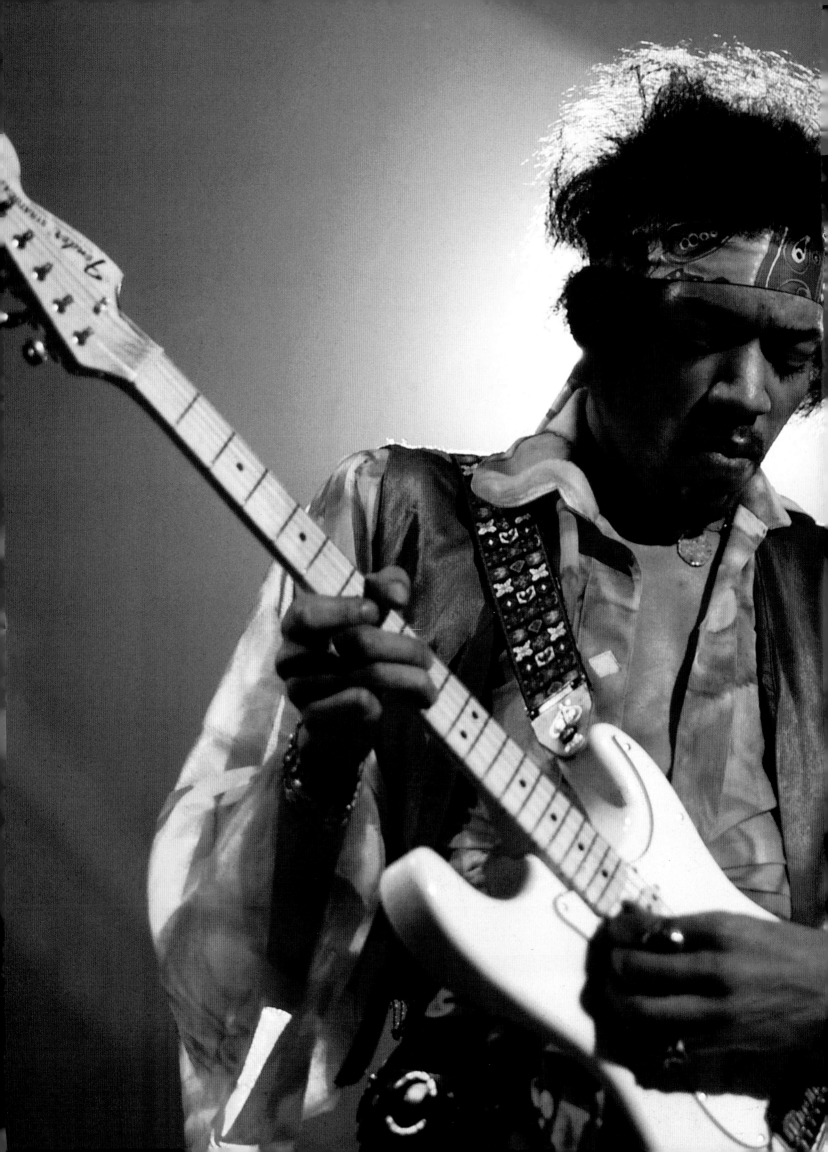

JIMI HENDRIX

AL & LUCILLE

16

WEST COAST
SEATTLE BOY

30

SCREAMIN' EAGLE

44

1942

1942–1960

1961–1964

THE SIDEMAN

56

1964–1966

THE JIMI HENDRIX
EXPERIENCE

68

1966

WILD THING

86

1967

ELECTRIC
LADYLAND

144

SEEDS OF CHANGE

WOODSTOCK

208

CRY OF LOVE

THE LAST DAYS

258

1968

1969

1970

INFLUENCE

290

JIMI AT 80: JANIE HENDRIX

It's hard to imagine that Jimi would be 80.... Perhaps it's because he will be forever young in our minds and alive in our hearts. What would he have taught us as the years passed and he increased in age and wisdom? I don't believe we have to wonder because he taught us so much in such a short time. Jimi taught us the value of family—that anything is possible with the power of love. He taught us about moonbeams and fairytales and that music is magical. He taught us that you don't need a spaceship to be an astronaut—you can soar through imagination. One of the best lessons he taught was the importance of leaving a place better than you found it. That is exactly what Jimi did in his brief lifetime. And we are better for having experienced this amazing human being—who the world knew as a legendary guitarist and iconic musician, and who we had the privilege of knowing as family—a son, a brother, our beloved Jimi.

We celebrate his inspiring life with this collection of images, art, and memories that tell his story. Each photograph handpicked to create a moving visual experience. An eighty-year journey through pictures that reflect the many dimensions of an incomparable human being who so briefly graced planet Earth with his presence, yet left it forever changed. It is my pleasure to share with you Jimi, as we knew and loved him. And, I'm sure you'll agree, Jimi sure looks good for his age! Enjoy!

Jimi and Janie, September 1968.

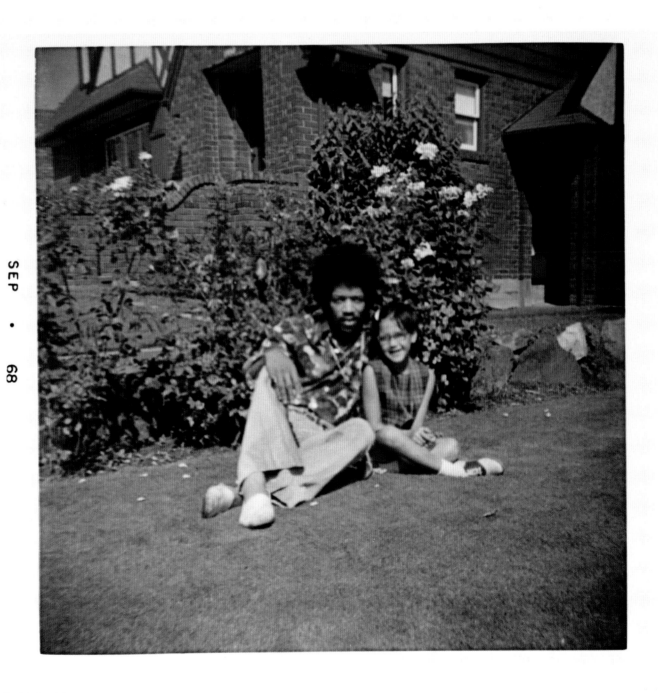

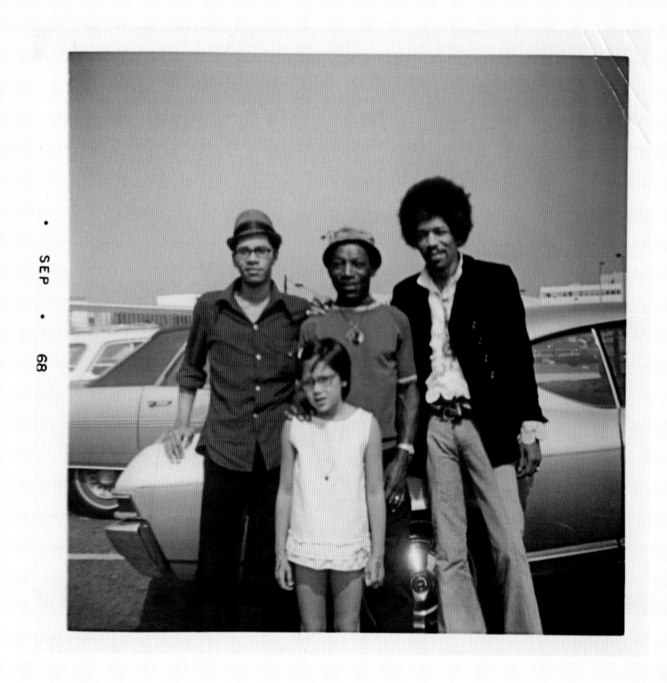

Left to right, Leon, James, and Jimi with
Janie, September, 1968.

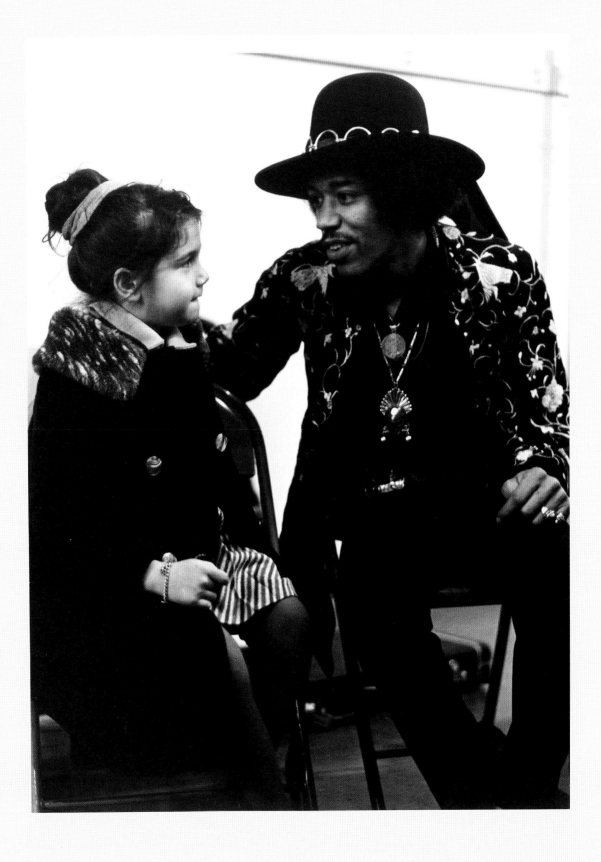

Janie and Jimi backstage, Seattle, 1968.

INTRODUCTION

During the course of just four extraordinary years, Jimi Hendrix left an indelible stamp on the world, shaping popular music and culture with his clear ambition and groundbreaking creative impulses. He remains the most innovative guitarist of his, or any other, era, literally creating the vocabulary of the guitar while redrafting the parameters of electric blues.

Though Hendrix could not read nor write music, he was a devoted student, fascinated by the wondrous sounds he heard on radio and records. Rooted in the vibrant Delta blues of Muddy Waters, Jimi's intense curiosity propelled him to cast his net even wider, discovering the stylistic elements that informed early rock 'n' roll. Hendrix drew encouragement from greats like Chuck Berry, Elvis Presley, and later, the Beatles and Bob Dylan—not to imitate but to continue on his own path, to create, as he would later describe, an updated, modern form of electric blues.

This blurring of musical and cultural styles composed an essential element of Hendrix's appeal, perhaps in part explaining and making it so difficult to fathom how long the guitarist languished in impoverished obscurity before finally achieving success in the United Kingdom. Even so, London was entirely unprepared for the compelling lyrics, irrefutable talent, and dynamic stage presentation he infused with an unrefined sexuality.

Given the scope of his achievements, it is still difficult to believe that established music impresarios passed on Hendrix time and again, until Animals bassist Chas Chandler changed Hendrix's fortune, plucking him from the depths of Greenwich Village in 1966. The Animals had enjoyed a string of chart hits, including "House of the Rising Sun," yet in Hendrix, Chandler saw a talent greater than his own. It was Chandler's passion and conviction in Hendrix's abilities that provided the guitarist with the opportunity he had long sought since, as a child in Seattle, he had strummed a broom as his first guitar. Chandler was able to translate Hendrix's "big picture" vision into practical business and marketing decisions that helped the guitarist skillfully navigate his way through Britain, Europe, and ultimately, a triumphant return to the United States.

Hendrix came to prominence in a fast-hanging world. While Carnaby Street and Swinging London embraced him quickly, America took longer. Hendrix worked diligently, carrying his message and music to a burgeoning youth culture struggling for racial equality and agonizing over Vietnam. Hendrix spoke to them through his music, challenging his listeners to "learn instead of burn," and to hear his "Message To Love." In "Machine Gun," Hendrix invoked the power of the Delta blues as he challenged man's inhumanity to man; "I Don't Live Today" was dedicated to the plight of the American Indian and other repressed minority groups; and in his unconventional and controversial rendering of the national anthem, he spoke to a youth culture that felt increasingly alienated from its country. In time, the interracial, intercontinental Jimi Hendrix Experience emerged as the biggest grossing concert act of the era.

As his popularity blossomed, Hendrix stood as a figure of rebellion—a counterculture outlaw focused on his music and altogether disinterested in the machinery of pop stardom. Throughout his career, Hendrix would refuse to be classified—by the fans, the press, his recording labels—and both his life and music demonstrated that, exuding a vibrant sense of freedom. An artist committed to innovation, he bristled at labels others applied to him and to his music. "What I hate is society these days trying to put everything and everybody into little tight cellophane compartments," Hendrix complained. "I hate to be in any type of compartment unless I choose it myself. They don't get me in any cellophane cage. Nobody cages me."

Despite his early, tragic death and the turbulent life that preceded it, Jimi Hendrix was not, as Chas Chandler would adamantly insist, a tragic figure. He remains, however, an enigma, an innovator frozen forever in time at the age of twenty-seven. Friends remember him as a complex, compassionate man who was loyal to those close to him and generous to a fault. Yet music was and would always be, first and foremost, his true love. Jimi lived in order to play his guitar, seizing every opportunity to explore its countless possibilities. Hendrix also adored making music with other artists, and his affinity for jamming with fellow musicians was legendary, with impromptu sessions often lasting hours on end. Be it a hip Manhattan nightspot or a dusty Southern roadhouse, Hendrix savored the chance to push himself further, feeding off the other musicians, dipping into different styles and bending them into something utterly new. In fact, jam sessions frequently served as a proving ground for fertile new rhythm patterns he would later refine into formal songs. When he wasn't performing or jamming, Jimi was recording music—both at home playing and singing into his hulking reel-to-reel tape deck, and at the studio.

Jimi details the rich life and remarkable career of one of the world's most important and influential musicians. This is his story.

JIMI HENDRIX

BORN NOVEMBER 27, 1942

"JIMI HENDRIX, BORN JOHNNY ALLEN HENDRIX, HAD A FAMILY HISTORY MARKED BY SLAVERY, RACISM, AND A HERITAGE OF PERFORMANCE."

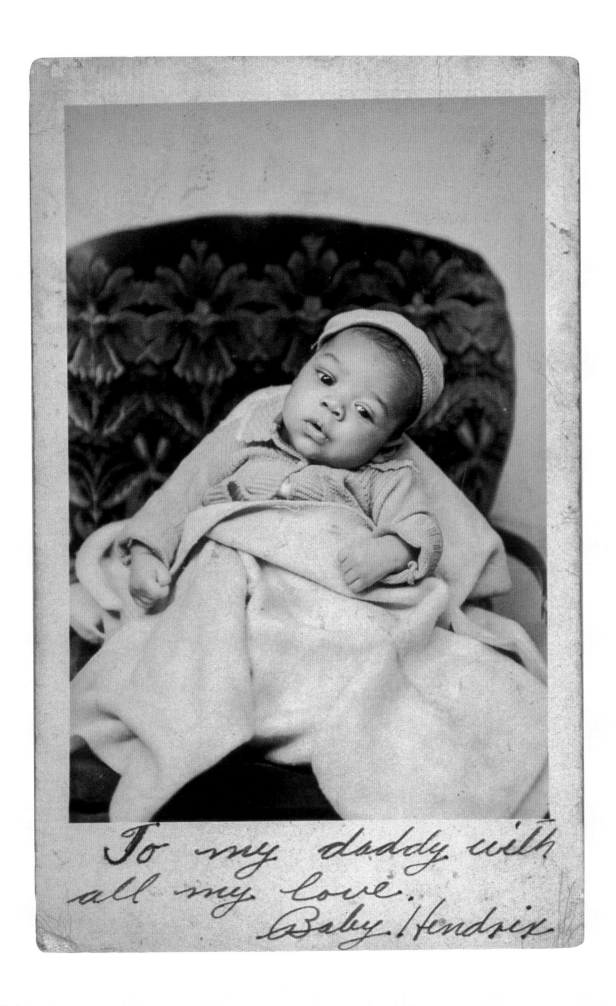

Baby Jimi.

AL &
LUCILLE

His father, James "Al" Hendrix, was born June 10, 1919, in Vancouver, Canada, the youngest of four children. Al's father, Bertram, originally hailed from Ohio, his mother a slave and his father a slave overseer. Al's mother, Zenora, or Nora, as she was called, was the granddaughter of a full-blooded Cherokee, raised on a rural farm. Their paths first crossed when both became involved in show business. "Dad was a stagehand and Mom loved to dance," Al Hendrix said. "They toured in a company owned by Mr. Cohen, traveling from city to city doing all-black entertainment with skits and a chorus line." The company disbanded in Seattle in 1911, and the tour dispersed. Mr. Cohen directed the couple to a friend in Vancouver, Canada, who could offer Bertram a job. Bertram accepted employment at a golf course on which he was not welcome to play, and he and Nora made the city their home and started their family.

Johnny's mother, Lucille Jeter, who was born in Seattle in 1925, the daughter of a longshoreman and a housekeeper, met Al Hendrix in 1941. He had come to Seattle to participate in a "Golden Gloves" boxing tournament and stayed on. Al loved to tour the Seattle dance circuit, entering jitterbug contests wherever he could. His landlady's eldest daughter, Berthelle, was Lucille's classmate. One evening, when Al was leaving to see a show at the Washington Club, Berthelle introduced him to Lucille and encouraged Al to take her along. Though Lucille had not yet turned seventeen and Al was six years older, the two were soon jitterbug partners at parties and dances and enjoyed each other's company.

Jimi Hendrix's father, James "Al" Hendrix, mother Lucille, and young Jimi Hendrix, Leschi Park, Seattle, Washington, 1946.

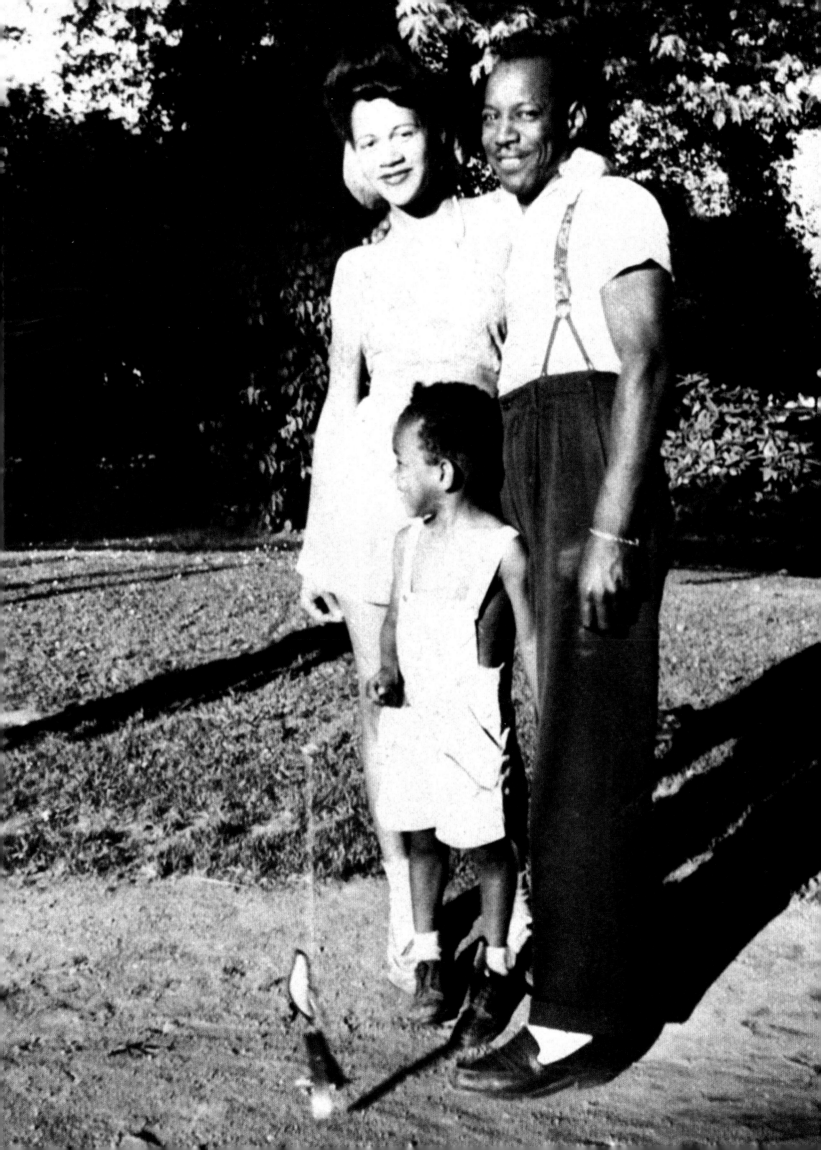

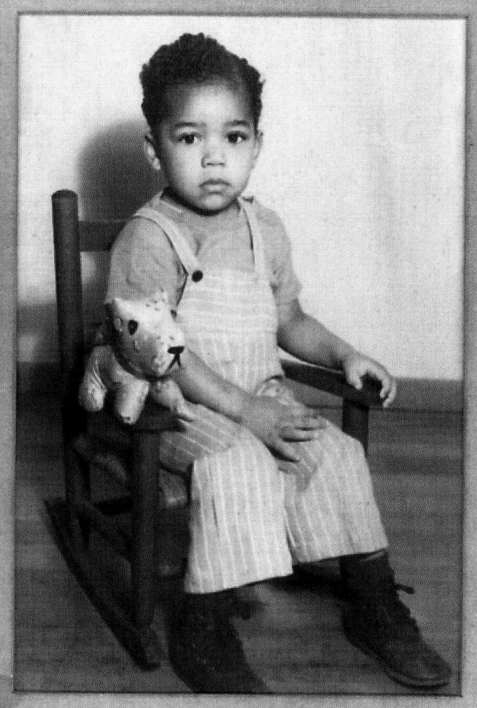

Jimmy Hendrix
age 3 yrs
Taken Jan 15-1946

Their courtship was brief, as Lucille soon became pregnant and the two quickly married. Adding to the urgency was the fact that Al was called to serve his country, which had recently entered World War II. "I wanted to get all married up before I went into the service, so our ceremony was a quickie," Al detailed in his book, *My Son Jimi*. "No one from our families was there, and we didn't even take a witness with us. It was just Lucille and me. Lucille and I didn't have time to make any plans for the baby, because Uncle Sam had my plans all made. We got married on March 31, 1942, and I went in the service three days later on April 3, 1942." Before their child was born or they had even lived together, Al left for Alabama, attached to a group that would serve the Eighth Air Force. When Lucille gave birth to Johnny on November 27, 1942, her sister Dolores sent Al a telegram at Camp Rucker to share the good news.

Just seventeen and already a mother, Lucille Hendrix was immature and ill-equipped to look after a young child. Her situation was made more difficult by a lack of financial stability, as she had little money to draw upon apart from the army pay sent overseas from Al. "I knew it was going to be hard on her by herself," Al recalled. "I know she tried to get help from the Red Cross. She was living at home at first, but she and her dad were having all kinds of difficulties. Lucille moved from there and was staying with her girlfriend Dorothy Harding when my Jimmy was born." In time, overwhelmed, Lucille left the baby in her mother's care. "I had heard of guys talking about how it was as hard on the wife at home as it was for the man away in the service," Al would later explain in his book. "Lucille held out a good long while, I guess, before she started running around with her girlfriends and other men. Sometimes my letters to Lucille were returned by the post office. Every time I got a letter from her, it was from a different return address." Jimmy was shuttled between caretakers until Al, still on active duty in the Pacific, received

a letter from a Mrs. Walls, a stranger to Al, who wrote she was now looking after his son and that he could come and collect him when he was discharged from the service. "I don't know when exactly Lucille got separated from Jimmy," Al recalled. "I don't think there was anyone in the Jeter family who was able to take care of Jimmy full-time, since [Lucille's sister] Dolores had started having kids. Lucille was still getting her allotment at that time, but she wasn't paying for Jimmy. So I started sending money to Mrs. Walls, who didn't know where Lucille was half the time." Mrs. Walls passed away shortly thereafter and left the baby in the care of her sister, Mrs. Champ.

Discharged in September of 1945, Al set out by train to Berkeley to reclaim his son. Though Mrs. Champ had shown love and compassion for his child, Al never wavered in his desire to take his son back with him to Seattle. "He's what I have been thinking of all these years I was in the service," he explained to Mrs. Champ. Father and son spent an awkward week in Berkeley growing familiar with each other. "The first time I saw him, Jimmy had on a little T-shirt, short pants, and sandals," Al later recalled. "I thought to myself, 'This little feller here—that's my son!' Of course, Jimmy didn't know me, but the Champs had a picture of me in my uniform there on the table and had told him that his daddy was coming to get him. It was a strange union. Jimmy wasn't scared or anything. He was just bashful and I felt the same way. A new warm baby would have been different. Here he was, three years old, and he was able to look and judge for himself. You hug each other, but it's still funny, and then after a while you get acquainted and start getting used to each other."

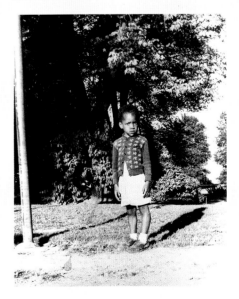

LEFT
Jimi with his stuffed dog.

RIGHT
Jimi, 1946.

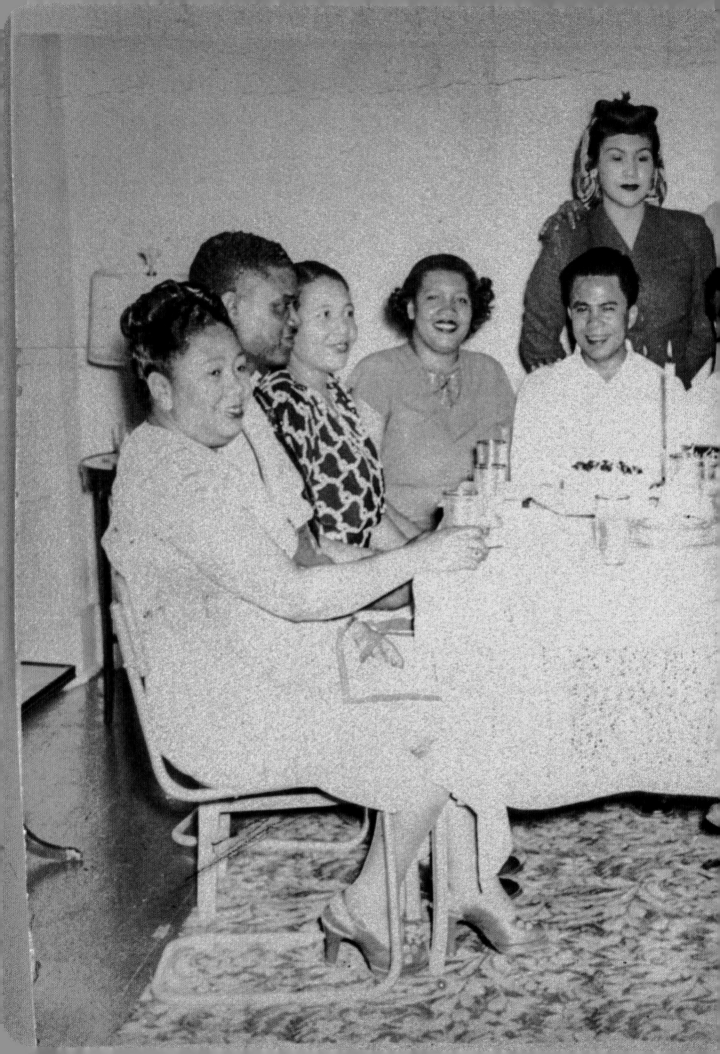

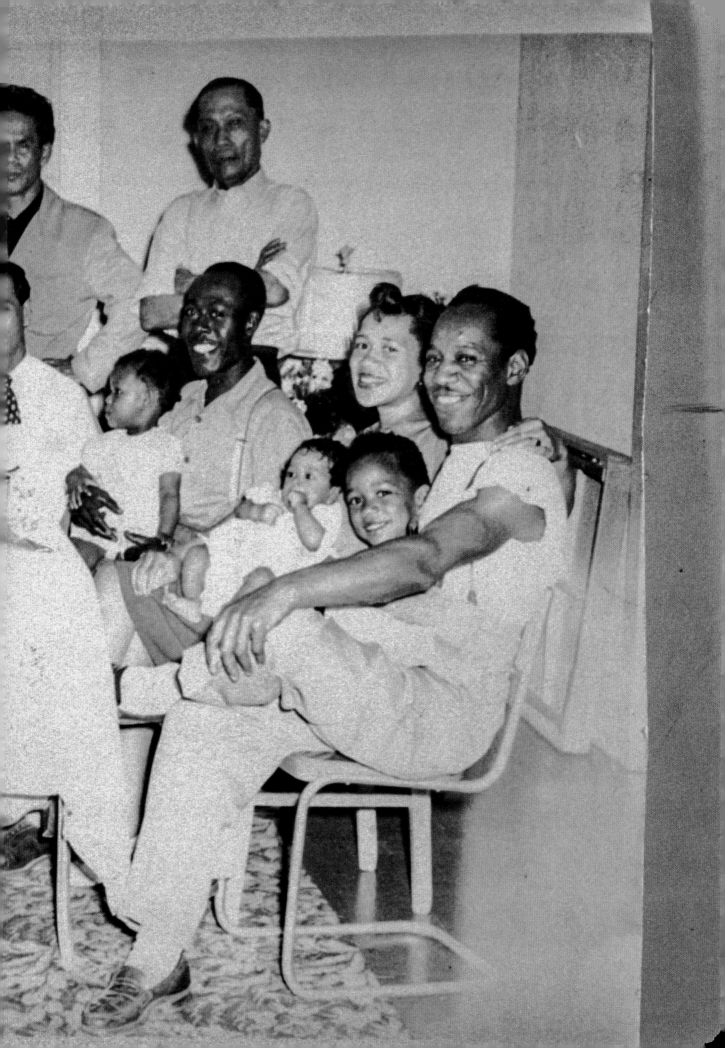

Back in Seattle, Al immediately set about legally changing his son's name, dropping the "Johnny Allen" Lucille had chosen without his input, and opting for "James Marshall Hendrix" instead.

Al struggled to find work in the war's aftermath. Seattle was no different than any of the other major urban centers across the United States, trying hard to place returning servicemen back into the workforce. "The war came long before civil rights," Al explained. "It was hard for blacks to get jobs, let alone one with good pay." To help make ends meet, Al and Jimmy moved in with Lucille's sister Dolores. When Dolores and her children moved into the racially integrated housing project on Yesler Terrace, Al and Jimmy joined them. It was there that Lucille returned to see her husband and son. Al had not seen Lucille since his return from the army. In fact, he had started divorce proceedings against her as far back as when Jimmy had first been put in the custody of Mrs. Champ. "I asked Lucille about her not taking care of Jimmy, and she said, 'Well, I was moving around so much,'" Al remembered. "My feelings were lukewarm, but I was still attracted to her. I thought, 'I was gone so long, and she was so young when I left.'" Al would later claim that he was one final payment of $75 away from finalizing the divorce when Lucille asked him to reconsider and take her back.

Al eventually found work as a merchant seaman and, in 1946, sailed for Yokohama to assist in the ferrying of US troops returning from Japan. His departure did little for his relationship with Lucille, and she was soon evicted from the room she, Al, and Jimmy had shared at the Golden Hotel. Upon his return, they struggled to provide a stable home for their son and make the marriage work once again, arguing frequently. "When it came to tempers, Lucille and I were about equal," remembered Al. "She'd get mad and bang things around. Jimmy knew the hardship. He was old enough to see the hassles we were having." And Jimmy did have a good handle on their relationship.

"Dad was very strict and levelheaded, but my mother liked dressing up and having a good time," Hendrix later detailed. "She used to drink a lot and didn't take care of herself, but she was a groovy mother."

PREVIOUS
Birthday party with friends, Seattle, 1948.
Jimi, Lucille, and James far right.

RIGHT
Jimi and his mother, Lucille.

FOLLOWING
Leschi Elementary School, Seattle, June 1955.
Jimi is in the second row, third from the left.

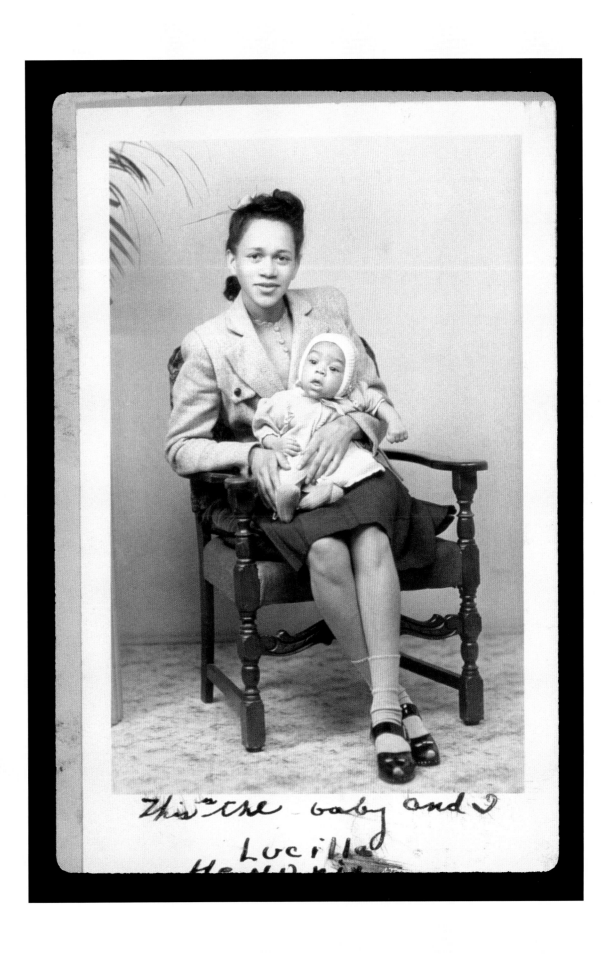

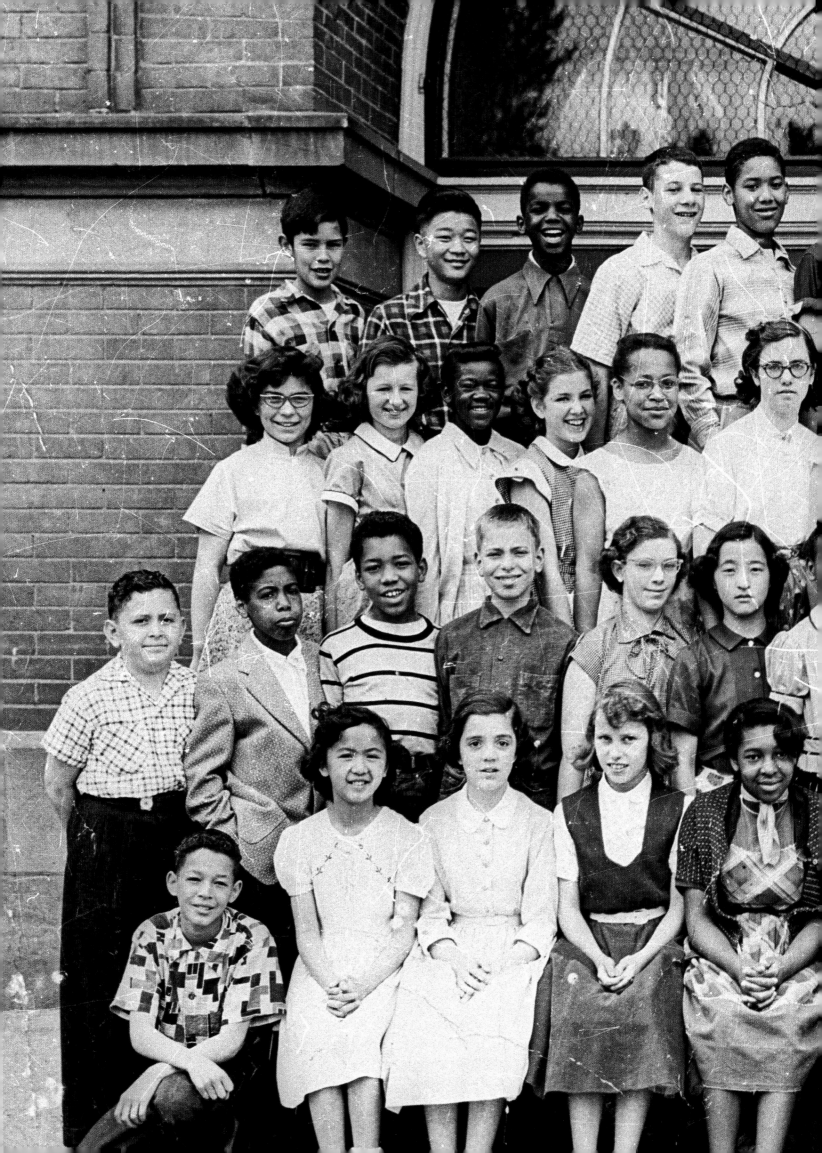

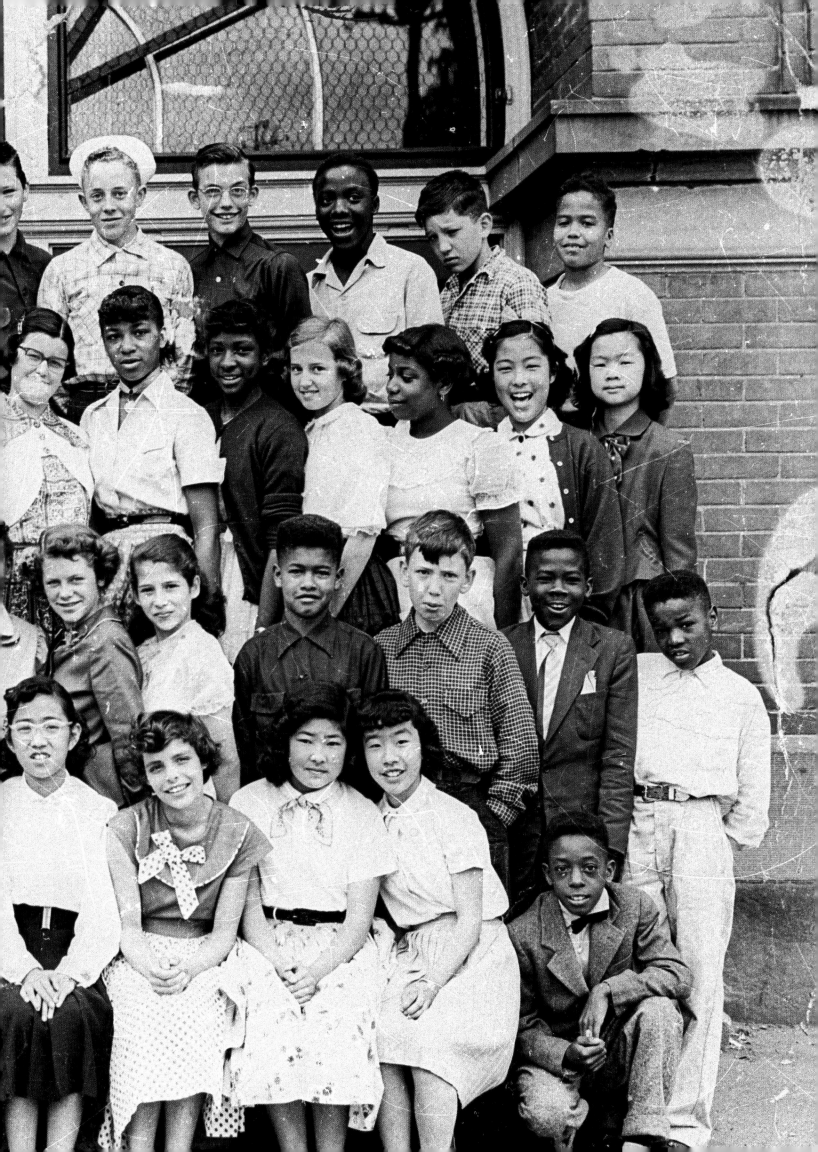

1943-

–1960

"
THE FIRST GUITARIST
I WAS AWARE OF WAS
MUDDY WATERS.
I HEARD ONE OF HIS OLD
RECORDS WHEN I WAS
A LITTLE BOY, AND IT
SCARED ME TO DEATH
BECAUSE I HEARD ALL OF
THOSE SOUNDS. **WOW,**
WHAT IS THAT ALL ABOUT?
IT WAS GREAT."

Jimi in his football uniform.

WEST COAST SEATTLE BOY

Throughout his childhood, Jimmy moved frequently within Seattle as money and circumstances necessitated. "Jimmy didn't seem to want much when he was little," Al later recalled. "He was pretty easy to please. He was always thrilled with any kind of toy he got because he didn't get too many of them. I didn't have all that much and I had to explain the situation to him. He'd be talking about how some kid had more than him, and I'd say, 'We can't keep up with the Joneses,' as the old saying goes."

"My dad was a gardener and we weren't too rich," Hendrix later remembered. "It got pretty bad in the winter when there wasn't any grass to cut."

Jimmy shuffled between elementary and junior high schools, friendly but shy. His parents' money and volatile marital troubles were an undercurrent in an otherwise normal childhood, which he spent playing youth football, joining the Cub Scouts, and drawing as much as he could.

Jimi and his father, James "Al" Hendrix.

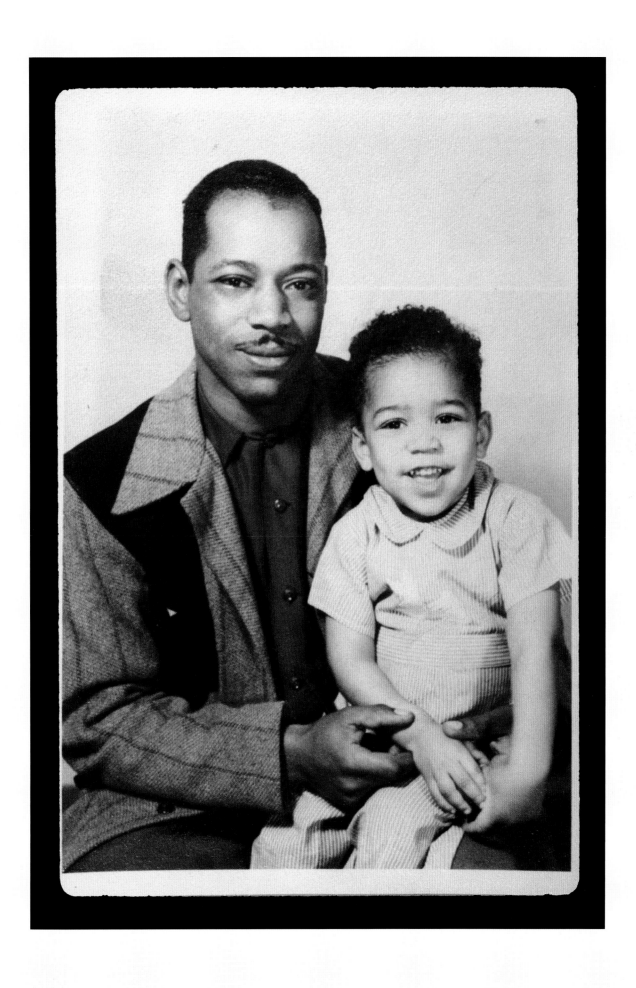

Jimi's childhood drawing of a
rock 'n' roll band.

T

"There were family troubles between my mother and father," Hendrix admitted. "They used to break up all of the time.... I used to go to different homes. I stayed mostly at my aunt's and grandmother's. I always had to be ready to go tippy-toeing off to Canada."

Ultimately, Lucille left Al and Jimmy and was soon pregnant with another man's child. After giving birth to a son, Leon, Lucille entered into another relationship that resulted in the birth of Joey, the second of Jimmy's half-brothers. Lucille and Al's turbulent relationship finally and officially came to an end in 1951, when they divorced. Al was granted custody of Jimmy. "After the divorce, Jimmy and Leon never went to stay with their mother," Al said. "She wanted to be around the kids, but she wanted her freedom too. It was like that old saying, 'You can't have your cake and eat it too.'"

"Mostly my dad took care of me," Hendrix echoed. "He taught me that I must respect my elders always. I couldn't speak until I was spoken to by grownups, so I have always been very quiet. My dad used to say that a fish wouldn't get into trouble if he kept his mouth shut. But I saw a lot of things."

As he grew older, Jimmy developed a keen interest in music. When he mined his father's record collection, he discovered artists like Louis Jordan, as well as the unvarnished power of down-home blues. "The first guitarist I was aware of was Muddy Waters," he explained. "I heard one of his records when I was a little boy and it scared me to death because I heard all of these sounds. Wow! What is that all about? It was great." As a teenager, the unbridled energy and enthusiasm of rock 'n' roll captivated Jimmy. When he saw Elvis Presley perform at Seattle's Sicks Stadium in 1957, it broadened his horizons, expanding his influences. "I was digging everything from Billy Butler, who used to play with Bill Doggett, Buddy Holly, Eddie Cochran, B.B. King, and Elmore James," Hendrix recalled. "But I didn't try to copy anybody. Those were just the people that gave me the feeling to get my own thing together."

Early in Jimmy's teen years, Al took notice of his son's interest in the guitar. "I used to have Jimmy clean up the bedroom all the time while I was gone, and when I would come home I would find a lot of broom straws around the foot of the bed. I'd say to him, 'Well, didn't you sweep up the floor?' and he'd say, 'Oh yeah,' he did. But I'd find out later that he used to be sitting at the end of the bed there and strumming the broom like he was playing a guitar."

"For Jimmy, it was always about the music."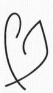

A battered ukulele Jimmy used for practice soon gave way to a second-hand acoustic guitar Al purchased for five dollars from a family friend. "I learned all the riffs I could," Hendrix detailed. "I never had any lessons. I learned guitar from records and the radio. I loved my music, man. I'd go out there on the back porch in Seattle, because I didn't want to stay in the house all the time, and I'd play the guitar to a Muddy Waters record. You see, I wasn't interested in any other things, just the music."

Jimmy soon wore out his acoustic and wanted an electric guitar. Al acquiesced and diligently made the payments. He also decided to join his son, taking up the saxophone so the two could play together. It was soon clear Jimmy was much more serious about music than Al, and when Al got behind in his payments, he returned the saxophone and continued making payments on the guitar.

Unable to read music, Jimmy concentrated on studying records and developing his own musical style. Countless hours of solitary practice at home soon led to the chance to perform in public as rock 'n' roll's infectious popularity created numerous opportunities for struggling local bands. One such band was the Velvetones, the first group with whom Hendrix performed. Jimmy was barely in high school when he took to the stage. "I started looking around for places to play," Hendrix remembered. "My first gig was at an armory—a National Guard place—and we earned thirty-five cents apiece. We used to play stuff by people like the Coasters."

After the Velvetones, Hendrix joined the Rocking Kings, a new six-piece combo that performed at dances and youth functions. "It was so hard for me at first," Hendrix later admitted. "I knew about three songs, and when it was time for us to play onstage I was all shaky, so I had to play behind the curtains. I just couldn't get up in front. Then you get so very discouraged. You hear different bands playing around you, and the guitar player always seems like he's so much better than you are. Most people give up at this point, but it is best not to. Just keep on, just keep on. Sometimes you are going to be so frustrated that you hate the guitar, but all of this is just a part of learning. If you're very stubborn, you can make it."

While music captivated Jimmy's imagination and monopolized more and more of his time, he struggled to maintain his grades at Garfield High School. His attendance suffered, and by the fall of 1960, when he was seventeen, he had dropped out altogether. "School was nothing for me. I wanted something to happen for me." He went to work with his father, gardening and landscaping during the day and dedicating his nights to music. He started performing locally with the Tomcats, a local combo headed up by James Thomas, a childhood friend.

In May 1961, Jimmy was arrested for "taking a motor vehicle without permission," and then arrested again just three days later as the passenger in another stolen car. Though Hendrix claimed not to have known either car was stolen, the two juvenile indiscretions brought him before a Seattle judge. He served no jail time but did receive a suspended sentence that remained part of his permanent record.

"I was eighteen," Hendrix later said. "I didn't have a cent in my pocket." He had no intention of returning to Garfield High School. He had also been classified 1-A by the local draft board. The choice before him was to select a service branch and enlist or wait for a draft notification. "I figured I would have to go in the Army sooner or later, so I walked into the first recruiting office I saw and volunteered.

"I volunteered to get it over with," he said, "so I could get my music together later on."

Jimi with Danelectro guitar, Seattle,
August 1960.

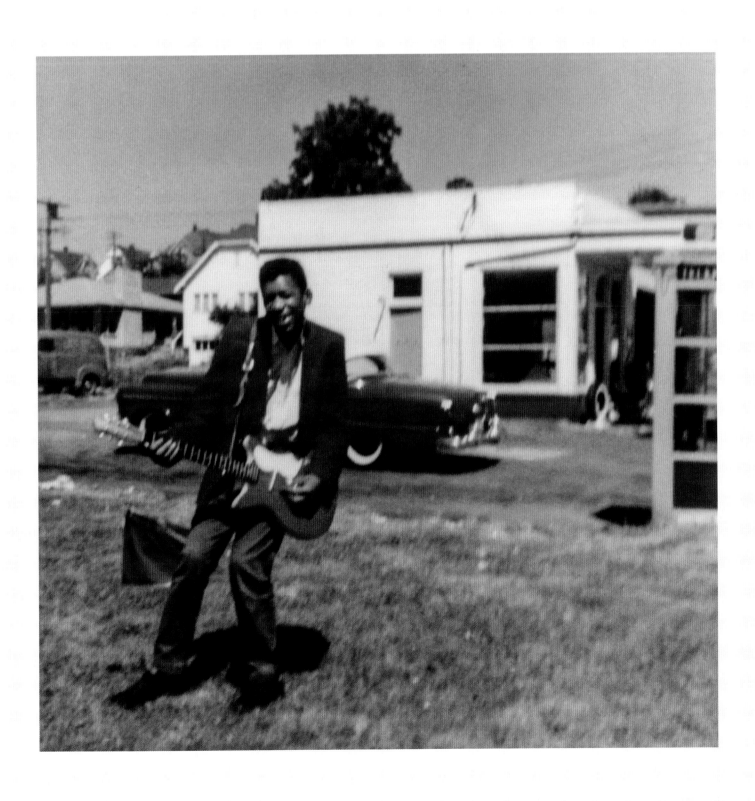

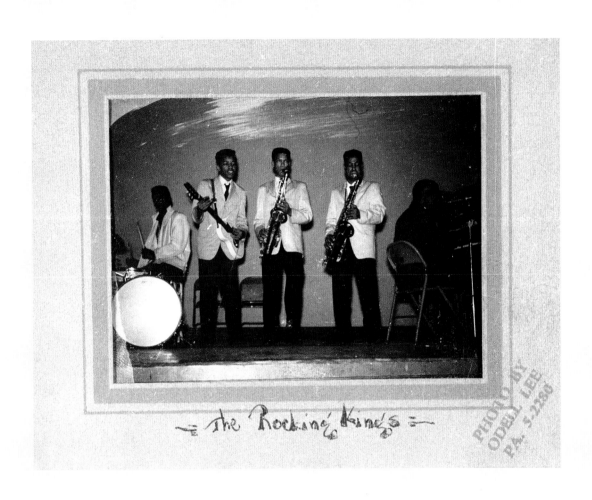

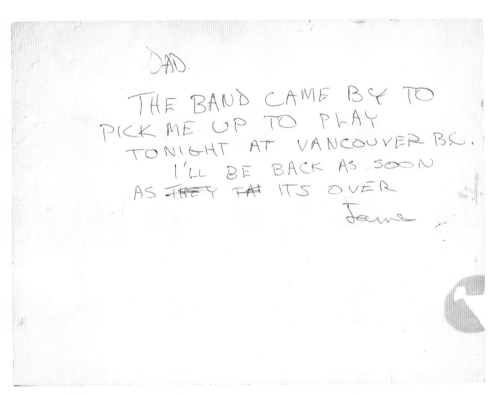

LEFT
Jimi with his girlfriend Joyce Lucas at the Impressions Dance, Nashville, December 1962.

TOP RIGHT
Jimi and the Rocking Kings, February 20, 1960, Washington Hall, Seattle.

BOTTOM RIGHT
Handwritten note by Jimi.

FOLLOWING
Jimi performing with Thomas And The Tomcats, Bors Brumo nightclub, Seattle, Washington, April 1961.

–1964

"

PRIVATE HENDRIX
PLAYS A MUSICAL INSTRUMENT DURING HIS OFF-DUTY HOURS, OR SO HE SAYS. THIS IS ONE OF HIS **FAULTS**, BECAUSE HIS MIND APPARENTLY **CAN NOT FUNCTION** WHILE PERFORMING DUTIES AND **THINKING ABOUT HIS GUITAR."
—SGT. LOUIS HOEKSTRA

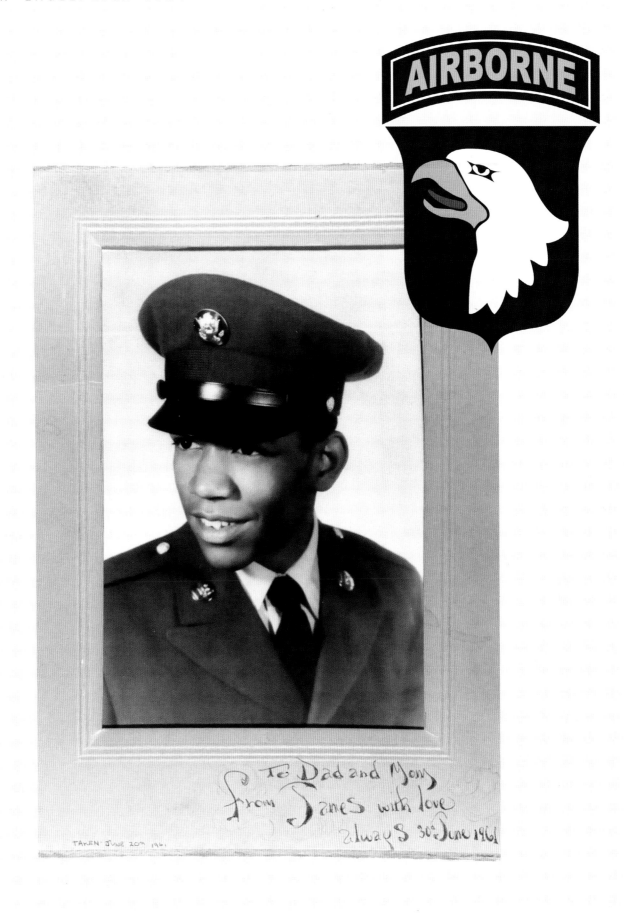

TAKEN JUNE 20TH 1961

To Dad and Mom
from James with love
always 30th June 1961

Jimi, Fort Ord, California,
June 20, 1961.

SCREAMIN' EAGLE

In 1961, military service was still not a choice for young men of Jimmy's era but a legal requirement, even though the United States was between armed conflicts.

"When I joined I figured I might as well go all the way," said Jimmy, "so I joined the Airborne." From his letters to Al, it is clear that the army didn't provide a respite from the poverty that had plagued Jimmy and his family throughout his childhood. Still in basic training, Jimmy wrote, "I believe it is more expensive being in the Army than living as a civilian. So far we had to get two laundry bags $1 each, a block hat $1.75, two locks 80 cents each, three towels 50 cents each, stamping kit $1.75, haircut $1, shoe polish kit $1.70, shaving razor, blades and lather $1.70, insignias 50 cents. So I guess this isn't all that good financially, as I first thought. . . . We don't get paid until June 30th, so I would like to know if you can send about five or six dollars. They only gave us $5 when we first came and that's all gone except $1.50 and that isn't going to last a minute around here."

In later letters to his father, he expressed pleasure at the news his half-brother, Leon, had moved in with Al, and that the family was doing a little better financially. "Tell Leon to do what he's supposed to because, just as you used to tell me, it pays off later in life," he wrote. "I'm so happy too about you getting a TV, and I know that you're fixing the house up 'tuff.' Keep up the good work and I'll try my very best to make this Airborne for the sake of our name. I'm going to try hard and will put as much effort into this as I can. I'll fix it so the whole family of Hendrix's will have the right to wear the Screamin' Eagle patch of the US Army Airborne!"

Hendrix endured eight weeks of basic training at Fort Ord, California, before the young soldier was dispatched to Kentucky and stationed at Fort Campbell.

Page I.

PVT. James Hendrix
RE19693632
@ HQ•2Co. BO.15 MNT.BV
101ˢᵗ AIRBORNE DIV.
fort Campbell ky.

Dear Dad. —

Well, here I am — Exatly where I
wanted to go — In the 101ˢᵗ AIRBORNE —
How are you and Leon, and every body? fine, I
really hope — Well, it is pretty rough , but
I can't complain and I don't regiret it So far —
We jumped out of the 34 ft. tower on the 3ʳᵈ day
we were here — It was almost fun —
we were the first 9 out of about 150 in our
group — When I was walking up the stairs
to the top of the tower , I was walking nice
and slow , just taking it easy — there
were 3 guys that quit when they got to
the top ● of the tower — You can quit anytime .
And they took one look outside and just quit.

Personal letter from Jimi to his
father, 1961.

"The parachute jumps were about the best thing in the Army. I did about twenty-five. It's the most thrilling thing I ever did before."

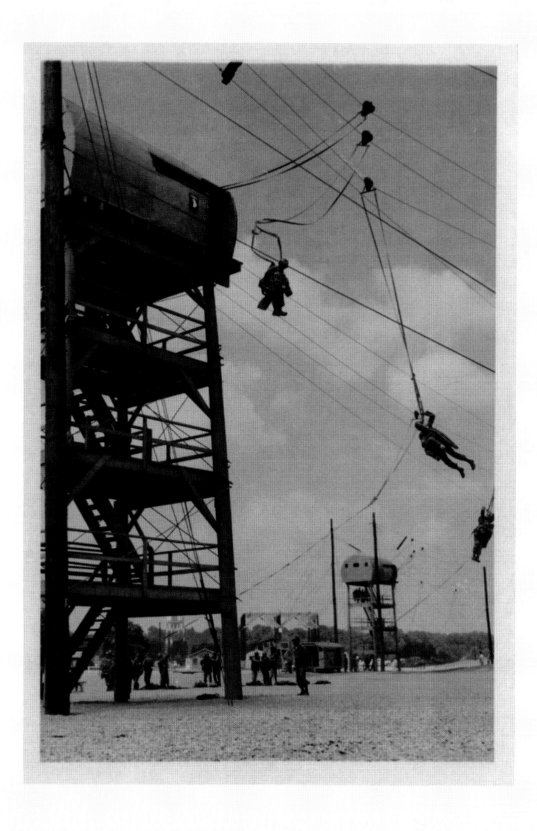

Hendrix did ultimately earn the patch as a member of the famed army paratroop division, but his initial enthusiasm soon waned. He proved to be an unmotivated soldier, disinterested in routine and the rigors of army discipline. "I hated the Army immediately," Hendrix later admitted. "The training was really tough. It was the worst thing I had ever been through. They were always trying to see how much you could take."

In addition to disliking the rigor of the army, Hendrix's shy, introverted personality and his preoccupation with his guitar caused many soldiers to view him as odd or distant. However, it was his raw skill as a guitarist that eventually drew the attention of Billy Cox, a fellow soldier and aspiring musician. Born in West Virginia and educated in Pittsburgh, as a youth Cox had tried his hand with a variety of instruments, including violin, piano, baritone horn, and trumpet. He fell in love with the electric bass sound established by R & B legend Lloyd Price's band. Two years older than Hendrix, Cox too had enlisted and was stationed at Fort Campbell. One evening in 1961, a heavy rainstorm on the base drove Cox for cover and, purely by chance, into contact with Jimmy Hendrix. "I had gone to the post theater to watch a movie," remembered Cox, "and when we left the theater it was raining. We all scattered for cover and me and one of my friends wound up on the doorstep of Service Club No. 1. We heard some guitar coming out of the window that was half raised. I heard something I never heard before and I told the guy, 'Hey, listen. That's really good guitar playing.' He said, 'It don't sound good to me.' He left and I went inside and introduced myself.

"I told [Jimmy] that I played bass and asked if he would mind if I joined him. In the service clubs, if you showed your military ID card you could check out all these wonderful instruments. If you had an ID, they would give you a trumpet, saxophone, guitar, bass or whatever you wanted to play.... [We] found out that we had a lot in common musically."

Cox and Hendrix became friends, and, together with drummer Gary Ferguson, formed the King Kasuals. Like other budding groups of this era, the King Kasuals developed a stage repertoire chock-full of blues and R & B favorites by such artists as B.B. King and Bobby "Blue" Bland. "I booked some small gigs for us at places like Service Club 1 and Service Club 2 on the base until we got good," recalled Cox. "Then we finally got a job working in the city, at the American Legion in Clarksville, Tennessee."

Though Hendrix still lacked formal guitar training, he honed his skills through hours of arduous practice. His fierce determination made a lasting impression on Cox, who had never witnessed such slavish devotion by a musician. "Guitar playing was a night and day affair with him," Cox said. "There were many mornings when I would go wake him up and see the guitar laying on top of his chest because he had practiced all night long. He had calluses on his fingers!"

As Hendrix's music fortunes began to advance, his effectiveness as a soldier continued to steadily decline. He was disciplined for a host of minor offenses, including sleeping on duty, failing to pay overdue laundry expenses, and repeatedly missing bed checks. "There's nothing but physical training and harassment," Hendrix later said. But he also had brief moments where he enjoyed his time. "The parachute jumps were about the best thing in the Army. I did about twenty-five. It's the most thrilling thing I ever did before."

Though Hendrix achieved the rank of private first class and earned that prized Screaming Eagle patch, these advancements held little value when measured against his musical aspirations. Ultimately, an ankle and back injury received during a parachute jump soured his army outlook even further. Despite more contemporary rumors suggesting Hendrix used homosexuality as a device to avoid the remaining portion of his military service, the statement by platoon Sergeant James C. Spears in Hendrix's official military records makes clear the issues were based on Hendrix's abysmal performance as a soldier. "Pvt. Hendrix plays a musical instrument in a band off duty and has let this interfere with his military duties in so much as missing bed check and not getting enough sleep. He has no interest whatsoever in the Army."

Photograph taken by Jimi during jump school, 1961.

Hendrix was honorably discharged in 1962. "One morning I found myself standing outside the gate of Fort Campbell on the Tennessee-Kentucky border with my little duffel bag," Hendrix recalled. "In the Army I'd started to play the guitar very seriously, so I thought all I can do is try to earn money playing guitar."

Together with Cox, who had also been discharged, the King Kasuals tried to establish a foothold within the local, but highly competitive, R & B "chitlin' circuit," so called because the venues were all small, informal places that served soul food. "It was pretty tough at first," Hendrix said. "In Clarksville we worked for a set-up called W & W. Man, they paid us so little that we decided the two Ws stood for 'Wicked and Wrong.' This one-horse music agency used to come up on stage in the middle of a number, slip the money for the gig into our pockets and disappear. By the time the number was over and I got a chance to look in the envelope, I'd find they'd only slipped us a couple of dollars instead of ten or fifteen. Then we got in with a club owner who seemed to like us a lot. He bought us some new gear. I had a Silvertone amp and the others got Fender Bandmasters. But this guy took our money and he was sort of holding us back. So I moved about some more."

Cox and Hendrix struggled to make ends meet. With few opportunities in Clarksville, the two chased news of a steady gig in Indianapolis, traveling in Cox's battered car. The job never materialized. Stranded, they subsisted on crackers and shared bowls of chili before mustering enough resources to make their way to Nashville. Tennessee was better to them, and the King Kasuals secured a residency at the Club Del Morocco. The group now included Larry Lee, a guitarist and Tennesee State University student who had struck up a friendship with Cox and Hendrix. "We were the house band," said Lee. "We played four nights a week for eleven dollars a night." Jimmy and Cox moved right next door to the club, sharing a small apartment atop Joyce's House of Glamour on Jefferson Street.

Jimi and The King Kasuals, 1962. Billy Cox on bass guitar.

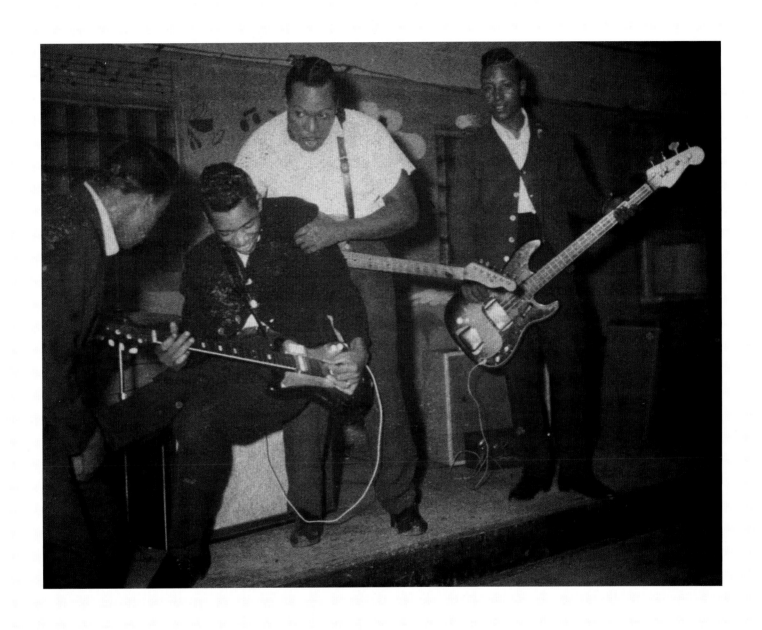

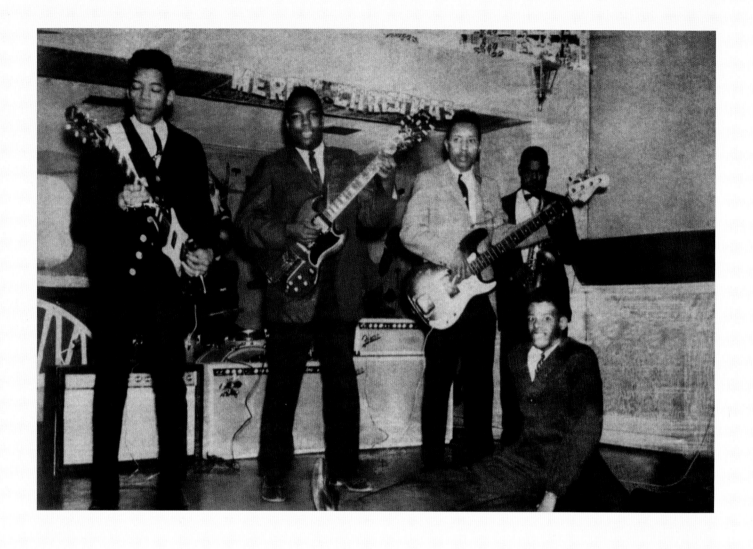

Jimi (left) with the King Kasuals,
1962. Billy Cox (second from right)
on bass guitar.

*"Bad pay, lousy living, and gettin' burned.
That was them days."*

By the fall of 1962, the King
Kasuals had begun to build a small but
steady audience at the Club Del Morocco,
but Hendrix was eager to move beyond
Nashville. "He used to say when he was
famous he would have a thousand gui-
tars," Lee remembered. "And he said
'when' I get famous—not 'if.'" In early
1962, he parted ways with Cox when R & B
gadfly Gorgeous George urged him to join
an R & B package tour.

"I started traveling around, play-
ing around the South," Hendrix recalled.
"After a couple of months there was a
soul package coming into town with Sam
Cooke, Solomon Burke, Jackie Wilson,
Hank Ballard, B.B. King and Chuck
Jackson, and I got a little job playing in
the backup band. I learned an awful lot
of guitar picking behind all those names
every night.

"After that I traveled all over the
States, playing in different groups. Oh
God, I can't remember all their names.
I used to join a group and quit them so
fast! There I was, playing in this Top 40
R & B Hit Parade package, with patent
leather shoes and hairdo combined. But
when you're running around starving on
the road, you'll play almost anything. . . . I
didn't hear any guitar players doing any-
thing new and I was bored out of my mind.
I learned how not to get an R & B band
together. The trouble was too many lead-
ers didn't seem to want to pay anybody.
Guys would get fired in the middle of the
highway because they were talking too
loud on the bus or the leader owed them
too much money—something like that."

Though he'd succeeded in moving
beyond Nashville, Jimmy consistently
looked back on this time disdainfully. "Bad
pay, lousy living, and gettin' burned. That
was them days."

1964-

-1966

"

I WAS ALWAYS KEPT IN THE **BACKGROUND,** BUT I WAS THINKING ALL THE TIME ABOUT WHAT *I WANTED TO DO.*"

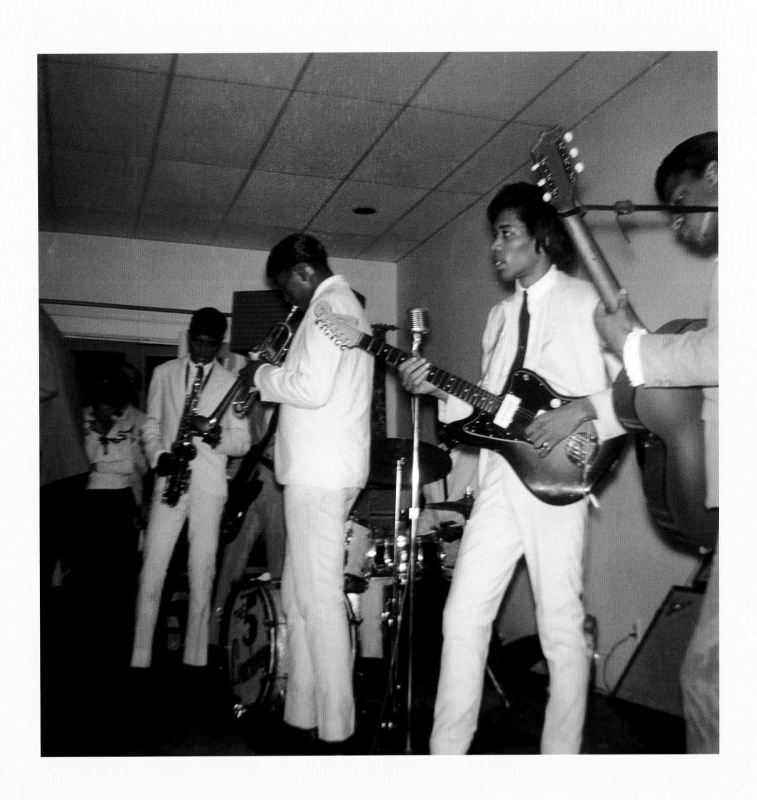

Jimi on guitar with the Isley Brothers.
Essex County Country Club, West
Orange, New Jersey, August 1965.

THE SIDE MAN

By 1964, Hendrix had gravitated to Harlem, the home for Black music on the East Coast, brimming with aggressive, independent Black entrepreneurs. Despite the continuing success of core blues artists such as Jimmy Reed, Elmore James, and Big Maybelle within the Harlem community, the music scene was evolving to R & B. Harlem was increasingly turning to the strident, youthful voice of James Brown while considering artists like Muddy Waters either old-fashioned or too down-home. Hendrix's tastes ran apart from the mainstream, as they always had. Remaining steadfast in his admiration for the blues, he also sought out the music of progressive, white folk and rock acts such as Bob Dylan and the Beatles.

Hendrix arrived in Harlem with virtually nothing to show for his musical exploits to date. He had only begun to showcase his emerging instrumental skills and had yet to demonstrate any ability as a composer or lead vocalist. Finding himself outside the perimeter of the tight-knit, insular Harlem music community, Hendrix was forced to begin anew, making connections and finding work. Worse still, he was broke and teetering on the brink of homelessness. In direct contrast to his depleted finances, Hendrix was full of fierce determination and entered an amateur contest at the fabled Apollo Theater, taking the $25 first prize. "I dug playing at the Apollo Theater," Hendrix said later. "So I stayed up there, starved up there for two or three weeks. I'd get a gig once every twelfth of never. I lived in very miserable circumstances. Sleeping among the garbage cans between them tall tenements was hell. Rats runnin' all across your chest, cockroaches stealin' your last candy bar from your very pockets. I even tried to eat orange peel and tomato paste."

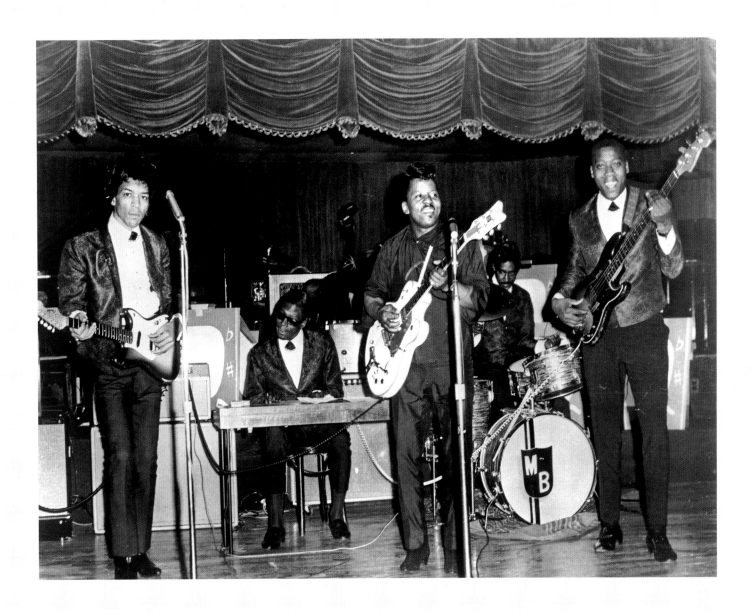

The Purple Onion, New York,
New York, 1966.

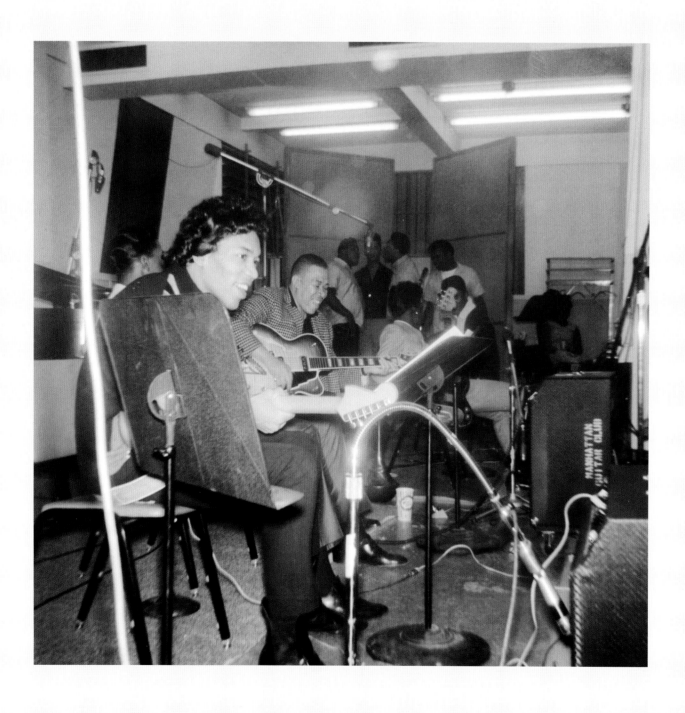

Jimi at Atlantic Studios, New York,
August 5, 1965.

Flat broke and with few options at his disposal, Hendrix met Fayne Pridgeon, a fixture in the Harlem scene, at a club. A strong, beautiful woman, Fayne was a diva of the Harlem scene, admired by men and women alike; although not a musician herself, she dated luminaries such as Otis Redding and Little Willie John. Pridgeon and Hendrix enjoyed an immediate connection. The two shared a love for each other and music and spent hours together listening to favorites from her mother's deep collection of blues 45s and 78s. She would later say that Hendrix would sit, transfixed, playing and singing to the likes of "Anna Lee" by Elmore James, lifting the needle back over passages he loved over and over again. Pridgeon was struck by Hendrix's knowledge and understanding of these artists and their music.

Pridgeon understood the guitarist's struggle to find steady work in Harlem and quickly intervened on his behalf. Through a mutual friend, she secured Hendrix an audition with the Isley Brothers. He made a positive impression and earned a position in the I.B. Specials, their backing group.

It was during his time with the Isley Brothers that Jimmy attracted the attention of Sue Records chief Juggy Murray. Murray had achieved national prominence for the independent label with breakout singles like "A Fool in Love" by Ike and Tina Turner and Baby Washington's "That's How Heartaches Are Made."

"King Curtis and I were out with a couple of dates," Murray said of the first time he and the great R & B saxophonist saw Hendrix. "We went to Small's Paradise, where they always had music. The Isley Brothers were there and Hendrix was playing guitar with them. I'd never seen this guitar player with the Isley Brothers before, but he was playing the guitar with his teeth, behind his back, and everything. He was just amazing, a hell of a guitar player. So, after the break, I approached him, gave him my card. Later he came down to the office and I signed him to an artists and management contract."

Murray viewed Hendrix as a latter-day Ike Turner, an artist whose instrumental skill could be paired with other talent or exploited on its own. In fact, Murray's emerging reputation as a hitmaker was due in part to his successful association with Turner. Murray hoped to replicate that same success with Hendrix, even though, unlike Turner, his new discovery had no experience as a bandleader, arranger, or songwriter.

"After I signed Jimmy," said Murray, "I had him up to the studio a couple of times. The problem was, how do you make a hit with a guitar player? Hendrix was different from Ike Turner. He wasn't a jazz guitar player, he was a rhythm and blues player who could also do rock. So how do you get a hit with that? It's all about making hits. It's not about how great somebody can play. We tried a couple of different things but nothing worked."

Murray turned his attention to other artists in his stable, and Jimmy continued playing with the Isley Brothers. Of all of his stints as a guitarist for hire, his tenure with the Isley Brothers was perhaps the most stable. He chafed at having to wear uniforms and replicate the same set exactly the same way night after night, but there were brief glimpses of light, as unlike previous groups with whom he toured, the Isley Brothers accorded him the opportunity to record with them. The raw, blistering solo Hendrix provided to "Testify" is a superb example of burgeoning talent. Nonetheless, Hendrix soon grew restless and left the group in the fall of 1964.

Next Jimmy played with Little Richard, though the arrangement was brief and turbulent. The flamboyant Richard was on the downside of a storied career by that period, and he had little tolerance for what he viewed as breaches of his authority. Hendrix ran afoul of Richard's strict dress code almost from the start. Richard also considered Hendrix's backline gyrations to be an effort to draw the spotlight from the fading star. "I played with Little Richard for about five or six months," Hendrix recalled. "I worked with him all over America, finally landing in Los Angeles where I had enough of Richard. He wouldn't let me wear frilly shirts on stage. . . . He had another meeting over my hairstyle. I said I wasn't going to cut my hair for nobody. If our shoelaces were two different types we'd get fined five dollars."

Still, Jimmy's departure from Richard was not over wardrobe constraints. "I quit because of a money misunderstanding," Jimmy said. "He didn't pay us for five-and-a-half weeks. You can't live on promises when you're on the road, so I had to cut that mess loose."

While steady gigs eluded him, Hendrix took comfort and strength from his relationship with Fayne Pridgeon. Together in Harlem, the two struggled to make ends meet, subsisting on hot dogs and whatever food they could afford. On more than one occasion, Jimmy's desire to outfit Fayne in a new dress or to buy the blues 45s he loved cost the couple their rent money. Desire to succeed burned within Hendrix, yet he seemed incapable of rising above his status as a capable R & B sideman.

Throughout 1965, Hendrix continued to work as a guitarist for hire, accepting positions with R & B stalwarts Joey Dee and the Starliters, and Curtis Knight & the Squires.

"I was always kept in the background," Jimmy said, "but I was thinking all the time about what I wanted to do."

Hendrix's tenure with Curtis Knight & the Squires was unique to any other professional experience he had enjoyed to date, as Knight shared the spotlight with the guitarist, allowing him much more leeway than other musicians had. In September 1965, Knight introduced Hendrix to a record producer named Ed Chalpin.

Chalpin auditioned Curtis Knight & the Squires at his studio and signed the group, including Hendrix, to recording contracts. According to Chalpin, at no time during this process did Hendrix inform him of the recording contract he had already signed with Murray at Sue Records.

Like his other work experiences, Hendrix's tenure with Curtis Knight & the Squires was brief. Knight's limited popularity earned them club dates throughout New York and New Jersey, but these were not sufficient enough to sustain Hendrix financially, and so with two recording contracts signed and nothing to show for it, he looked for work with other groups.

Hendrix found occasional employment in the form of short tours and recording session work with King Curtis and others. "I just got tired, man," Hendrix said of this time. "I just couldn't stand it anymore. I can't tell you the number of times it hurt me to play the same notes, the same beat. I was just kind of a shadowy figure up there, out of sight of the real meaning. I wanted my own scene, making my own music.

"I had these ideas and sounds in my brain, but I needed people to do it with and they were hard to find. I had friends with me in Harlem and I'd say, 'C'mon down to the Village so we can get something together.' But they were lazy, they were scared, plus they didn't think they were going to get paid. I said, 'Quite naturally you won't get paid on the audition, because it's us going down there being aggressive, it's us filtering down to them. So there's a few things you have to give up in the beginning.' They didn't want to do that, so I went down to the Village and started playing like I wanted."

Frustrated by his lack of progress, Hendrix shuttled from the Harlem base he shared with Fayne to Greenwich Village. Folk music had long been a centerpiece of the Village, but the area's crowded circuit of bars and nightclubs supported a variety of eclectic artists. In addition to folk, the traditional blues of Sonny Terry and Brownie McGhee was also welcomed. Despite the meager compensation that its intimate venues could offer an unknown blues guitarist such as himself, Hendrix embraced the spirit of Greenwich Village immediately. "In Greenwich Village people were more friendly than in Harlem, where it's all cold and mean," Hendrix recalled. "I couldn't stand it there because they talk about you worse than anyplace else! When I was staying in Harlem my hair was really long, and sometimes I might tie it up or do something with it. I'd be walking down the street and all of a sudden the cats, or girls, old ladies—anybody!—would be peekin' out, sayin', 'Oh, what's this supposed to be, black Jesus?' or, 'What is this, the circus or something?' God! Even in your own section. Your own people hurt you more."

Jimi with Curtis Knight & the Squires, 1965.

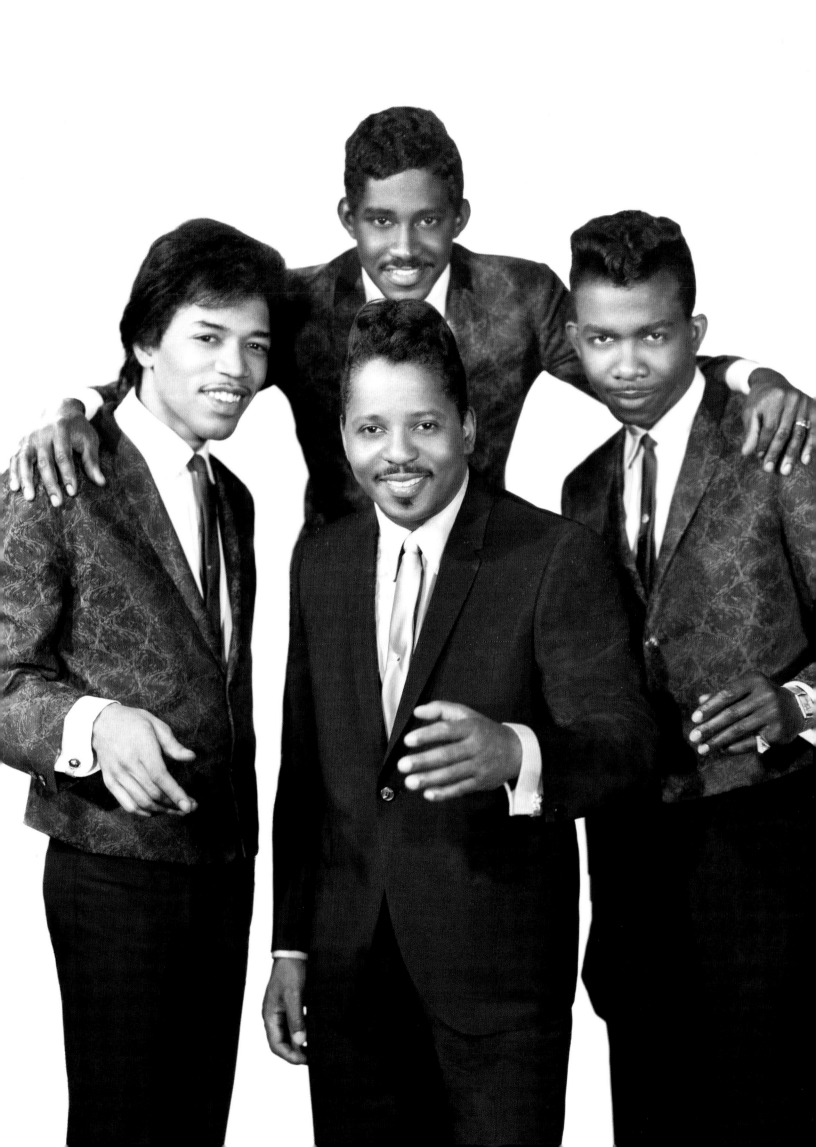

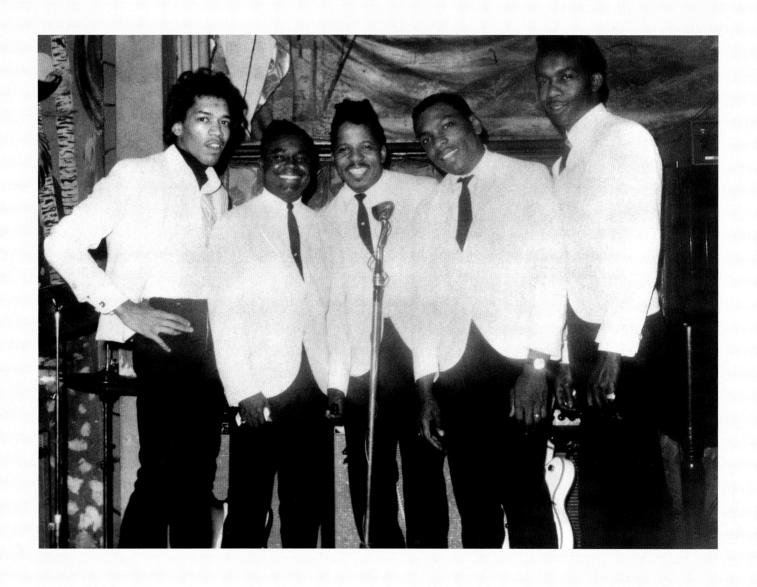

*George's Club 20, Hackensack,
New Jersey, 1966.*

Hendrix immersed himself within the bustling Village scene, befriending local artists like John Hammond Jr. and frequenting many of the small venues. Flat broke, he began taking part in afternoon jam sessions at the Nite Owl, where participating musicians were provided free lunch. Hendrix then set about drafting musicians from among the Village regulars for a new group he would front. "I changed my name to Jimmy James," he said, "and called the group the Blue Flames."

The quartet was made up of Village musicians, including rhythm guitarist Randy Wolfe, a local teenager Hendrix dubbed "Randy California." Soon the Blue Flames had low-paying gigs at tiny venues such as Cafe Wha?, a basement club known more for its free afternoon admission and cheap evening cover charge than the caliber of performers it presented. The Blue Flames' sets were filled with the blues favorites Hendrix loved but also his own interpretations of "Hey Joe," Bob Dylan's "Like A Rolling Stone," and the Troggs' "Wild Thing."

While Hendrix had found a bit more success, he was still struggling for recognition. It was then that he met Linda Keith, girlfriend of Rolling Stones guitarist Keith Richards, and she became his champion. Linda was impressed by Jimmy's polite demeanor, and Jimmy, in turn, immediately took to Linda. The two were not a couple, but Linda's assertiveness, not unlike Fayne's, impressed him, and their friendship accelerated rapidly. Linda talked up the guitarist to as many well-connected friends as she could. Both Rolling Stones manager Andrew Loog Oldham and future Sire Records chief Seymour Stein came to see Hendrix on her recommendation, but each passed.

Then, in July 1966, Linda met Chas Chandler, the Animals bassist who was embarking on a career as a record producer. Chandler was looking to find an artist to cover the song "Hey Joe," convinced it had excellent commercial prospects if performed by the right person. Linda encouraged Chandler to go see Jimmy perform at Cafe Wha?, and when Hendrix opened his set with "Hey Joe," Chandler sat transfixed, unable to believe no one had spotted Hendrix before. When Linda introduced the two after the set, Chandler immediately asked Hendrix to come to England to record "Hey Joe." He promised to make him a star. Though this meeting would change history, Jimmy's initial reaction was simply a practical response to the hard life he was living in New York. "I said that I might as well go because nothing much was happening. We were making something near three dollars a night and we were starving." Chandler set about securing a passport for the guitarist, and the two left for London on September 23, 1966. Chandler switched gears from musician to manager quickly. It was Chandler who suggested that Hendrix change the spelling of his first name, and "Jimi Hendrix" was born.

"SOME PEOPLE HAVE TOLD ME THAT THEY THINK WEARING A MILITARY JACKET IS AN INSULT TO THE BRITISH ARMY. LET ME TELL YOU I WEAR THIS OLD BRITISH COAT OUT OF RESPECT. THIS WAS WORN BY ONE OF THOSE 'CATS' WHO USED TO LOOK AFTER THE DONKEYS WHICH PULLED THE CANNONS WAY BACK IN 1900. THIS COAT HAS A HISTORY; THERE'S LIFE TO IT. I DON'T LIKE WAR, BUT I RESPECT A FIGHTING MAN AND HIS COURAGE."

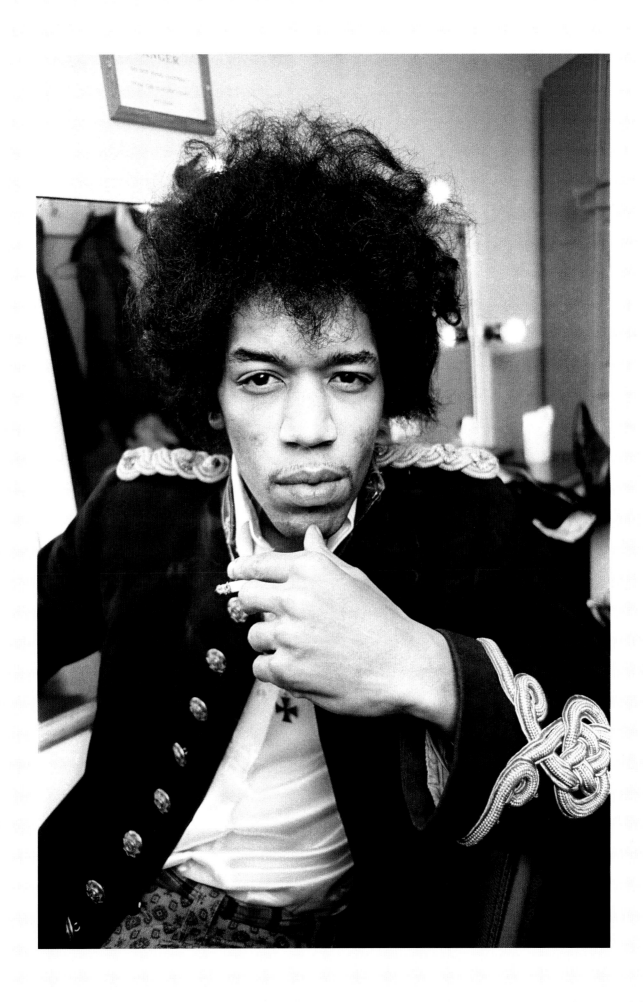

Jimi backstage, December 1966.

THE JIMI HENDRIX EXPERIENCE

Once in London, Hendrix quickly fulfilled Chandler's grand dream. Late in September, Chandler bumped into Eric Clapton and Jack Bruce at the popular venue the Cromwellian Club. He spoke of Hendrix in glowing terms. Bruce and Clapton were clearly intrigued, instructing Chandler that if Hendrix was as good as he claimed, he should bring the guitarist to jam with them at their October 1, 1966, Regent Polytechnic gig.

As promised, Chandler escorted Hendrix to the show and the two found their way backstage, where Chandler encountered a reluctant Ginger Baker, drummer for Cream. Baker, with whom Chandler had enjoyed a long friendship, allowed Hendrix to sit in with the group on the condition that guitarist Eric Clapton remain onstage in case the jam session failed. Hendrix took full advantage of the opportunity, tearing into his frenzied reworking of Howlin' Wolf's recent

"Killing Floor." Clapton left the stage in a daze. Chandler rushed to Clapton backstage, worried about his reaction. He needn't have, as Clapton said, "Is he that fucking good?" At that, Chandler knew that word of his new protégé's remarkable ability would soon spread throughout London's music community.

Chandler also arranged for Jimi to sit in with jazz-rock organist Brian Auger as French pop sensation Johnny Hallyday looked on. The jam session greatly impressed Hallyday, who was so taken by Hendrix that he offered Chandler an opportunity for the guitarist to open for him on his upcoming French tour. Hendrix didn't even have a band to play with as yet, but Chandler jumped at the opportunity.

*"Top of the Pops" BBC, Lime Grove
Studios, London, December 29, 1966.*

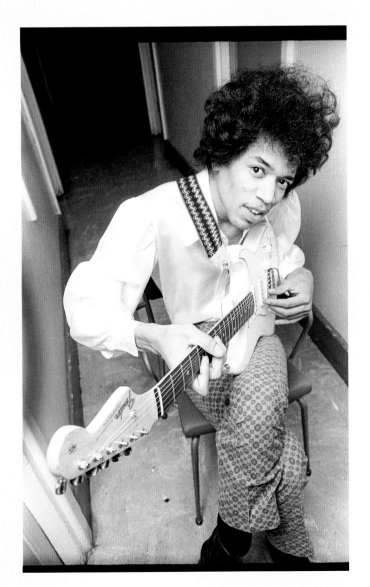

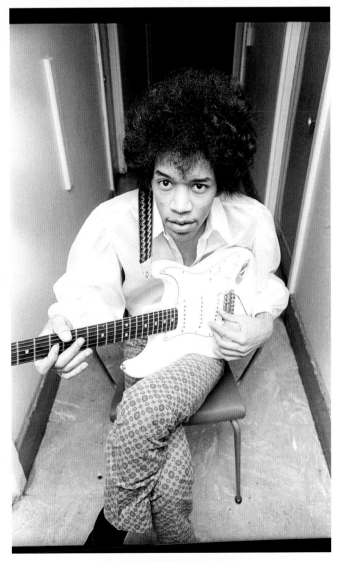

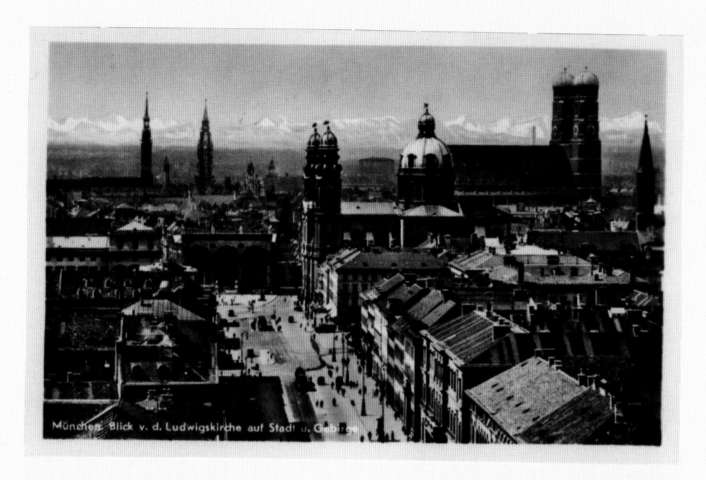

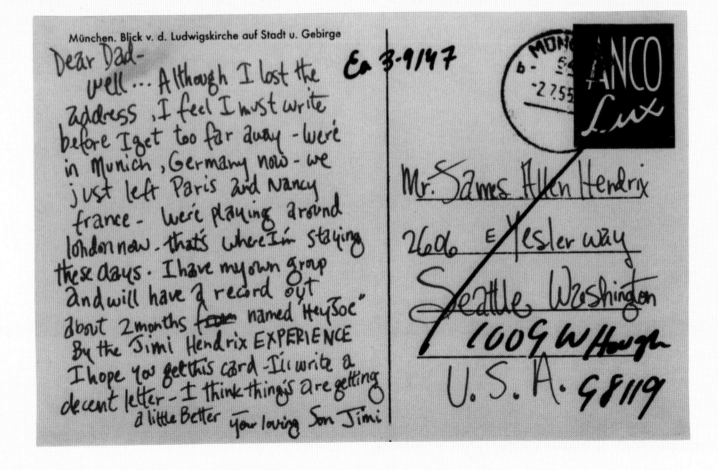

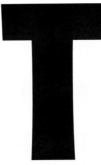

Though Chandler had enjoyed a string of international chart successes as a member of the Animals, he had little money to show for his efforts. Chandler had been one of five original Animals, leaving him a modest income after management commissions and expenses were paid. Moreover, many of the Animals' hit singles had been cover versions of songs composed by others, exempting them from valuable royalty income. He knew that in order to launch Hendrix using his own limited finances, he would have to take advantage of the Hallyday tour opportunity.

He needed to move swiftly to get a group for Jimi and used his Animals connections to do so. Aware that Animals lead vocalist Eric Burdon planned to form a new configuration of the group to continue his career, Chandler used auditions advertised for "Eric Burdon and the New Animals" to recruit musicians to back Hendrix's guitar and vocals.

The first musician selected was Noel Redding, an aspiring guitarist who had traveled from Kent to London's Birdland club hoping to secure a position in Burdon's band. When he arrived, the slot had been filled. "Chas wandered up to me and asked if I could play bass," Redding remembered. "I told him that I didn't play bass, but that I would give it a go." Chandler lent Redding his bass and Hendrix, joined by Aynsley Dunbar on drums and Mike O'Neill on keyboards, ran through a series of chord changes. "This American gentleman with a funny pair of shoes on and a funny overcoat just sort of told me the chords, and we went through them and then we played three tunes, that was it," Redding recalled. "There were no vocals involved. Then the American bloke said, 'Do you want to go down and have a pint of bitter or something?' So we went down to this place next door and had this discussion. I was asking him all about the American music scene—Sam Cooke and Booker T & the M.G.'s were my sort of favorites—and he was asking me about the English scene because he'd only been there for about a week. Then he said, 'Do you want to join my group?' That was it."

Finding a suitable drummer proved more difficult. Hendrix and Redding jammed with Aynsley Dunbar, John Banks of the Merseybeats, and Mitch Mitchell, who had won praise for his jazz-influenced work with Georgie Fame & the Blue Flames. Days after their auditions, with Hendrix deadlocked over Dunbar and Mitchell, Chandler flipped a coin and Mitchell came up a winner. With a bassist and drummer in place, the Jimi Hendrix Experience—as Chandler named the group—was complete.

Jimi called home to Seattle, where his dad had remarried and adopted his new wife's young daughter, Janie. Jimi told Al, "I'm on the way to the big time. They're forming this band around me and I'm going to have a bass player and a drummer—these two English guys—and we're going to be called the Jimi Hendrix Experience."

Jimi's postcard to his father from Munich, Germany, letting him know "things are getting a little better," 1966.

With their public debut just days away, the Experience needed to build a stage repertoire. Their slot on the Hallyday tour called for three or four songs per night. The trio built a set list of "Hey Joe," "Wild Thing," and a handful of Hendrix's R & B staples, including "Have Mercy," "Land Of 1000 Dances," and "Everybody Needs Somebody To Love." But they didn't have anything original, no song that another group hadn't already made famous.

The group's energy and enthusiasm carried them through the first three performances of the tour. In Paris, Hendrix thrilled the sold-out house at the famed Olympia theater, winning over an audience the guitarist described as tougher than the Apollo's rowdy crowds. Their enthusiastic reception on tour boosted the group's confidence and sent them back to London riding a wave of momentum.

Hendrix recorded the basic track for "Hey Joe" at De Lane Lea Studios in London, including a lead vocal, but neither he nor Chandler considered the effort his best performance. While Chandler's faith in Hendrix's abilities was unshakable, Jimi held deep reservations about the quality of his voice prior to the initial recording session. "It was the first time I ever tried to sing on a record actually," admitted Jimi. "I was too scared to sing." Chandler then escorted Hendrix to a host of different London studios in the weeks that followed, trying to perfect Jimi's take on the song. When it was finally mastered, the group focused on material for the flip side of their debut single. They now ran afoul of the same problem they had faced when the Experience established their repertoire: Hendrix had no original material prepared. The guitarist suggested a cover of the popular R & B dance hit "Land Of 1000 Dances," but Chandler refused, imploring him to compose a new original. Hendrix rose to the challenge, responding with the energetic "Stone Free." The song—the first ever Hendrix had composed for the Experience—was recorded and mixed in a single day.

With the new single in hand, Chandler and his partner, Animals manager Michael Jeffery, sought a record deal. Their first stop was a meeting with Decca A & R representative Dick Rowe, who was perhaps best known for having turned down the Beatles some years previously. True to form, he passed on Hendrix as well.

Chandler had better success with Kit Lambert, co-manager of the Who. Lambert and his partner Chris Stamp were launching Track Records, a fledgling, independent label distributed by Polydor, an established European label. Lambert watched Hendrix perform at the Scotch of St. James club in London and was so taken by the guitarist that he and Chandler wrote out a deal on a beer mat right there and then.

Even prior to the release of "Hey Joe," the Experience had become the talk of the London music community, fueled by curiosity about Hendrix and his music. Here was a heretofore undiscovered American artist imbued with the same authenticity of Muddy Waters, Elmore James, Buddy Guy, and other heroes whose music had informed the burgeoning British blues boom.

Club appearances by the Experience at small venues such as the Bag O' Nails were packed full with people all eager to witness the amazing guitarist Chas Chandler had imported from America. "Suddenly we noticed we were filling the places," remembered Redding. "Suddenly you'd look up and see John Lennon over in the corner or Paul McCartney and Bill Wyman watching us play." Eric Clapton, Jeff Beck, and Pete Townshend also flocked to the Experience's club appearances to bear witness to Hendrix's seemingly limitless ability.

"Top of the Pops" BBC, Lime Grove Studios, London, December 29, 1966.

"Jimi told Al, 'I'm on the way to the big time. They're forming this band around me and I'm going to have a bass player and a drummer— these two English guys—and we're going to be called the Jimi Hendrix Experience.'"

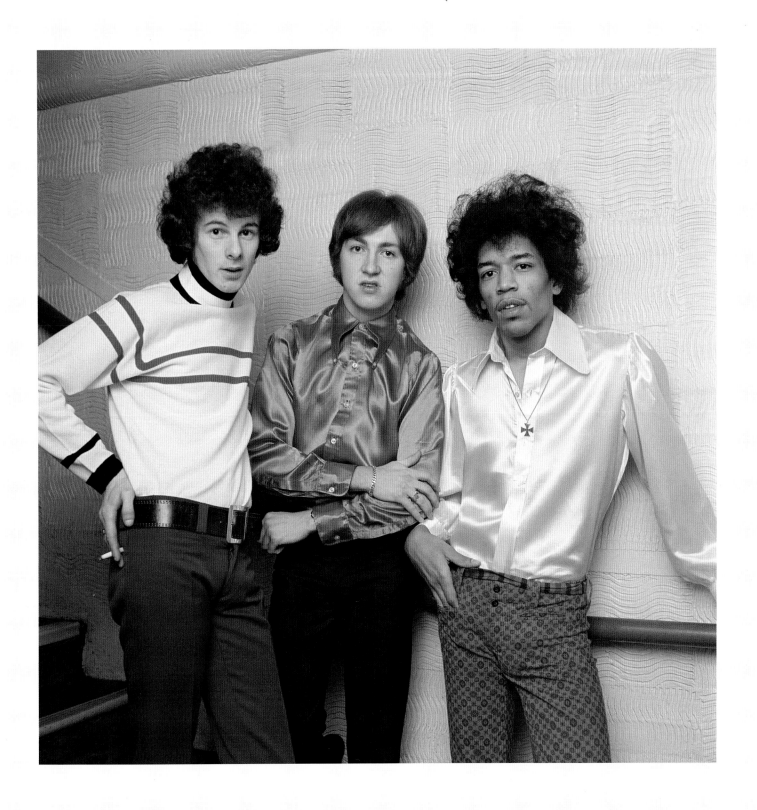

ABOVE
"Top of the Pops" BBC, Lime Grove
Studios, London, December 29, 1966.

BELOW
Big Apple Club, Munich, Germany,
November 8, 1966.

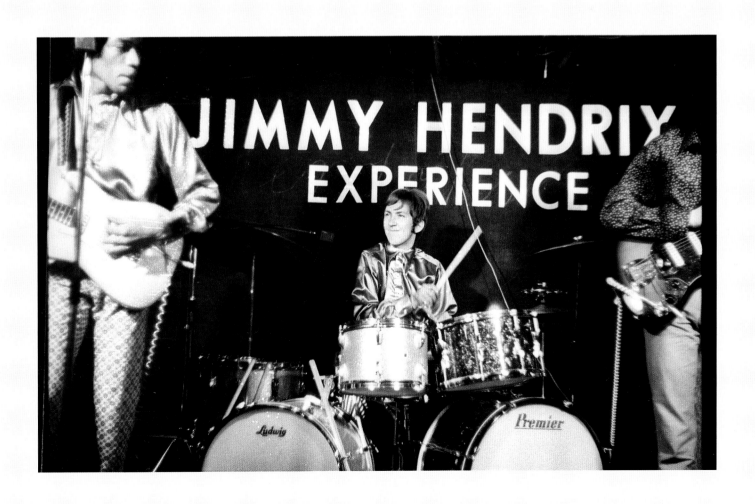

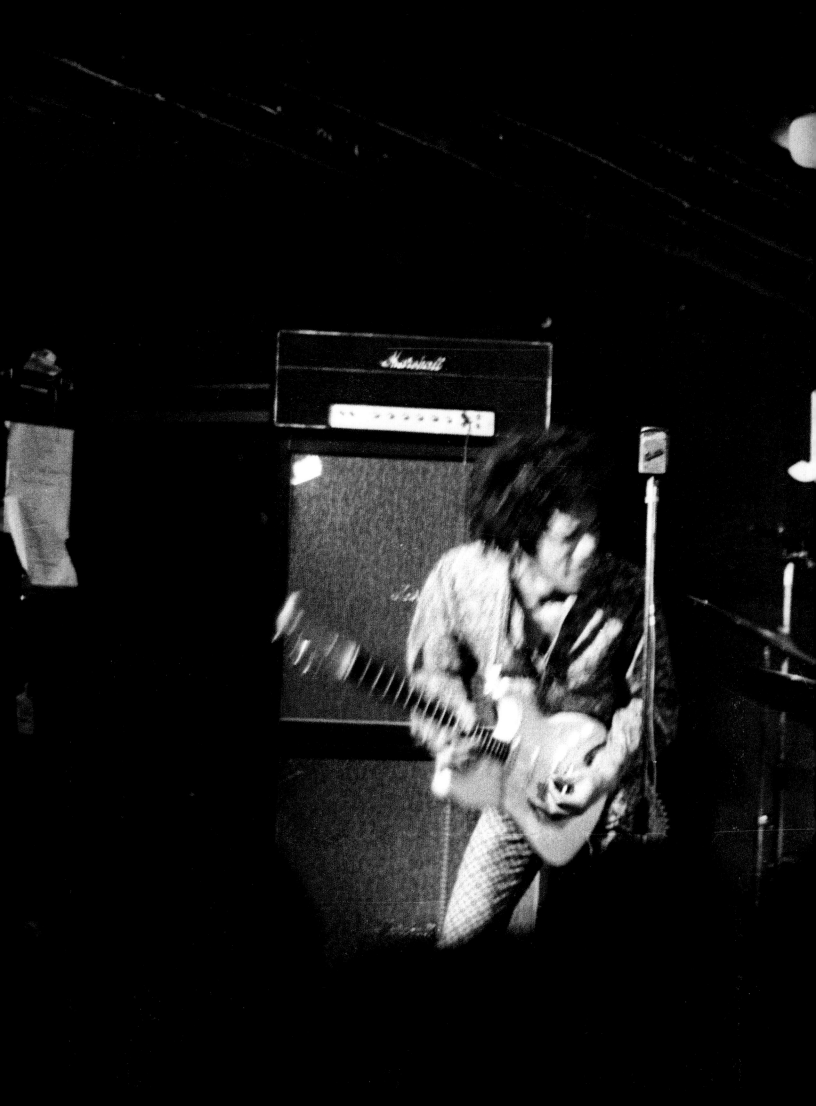

Hendrix was Chandler's only client, allowing the tall, affable Geordie from Newcastle to carefully consider and develop every aspect of the guitarist's career. Chandler and his wife Lotte opened their home to him, and Hendrix moved into their Berkeley Street apartment in London. The move to Chandler's provided Hendrix with the first stable living environment he had enjoyed for years, producing a marked impact on him and his creative output. New songs took form, with Chandler using his keen pop sensibility to act as a sounding board. In the flat, he would position himself across from Jimi, listening intently to new material and offering comments about arrangements and other refinements.

Living with Chandler had a pronounced influence on Hendrix's lyrics and poetry as well. Chandler's penchant for science-fiction novels helped shape Hendrix's new material. The roots of future Experience classics such as "3rd Stone from the Sun" and "Up from the Skies" traced back to the inspiration Hendrix discovered in Chandler's library.

After all of Chandler's hard work and his steadfast belief in both Hendrix and the commercial prospects of "Hey Joe," he and Jimi were rewarded when the song, issued in December 1966 by Track, spent ten weeks on the UK singles chart. The song reached number six in February 1967, as high as it would go. More importantly, the success of "Hey Joe" established Hendrix as a rising star across Europe.

As "Hey Joe" climbed the charts, Hendrix readied his next single. "'Purple Haze' was written backstage at the Upper Cut Club on Boxing Day [December 26, 1966]," recalled Chandler. "The riff had come to him about ten days before. I heard him playing it at the flat and was knocked out. I told him to keep working on that, saying, 'That's the next single!' That afternoon at the Upper Cut, he started playing the riff in the dressing room. I said, 'Write the rest of that!' so he did." With the song finished, Chandler urged Hendrix into the studio, eager to produce the song he instinctively knew would land the Experience back on the charts. As a producer, Chandler's guiding principle focused on good preparation

in advance of recording so as not to waste time or money once a session had begun. The Animals, he often cited, had cut "House of the Rising Sun" cheaply and efficiently, and it had become one of their biggest hits.

The success of "Hey Joe" gave Hendrix the money to upgrade to Olympic Studios, London's leading independent recording facility. There he was introduced to staff engineer Eddie Kramer, who fast established an easy rapport with Chandler and the group. His sympathetic understanding of Hendrix's desire to experiment with sound manifested itself immediately in "Purple Haze." The song's sped-up guitar and inventive mixing techniques opened Hendrix's imagination toward the infinite possibilities of the recording process. "Purple Haze" was released in March 1967. It soon outpaced "Hey Joe" in Britain, earning the group its second consecutive UK top-ten chart success, peaking at number three.

With the bitter frustration he had endured prior to arriving in London fresh in his memory, Hendrix relished having found someone in Chandler who recognized his ability and shared his determination. Chandler's steady encouragement generated a burst of creativity from Hendrix, and new songs began to flow in a steady stream. As Hendrix developed new material, Chandler pounced upon each original song, booking studio time based upon the readiness of new material. Terrific new songs such as "Fire" and "Foxy Lady" were refined and stage tested for audiences in clubs and theaters across Europe before being added to the growing pile Chandler had set aside for Hendrix's debut album.

In March 1967, the Experience embarked on a package tour across Britain together with Cat Stevens, teen idols the Walker Brothers, and Engelbert Humperdinck, among others. With the tour, Chandler hoped to catapult Hendrix into the mainstream, elevating the Experience from the club circuit and introducing the band to a broader demographic.

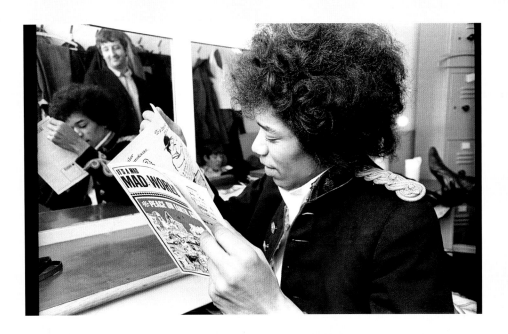

PREVIOUS
Big Apple Club, Munich, Germany,
November 8, 1966.

RIGHT
"Top of the Pops" BBC, Lime Grove
Studios, London, December 29, 1966.

Opening night at London's Astoria Theatre, the excitement was palpable, and Hendrix was eager to make an impression. Backstage before the band went on, music reporter Keith Altham offered a casual suggestion to Hendrix that he consider setting his guitar on fire to accompany the eponymous song. Hendrix was taken by the idea and discussed with Chandler how to incorporate the stunt within his set. Road manager Gerry Stickells was discreetly dispatched to purchase lighter fluid, and no one outside the group was made aware of what would take place.

When the Experience took the stage, Hendrix was at his most outrageous, incorporating all of his now patented stage moves. Throughout his forty-five minute set, he joyously played the guitar one-handed, with his teeth, through his legs, and behind his back, all to the howling delight of the sold-out crowd. At the close of his set and the song "Fire," he placed his guitar on the stage floor, doused it with lighter fluid, and set the instrument ablaze. The Astoria crowd absolutely erupted.

The popular success of "Purple Haze," coupled with Hendrix's burning of his guitar at the Astoria, sent London's Fleet Street press into a frenzy. Hendrix was dubbed "The Black Elvis" and the "Wild Man of Borneo." Chandler and Jeffery were thrilled by the priceless publicity working to quickly elevate Hendrix's profile. "[Hendrix and I] used to sit at our apartment in the evenings and work out who we were going to offend tomorrow," Chandler explained. "We did nothing but sit home, play Risk, and talk about his career."

Amid this fervor, Hendrix readied both "The Wind Cries Mary," the group's next UK single, and Are You Experienced, the group's groundbreaking debut album. "The Wind Cries Mary" continued a remarkable run of chart successes across Europe. "That was recorded at the tail end of the session for 'Fire,'" Chandler explained. "We had about twenty minutes or so left, because in them days, I would book two hours and that was it. I suggested that we cut a demo of 'The Wind Cries Mary.' Mitch and Noel hadn't heard it, so they were going at it without a rehearsal. They played it through once and I remember saying that I really liked the feel of the song. Jimi came back in and said, 'I have a good idea for an overdub.' So he went back in and played 'Between,' as he called

it, the notes he had already recorded. He didn't even come back into the control room after he put the second guitar on. He said, 'I have another idea. Can I put it on?' In all, he put on four or five overdubs, but the whole thing was done in twenty minutes. That was our third single."

A flurry of work at Olympic Studios rounded Are You Experienced into final form. Chandler again drew on his keen understanding of pop formula to establish parameters for Hendrix. These boundaries required Hendrix to channel his vision into a more conventional song structure. "Most of the songs, like 'Purple Haze' and 'The Wind Cries Mary' were about ten pages long," Hendrix explained. "We are restricted to a certain time limit so I had to break them all down."

Issued in May 1967, Are You Experienced was a supreme achievement for the time, its scope encompassing blues, rock, and R & B. The rich diversity of sounds Hendrix achieved on the debut album would become one of its hallmarks. "It's a collection of free feeling and imagination," Hendrix detailed shortly after its release. "I've written songs for teenyboppers like 'Can You See Me.' 'I Don't Live Today' is dedicated to the American Indian and other minority repressed groups. 'Manic Depression' is ugly times music. It is so ugly you can feel it. It's a story about a cat wishing he could make love to music instead of the same old everyday woman. It's a frustrating type of song, a today's type of blues." In "Red House," Hendrix had created an updated blues song full of the same emotion, power, and clarity that idols such as Buddy Guy, Howlin' Wolf, and Otis Rush had incorporated into their work.

Are You Experienced became an immediate best seller across Europe and has long since been considered one of the finest debut albums in rock history. In a Rolling Stone review, writer Jon Landau confessed he'd rather hear Jimi play the blues, but he couldn't deny the breakthrough aspects of the work and wrote, "On the Are You Experienced album Jimi has made a tremendous technical advance in the use of three instruments." He called Jimi "a great guitarist and a brilliant arranger.... [He] feeds and fuzzes just about everything, knows every gimmick in the book, and has a fantastic touch."

"Ready, Steady, Go!," BBC, Rediffusion Studios, London, December 13, 1966.

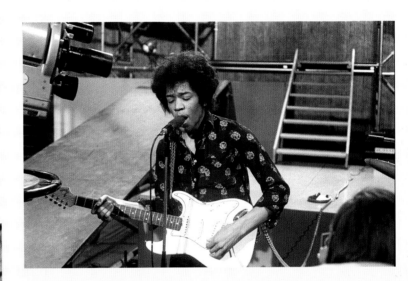

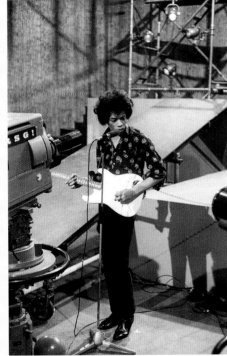

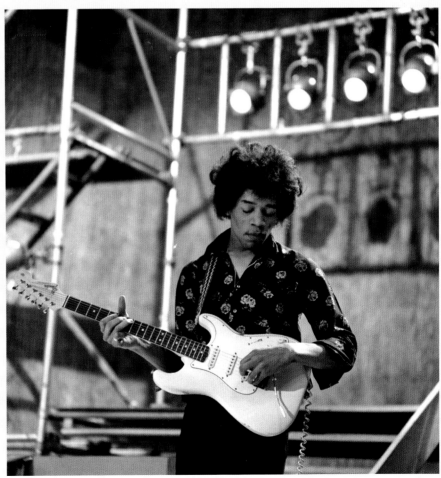

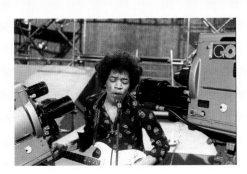

"AND WE MADE IT MAN, BECAUSE WE DID **OUR OWN THING**, AND IT REALLY WAS OUR OWN THING AND **NOBODY ELSE'S.** WE HAD OUR BEAUTIFUL ROCK/BLUES COUNTRY/FUNKY/FREAKY SOUND; IT WAS REALLY TURNING PEOPLE ON. I FELT LIKE WE WERE TURNING THE **WHOLE WORLD** ON TO THIS NEW THING. **THE BEST, MOST LOVELY NEW THING.**"

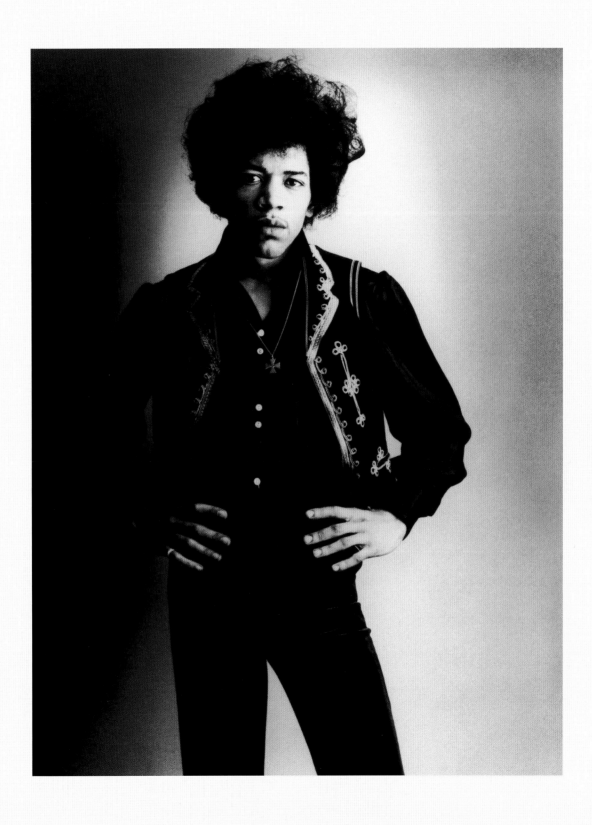

Hendrix in London, 1967.

WILD THING

During Jimi's early days in London, the Beatles had been his enthusiastic champions. The admiration was mutual, as Hendrix enjoyed the Beatles and the creative freedom found in their music.

The release of *Sgt. Pepper's Lonely Hearts Club Band* on June 1, 1967, legitimized a new sound and movement known as "psychedelia." Three days later, with *Are You Experienced* still riding high in the UK album charts, the Experience headlined a show at London's Saville Theatre, a venue owned by Beatles manager Brian Epstein. Most of Saville's audience had only just begun to absorb *Sgt. Pepper's* incredible new sounds, so when Hendrix and the Experience opened their set with their own version of *Sgt. Pepper's* title track, it brought the audience—which included Paul McCartney and George Harrison— to their feet. McCartney later described Jimi's version as "simply incredible, perhaps the best I had ever seen him play."

In fact, it was McCartney's admiration for Hendrix that helped the Experience secure a coveted booking at the Monterey Pop Festival that June. McCartney had agreed to serve as a board member for the ambitious music festival, and recommended Hendrix to festival organizers Lou Adler and John Phillips, front man for the Mamas and the Papas. Without seeing or hearing Jimi play, the two accepted McCartney's word that he would make a great addition to the festival lineup. The Experience was now set to make a high-profile US debut.

The Monterey organizers had assembled a diverse pool of talent that included emerging psychedelic groups from Los Angeles and San Francisco, but also the likes of Lou Rawls, Hugh Masekela, Simon & Garfunkel, and Otis Redding. The Experience were scheduled to perform on Sunday, the final evening of the festival. Sunday's programming began with a lengthy set by Indian sitar master Ravi Shankar, followed by sets from the Grateful Dead and the Blues Project. Then the Who took the stage.

Monterey International Pop Festival, Monterey, California, June 18, 1967.

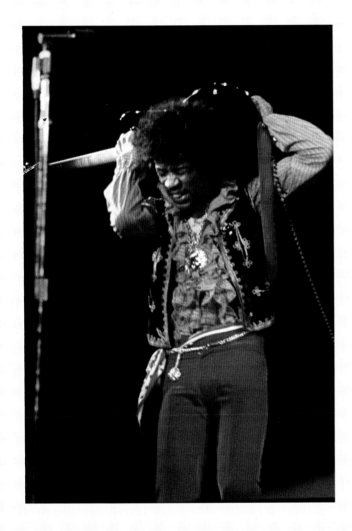

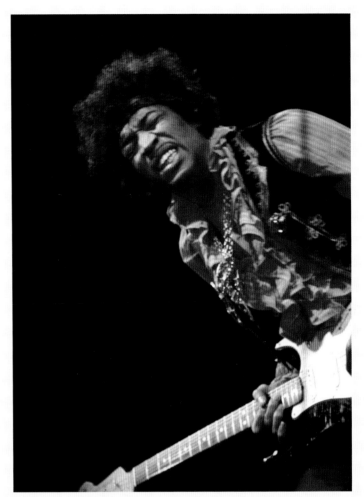

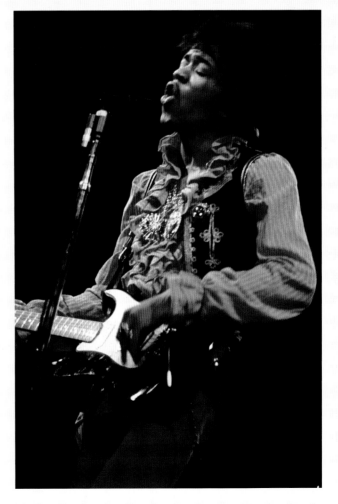

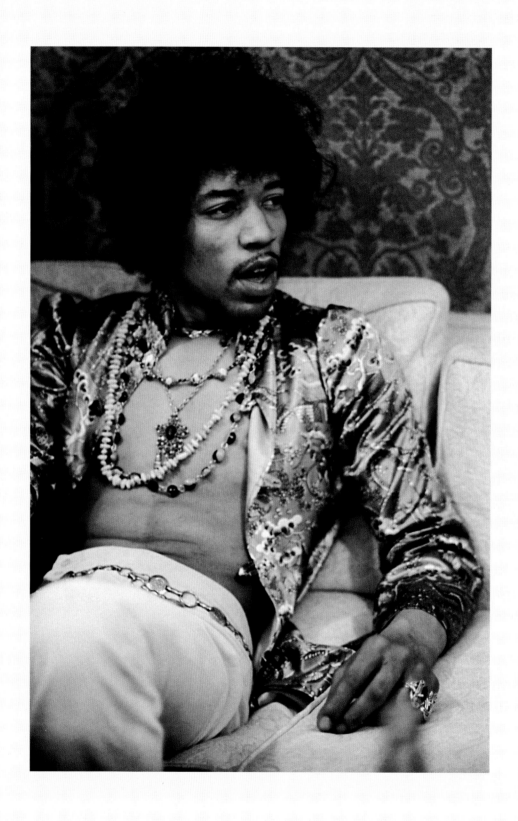

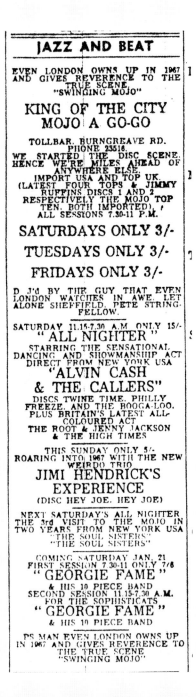

Jimi reclining on sofa backstage at Hollywood Bowl, Hollywood, California, August 18, 1967.

Before the Who went on, there had been much backstage deliberation regarding the lineup. Neither the Who nor the Experience had wanted to follow the other, concerned by the talent of the other band. Success at Monterey was crucial to both bands in terms of gaining a foothold in the US market. In the end, it took a backstage coin toss by John Phillips to decide the matter. When he lost, Hendrix jumped up onto a chair and announced that if he had to follow the Who, he was going to pull out all of the stops. Hendrix watched with interest as the group energized the Monterey audience with furious renditions of "Pictures of Lily" and "Substitute." During the destructive climax of "My Generation," Pete Townshend began smashing his guitar as singer Roger Daltrey swung his microphone defiantly through the air. Keith Moon toppled his drum kit as smoke filled the stage and bleating feedback emanated from the group's stacks of amplifiers. The Who had proved as difficult an act to follow as Hendrix had feared.

The Experience were introduced by Rolling Stones guitarist Brian Jones and took the stage to polite applause. Whereas some Monterey audience members were familiar with the Who, whose single "Happy Jack" had made the US charts, the Experience was almost entirely unknown. Reprise had recently issued "Hey Joe" as a single, but the song was deemed too "hard" for AM Top 40 radio stations across the United States, and had no commercial impact.

Hendrix rose to the challenge immediately. The group opened with furiously paced covers of Howlin' Wolf's "Killing Floor" and B.B. King's "Rock Me Baby," punctuated throughout by Hendrix's dynamic stage presentation. The group tore through a charged set, effortlessly blending the sheer frenzy of "Can You See Me" with the R & B-infused beauty of "The Wind Cries Mary." Bob Dylan's "Like A Rolling Stone" was instilled with remarkable power and intensity. Hendrix sang every line as if the words had been written to describe his own struggle. "Hey Joe" was no less convincing. Hendrix played brilliantly, seamlessly biting the guitar with his teeth and playing behind his head, building toward a finale no one at Monterey could have imagined.

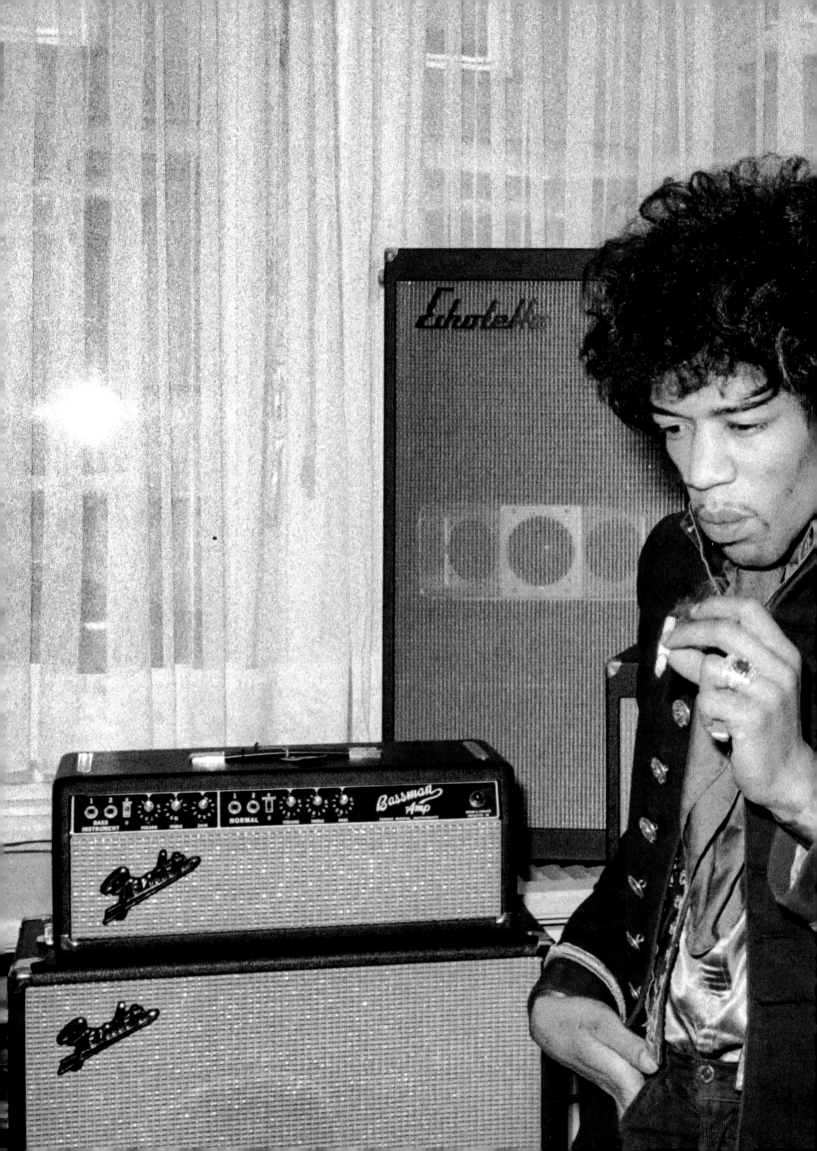

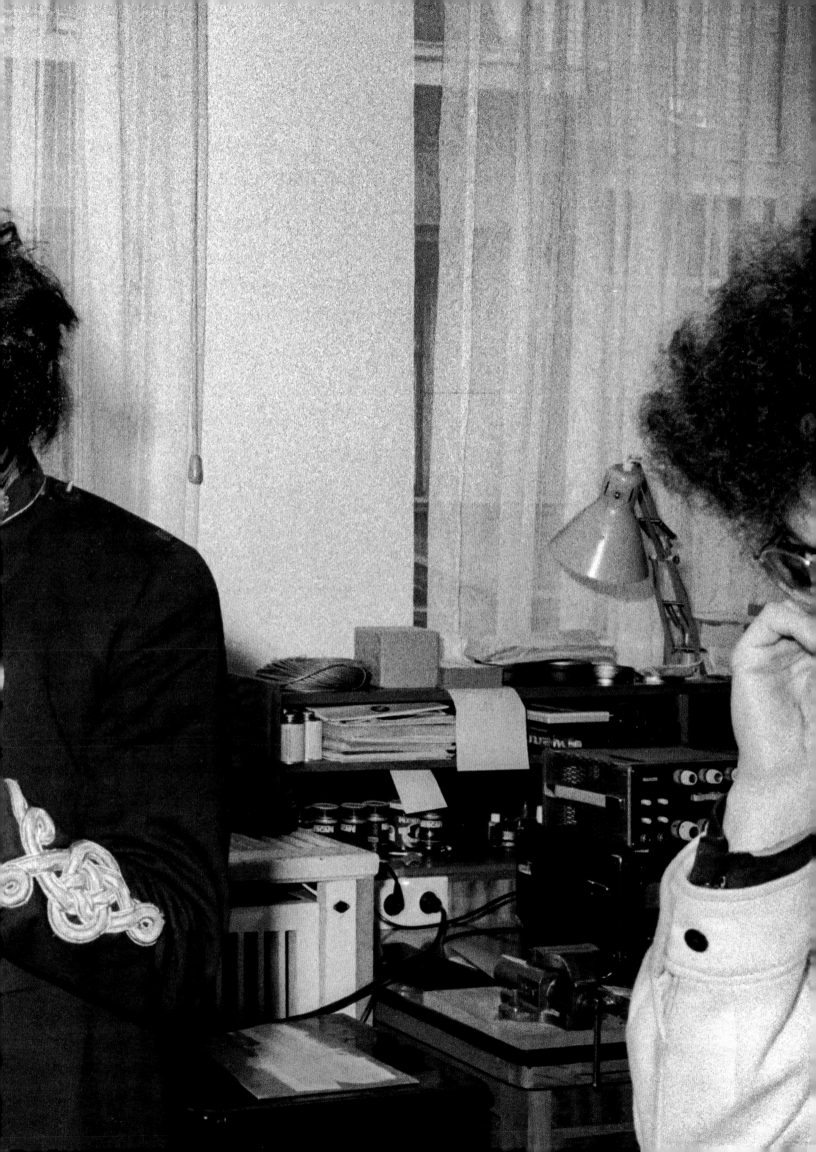

PREVIOUS
Musik Zinngrebe, Hamburg, Germany,
March 20, 1967.

BELOW
Monteray County Fairgrounds,
Monterey California, June 18, 1967.

"So I decided to destroy my guitar at the end of a song as a sacrifice. You sacrifice things you love. I love my guitar."

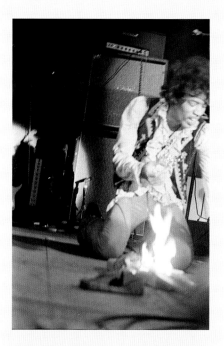

When Hendrix announced "Wild Thing," describing the song as the "English and American anthem combined," he also cryptically added that he planned to sacrifice something he really loved. As he had promised backstage, he pulled out all of the stops, incorporating as many of his fabled stage moves into this one number. He began with an elaborate, feedback-drenched opening before launching into the song. Hendrix held nothing in reserve, thrusting his pelvis, suggestively flicking his tongue, and waving his arm in perfect syncopation with the music. The guitar seemed an extension of his fluid body movements. Where Townshend's stage destruction seemed born of rage, Hendrix's act seemed overtly sexual, and overwhelmed an unsuspecting Monterey audience. In his solo, Hendrix included a wonderfully appropriate, one-handed version of Frank Sinatra's "Strangers in the Night" before savaging his amplifiers in a vicious frontal assault. As Redding and Mitchell frantically continued, Hendrix walked back to his amplifier, grabbed a can of Ronson lighter fluid, and set his hand-painted Fender Stratocaster on fire. Squatted over his instrument, he coaxed the flames higher and higher before raising and smashing the guitar to pieces. The group walked off stage as the audience looked on in shock, uncertain of what they had just witnessed.

Hendrix's Monterey performance may have startled many of those who witnessed it, but few members of the legitimate press took notice. *Billboard* magazine, in fact, was thoroughly unimpressed

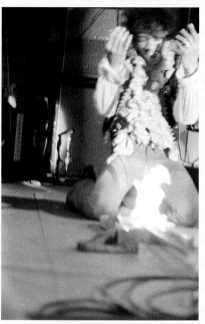

with the Experience and Hendrix's performance. "The Jimi Hendrix Experience proved to be more experience than music, pop or otherwise. Accompanied by overmodulated squeals and bombastic drumming, the Hendrix performance is quite a crowd rouser but its sensationalism is not music, and unlike Chuck Berry (who was doing some of this stuff fifteen years ago), when Hendrix sings he has trouble phrasing, and his modal turned chicken choke handling of the guitar doesn't indicate a strong talent either."

Yet despite the criticism, Hendrix's triumphant homecoming at Monterey concluded a remarkable reversal of fortunes for the guitarist. In just one year, Hendrix had emerged from virtual obscurity in Greenwich Village to take first Europe and then America by storm as the charismatic leader of the Jimi Hendrix Experience. Rock 'n' roll had never before witnessed this special blend of verve, sexuality, and raw power. At Monterey, Hendrix said, "Everything was perfect. When I was in Britain I used to think about America every day. I'm American. I wanted people here to see me. I also wanted to see whether we could make it back here. And we made it, man, because we did our own thing, and it really was our own thing and nobody else's. We had our beautiful rock/blues/country/funky/freaky sound and it was really turning people on. I felt like we were turning the whole world on to this new thing, the best, most lovely new thing. So I decided to destroy my guitar at the end of a song as a sacrifice. You sacrifice things you love. I love my guitar."

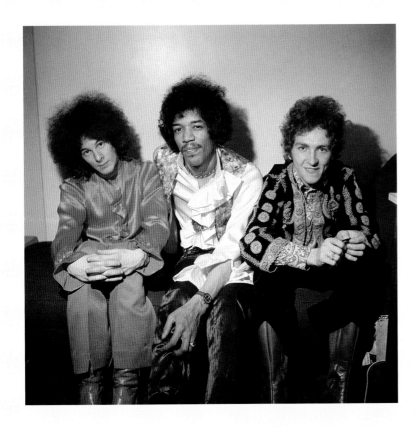

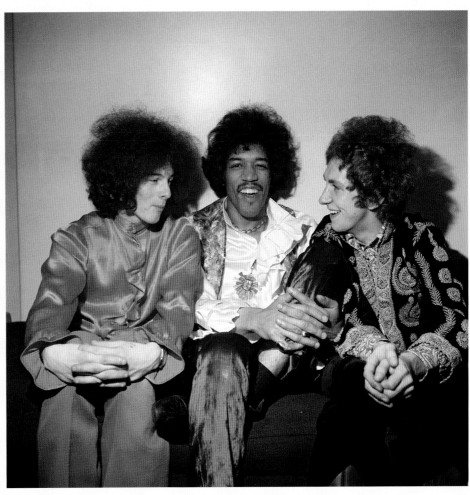

Press Reception, London, 1967.

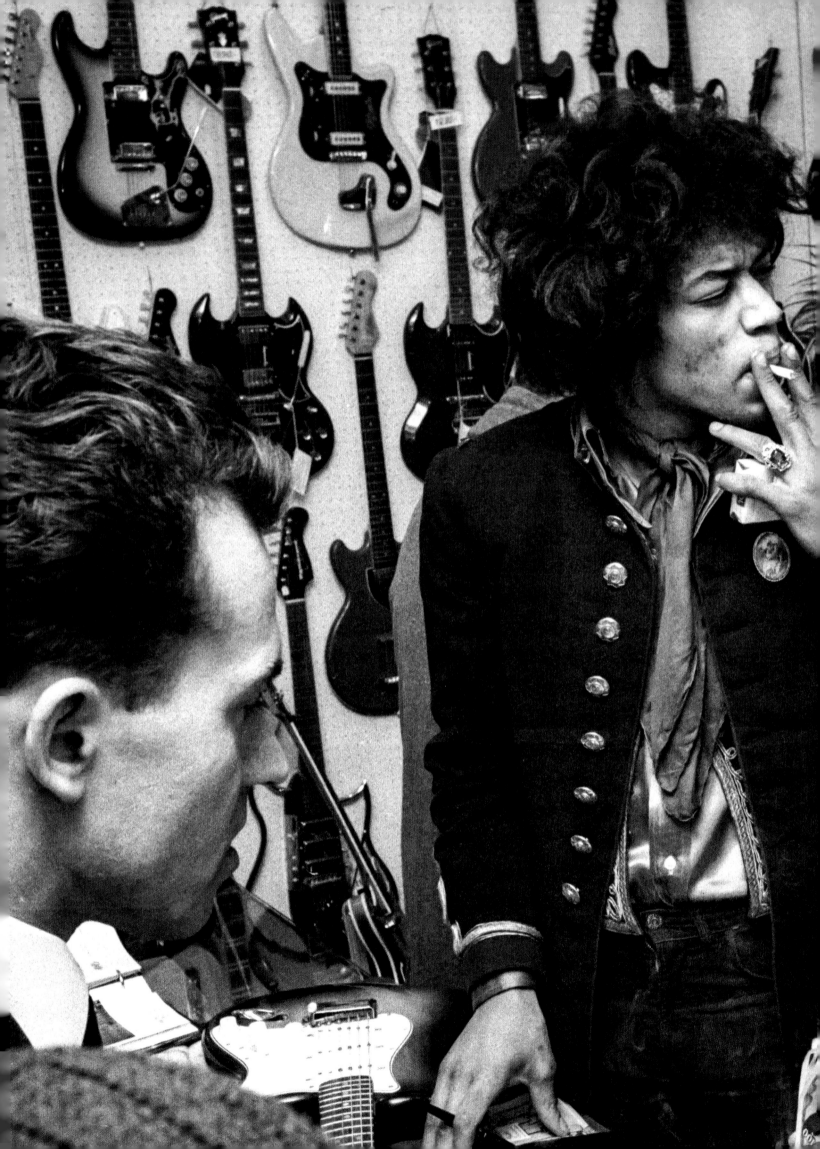

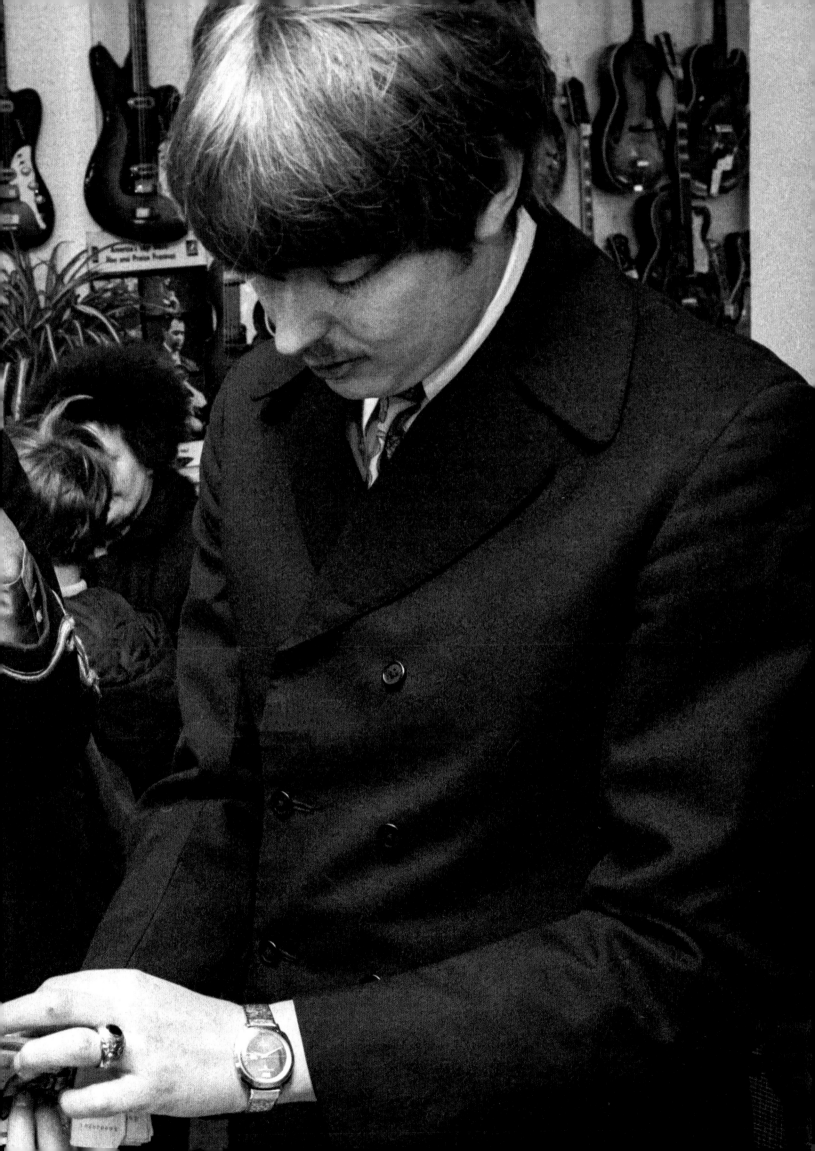

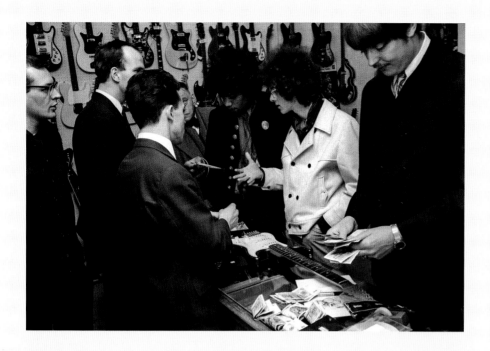

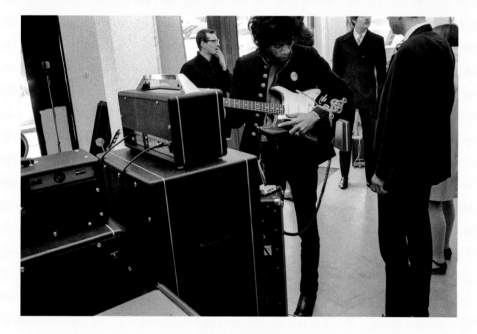

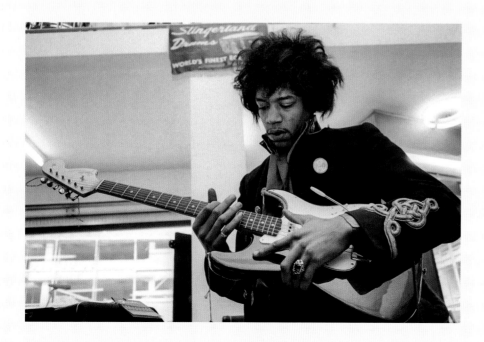

PREVIOUS and LEFT
Musik Zinngrebe, Hamburg, Germany,
March 20, 1967.

THE RAM JAM CLUB
390 BRIXTON RD., LONDON, S.W.9 Tel. RED 3295
NON-MEMBERS' PRICE INCLUDES 1 YEAR'S MEMBERSHIP

THURS., FEB. 2nd 7.30-11.30 p.m.	RAMJAM "HOT 100" DISC NIGHT
FRI., FEB. 3rd 7.30-11.30 p.m.	JOHN MAYALL'S BLUES BREAKERS
SAT., FEB. 4th 7.30-11.30 p.m.	THE JIMI HENDRIX EXPERIENCE + ALL NIGHT WORKERS
SUN., FEB. 5th 3-6 p.m.	RAMJAM "HOT 100" DISCS
SUN., FEB. 5th 7.30-11 p.m.	AMBOY DUKES

***LOCARNO* TEL: 26193-4**
TONIGHT
7-30 p.m. 11-0 p.m.
THE
JIMI HENDRIX EXPERIENCE
* Admission 6'3 *
NEXT WEEK * THE ACTION *
FROGMORE STREET, BRISTOL 1

THE PAVILION WORTHING
Thursday, Feb. 23rd
UNBELIEVABLE
THE JIMMI HENDRIX EXPERIENCE
(HEY JOE)
ADMISSION 6/-
7.30 to 10.45 p.m.

THE CIVIC HALL, GRAYS
TUESDAY, FEBRUARY 7
THE GREAT COLOURED RAM JAM SOUND OF
THE GASS

TUESDAY, FEBRUARY 14
YOU DARE NOT MISS THE DISCOVERIES OF '67
THE
JIMI HENDRIX
EXPERIENCE
Smashing up the charts with "Hey Joe"
FROM 8 P.M. COME EARLY TO BE SURE OF GETTING IN

PLAZA NEWBURY
JIMI HENDRIX EXPERIENCE
FRI. 10 FEB. 7'6

RICKY-TICK
THAMES HOTEL — WINDSOR
JIMI HENDRIX EXPERIENCE
FRI. 17 FEB. 7'6

BLUE MOON
170, HIGH STREET, CHELTENHAM
EDDIE NORMAN and BILL REID

TOMORROW SATURDAY, 11th FEB. 8/6 7.30—11.30
HEY JOE! — Top Ten Hit
JIMMIE HENDRIX EXPERIENCE

DISCOTHEQUES—FRIDAY & SUNDAY, featuring
Top D/J's Frankie and Rocky and the Moon Go-Go Girls

NEXT SATURDAY —— THE ACTION!!!
Coming Soon —— GENO WASHINGTON

BOB ANTHONY PROMOTION
8 to 11.30 p.m.
CORN EXCHANGE • CHELMSFORD
Saturday Scene
FEBRUARY 25th
"HEY JOE"
The JIMI HENDRIX EXPERIENCE
Plus! THE SOUL TRINITY
Admission: 8/6 in advance. Tickets Corn Exchange
10/- on the night

TONIGHT (TUESDAY), APRIL 25. at 6.30 and 8.45
THE WALKER BROTHERS
CAT STEVENS :: JIMI HENDRIX
ENGELBERT HUMPERDINCK
15/- 12/6 10/6 8/6 6/-

CLUB a' GOGO
Tonite
8-2 a.m.
THE MANCHESTER PLAYBOYS
2/- & 4/-

Friday
8-2 a.m.
JIMI HENDRIX & THE EXPERIENCE
6/- & 10/-
Doors Open 6.30

BARBEQUE '67
TULIP BULB AUCTION HALL, SPALDING, LINCS.
Spring Bank Holiday Monday, May 29th
● NON-STOP DANCING 4.0 p.m. TO MIDNIGHT
JIMI HENDRIX EXPERIENCE
CREAM • GENO WASHINGTON & THE RAM JAM BAND
MOVE • PINK FLOYD • ZOOT MONEY
LICENSED BAR APPLIED FOR — HOT DOGS
U.V. SOFT LIGHTS — DISCOTHEQUE from 6.0 p.m.
ADMISSION £1
Pay at door. Or for tickets in advance send S.A.E. to:
RIVONIA, 2 CONERY GARDENS, WHATTON, NOTTS.

In the weeks following the band's magnificent Monterey appearance, co-manager Michael Jeffery booked the Experience to open for the Monkees on their US tour, attempting to mirror the strategy Chandler had employed when the Experience toured with the British teen idols the Walker Brothers. Chandler was aghast, furious at Jeffery's miscalculation of the US music landscape. The Experience, Chandler argued, should be showcased in theaters such as the Fillmore West in San Francisco, where the city was still abuzz after the group's impressive weeklong stand there. The Experience pulled out from the tour after only a handful a dates, remedying Jeffery's gaffe with a fabricated claim that the Daughters of the American Revolution considered the group's act obscene. Determined to succeed in his home country, Hendrix was relieved that the group had been freed from their commitment. "The Monkees were like plastic Beatles," Hendrix remarked. "Don't get me wrong, I liked the Monkees themselves. The personal part was beautiful. I got on with Mickey and Peter and we fooled around a lot together. We pulled out of the tour because there was a hassle. Firstly, we were not getting any billing. All the posters for the show just screamed out Monkees! They didn't even know we were there until we hit the stage. Then they gave us the death spot on the show, right before the Monkees were due on. The audience just screamed and yelled for the Monkees. It was just the wrong audience."

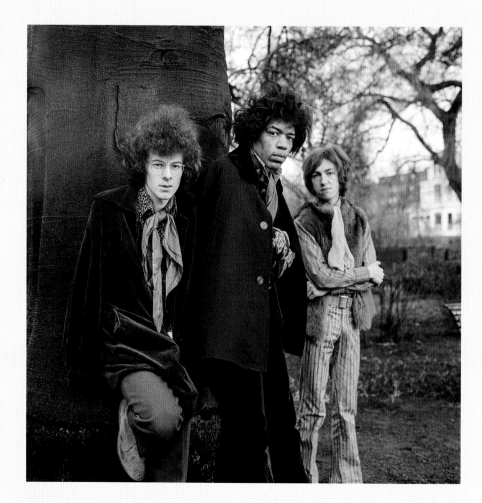

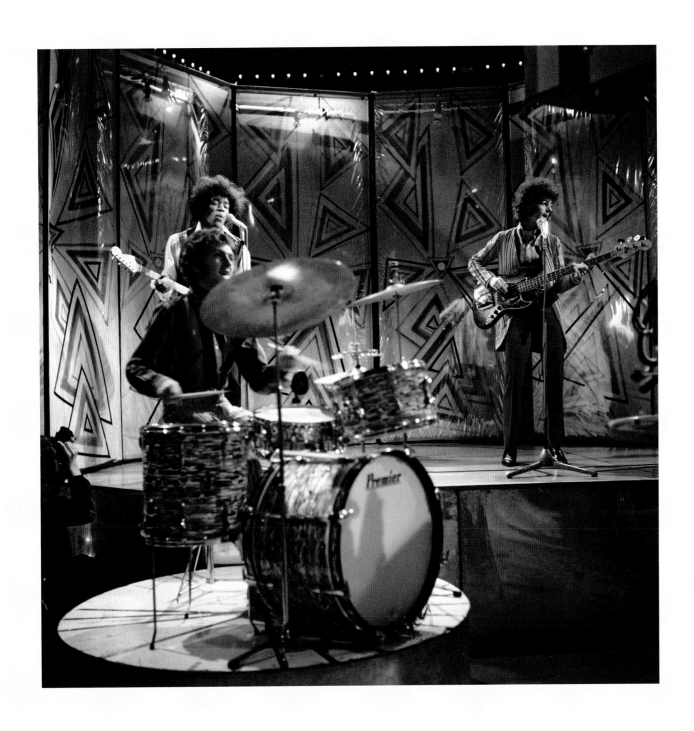

ROUNDHOUSE
CHALK FARM ROAD, N.W.1

LIGHT SHOW WITH

JIMI HENDRIX EXPERIENCE AND
THE SOFT MACHINE

7.30 - 12 p.m., Wed., Feb. 22

LEFT
St. Pauli Hotel Gardens, Hamburg,
Germany, March 19, 1967.

ABOVE
"Top of the Pops" BBC, Shepherds Bush
Studios, March 30, 1967.

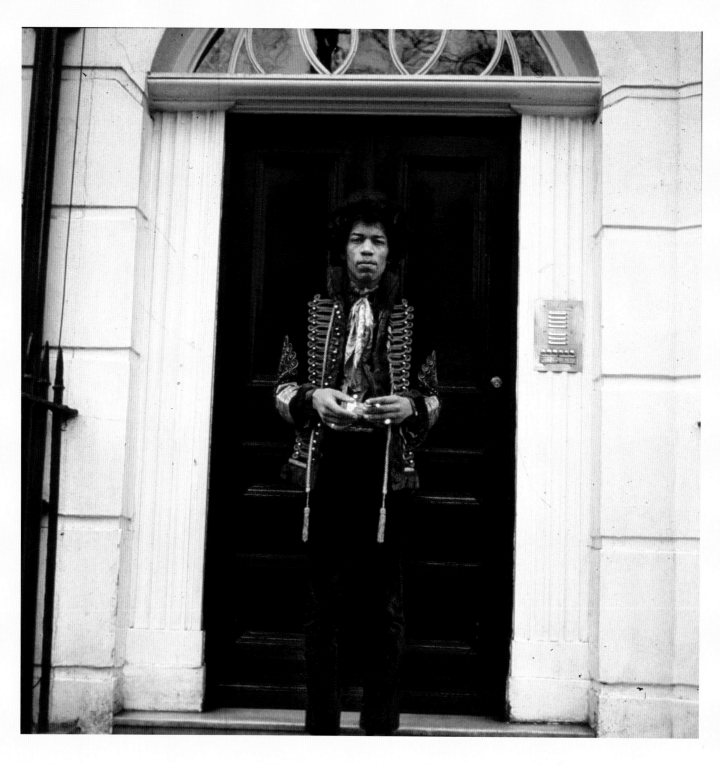

Jimi's apartment, 34 Montagu Square,
London, February 1967.

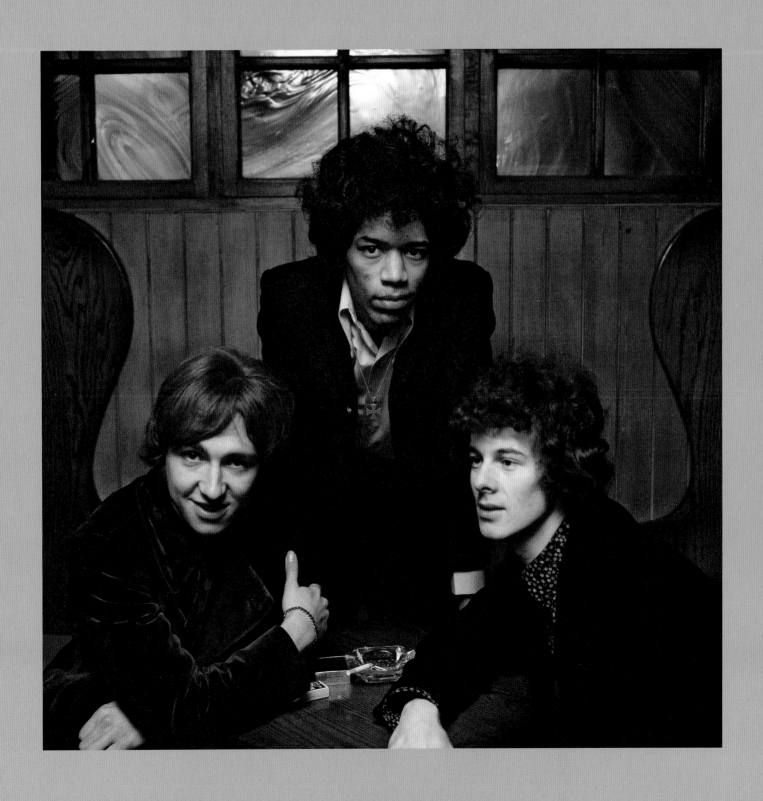

The Jimi Hendrix Experience at George pub, London, January 1967.

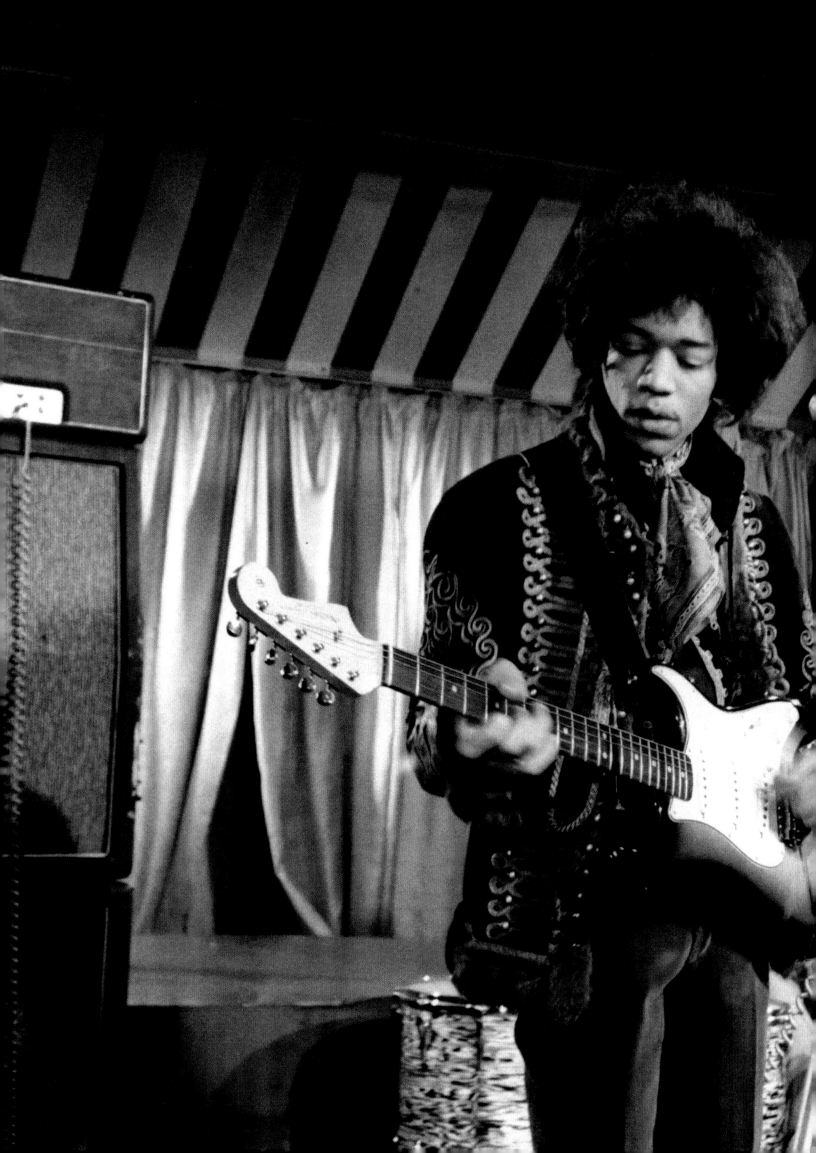

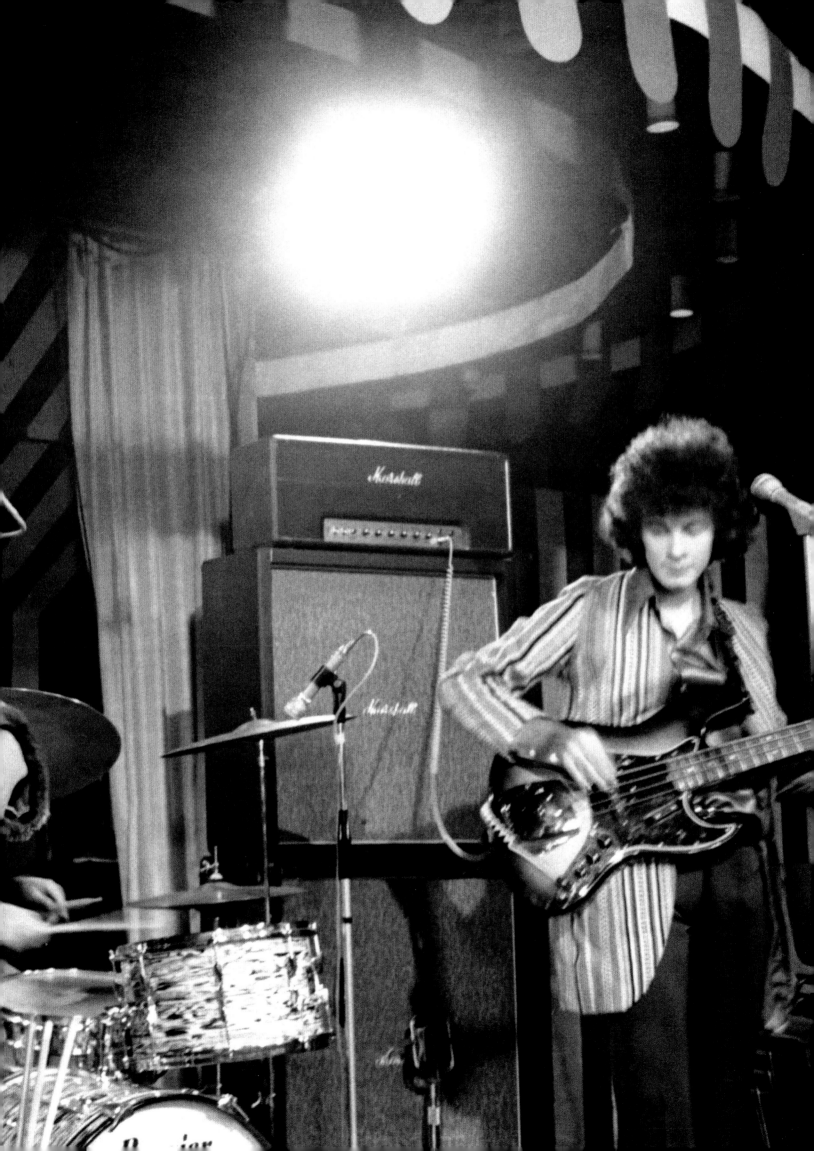

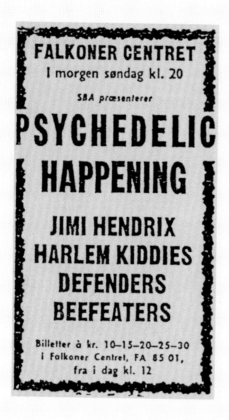

The ensuing publicity did catch the attention of the mainstream media, focusing attention on the August 1967 US release of *Are You Experienced* by Reprise, the record label started by Frank Sinatra and distributed by Warner Bros.

Hendrix may have deftly escaped the Monkees tour, but he was soon to be drawn into a bitterly contested legal nightmare, the origins of which traced back to 1965 and his recording sessions with Curtis Knight & the Squires. Despite having already signed an exclusive recording contract with Sue Records, Hendrix had signed a one-page artist agreement with Ed Chalpin's PPX Industries for those sessions. That contract (for which Hendrix received $1) bound his services not just for the Knight sessions but for a period of three years.

Word of Hendrix's remarkable success had not escaped Chalpin. His last contact with Hendrix had come in December 1965, and he was stunned to read trade magazine reports trumpeting the achievements of the Jimi Hendrix Experience. Unlike Juggy Murray, who had sold Hendrix's July 1965 Sue Records contract to Chandler and Jeffery outright, Chalpin had never been approached. He felt passionately that Hendrix's current work violated his exclusive artist agreement. Determined to reverse the situation in his favor, Chalpin initiated a legal battle to reclaim Hendrix and the rights to his recordings for his company.

PREVIOUS
The Jimi Hendrix Experience perform at Marquee Club, London, March 2, 1967.

BELOW
Outside the George, London, January 6, 1967.

FOLLOWING
Hamburg, Germany, March 20, 1967.

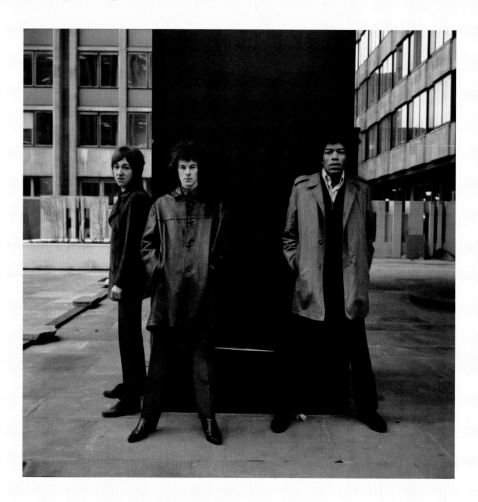

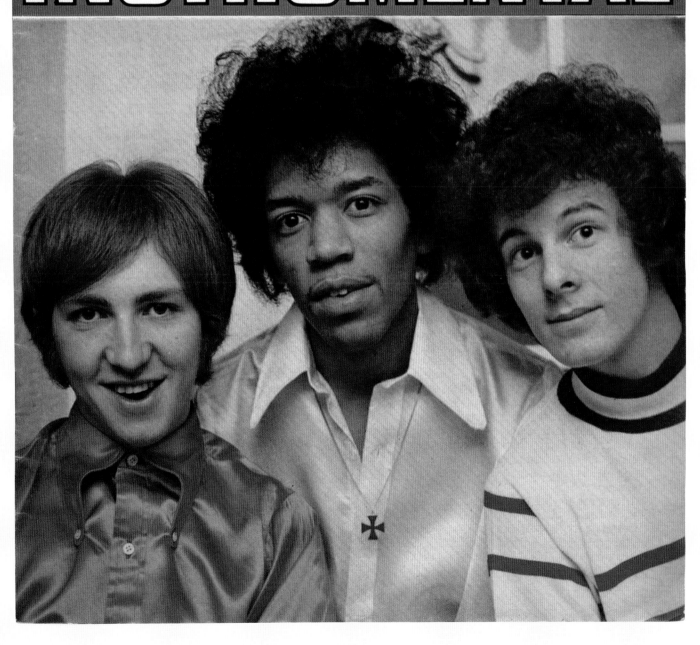

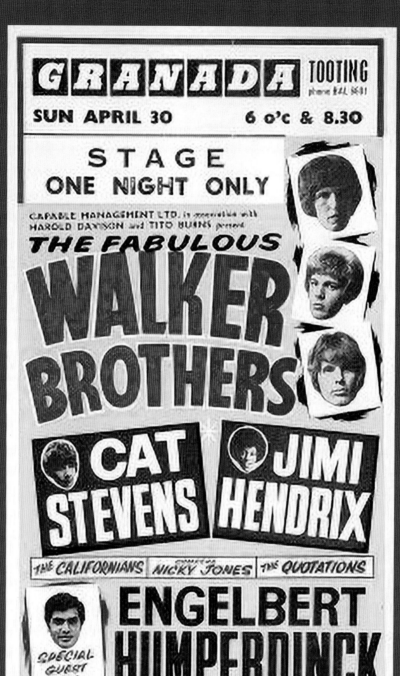

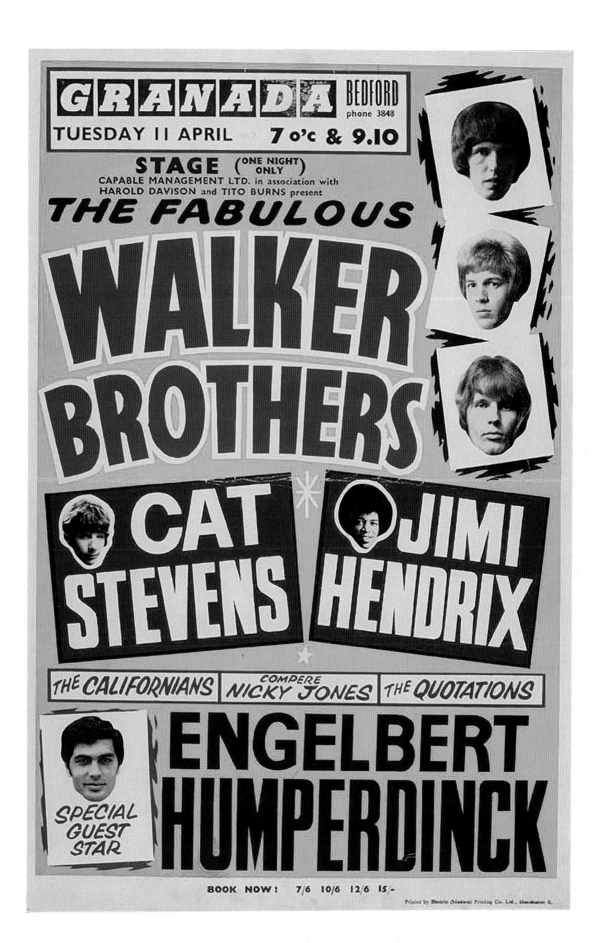

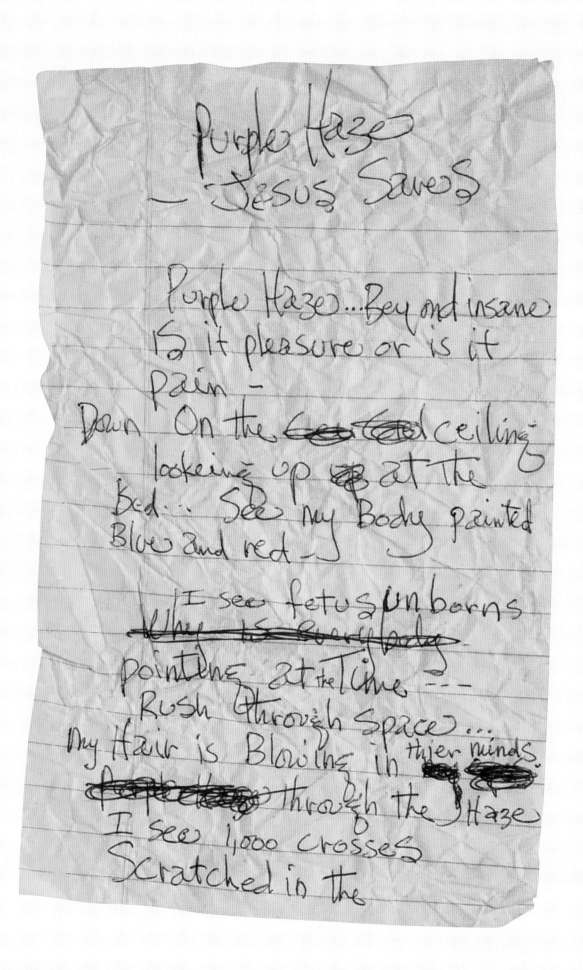

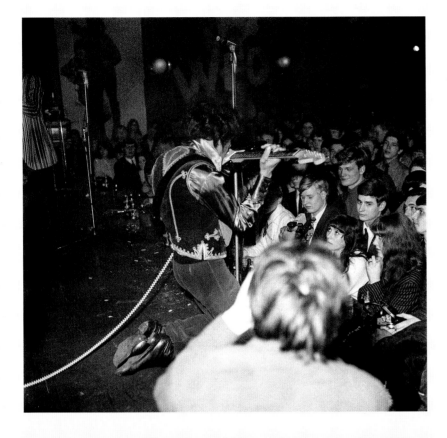

ABOVE
Star-Club, Hamburg, Germany,
March 18, 1967.

LEFT
"Purple Haze," original lyrics by Jimi.

Over the summer, as both sides traded accusations, Hendrix volunteered his services to Chalpin and Curtis Knight on two occasions. At recording sessions staged for Knight & the Squires at PPX Studios, Hendrix engaged in jam sessions with his former group and lent bass and guitar parts to their recordings. While he'd hoped his gestures would close the matter, they instead would further complicate a difficult situation.

The Experience returned to London's Olympic Studios on October 1, 1967, to resume sessions for what would become their second album, *Axis: Bold As Love*. Much had changed since the group's last booking at Olympic the previous spring. The international success of *Are You Experienced* and their warm reception in America had given the group momentum, and Hendrix was brimming with confidence, eager to become involved with every facet of the recording process.

The trust that Chandler, Hendrix, and Kramer developed during *Are You Experienced* had created an atmosphere where ideas and suggestions were exchanged freely between the producer, the musician, and the engineer. But while Kramer was infinitely patient with Hendrix, Chandler soon grew irritated with the guitarist's ceaseless quest for perfection as work on *Axis* continued. Chandler felt that Hendrix was wasting too much time on endless retakes of backing tracks. He favored spontaneity. Also, given Hendrix's crowded schedule, the two had less opportunity to refine the guitarist's new material prior to entering the recording studio, as they had done in the past. Hendrix increasingly used sessions at Olympic to introduce his new material to Chandler and the group, rather than to record and perfect the tracks.

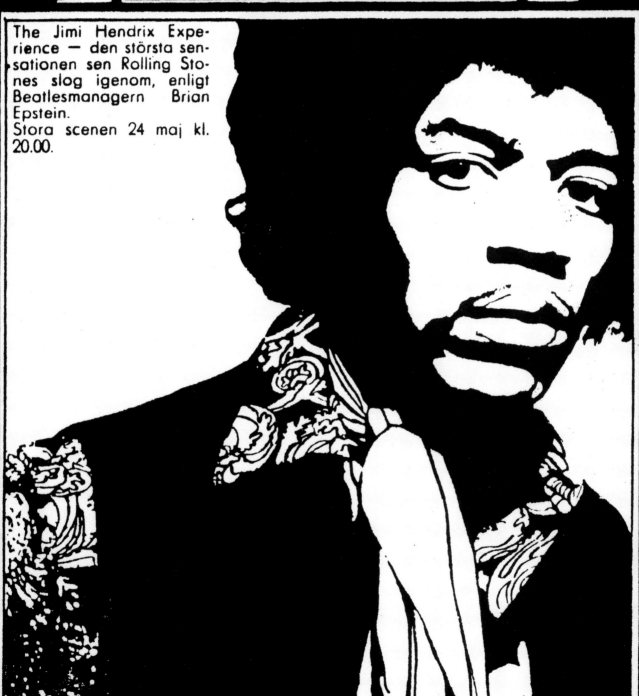

GRÖNA LUND
PROGRAM

The Jimi Hendrix Experience — den största sensationen sen Rolling Stones slog igenom, enligt Beatlesmanagern Brian Epstein.
Stora scenen 24 maj kl. 20.00.

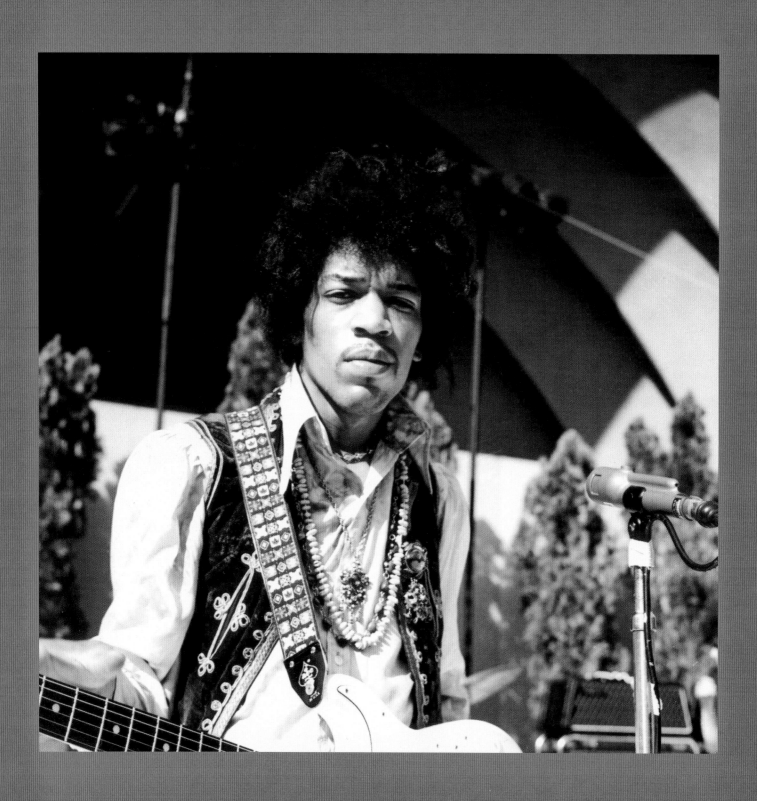

*Afternoon rehearsal, Hollywood
Bowl, Hollywood, California,
August 18, 1967.*

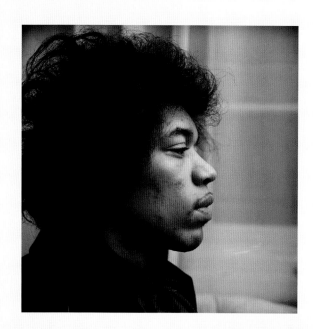

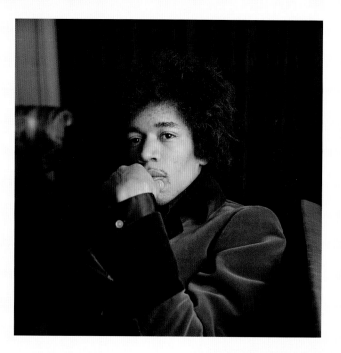

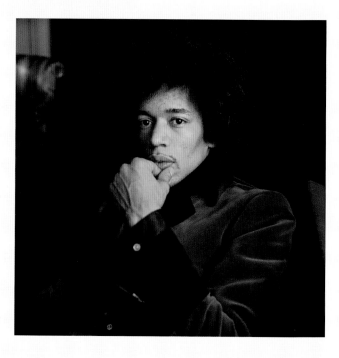

*Jim's apartment, 34 Montagu Square,
London, January 1967.*

BELOW
Nottingham, England, April 20, 1967.

FOLLOWING
Star-Club, Hamburg, Germany,
March 18, 1967.

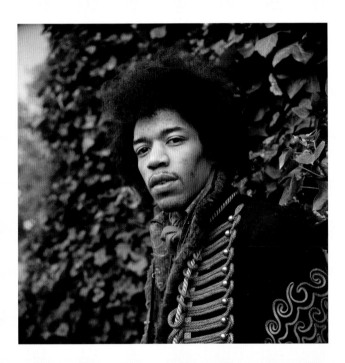

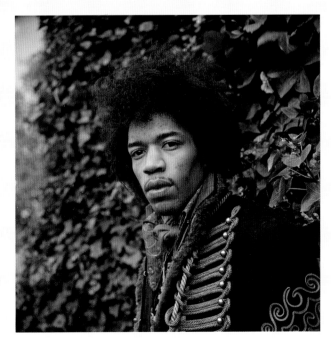

When completed, *Axis: Bold As Love* offered a winning blend of well-crafted songs and superb playing by each member of the Experience. The album, Hendrix decreed, was designed to showcase the group's skills apart from his guitar playing. His facility with graceful ballads such as "Little Wing" and "Castles Made of Sand" showed his remarkable range. "I dig writing slow songs, because it is easy to get more blues and feeling into them," explained Jimi. "Most of the ballads come across in different ways. Sometimes you see things in different ways than other people see it. So then you write it in a song. It could represent anything. Some songs, I come up with the music first, then I put the words that fit. It all depends. There is no certain pattern that I go by because I don't consider myself a songwriter. Not yet anyway. I just keep music in my head. It doesn't even come out to the other guys until we go into the studio."

Much care was given the majestic "Bold As Love." Hendrix tinkered with the song, overdubbing harpsichord and bass parts, but perhaps the most significant new element came from the control room. With Chandler's encouragement, engineers Eddie Kramer and George Chkiantz introduced phased stereo sound—a noteworthy engineering feat considering the limitations of four-track recording—for the first time on a Hendrix record. Jimi was thrilled with the results. "That's the sound I've been hearing in my dreams!" he exclaimed.

Chandler and Jeffery were under pressure to deliver the album to Track Records so that it could be readied for a Christmas release. In the rush to finish, Hendrix managed to lose the mixes for all of what was to become side one of *Axis: Bold As Love* during the early hours of Halloween 1967. Ironically, Hendrix had taken the master tapes home with him for safekeeping. "He went off to a party," recalled Chandler. "Coming back, he left one of the boxes in a taxi. It was all scheduled for release! So we rang up Eddie Kramer and went into Olympic the next night and mixed the entire 'A' side of the album again, all in one night."

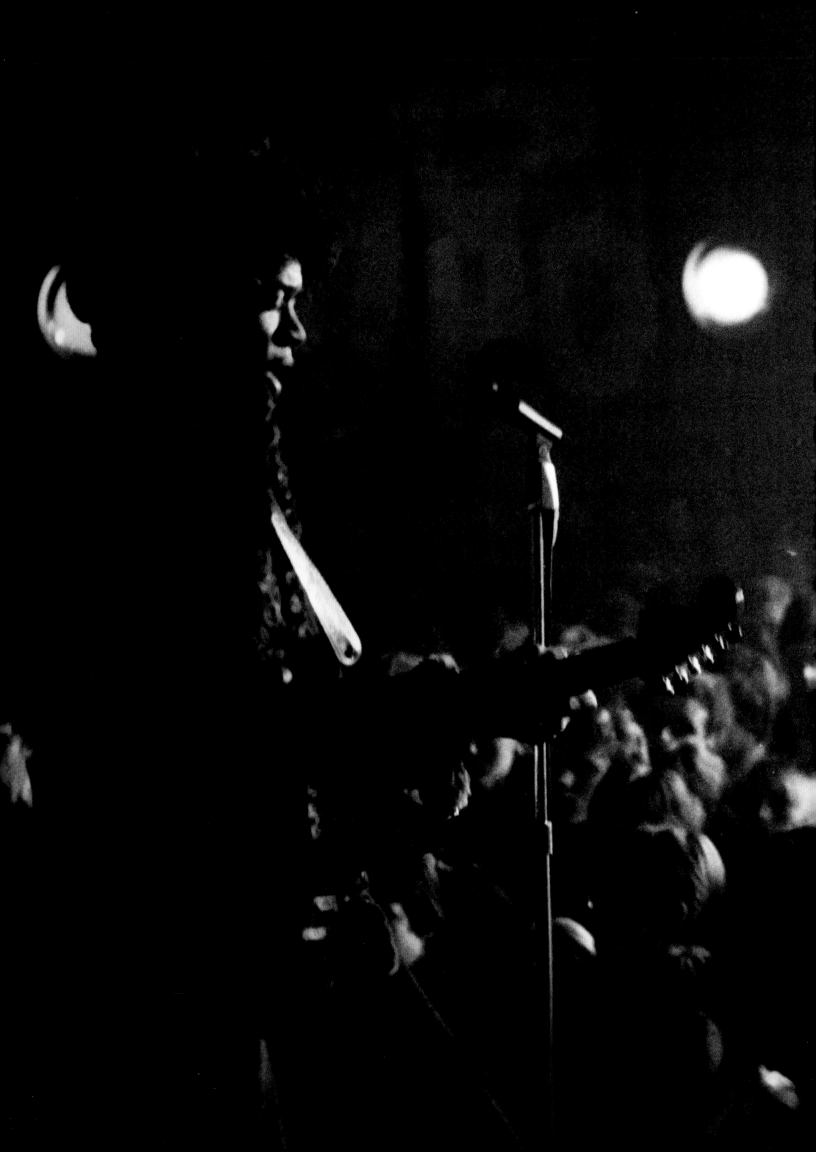

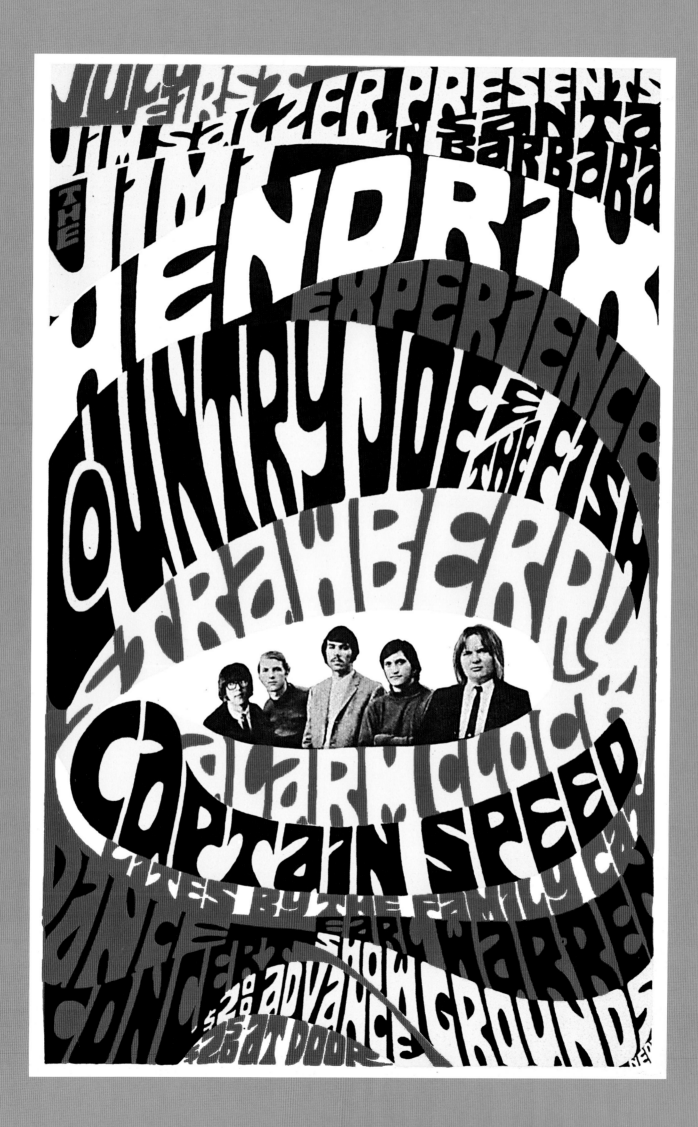

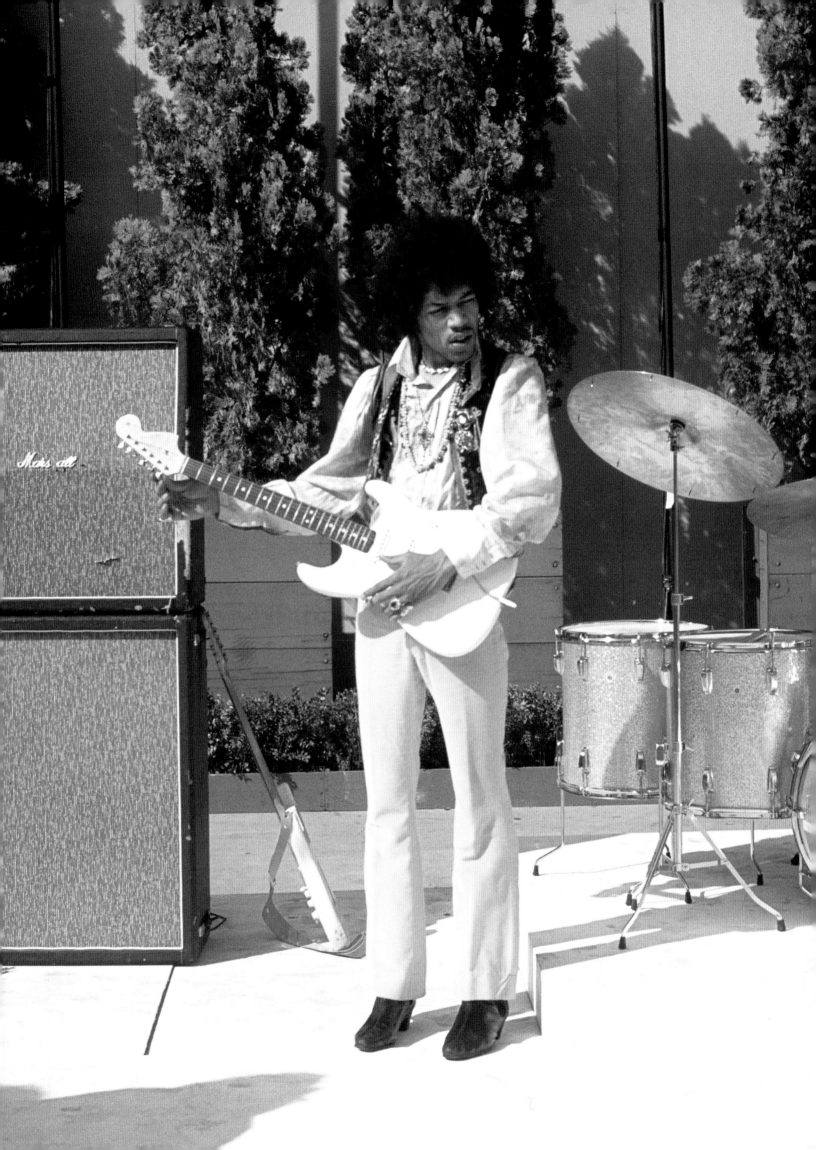

TICKETS

Are Now Available

FOR THE

RHEINGOLD CENTRAL PARK MUSIC FESTIVAL

in our
CREDIT DEPT.
MAIN FLOOR

This Week At The Rheingold Central Park Music Festival.

Salute to Israel
Sunday,
July 2, 6 pm

Monday, **Friday,**
Nina Simone Phil Ochs
Montego Joe Sneaky & Our Gang
July 3, 6:30 & 10:30 pm July 7, 8 & 10:30 pm

Wednesday,
The Young Rascals **Saturday,**
Len Chandler Dave Brubeck Quartet
Jimmy Hendrix Willie Bobo
(10:30 pm only) July 8, 6:30 & 10:30 pm
July 5, 8 pm (Sold Out)
& 10:30 pm

No mail orders accepted.

ALL SEATS $1.00
WOLLMAN MEMORIAL SKATING RINK
5TH AVENUE AND 59TH STREET
Tel: 249-8870

TICKETS FOR ALL CONCERTS AVAILABLE AT MANHATTAN:
STERN BROTHERS, 6TH AVE 42ND ST /E. J. KORVETTE, 5TH
AVE. 47TH ST. /RECORD SHACK 125TH ST. 8TH AVE. WOLL-
MAN MEMORIAL SKATING RINK, 5TH AVE 59TH ST. TICKETS
AVAILABLE: 2 MRS. BEFORE SHOWTIME; BROOKLYN: E. J.
KORVETTE FULTON ST. BRONX: E. J. KORVETTE, BRUCKNER
BLVD. NEW JERSEY: STERN BROS, BERGEN MALL, PARAMUS

These summer sounds are brought to you by Rheingold.

The Rheingold
Central Park Music Festival

Of all the songs on the album's magnificent first side, the final mix of "If Six Was Nine" proved the hardest to recreate. The Experience had recorded the song six months prior and set it aside for the album. "We kept saying to ourselves, 'I'm sure this isn't the sound we had originally,'" remembered Chandler. Fortunately, bassist Noel Redding had a consumer-grade tape copy of a rough mix on a small, three-inch reel made the previous June. A taxi was dispatched to retrieve the reel and work began in earnest. "It was on a tiny little spool and was all wrinkled," explained Kramer, who managed to salvage the mix. The album was finished.

The elation of having delivered the new album was quickly replaced with anxiety as Hendrix's dispute with PPX escalated once again. Ed Chalpin entered into an agreement with Capitol Records to release his recordings of Curtis Knight & the Squires, featuring Hendrix on bass and guitar. Selections were culled from both the 1965 master tapes and the two 1967 sessions and released as *Get That Feeling* in December 1967. The album competed for sales with *Are You Experienced*, infuriating Hendrix and his two managers. Despite Hendrix's limited role in the recordings, the cover art magnified his overall contribution to the album.

When the PPX legal struggle began months before, Jimi had been fairly unconcerned. Initially, he believed Chandler and Jefferey would work out a reasonable solution with Chalpin and the record labels. As the case dragged on, Hendrix became more emotionally invested in the proceedings, fearful of the damage the inferior Knight recordings could have on his reputation. He felt exploited by the release of *Get That Feeling*, describing the album's contents as "confetti" drawn together from loose, informal jam sessions.

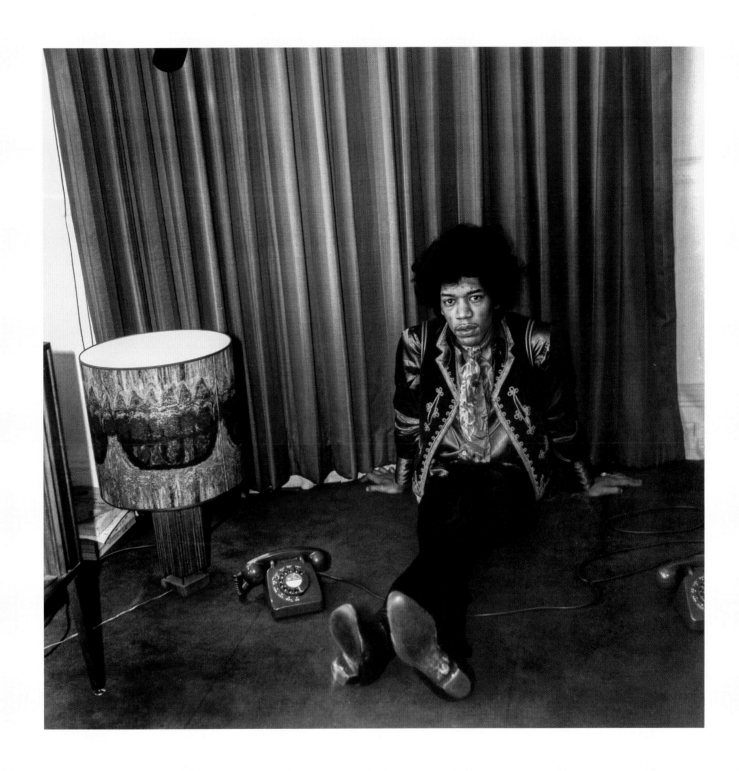

PREVIOUS
Afternoon rehearsal, Hollywood
Bowl, Hollywood, California,
August 18, 1967.

ABOVE
Jimi's apartment, 34 Montagu Square,
London, February 1967.

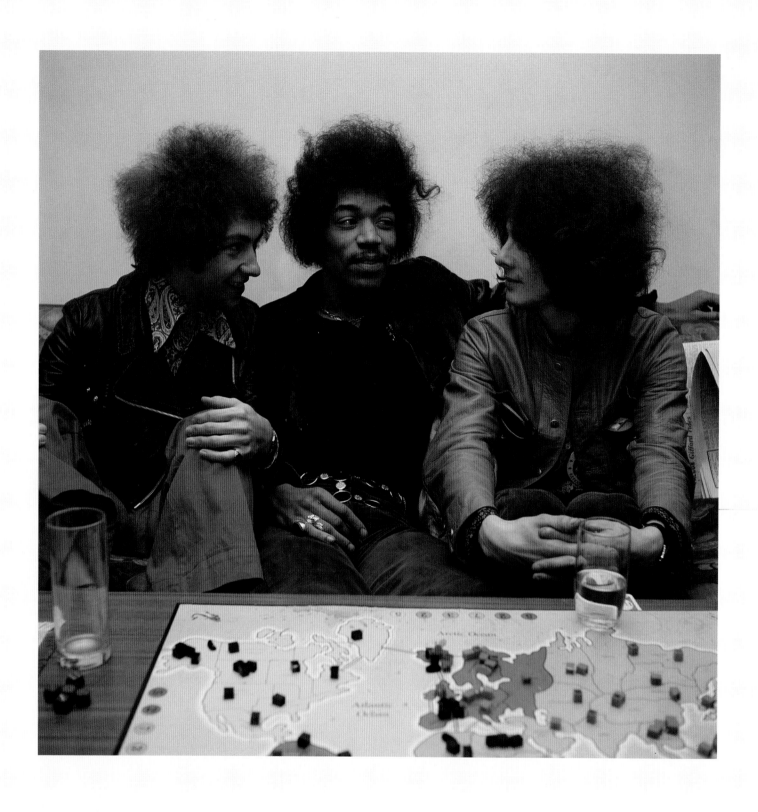

Mitch Mitchell, Jimi, and Noel
Redding, 43 Upper Berkeley Street
apartment, London, November 7, 1967.

New Acts

AN AMERICAN EXPERIENCE

THE Jimi Hendrix Experience came to New York with poor billing and nobody knowing who they were. They left to recognition. Two nights at Steve Paul's Scene Club and another in Central Park playing to an audience of 18;000 were all they needed.

Now they're on a seven-week tour of America with the Monkees, but because of their success here they'll be returning to New York for a whole week before they finally jet home to Britain.

New York, the Village apart, is still pretty intolerant of long hair and multi-coloured clothes. The Hendrix hairstyle stopped them in the streets. Jimi didn't seem to mind taking it all quite coolly but drummer John Mitchell gave a few words back here and there.

SHORTS

"It's ridiculous people standing laughing at us at New York airport when they were dressed in ill-fitting Bermuda shorts," he said. "If they knew how stupid they look they wouldn't stare at us so much."

One hotel refused the group accommodation but Loew's Motor Inn on Eighth Avenue treated them well enough and it was only just round the corner from the Scene.

They really captured that place with Experience treatment of tunes like "Satisfaction" and "Wild Thing." Talking of Wild Thing I saw a group of rather dejected Troggs on their way at the airport. The difference in hours, five between New York and London, all adds up to tire British groups out.

STRINGS

Back at the Scene Hendrix broke several of his guitar strings on the second night while he was playing the instrument with his teeth, which caused road manager Gerry to run on stage like a football trainer with a new string every time there was a breakage. At a reckoning they got through seven that night.

They were billed smaller than the Seeds, an American group. But they soon showed that British groups are still best and America is very ready to hear them.

Also on the bill at the Scene was a guy called Tiny Tim. He has hair down to his shoulders like a curly Barry Fantoni and sings old music hall songs to a uke. Everytime the audience bursts into applause Tiny Tim puts his fingers to his lips and says: "Why, thank you, thank you."

Mitch and Noel were so impressed that they want to bring him to England. The Who were also in town and Pete Townshend was another confessed fan of Tiny Tim.

The Experience played at the Rheingold Festival in Central Park co-billed with the Young Rascals who are pretty big out here. Admission is 7s 6d and 18,000 turned up. But it was the Experience who won the night while the Young Rascals were actually booed during one number.

Off duty, Mitch spent his time trying to hear Gene Krupa play in a bar uptown and Miles Davis and Dizzy Gillespie in the village. Jimi and Noel went down to the village to see the Mothers of Invention at the Garrick.

Outside Noel was stopped by two American girls who said. "Hey we saw you at your Finsbury Park Empire in London." Passers by crowded round because they seemed to think the Finsbury Park Empire was Buckingham Palace. Still things are like that here in the city of few mini-skirts and white button-down shirts.

Chas Chandler put the group into a studio for a day while they are here and hopes he's got their next single. Meanwhile the Experience look like becoming more popular in the States than the Procul Harum who's record hasn't caught in New York.

JIMI HENDRIX EXPERIENCE (3)
Rock 'n' Roll
45 mins.
The Scene, N.Y.

In their U.S. preem at Steve Paul's The Scene the Jimi Hendrix Experience proved to be an up-to-date—i.e. loud—rock combo, sans significant lyrics or vocal style but avec the excitement of rock 'n' roll circa Presley.

The trio pounds incessantly in tune with a contemporary format, and Hendrix attains far-reaching electronic tangents on his guitar. Supporting him are Noel Redding on bass and Mitch Mitchell, drums, a duo of Britishers who are well-schooled in achieving spike-driving sounds and appealing appearance. Enhancing the physical presentation is Hendrix's colorful, bejeweled attire, which combines the aura of Jerry Lee Lewis with that of Liberace.

However, for all the external personality, the root of the combo's appeal is its actual simplicity. As dynamic as they play and appear, they do so for entertainment. This is a contrast to much of today's music, wherein the artist seeks attention to the sociological, psychological and or musical composition of his material. Hippies will enjoy this opportunity to relax with performers they can accept, and teenyboppers should respond accordingly, thus transcending today's age-split market.

With these plusses, Hendrix should eliminate some extraneous output. His sexual gestures are vulgar, and will embarrass youngsters besides being unnecessary for older hipsters. In addition, his display of physical destruction to his guitar and speaker comes off as low class, and supports a sick fad current among a few bands.

The Jimi Hendrix Experience has the act to sell records. Highlights are Hendrix's Presley gyrations and Chuck Berry guitar handling. The detracting element is a flaw in taste, and only its improvement will determine the lasting success that the combo's flash rates. Bent.

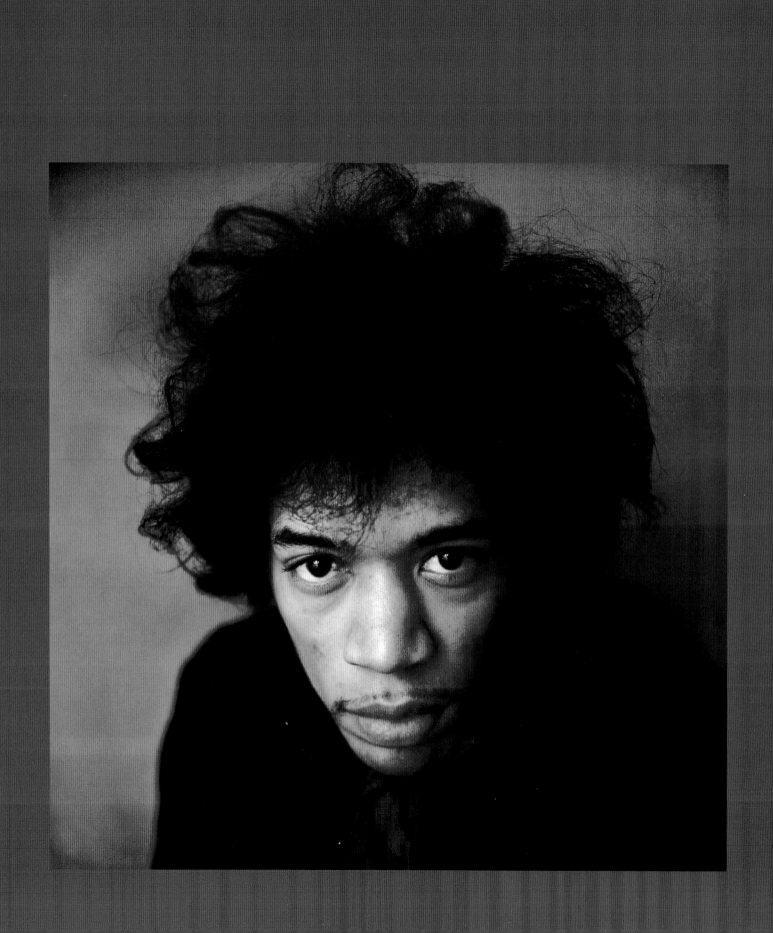

NEWSLETTER

HOLLYWOOD, CALIFORNIA JULY, 1967

MICKY

Dear Monkee Club Member:

Here it is, your own private and confidential newsletter direct from The Monkees to the members of their only official national club.

Right now The Monkees are in Hollywood filming episodes for next season's television show. The network has already ordered enough programs to keep the show on the air until at least the middle of 1968, so Micky, Davy, Peter and Mike have a lot of work ahead of them!

At the end of June, the boys leave for a quick weekend of concerts in London, and then return to the United States for a personal appearance summer tour. The dates of the tour are listed below along with the radio station sponsoring the concert. Listen to the station for all the information on how to get your tickets. If The Monkees are coming to a

MIKE

city near you, don't miss the concert. The boys are on stage for almost an hour, play and sing more than a dozen songs, along with a background of film, giant pictures, and even psychedelic lights. It's the most amazing concert you'll ever see:

July	8	-	Jacksonville,Fla.	(WAPE)
July	9	-	Miami Beach, Fla.	(WQAM)
July	11	-	Charlotte, N.C.	(WAYS)
July	12	-	Greensboro,N.C.	(WCOG)
July	14	-	New York City	(WMCA)
July	15	-	New York City	(WMCA)
July	16	-	New York City	(WMCA)
July	20	-	Buffalo, N.Y.	(WKBW)
July	21	-	Baltimore, Md.	(WCAO)
July	22	-	Boston, Mass.	(WBZ)
July	23	-	Phila., Pa.	(WFIL)
July	27	-	Rochester, N.Y.	(WBBF)
July	28	-	Cinn., Ohio	(WSAI)
July	29	-	Detroit, Mich.	(WKNB)
July	30	-	Chicago, Ill.	(WLS)
Aug.	2	-	Milwaukee, Wis.	(WRIT)
Aug.	4	-	St. Paul, Minn.	(KDWB)
Aug.	5	-	St. Louis, Mo.	(KXOX)
Aug.	6	-	Des Moines, Iowa	(KIOA)
Aug.	9	-	Dallas, Texas	(KVIL)
Aug.	10	-	Houston, Texas	(KNUZ)
Aug.	11	-	Shreveport, La.	(KEEL)
Aug.	12	-	Mobile, Ala.	(WABB)
Aug.	17	-	Memphis, Tenn.	(WMPS)
Aug.	18	-	Tulsa, Okla.	(KAKC)
Aug.	19	-	Denver, Colo.	(KIMN)
Aug.	25	-	Seattle, Wash.	(KJR)
Aug.	26	-	Portland, Ore.	(KISN)
Aug.	27	-	Spokanne, Wash.	(NJRB)

In every city The Monkees appear, they will be meeting personally with members of the local Chapter of the Monkee Club, and taking some more lucky members to the concert as The Monkees' personal guests. Letters to the chapter presidents with all the details have already been mailed, and The Monkees are looking forward to meeting as many of their club members as possible.

For those cities that The Monkees can't visit personally on this tour, the four boys will be making personal phone calls to select chapter meetings. Among the clubs that have already received personal phone calls from The Monkees are:

Chapter #128 - Arabi, La.
Chapter #139 - Buffalo, N.Y.
Chapter #124 - Memphis, Tenn.
Chapter #110 - Honolulu, Hawaii

There have been a lot of silly rumors about Davy being drafted. As a British citizen living permanently in the United States, David

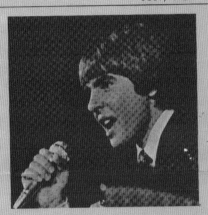

DAVY

does have to register with his local draft board. The board is now reviewing his draft status, but it will be many months before David is called for even a physical examination, so it's much too soon to worry about him going into the army.

The Monkees' new album "HEADQUARTERS" is now in record stores everywhere. Davy, Micky, Peter and Mike spent almost a whole month at RCA's recording studios in Hollywood playing and singing the 14 songs on the album, even writing a good number of them. You can help The Monkees by asking your favorite disc jockey and radio stations to feature songs from the album, and by playing the record for your friends.

Songs from the album will also be heard on The Monkees' summer

(continued on back)

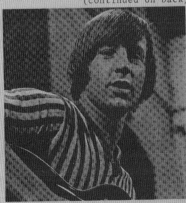

PETER

Star-Club, Hamburg, Germany,
March 18, 1967.

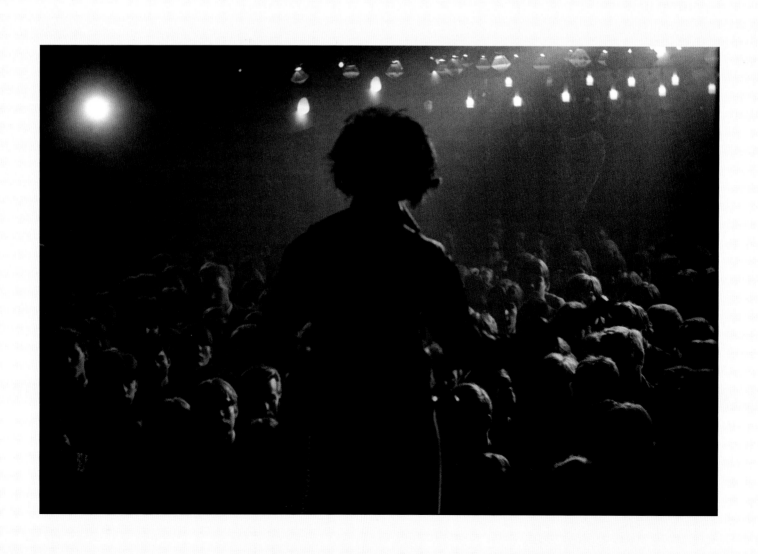

Star-Club, Hamburg, Germany,
March 18, 1967.

After the release of *Axis: Bold As Love*—hailed by the British music press and record retailers alike as a triumph—the Experience embarked on what would be Hendrix's last tour in Britain. Their popularity meant the group had outgrown provincial theaters. In little more than a year, the Experience had maximized their earning potential in Britain. The United States was far too lucrative to ignore, and in 1968, the group moved its base to New York.

The UK tour concluded in Glasgow on December 5, 1967, and Hendrix returned to Olympic Studios for more recording. These new sessions saw Hendrix and Chandler drifting further apart musically. Hendrix's drug use and social life had accelerated noticeably, and more and more a full entourage accompanied him to the studio. Despite some of these cracks, the Experience recorded some of the band's strongest work during the December–January sessions. The compact classic "Crosstown Traffic" signaled the beginning of production for what would become *Electric Ladyland* and set the tone for the adventurous double album.

Hendrix turned to the piano for inspiration, inverting a series of chords he had successfully incorporated within *Axis: Bold As Love*'s "Spanish Castle Magic." Traffic's Dave Mason, a loyal supporter of the Experience, teamed with Redding on backing vocals while Jimi delivered his most forceful lead vocal to date. Hendrix's strength as a vocalist came as little surprise to Chandler, who had always strongly encouraged his development. "Jimi would always want to bury his voice," recalled Chandler. "But I loved its rhythm and thought it was great."

Dave Mason also contributed to another memorable track, "All Along the Watchtower," a favorite of Hendrix's, full of the wonderful lyrical imagery for which he loved Bob Dylan. "I felt like 'All Along the Watchtower' was something I had written but could never quite get together," Hendrix explained. "I often feel like that about Dylan. Anyone who doesn't appreciate him should read the words of his songs. They are full of the joys and tragedies of life."

In the studio, Hendrix assumed the role of producer while recording "Watchtower," joined by Mitch Mitchell, Dave Mason, and Rolling Stones guitarist Brian Jones. Noel Redding did not participate. Over the past months, Redding's relationship with Hendrix had begun to deteriorate, for many of the same reasons Hendrix and Chandler were experiencing tension—namely, Jimi had a different approach to music and the recording process.

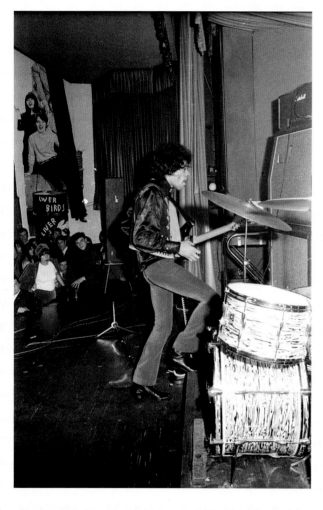
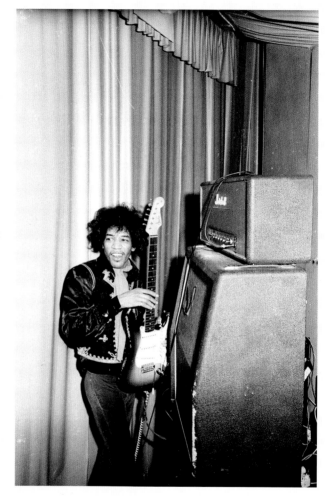
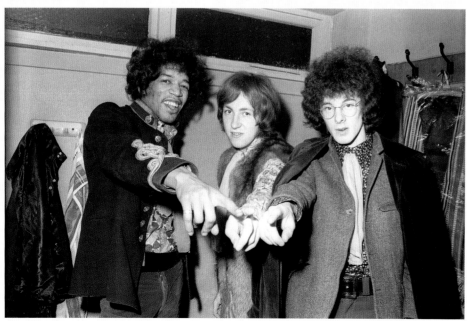

Star-Club, Hamburg, Germany,
March 18, 1967.

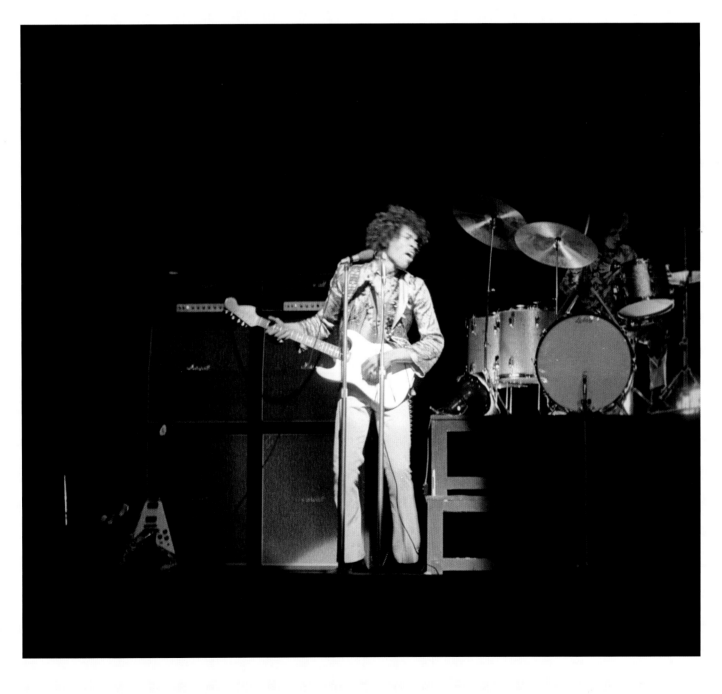

Saville Theater, London,
October 8, 1967.

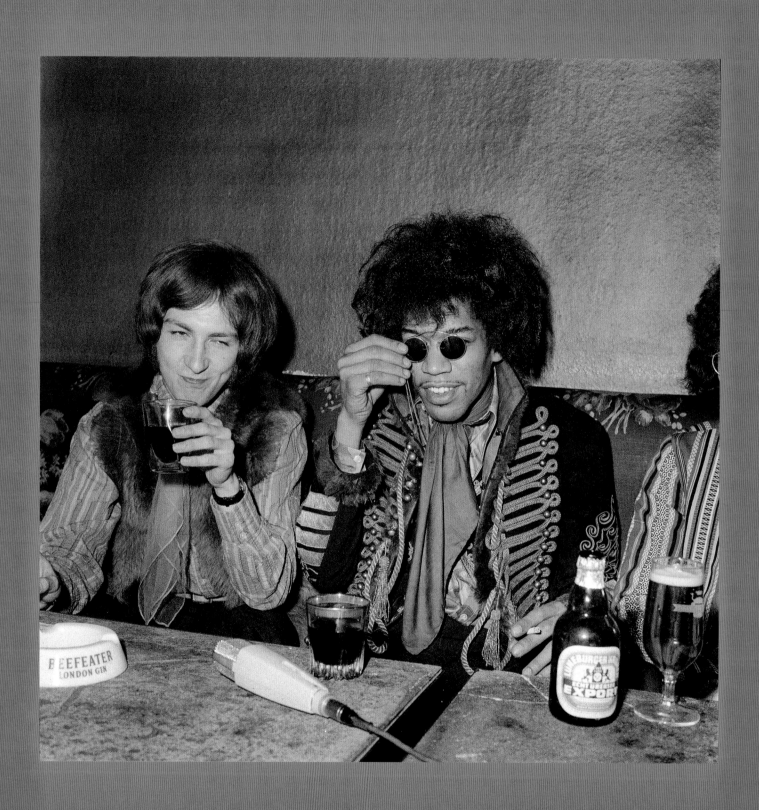

Danny's Pan Club, Hamburg,
Germany, March 17, 1967.

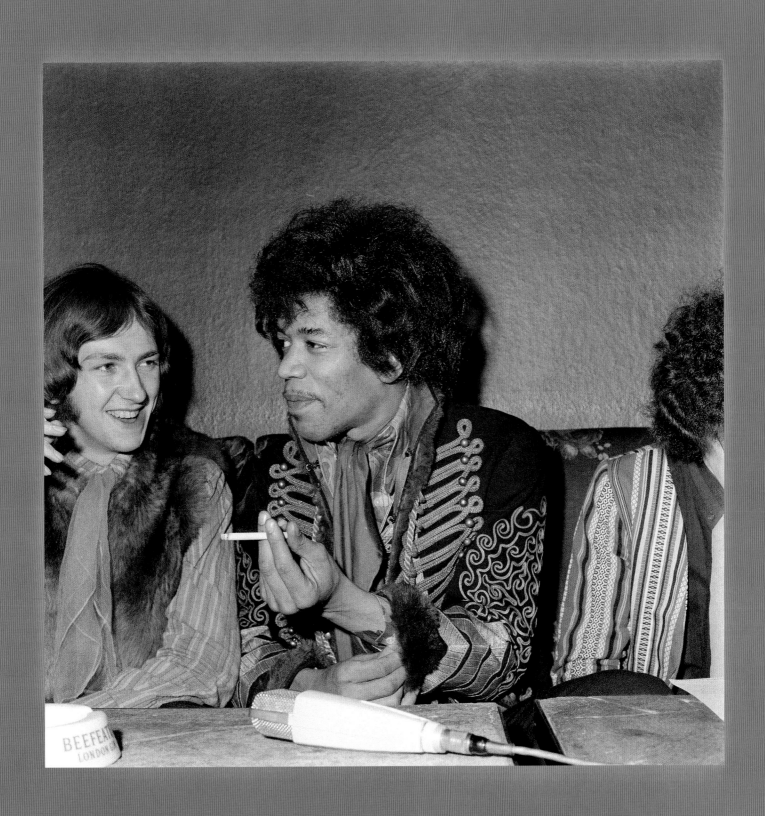

City Hall - Sheffield
Friday, 17th November at 6.20 & 8.50

Seat Prices: 15/- 12/6 10/6 7/6 5/-

Book at Wilson Peck Ltd., Leopold Street, Sheffield. Telephone: 27074

HAROLD DAVISON & TITO BURNS PRESENT

JIMI HENDRIX EXPERIENCE THE MOVE

illustration/design A Litri/Paul Martin & Associates

THE PINK FLOYD
THE NICE THE OUTER LIMITS THE EIRE APPARENT
COMPERE PETE DRUMMOND
THE AMEN CORNER

POSTAL BOOKING SLIP

To Box Office Manager, City Hall, Sheffield Wilson Peck Ltd. Jimi Hendrix/The Move Show
Please forward seats at for the 6.20/8.50 p.m. performance on Friday, 17th November
I enclose stamped addressed envelope and P.O./Cheque value ...
Name ..
Address ..

Printed by Hastings Printing Co., Drury Lane, St. Leonards-on-Sea, Sussex Telephone Hastings 2450

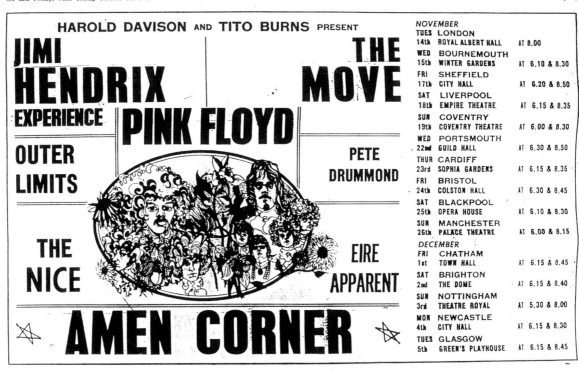

On sale Friday, week ending October 28, 1967 NEW MUSICAL EXPRESS * 7

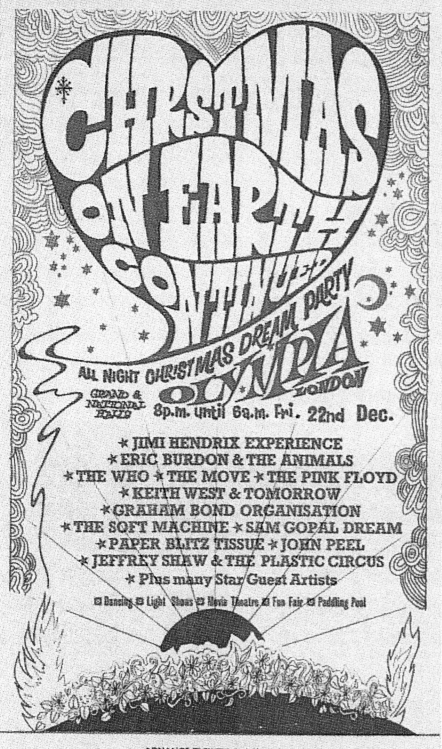

TOP LEFT
Saville Theater, London,
October 8, 1967.

BOTTOM LEFT
Fillmore West, San Francisco,
June 1967.

FOLLOWING
Gibson Flying V guitar, BBC
"Top Gear," The Playhouse Theatre,
London, December 15, 1967.

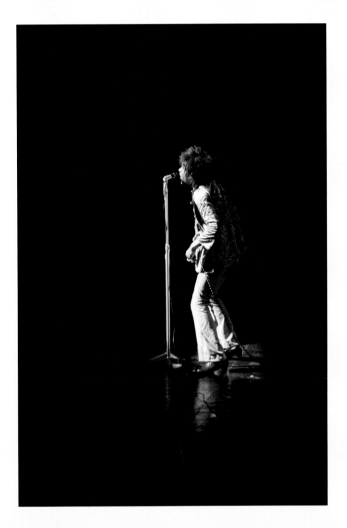

The basic "Watchtower" track consisted of Hendrix on acoustic guitar, Mason on a twelve-string acoustic guitar, and Mitchell on drums. Brian Jones began the session on piano, but Hendrix abandoned that concept after a few unsuccessful takes. Hendrix later overdubbed the part himself. Hendrix would also add vocal and guitar overdubs, including a slide part he performed by running a cigarette lighter over his guitar strings. Chandler, Hendrix, and Kramer mixed the song five days later and set it aside for the new album.

Meanwhile, the PPX contract battle now extended to two continents. Track Records, Jimi's UK company, remained convinced Chalpin had no rights to Hendrix's music with the Experience and vowed to fight to the finish. In the United States, Reprise, Jimi's American label, increasingly feared the negative impact made by Capitol Records' release of the Curtis Knight material. The initial sales of *Axis: Bold As Love* did not reach the figures attained by *Are You Experienced*, and Reprise believed the Curtis Knight material was the reason. Reprise thought that *Flashing*, a second album compiled by Capitol from Chalpin's various Curtis Knight session tapes, might damage Hendrix's reputation and popularity beyond repair. With the potential ramifications of the PPX litigation hanging over the group, the Experience dashed off to begin a full-scale US tour.

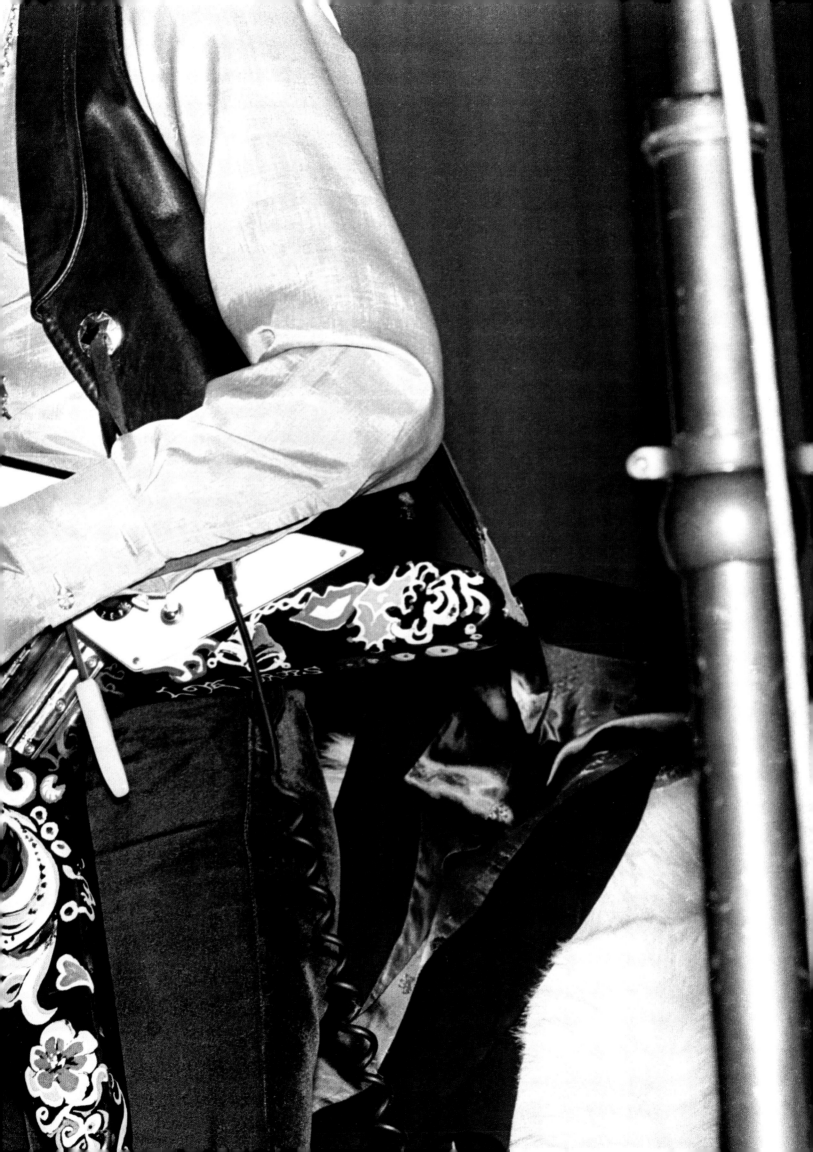

"

I HAVE PLAYED IN FRONT OF A **THOUSAND PEOPLE** AND I'M NEVER NERVOUS, BUT THERE IS SOMETHING ABOUT PLAYING IN FRONT OF YOUR **FAMILY**."

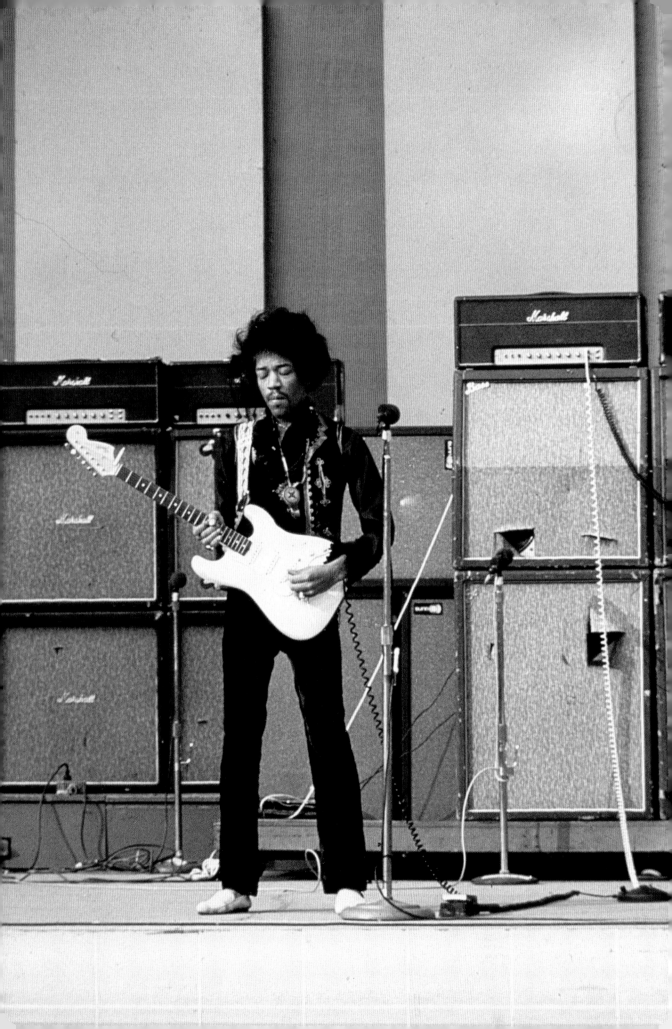

ELEC TRIC LADY LAND

The Experience flew to San Francisco, where an extensive US tour, organized in support of *Axis: Bold As Love*, began in earnest at the Fillmore Auditorium on February 1. From San Francisco, the Experience ventured across the United States, performing at a mix of clubs, colleges, and midsized auditoriums. Hendrix varied his set list throughout the tour, interspersing the likes of "Sgt. Pepper's Lonely Hearts Club Band," Bob Dylan's "Can You Please Crawl Out Your Window," and Howlin' Wolf's "Killing Floor" to the delight of his unsuspecting audiences.

In February, the Experience traveled to Seattle, giving Hendrix an opportunity to see his family. While Hendrix spoke frequently with his father via telephone, he had not returned home for more than five years.

When Jimi returned, Al was "in dreamland." The family waited for him at the airport, and Janie recalled he was the last one off the plane. He was wearing his stage clothes, and they all noticed a tear in his jacket. When they pointed it out to him, Jimi said, "Oh well, I guess I'll have to buy another one." Al's amused reaction was, "Oh, you have it like that, huh?" Whereas when he left Seattle, he could barely buy a candy bar, now he thought nothing of replacing expensive clothing.

In his book, Al recalled, "It was a homecoming, but now he was a rock star and the reaction was bigger than what I anticipated." Janie remembered the crowds of people screaming at Jimi's Coliseum concert. "I remember my dad pinching himself and I was like, 'What are you doing?' He said, 'It's like I'm not here,' and he just kept pinching himself all night long." The performance also held great importance for Jimi. He told them afterwards that, "I've played in front of a thousand people and I'm never nervous, but there is something about playing in front of your family." While in Seattle, Jimi was also given an honorary diploma from Garfield High School and the key to the city.

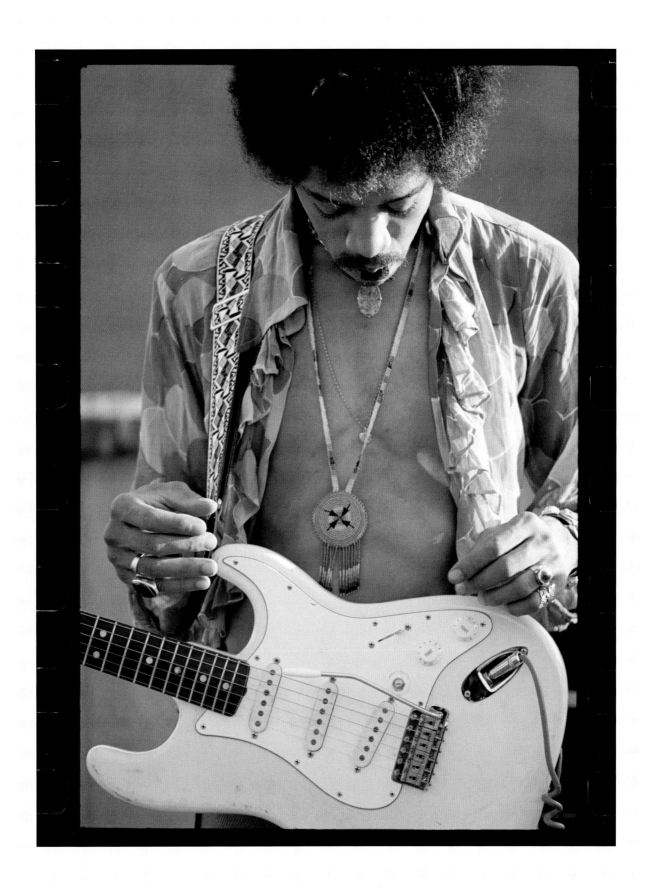

PREVIOUS
Afternoon rehearsal, Hollywood Bowl,
Hollywood, California, September 14, 1968.

ABOVE
2850 Benedict Canyon Drive, Beverly
Hills, California, September 13, 1968.

2850 Benedict Canyon Drive, Beverly
Hills, California, September 13, 1968.

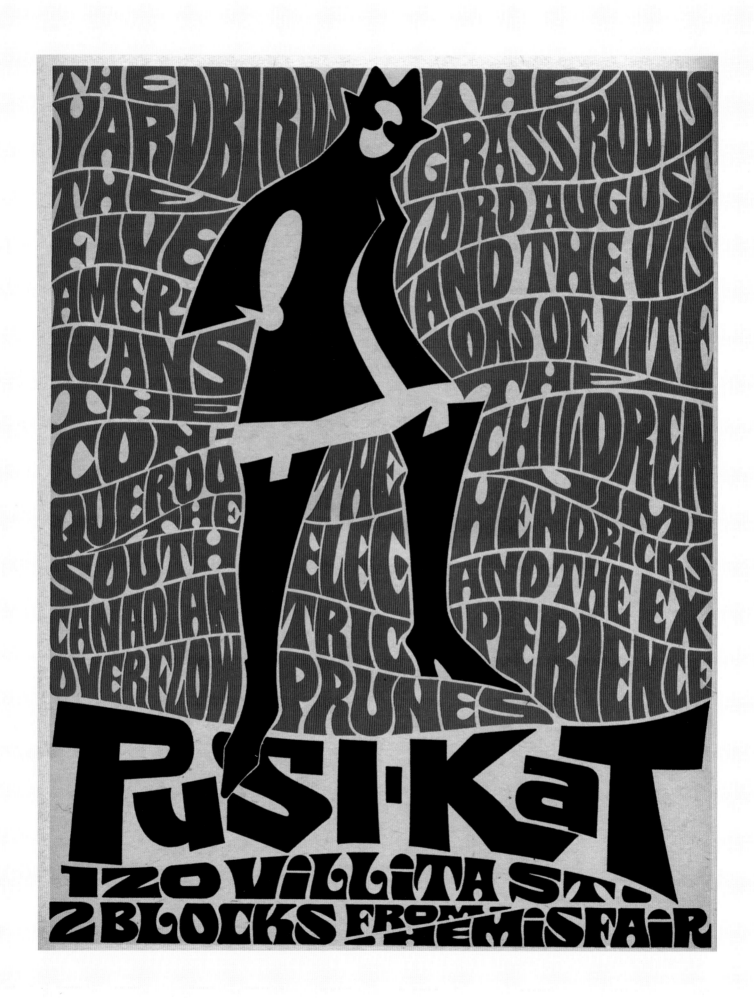

Jimi was eager to help Al and June out financially and wanted to buy them a house. Al declined, but Jimi, who was generous with everyone, wanted the opportunity to be so with his dad. Al later agreed to let Jimi give him the money for a car and a truck. For Al, going to a dealership, cash in hand, and having the pick of the lot was one of the best feelings he ever had.

Jimi's visit home was packed but brief. Following his sold-out performance, the Experience had six concerts in six different cities before they had another day off.

Despite the growing popularity of *Are You Experienced*, the Experience had only begun to develop an American following. As a result, limited finances made the comforts of a tour bus or leasing an airplane impossibilities. Instead, the group, guided by their faithful road manager Gerry Stickells, made much of their journey across the country in a rented station wagon. In what can only be described as a remarkable test of their endurance and enthusiasm, the Experience performed sixty concerts in sixty days during the first leg of this tour.

Hendrix was brimming with new material, and in April the band returned to the studio and resumed work on *Electric Ladyland*. This time, sessions were held at the Record Plant, a twelve-track recording facility opened by producer Tom Wilson (best known for his work with Bob Dylan), former Mayfair Studios recording engineer Gary Kellgren, and Revlon Cosmetics executive Chris Stone.

Where Hendrix's first two albums had been recorded on four-track equipment in London, Kellgren had installed new twelve-track Scully recording machines, giving the facility a technological edge over established New York studios. This was a significant advance, as it accorded artists the opportunity to have twelve discrete tracks to start each session. For artists such as Hendrix, their canvas had been significantly expanded. A multitude of voices, instrumentation, and effects could be placed in the stereo image during the final mixing process. Expanded sound paintings such as "1983 … (A Merman I Shall Turn To Be)" would reap immediate dividends from this technological advance. Adding to the studio's appeal was the fact that they'd recruited Hendrix's favored engineer Eddie Kramer, luring him away from London's Olympic Studio and installing him in the Record Plant.

Jimi's first Record Plant session focused on the whimsical "Long Hot Summer Night." In the days that followed, new songs such as "Gypsy Eyes" and "1983 … (A Merman I Should Turn To Be)" began to take form.

In part because Hendrix had felt that the mixing and recording sessions for *Axis: Bold As Love* had been rushed, he now sought sufficient time to craft his new songs. One day in the studio, Hendrix and Mitchell attempted forty-one takes of "Gypsy Eyes" without success. This approach irritated Chandler, who preferred to develop a basic track quickly. "It was slow going from the moment we started at the Record Plant," Chandler said. "I was sitting there listening to him play the song over and over again thinking to myself, 'What is going on?' Jimi had wanted this to be a double album and I distinctly recall being glad that I had done so much at Olympic, because at this pace, the album would never be finished." Chandler viewed Hendrix's inability to complete a satisfactory backing track as an indication that the guitarist was struggling. Hendrix, for his part, soon began to chafe at Chandler's firm hand and openly challenged his decisions. The difficulty perfecting "Gypsy Eyes" plainly illustrated the growing divide between the two musicians' approaches to recording. And the tension between Hendrix and Noel Redding also mounted daily.

FOLLOWING
KMET Radio Station, Hollywood,
California, September 12, 1968.

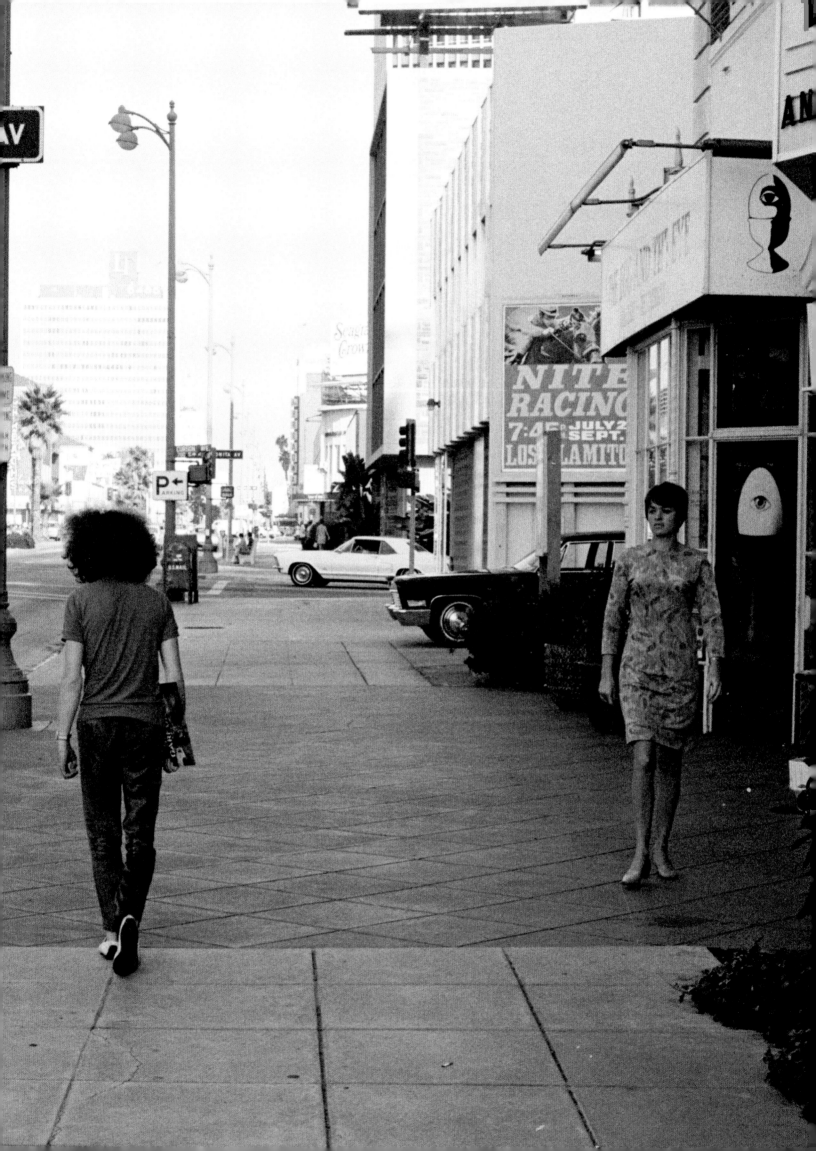

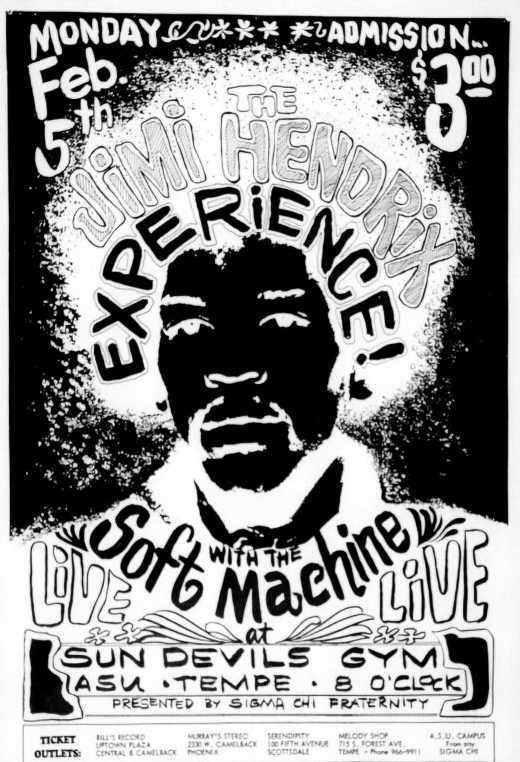

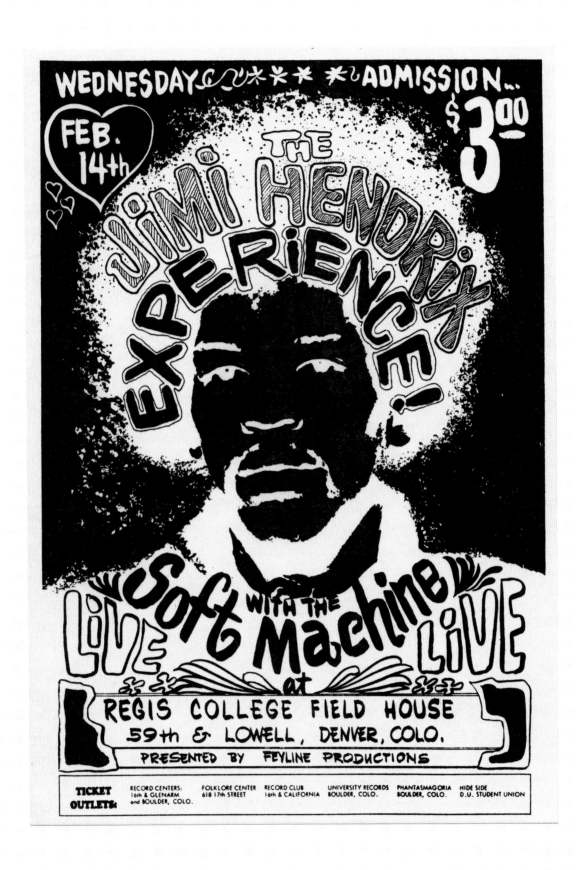

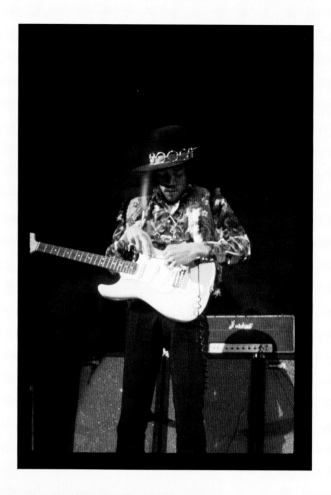

Redding had grown extremely agitated at Hendrix's tolerance of the many hangers-on that now crowded the Record Plant control room. Recording sessions, Redding complained, had become parties. As Chandler later described, Hendrix was enjoying the "lap of honor," having returned home after finally making good. Redding grew frustrated when Hendrix would play to the assembled crowd or allow his focus to be diverted by the stream of human traffic weaving in and out of the Record Plant control room, and confronted Jimi one day. Hendrix didn't take Redding's concerns seriously, instructing him to "relax." Embarrassed and infuriated, Redding stormed out, teeming with frustration.

Later that evening, absent both Chandler and Redding, Hendrix went to the Scene Club, located just around the corner from the Record Plant. The club had become the chosen venue for Hendrix and friends to hang out, listen to music, and occasionally, play together. After a long evening of revelry, Hendrix led Mitchell, Steve Winwood, Jefferson Airplane bassist Jack Casady, Eddie Kramer, and a host of friends back to the Record Plant studio to jam. The resulting "Voodoo Chile," the third of three attempts made that late night/early morning, stands as one of *Electric Ladyland*'s finest achievements.

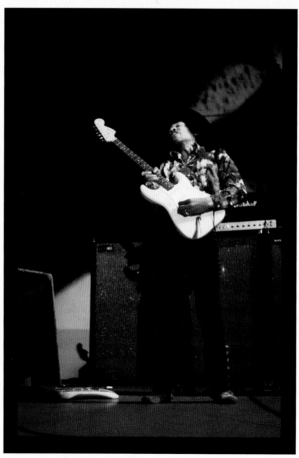

The following day, Chandler and the Experience assembled at the Record Plant to resume recording. ABC-TV was present to film the group for a proposed news feature. Jimi premiered his new song, "Voodoo Child (Slight Return)," for the occasion. This version not only maintained the exotic voodoo theme Hendrix established with the lengthy blues song recorded during the late-night session, but his foreboding lyrics, wah-wah drenched guitar work, and superb accompaniment by Mitchell and Redding established this as one of Hendrix's signature works.

Shrine Auditorium, Los Angeles, California, February 10, 1968.

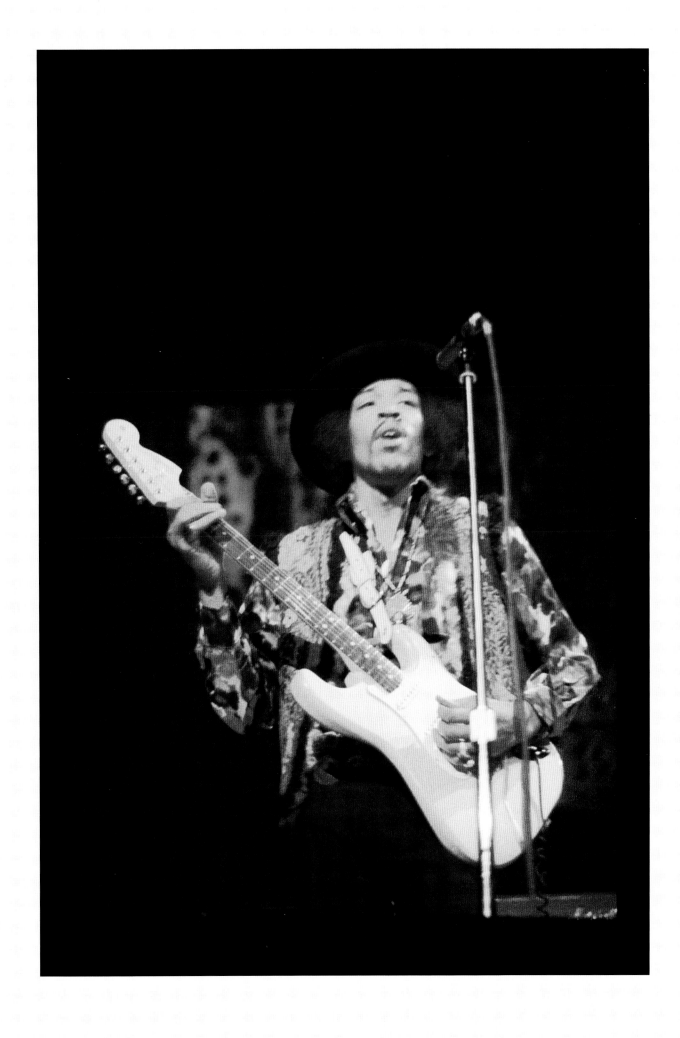

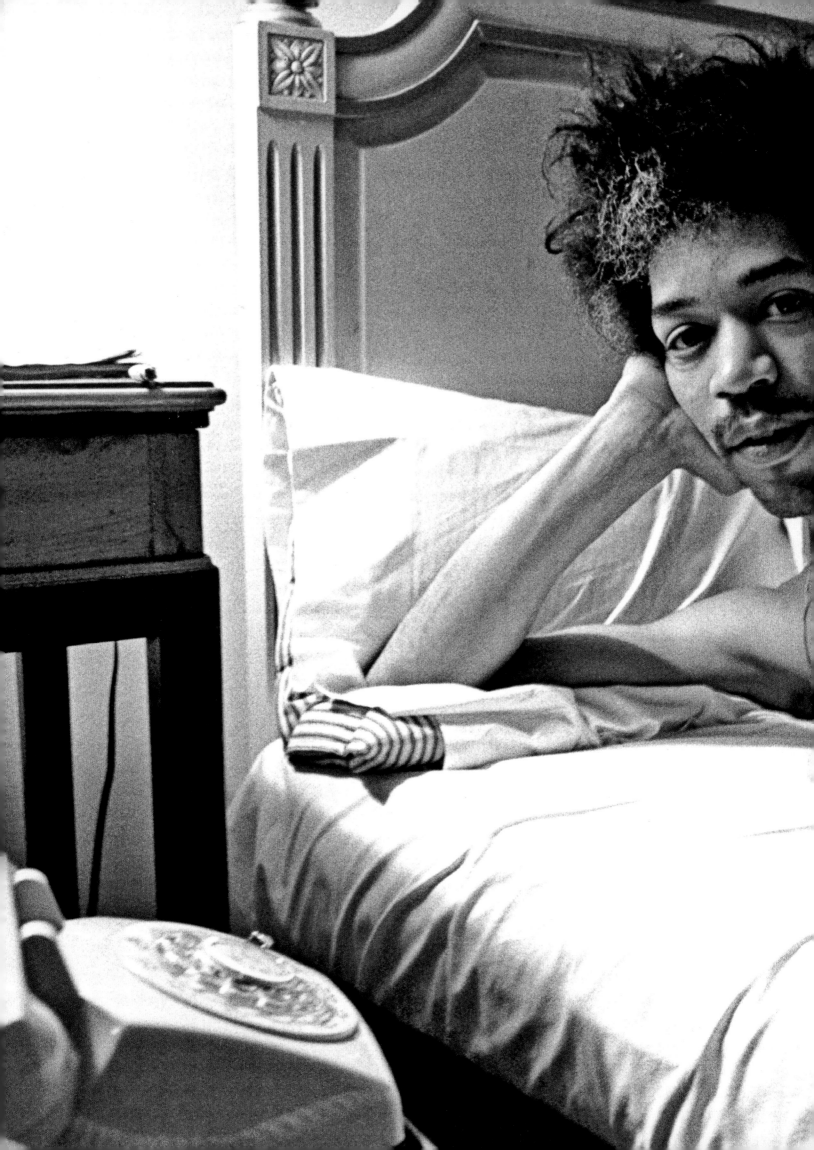

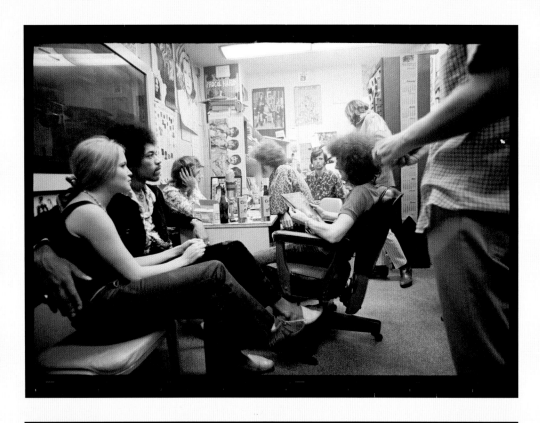

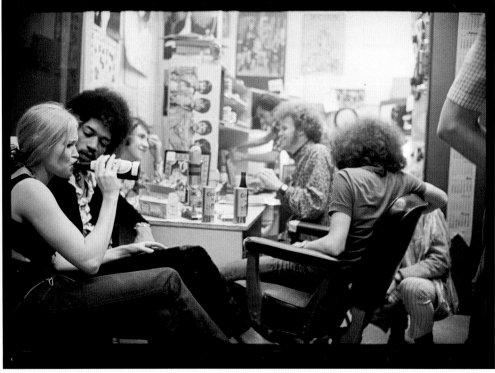

PREVIOUS
Drake Hotel, New York, June 1968.

ABOVE
KMET Radio Station, Hollywood,
California, September 12, 1968.

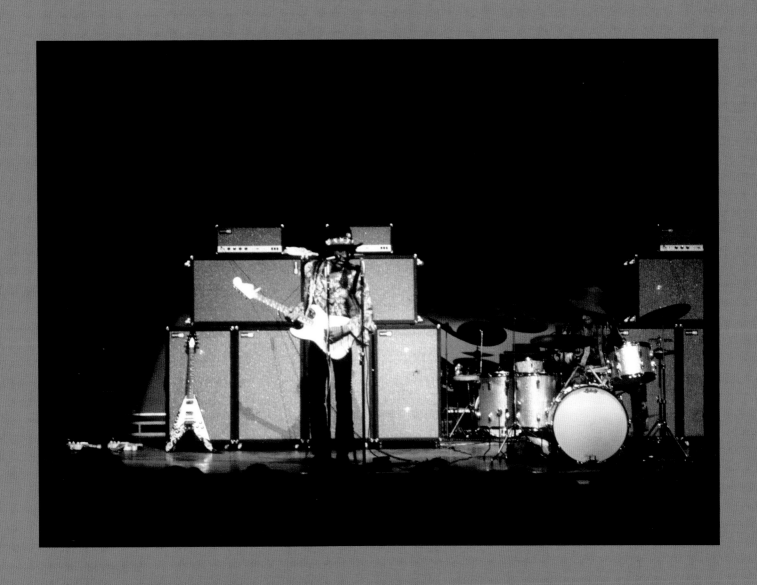

Hunter College, New York,
March 2, 1968.

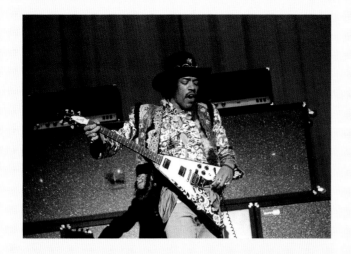

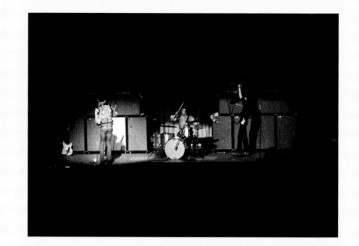

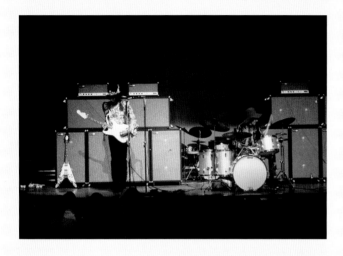

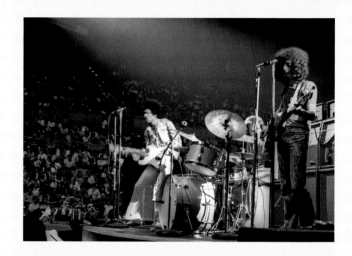

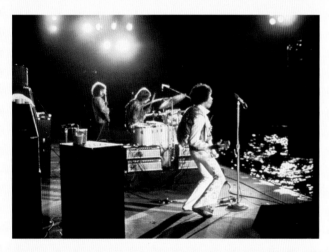

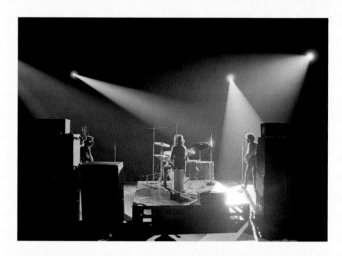

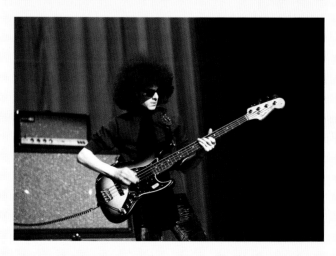

LEFT
Various live shows, 1968.

BELOW
TTG Studios, Hollywood, California,
October, 1968.

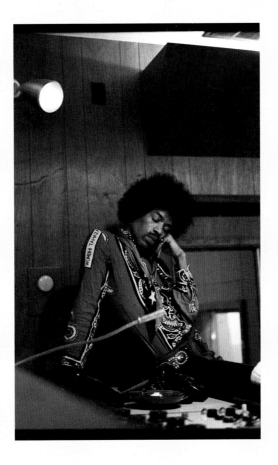

Despite the victory of Hendrix's new song, by early May, Chandler's patience was exhausted. Tired of what he viewed as Hendrix's lack of focus, Chandler stepped down as producer, although he continued to act as Jimi's co-manager. Undaunted, Hendrix took up the production reins and continued to make refinements to his growing pile of new material.

As the Experience struggled to maintain their creative focus, the bitter wrangling caused by the PPX litigation reached a peak. After all the acrimonious litigation, Hendrix and Warner Bros. Records, then his US distributor, elected to rid themselves of the situation by agreeing, in June 1968, to a legal settlement granting Chalpin and Capitol certain financial considerations and the distribution rights to one album featuring performances by the Jimi Hendrix Experience.

Meanwhile, the relationship between Hendrix and Redding was still strained, particularly in the recording studio. Without Chas Chandler to referee these disputes, the two grew more estranged. Experience sessions with Redding present were often unproductive, with the bassist unwilling to sit through Hendrix's lengthy efforts at perfecting his respective guitar parts. The situation worsened when Hendrix elected to play the bass parts himself when Redding was absent, or made alterations via overdubs during later sessions. Redding, meanwhile, was writing and recording his own material, activities that provided him with the opportunity to both sing and play his instrument of choice, the guitar.

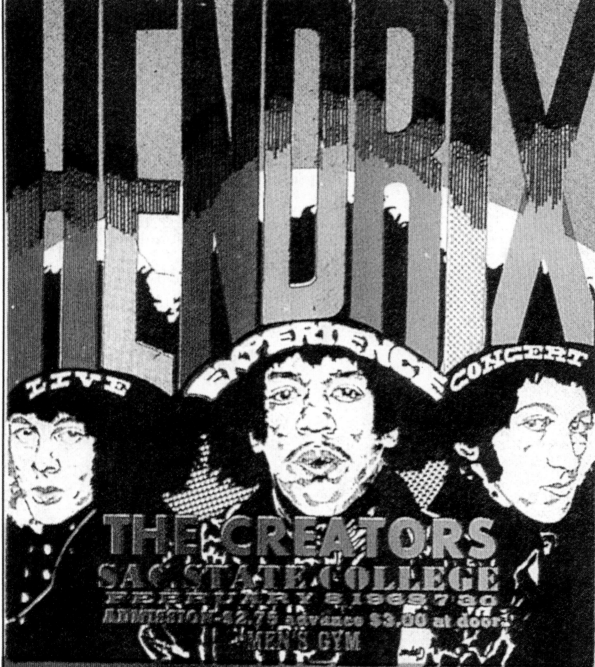

TONIGHT THROUGH SUNDAY
BEST OF THE BOSTON GROUPS
BEACON STREET UNION MGM RECORDS

MARCH 11 THRU 17
DIRECT FROM ENGLAND AND THE JIMI HENDRIX TOUR
SOFT MACHINE
Featuring EUROPE'S AWARD-WINNING LIGHT SHOW
MARK BOYLE'S SENSUAL LABORATORY
ONLY $2.50 ADM. ALWAYS ● BODY & SOUL DANCING AVAILABLE

While in my own universe, having stopped time and made energy, I can still
do no more than hope for and do my best For my universe. For yours.
For all others.

PLEASE COME TO

STEVE
PAUL'S **SCENE** 301 W. 46th St.
 JU 2-5760

MONDAY FEB. 12 - 8pm
SEATTLE CENTER ARENA

JIMI HENDRIX EXPERIENCE

TICKETS BON MARCHE & SUBURBAN OUTLETS
U DISTRICT "CAMPUS MUSIC"

The
Jimi
Hendrix
Experience

England's Underground Sensation

The Soft Machine

With

**THE MARK BOYLE
SENSE LABORATORY**

TUESDAY, FEBRUARY 13, 1968
A.U. GRAND BALLROOM
8:00 P.M.
TICKETS $2.00
AT KH TICKET OFFICE

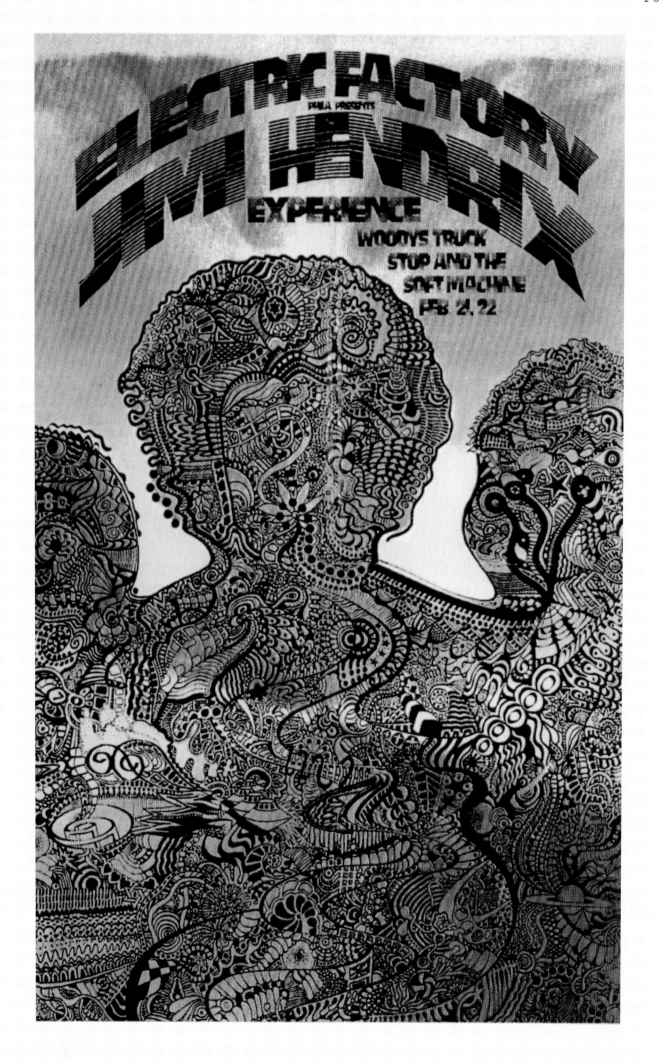

Dear Sirs.

Here are the pictures we would like for you to use anywhere on the L.P. cover. preferably inside and back.
with out the white frames around some of the B/w ones.
and with most of them (inside) next to each other in different sizes and mixing the color prints at different points.

for instance

Rough Sketch of L.P

INSIDE and OUTSIDE

Please use picture (color) with all of us and the kids on the statue for front or BACK COVER. (OUTSIDE) cover

And the other back or front side (outside) cover Please use three

Good Pictures of us. In B/w or color

OUT SIDE

we would like to make an apologise for Taking so very long to send this but we have been working very hard indeed, doing shows, AND Recording.

yes sir!

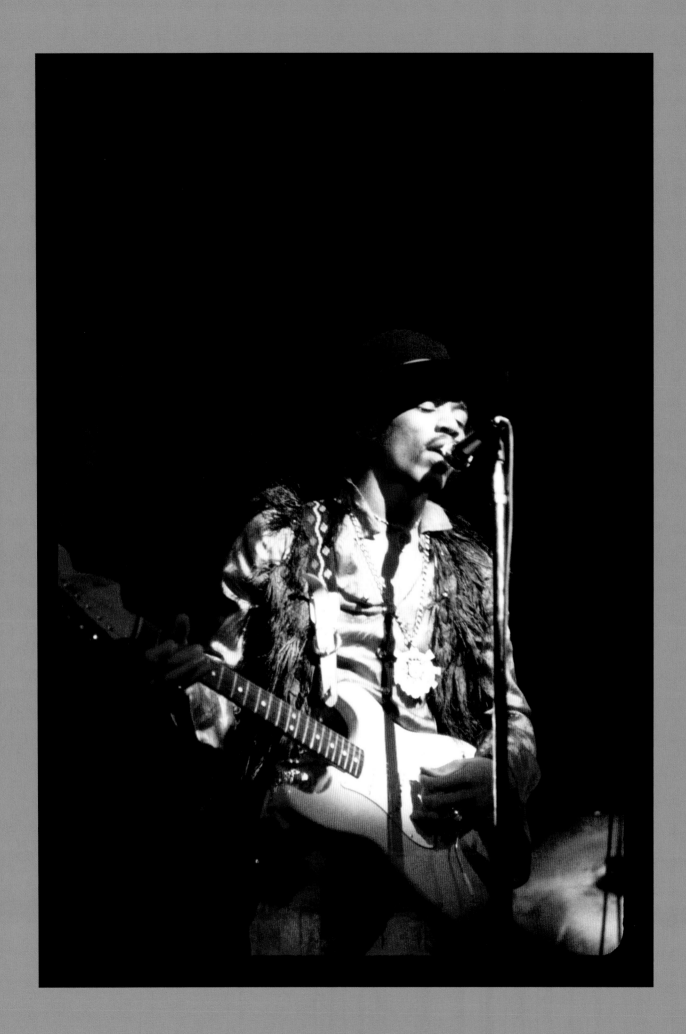

Both the band's personal troubles and Hendrix's crowded schedule of personal appearances wreaked havoc on Hendrix's efforts to steer *Electric Ladyland* toward completion. To the guitarist's dismay, the album wasn't finished before the Experience embarked on another US tour, beginning in Baton Rouge, Louisiana. Between shows, Hendrix returned to the Record Plant to labor over mixes and overdubs for "House Burning Down." Another frenzied, final session saw Hendrix finally complete "Gypsy Eyes" to his exacting specifications. Needing one final song to complete the album, Hendrix directed the group through an animated, live-in-the-studio interpretation of Earl King's classic "Come On (Let the Good Times Roll)." *Electric Ladyland* was finally sequenced and delivered to Reprise in the United States and Track in the United Kingdom.

The album's final cost approached $70,000, a considerable sum for that era. Unlike contemporaries such as Bob Dylan and the Beatles, whose master recordings were owned by their record label, Hendrix himself underwrote *Electric Ladyland*. "It was really expensive because we were playing and recording at the same time, which is a whole lot of strain on you," Hendrix explained in an interview conducted after the album's release. "Therefore you have to go back into the studio again and redo what you might have done two nights ago. The money doesn't make any difference to me, because that's what I make the money for, to make better things."

Hendrix had been involved in nearly every facet of the creation of *Electric Ladyland*, reaching far beyond supplying his voice and instrumentation into the album's final mixing and sequencing. His vision for the album even extended to its packaging. Friend and photographer Linda McCartney had taken photographs of the Experience in Central

Park surrounded by children. In addition, Eddie Kramer was also an amateur photographer, and Jimi selected a host of Kramer's black-and-white photographs, in addition to those of Linda McCartney and photographer David Sygall, to ring the inner gatefold sleeve. As the Experience tour wound through Salt Lake City and Denver, Hendrix finished his *Electric Ladyland* sleeve designs as well as the poem titled, "Letter to the Room Full of Mirrors" he wished to include inside the gatefold sleeve. Hendrix then dispatched elaborate instructions on the jacket design to Reprise so that manufacturing of the album could commence.

When the album was issued in October 1968, Hendrix was bitterly disappointed to see that his artwork directions had been altered by both labels. Reprise replaced the McCartney Central Park images with two color shots by Karl Ferris, whose images had graced the US edition of *Are You Experienced*. Track opted for a much more controversial approach. Because the Experience had moved its base of operations to America, Track executives Kit Lambert and Chris Stamp were eager to recapture the attention of the British press. They commissioned photographer David Montgomery to shoot an image of nineteen naked women, and the resulting cover created a public relations uproar that exceeded Lambert and Stamp's expectations and soon spread across Europe. The photograph was so controversial that remedies such as housing the LP jacket in a brown paper bag were bandied about. Hendrix seethed, feeling that the stunt demeaned the labor he had invested into the album. "All I can say is that I had no idea that they had pictures of dozens of nude girls on it," Hendrix complained in an interview. "People have been asking me about the English cover and I don't know anything about it. I didn't know it was going to be used. It's not my fault."

Fillmore East, New York, New York, May 10, 1968.

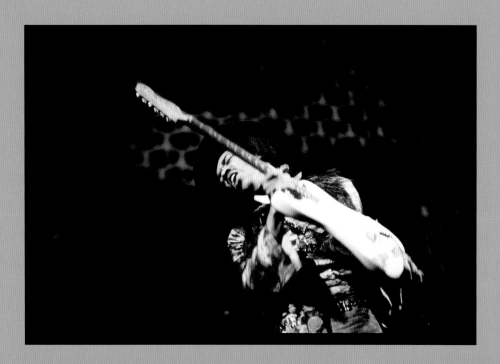

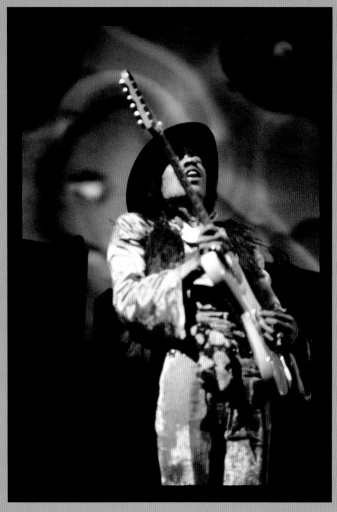

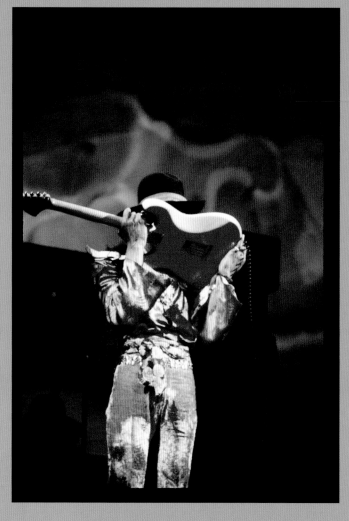

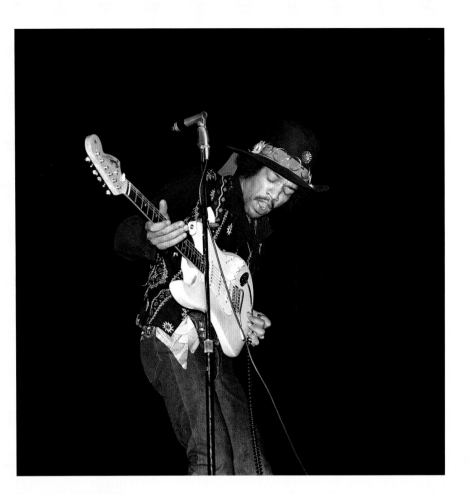

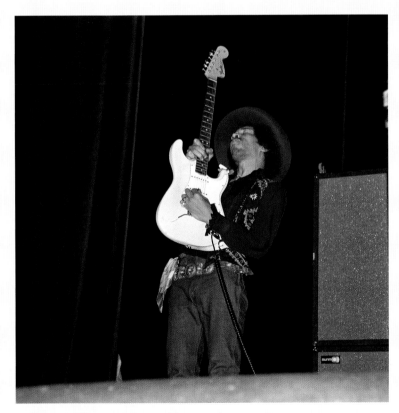

Public Music Hall, Cleveland, Ohio,
March 26, 1968.

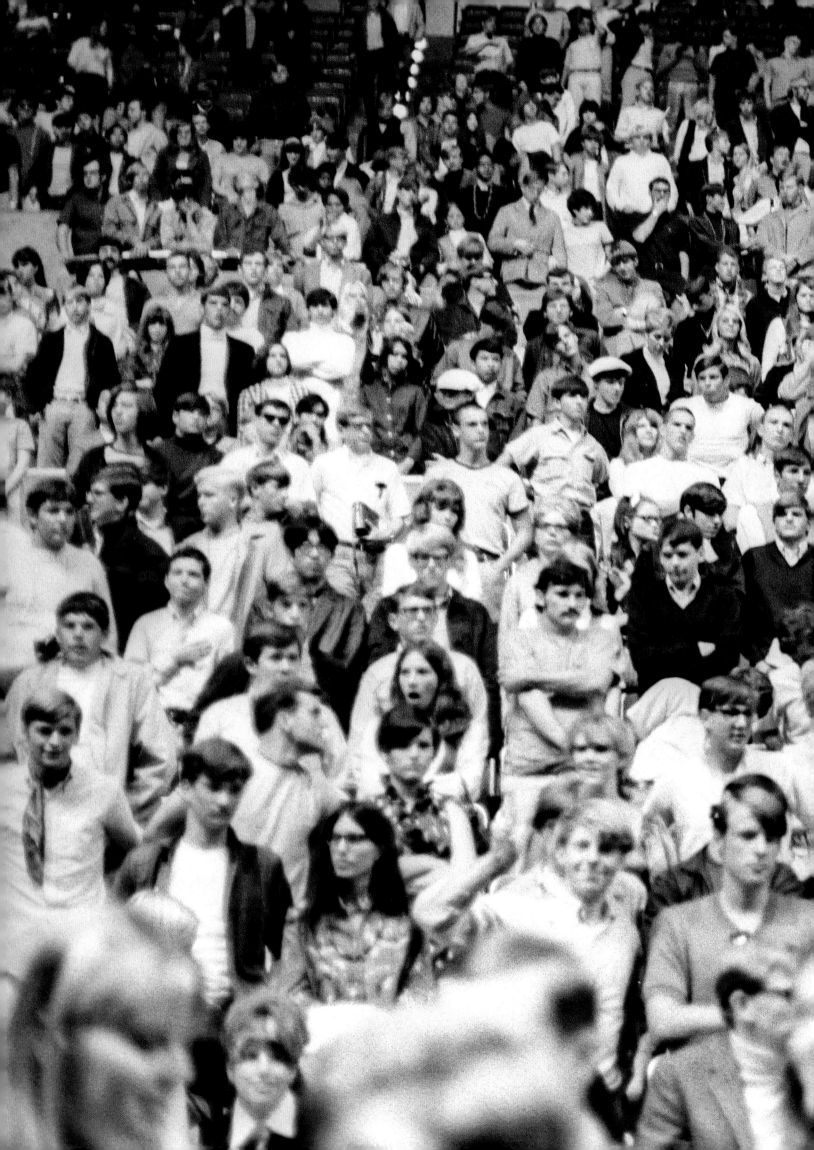

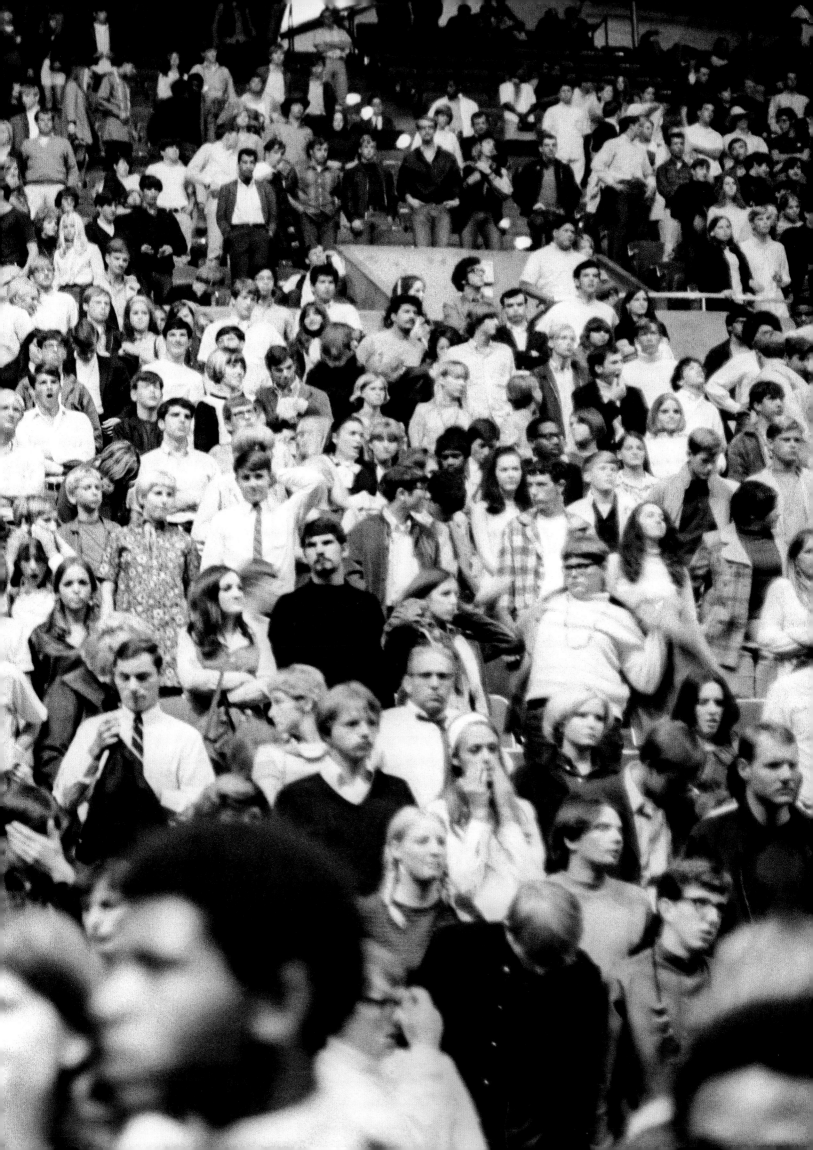

"You can mix and mix and mix and get such a beautiful sound and when it's time to cut it they just screw it up so bad. Some people don't have imagination."

Not only was Hendrix deeply disappointed by the album's artwork, he was frustrated that the final mastering had compromised the elaborate mixes he and Eddie Kramer had labored over. "We were recording while we were touring and it's very hard to concentrate on both," Hendrix explained. "You can mix and mix and mix and get such a beautiful sound and when it's time to cut it they just screw it up so bad. Some people don't have imagination."

However pained Hendrix was by these slights, neither had a negative impact on *Electric Ladyland*'s popularity. The album was a runaway success. Just one month after its release, *Electric Ladyland* topped Billboard's US album chart, while *Are You Experienced* continued to thrive in the top ten. "All Along The Watchtower," the first single issued from the album, broke into the UK top five and peaked at number twenty on the Billboard singles chart—the highest position ever for an Experience single.

WKYC Radio, Cleveland, Ohio,
March 26, 1968.

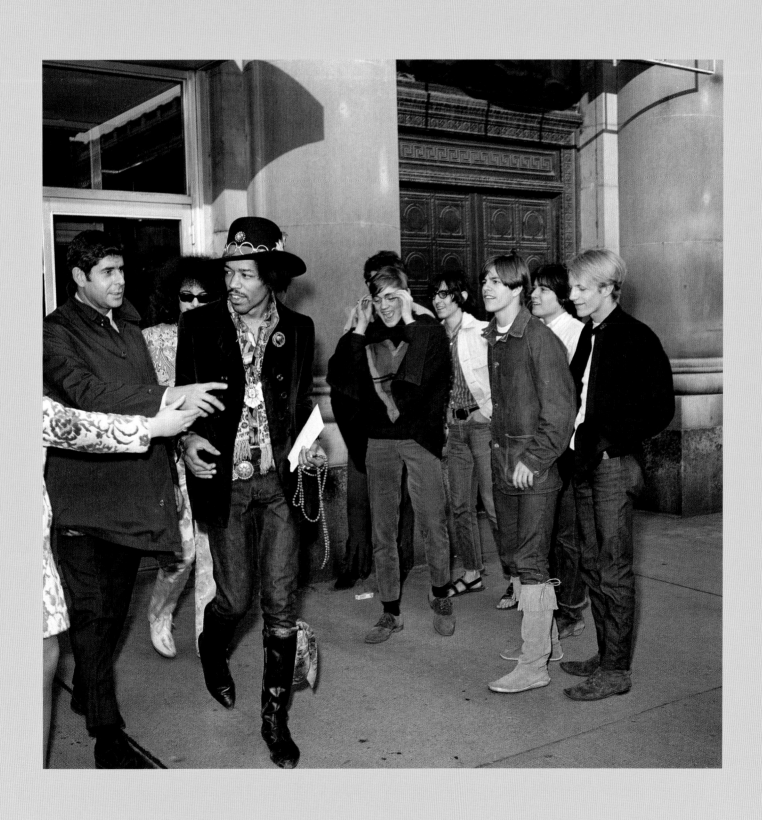

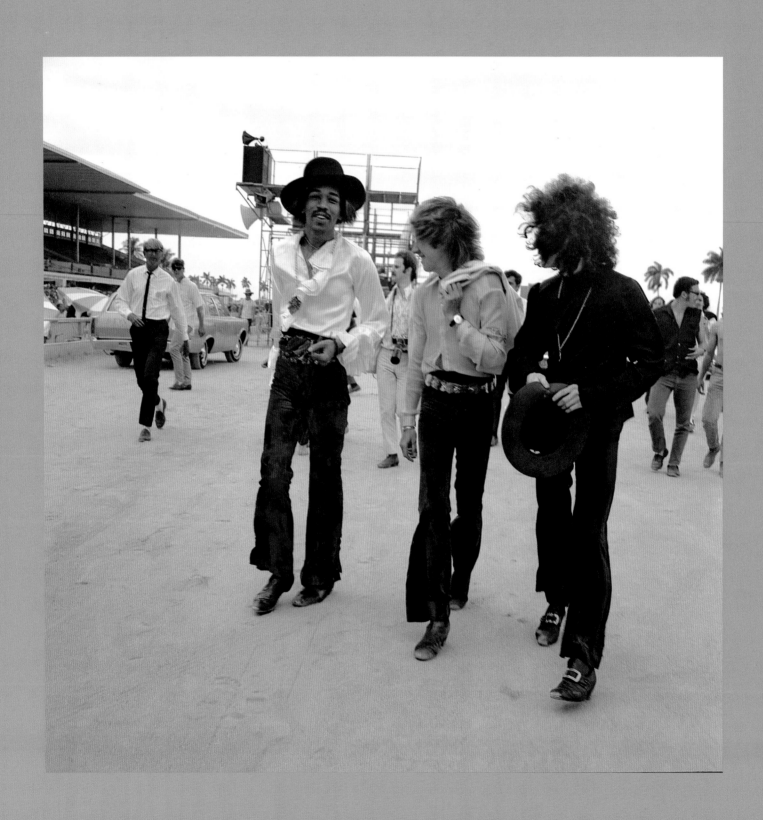

Miami Pop Festival, Gulfstream Park,
Hallandale, Florida, May 18, 1968.

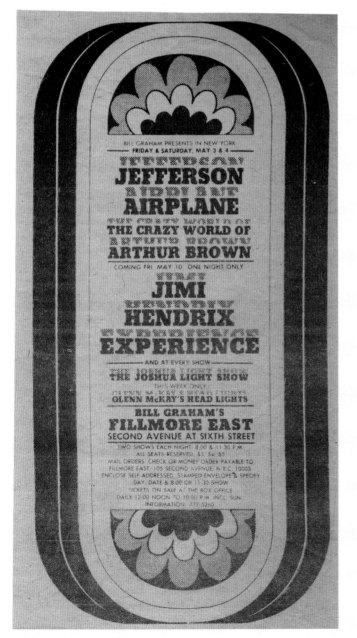

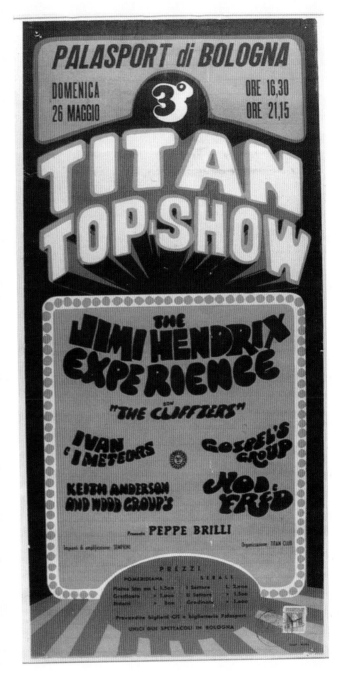

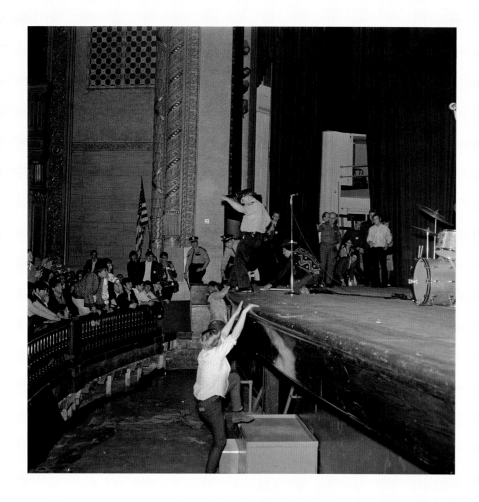

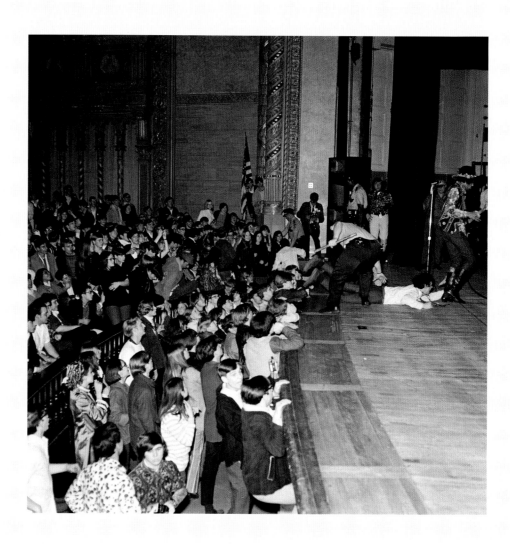

Public Music Hall, Cleveland, Ohio,
March 26, 1968.

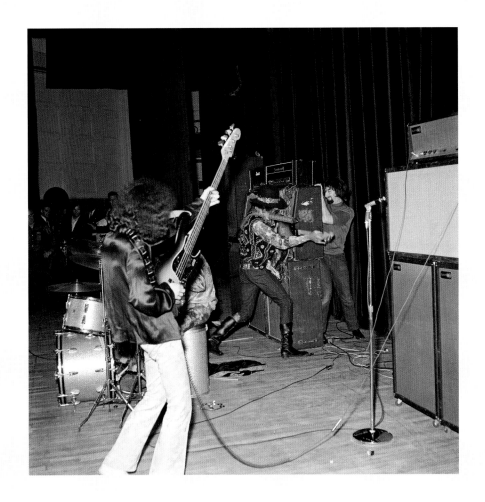

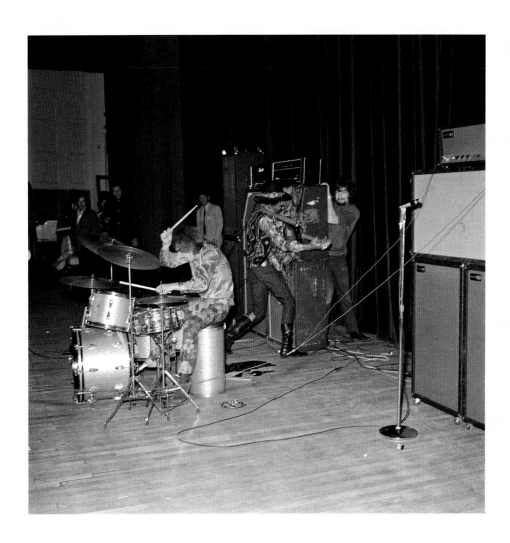

FRIDAY NOV. 15 - 8:00 P.M.
CINCINNATI GARDENS

WUBE AND CONCERTS WEST PRESENT
JIMI HENDRIX EXPERIENCE

TICKETS AVAILABLE AT
CINCINNATI GARDENS AND
ALL POGUE'S STORES

HENDRIX

XANADU-ST. LOUIS '64

by Guy Nassberg

Jimi Hendrix humped the stage of St. Louis' Kiel Auditorium, Sunday night, November 3, to the 'tune of the Foxy Star Spangled Banner. Hendrix played most of the concert "straight," radiating stud psychedelicism and pulling the neck of his guitar back and forth between his tapered legs.

Toward the end of one number, a young photographer scrambled onstage to catch Jimi going down on his instrument, and was pursued by the grasping hands of plainclothes guards. The audience cheered, and the cat tried a second picture as Hendrix concluded the number.

While the plainclothesmen pushed the photographer around a bit, star Hendrix announced that there was no room for violence on stage with him. Rock concerts are a good way to release frustration, he explained, but the audience must keep its place. "Peace, brothers, Peace," he crooned, sensuously waving the peace sign above his head. The audience threw back the sign -- "Yeah, Peace" -- as Hendrix announced that he would play the Star Spangled Banner.

He did. The audience stood. There are rumors that one former Civil Rights worker almost threw up. The last chord of the not too turned-on Banner (what can you do with that music anyway?) merged into Purple Haze.

As the air cleared, Jimi flashed the Peace Sign a few more times, penetrated the audience with the neck of his guitar, and proceeded to ram said aforementioned guitar into one of his monstrous amps. "Umph." Still there. "Umph." (or is it nngowahhh?) Turn around for an effeminate wave of the Peace Sign.

Hendrix took another guitar from his long-haired assistant, who spent the evening replacing instruments the Hendrix crew destroyed while releasing frustrations.

"Crack." Hendrix held up the broken neck of the guitar, in what must be the sado-masochistic act of the year, flashed the Peace Sign, and petered off.

Some may think that Hendrix is cock, but to St. Louis he came with his ass backwards.

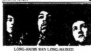

LONG-HAIRS BAN LONG-HAIRED

NEW YORK (LNS) - New York's long-hair establishment is getting up tight about long-haired youth.

The Jimi Hendrix Experience has been permanently banned from hallowed Carnegie Hall because, according to Ioana Satescu, the hall's booking manager: "We have information that in his other appearances in other places the audience got very much out of hand. They destroyed furniture and draperies. We cannot afford to take that chance."

Turning down an offer from the concert promoter to post a surety bond, the management said it would not permit Hendrix to play there under any circumstances.

Apparently Philharmonic Hall is less worried about interior desecrators. The Experience has been rescheduled there for November 28.

• • • • • • • • • • • • • •

10

Photos by Jim Wiseman

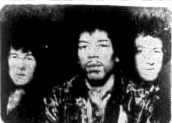

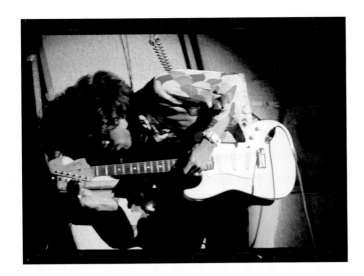

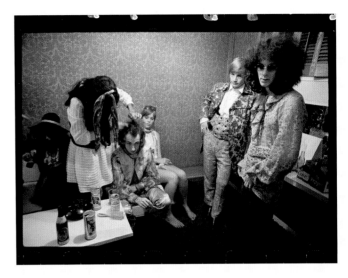

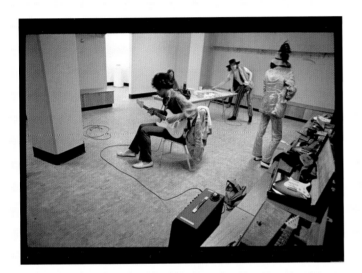

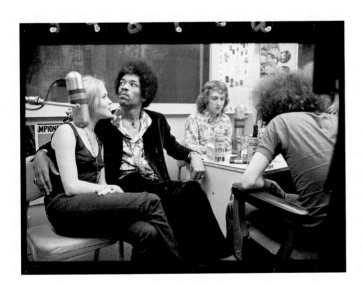

TOP and MIDDLE LEFT
Oakland Coliseum, Oakland,
California, September 13, 1968.

BOTTOM LEFT
KMET Radio Station, Hollywood,
California, September 12, 1968.

TOP and MIDDLE RIGHT
Backstage at Hollywood Bowl,
Hollywood, California,
September 14, 1968.

Despite the group's meteoric rise, co-managers Chas Chandler and Michael Jeffery had ceased to work effectively with the group. Serving as the producer for Hendrix had always been Chandler's primary interest, and having already relinquished this role during *Electric Ladyland*, Chandler was no longer interested in the managerial side, which primarily involved fighting Jeffery over every facet of Hendrix's career. He elected to quietly withdraw to London, divesting himself of his Hendrix interests. Just two years from the day he had brought Hendrix to London, Chandler returned home alone. And although Hendrix refused to acknowledge it immediately, he had lost more than a manager. He had lost his staunchest supporter.

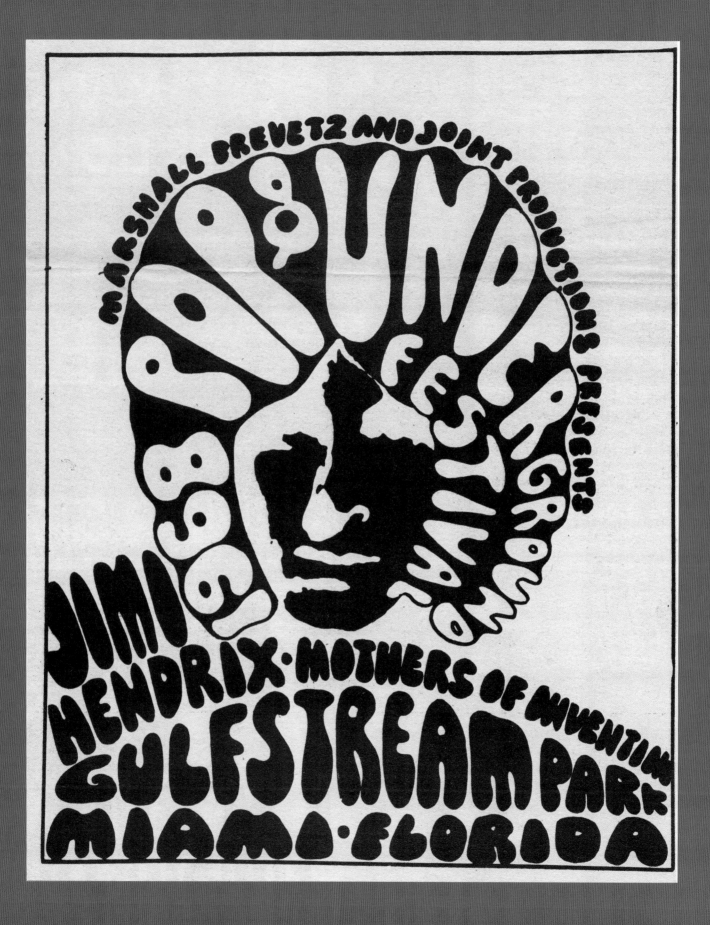

Shrine Auditorium, Los Angeles, California, February 10, 1968.

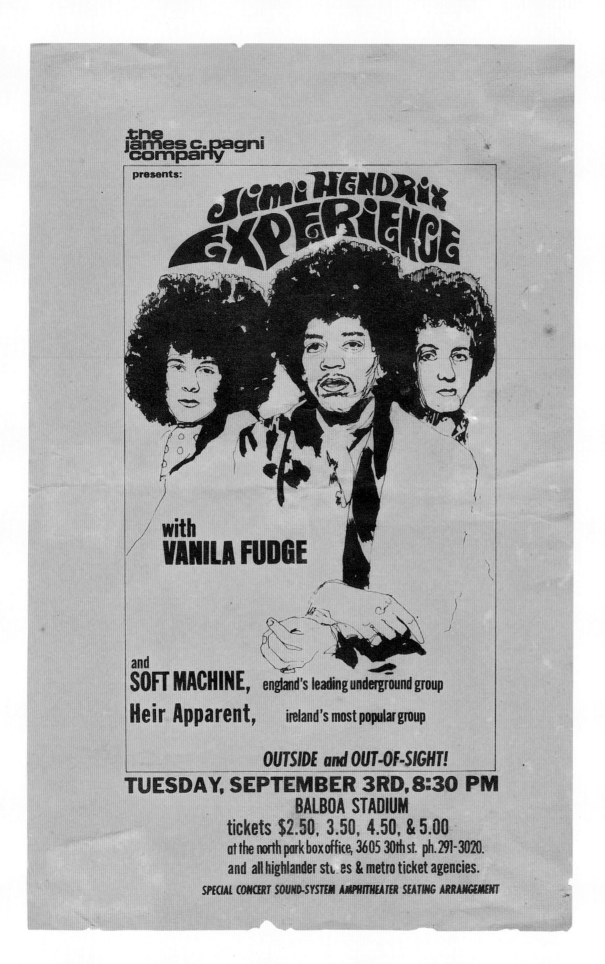

FOLLOWING
Unknown bar, Oakland, California,
September 1968.

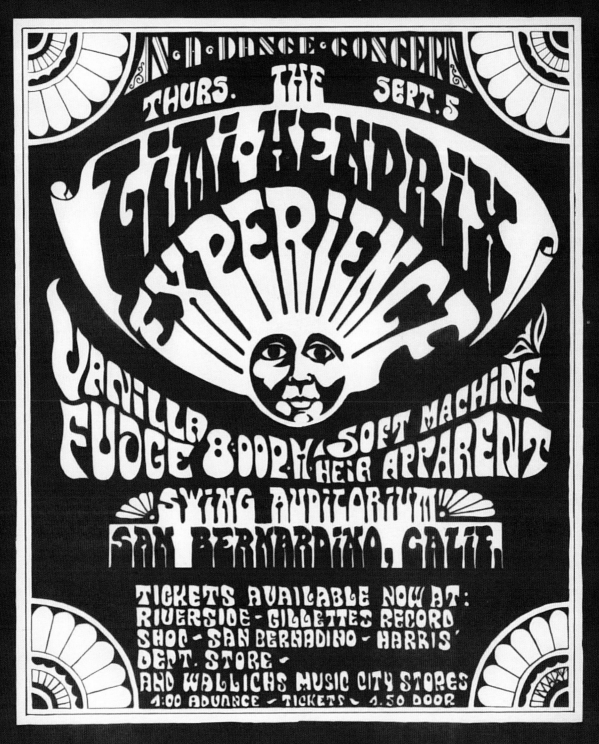

THE MELODY MAKER IN CONJUNCTION WITH RIK & JOHN GUNNELL
PRESENTS THE

WOBURN
MUSIC
FESTIVAL

BY COURTESY OF
HIS GRACE
THE DUKE OF BEDFORD

SAT
6th JULY
2·30-5·30pm
PENTANGLE
ROY HARPER · AL STEWART
ALEXIS KORNER · SHIRLEY & DOLLY COLLINS
10s

SAT
6th JULY
7-12pm
JIMI HENDRIX
EXPERIENCE
GENO WASHINGTON AND THE RAM JAM BAND
TYRANNOSAURUS REX · THE FAMILY
NEW FORMULA · LITTLE WOMEN
£1

SUN 7th JULY
2·30-5·30pm
12s6d
AN AFTERNOON OF DONOVAN

SUN
7th JULY
7-11·30pm
FLEETWOOD MAC
JOHN MAYALL AND THE BLUESBREAKERS
CHAMPION JACK DUPREE · TIM ROSE
THE TASTE · DUSTER BENNETT
15s

WOBURN ABBEY, BEDFORDSHIRE —
5 minutes by road from M1. Bus service to
and from Abbey connects with trains arriving
at Flitwick from London (St Pancras).

CAR PARK
FREE CAMPSITE
REFRESHMENTS
LICENSED BARS
SIDE SHOWS

SEASON TICKETS £2.0.0 IN ADVANCE ONLY.
Information and tickets now available from:
Rik Gunnell
56 Old Compton St. W1. GER 1001.
Keith Prowse.
90 New Bond St. W1. HYD 6000, and branches.

JULY 6+7.

Please send me tickets as marked.
I enclose PO/Cheque to the value of:
£ s d. INSERT Nº REQUIRED IN BOXES BELOW.
I also enclose a stamped self-addressed
envelope.

10s	£1	12s6d	15s
SAT. JULY 6. 2·30—5·30pm	SAT. JULY 6. 7—12pm	SUN. JULY 7. 2·30—5·30pm	SUN. JULY 7. 7-11·30pm

£2	
SEASON TICKET	Send to: RIK GUNNELL AG. 56 OLD COMPTON ST. LONDON. W1.

MONTEL PRESENTS
IN PERSON

THE

JIMI
HENDRIX
EXPERIENCE

TONIGHT
2 SHOWS
7 P.M. 10 P.M.

INDEPENDENCE
HALL
LAKESHORE AUDITORIUM

ADMISSION
PER PERSON
Limited Seating Capacity
$6

FOR TICKETS
CALL 344-0514

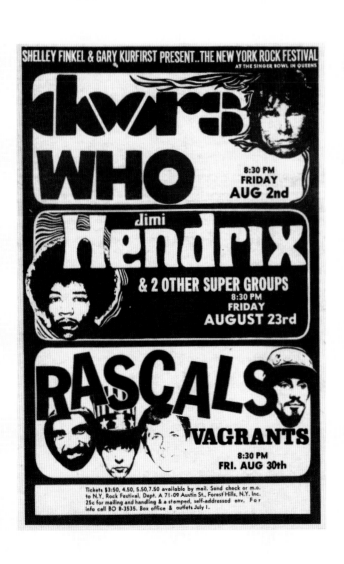

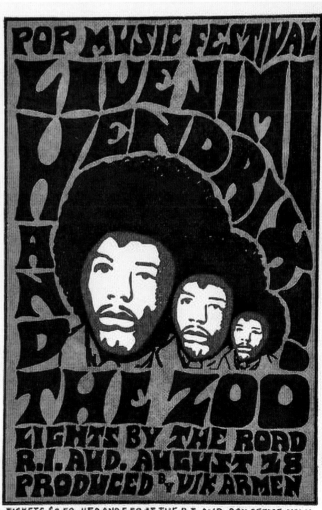

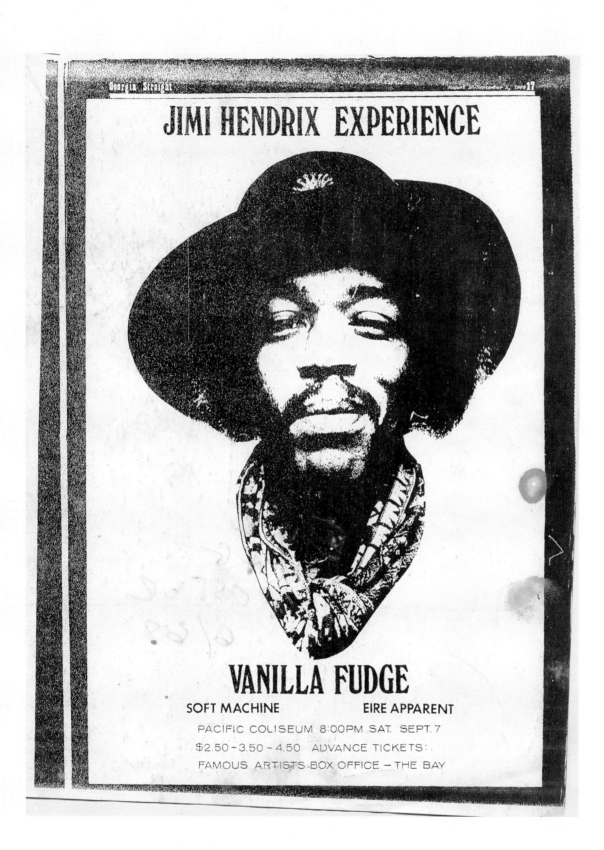

JIMI HENDRIX

VANILLA FUDGE

SOFT MACHINE
EIRE APPARENT

PORTLAND MEMORIAL COLISEUM
ADVANCE TICKETS: Coliseum Box Office, Stevenson & Sons — Lloyd Center & Salem, Radio KEED — Eugene

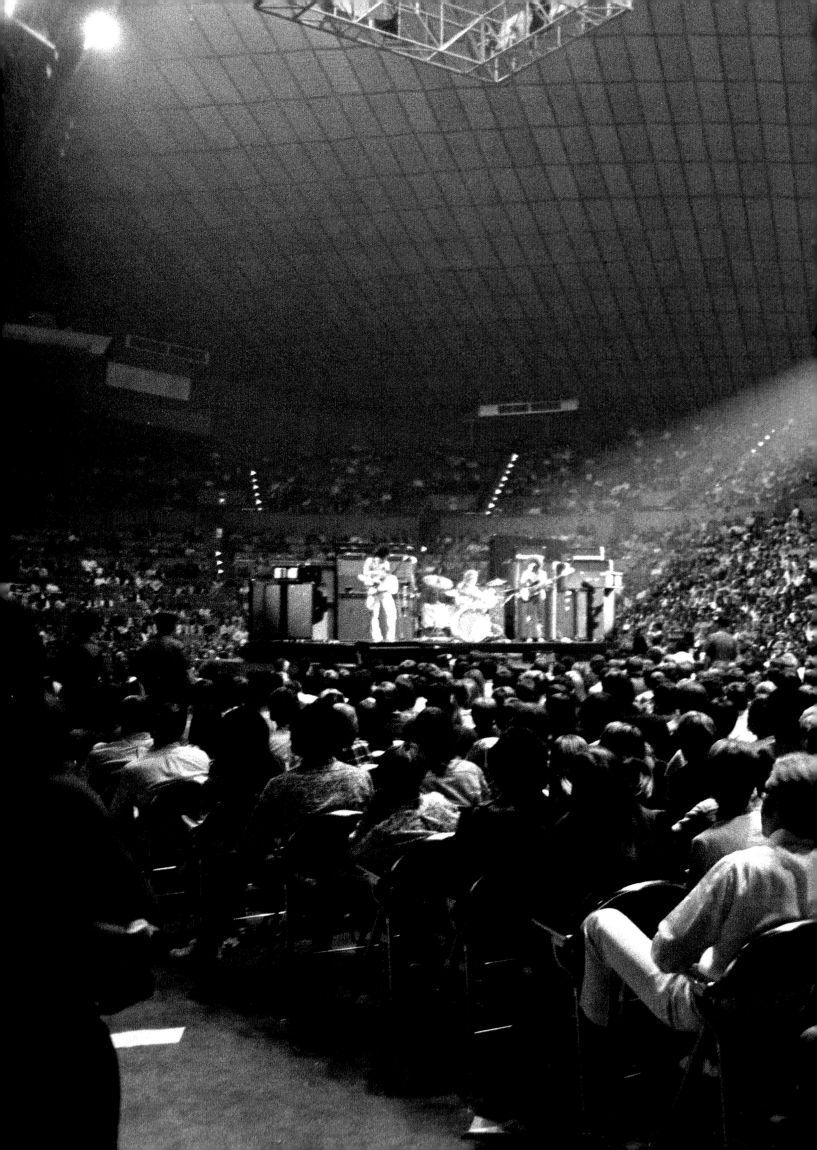

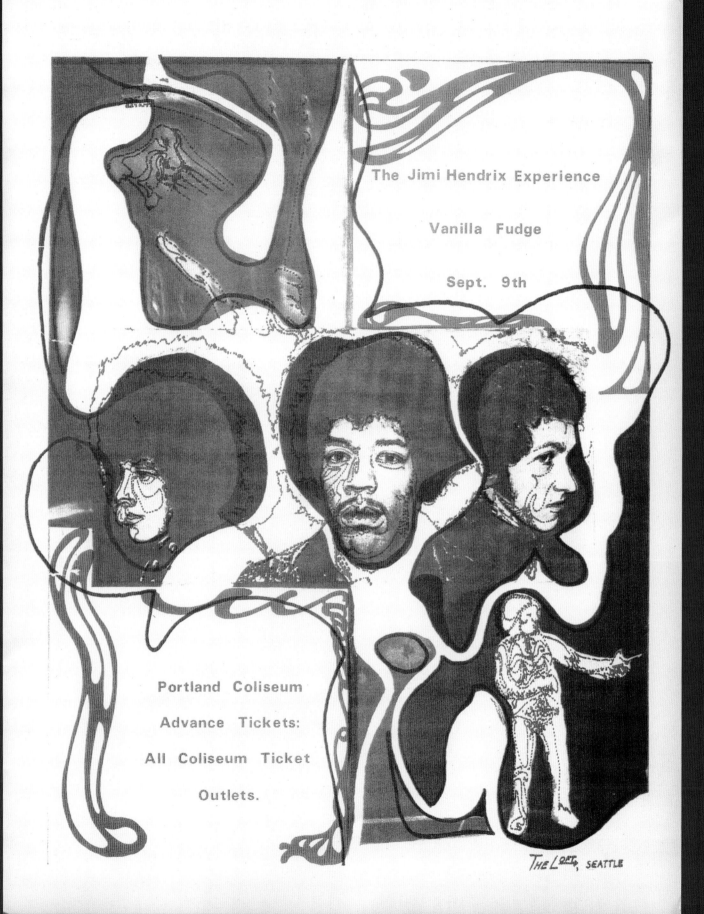

The Jimi Hendrix Experience

Vanilla Fudge

Sept. 9th

Portland Coliseum

Advance Tickets:

All Coliseum Ticket

Outlets.

THE LOFT, SEATTLE

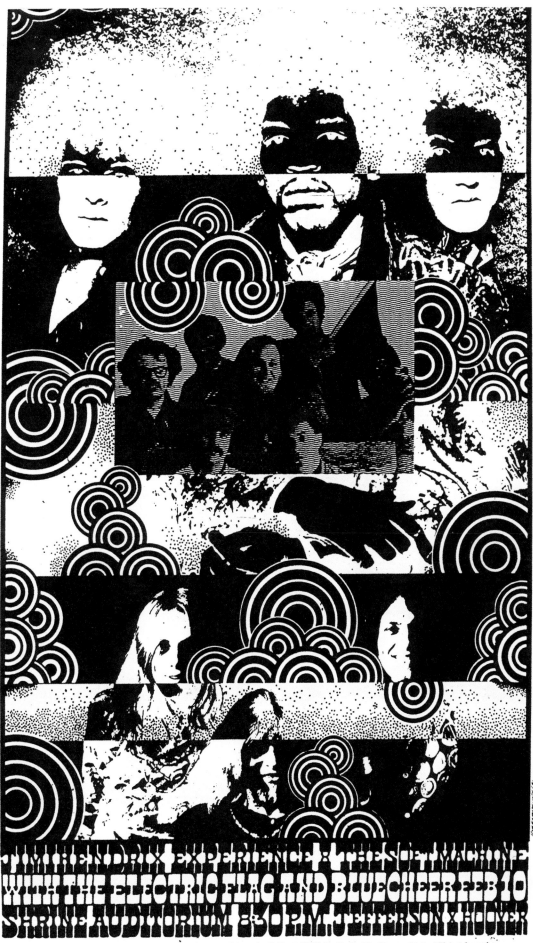

Visuals: Thomas Edison Lights & Acme Cinema · Tickets Available at Wallich's Music City Store · Mutual Ticket Agencies
Free Press Book Stores · Either Or Book Stores · Potpourri · Sound Spectrum
© Pinnacle Rock Shows

"Therefore you have to go back into the studio again and redo what you might have done two nights ago. The money doesn't make any difference to me, because that's what I make the money for, to make better things."

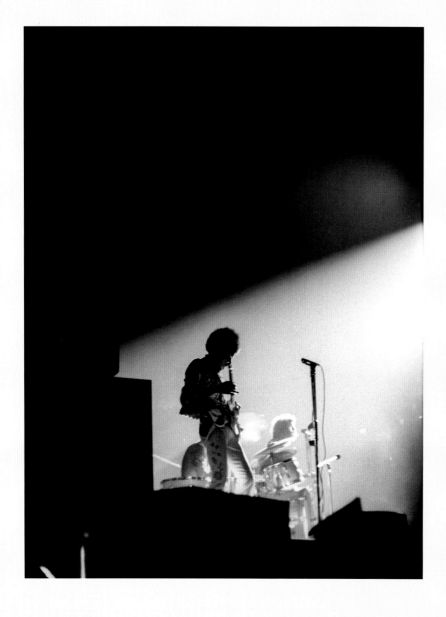

LEFT
Seattle Center Coliseum, Seattle,
Washington, September 6, 1968.

RIGHT
TTG Studios, Hollywood, California,
October, 1968.

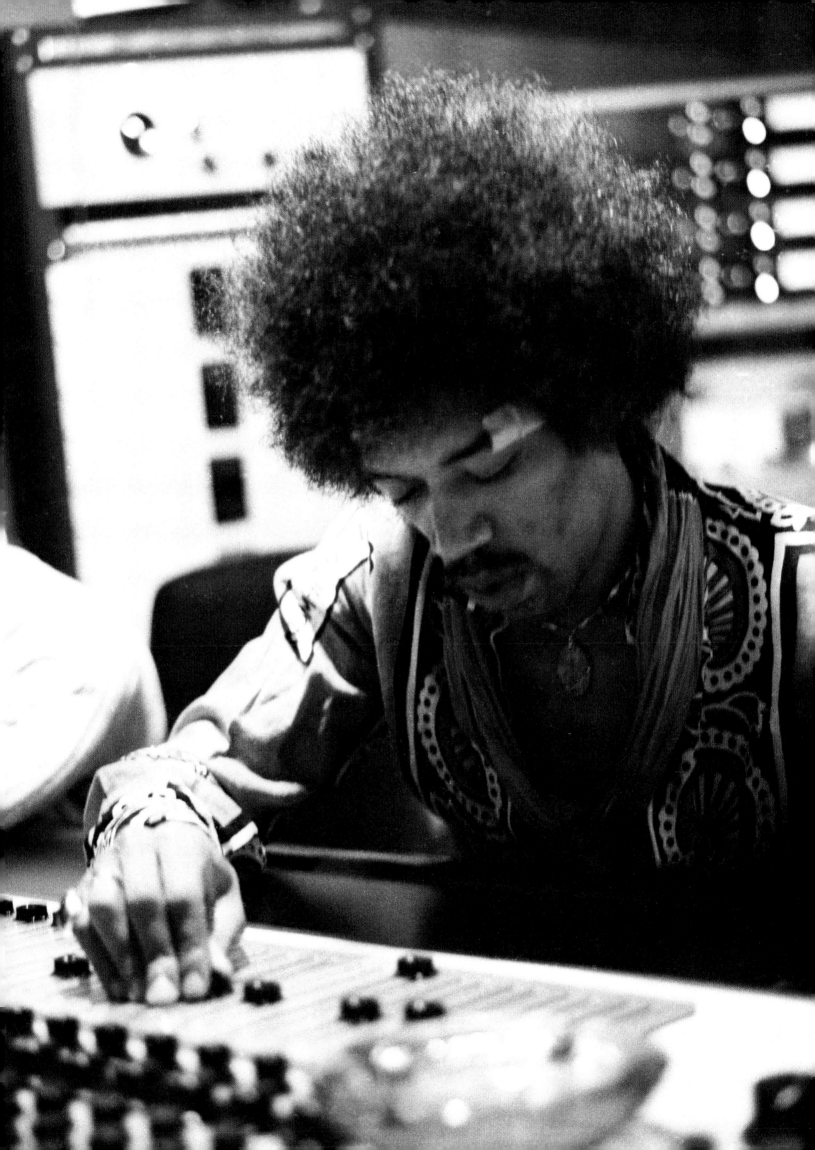

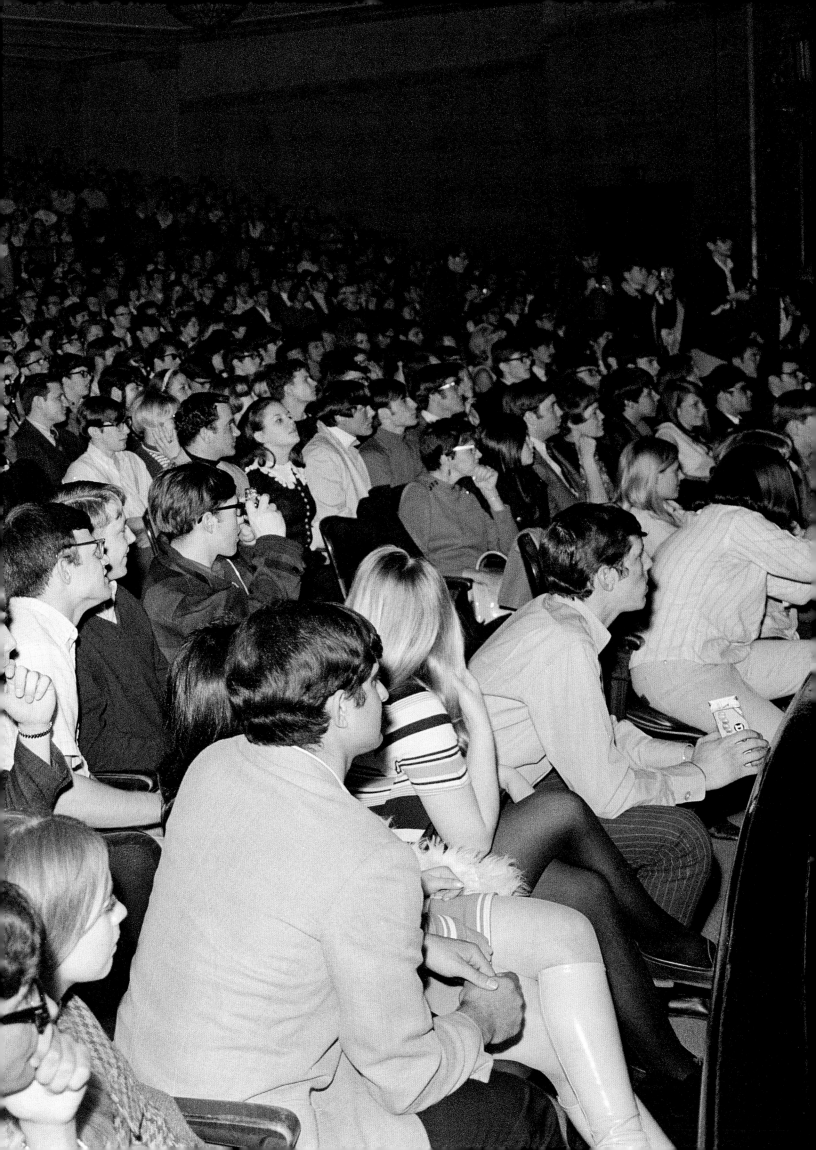

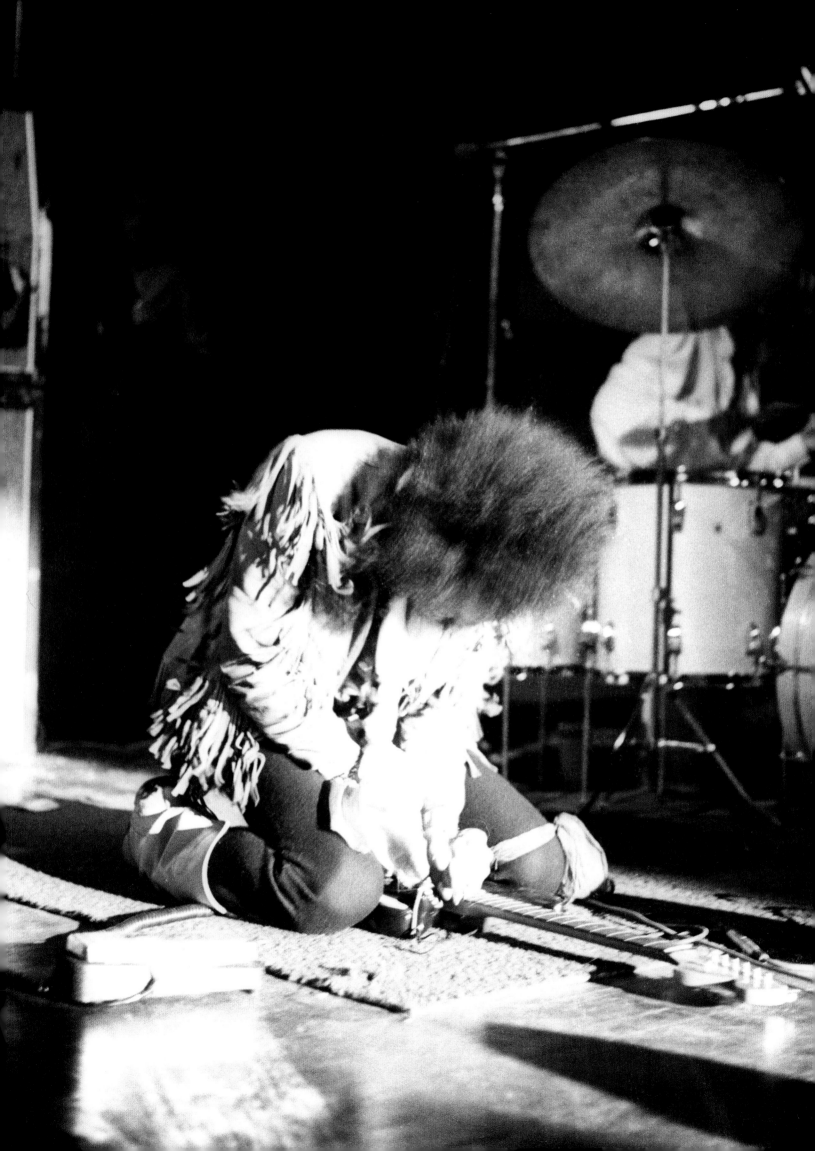

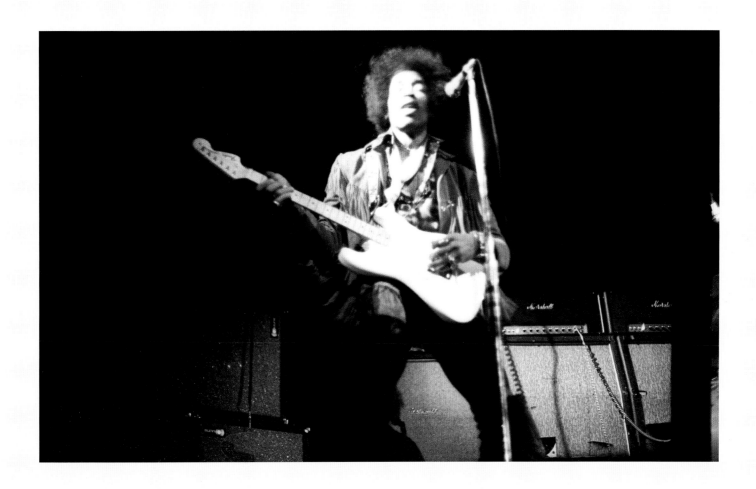

ABOVE and LEFT
Woolsey Hall, Yale University,
New Haven, Connecticut,
November 17, 1968.

FOLLOWING
Oakland International Airport,
September 13, 1968.

"

YOU KNOW, WHEN YOU'RE YOUNG, MOST PEOPLE HAVE A LITTLE BURNING THING, BUT THEN YOU GET YOUR LAW DEGREE AND GO INTO YOUR LITTLE CELLOPHANE CAGE. YOU CAN DO THE FAMILY THING. I'VE WANTED TO DO THAT AT TIMES. I'VE WANTED TO GO INTO THE HILLS SOMETIMES, BUT I STAYED. SOME PEOPLE ARE MEANT TO STAY AND CARRY MESSAGES."

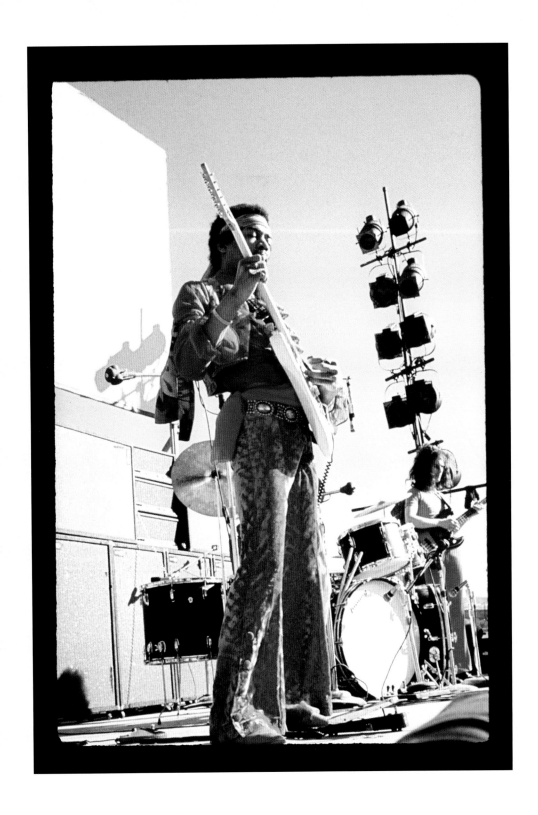

Santa Clara County Fairgrounds,
San Jose, California, May 25, 1969.

SEEDS OF CHANGE

The Experience's relentless schedule had sapped the stamina of its musicians. Hendrix was clearly both exhausted and frustrated. "For three years we've been working non-stop," Hendrix stated. "That is a lot of physical and emotional strain. You go somewhere and the show is a bit under what it should be and you are told you are slipping, but it is the strain. It is the strain of the moral obligation to keep going even when you don't think you can manage even one more show. Maybe I'll never get to take that break; all I know is that I'm thinking about it most of the time now . . . that's why groups break up. They just get worn out. Musicians want to pull away after a time or they get lost in the whirlpool."

Even the recording studio, once a welcome respite from the rigors of touring, no longer served as a means of creative rejuvenation for the group. In February 1969, a slate of sessions at London's Olympic Studios—where both *Axis: Bold As Love* and the bulk of *Are You Experienced* were recorded—produced no complete masters, only tension. Glimpses of promise were marbled throughout these stormy Olympic sessions, marked by an almost brutish intensity characteristic of the group's recent live performances.

Fillmore East, New York, New York,
December 31, 1969.

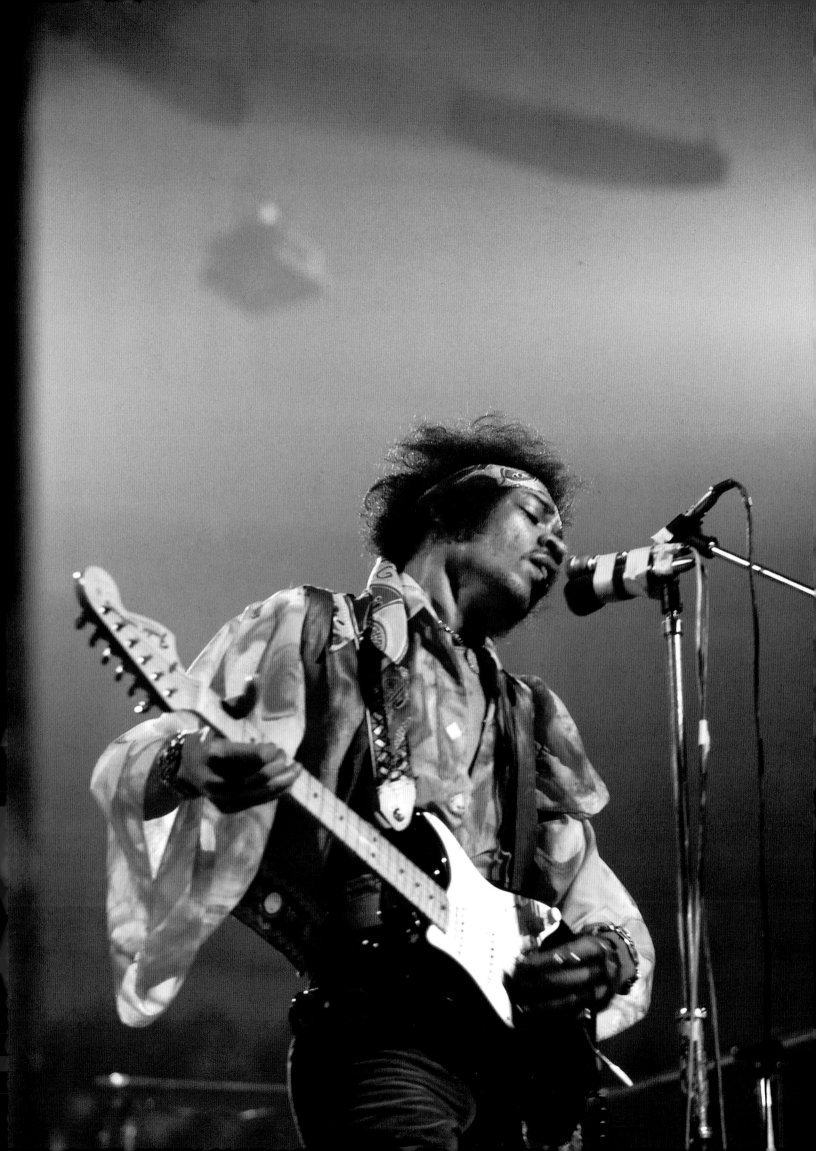

Two sold-out performances at the Royal Albert Hall on February 18 and 24 would conclude their European commitments. But the show on the twenty-fourth would prove to be more than just another concert. In December of 1968, Hendrix had agreed to create a theatrical film based largely on his stage performances. Concerts in Germany and France had been filmed, but the project lacked the dramatic, signature performance only Hendrix was capable of providing. He understood what was needed. With the Royal Albert Hall's house lights up to accommodate the filmmakers, Hendrix put forth what many feel was the finest concert performance he ever gave, offering three extended blues songs: his own "Red House," "Hear My Train A Comin'," and Elmore James's "Bleeding Heart." He also gave definitive readings of Experience favorites such as "Stone Free," "Foxy Lady," "Little Wing," and "Voodoo Child (Slight Return)." The evening closed with "Wild Thing" and a near riot as Hendrix's smashing of his guitar incited members of the audience to rush the stage.

As February drew to a close, the Experience splintered in three separate directions. Hendrix withdrew to New York, writing and jamming with friends. He also worked on producing tracks for the Buddy Miles Express. Jimi's sideline efforts fueled speculation by the music press about the future of the Experience. In interviews, Hendrix tried to downplay rumors that the Experience would be breaking up. "It's no definite breakup thing like that. I get very frustrated sometimes on stage when we play and I think it's because we are only three pieces. I would like to work with other people too, but that doesn't necessarily mean we have to break the group up." Fans and the press asked more questions when former manager Chas Chandler helped secure a reported advance of $150,000 for Fat Mattress, Redding's solo venture.

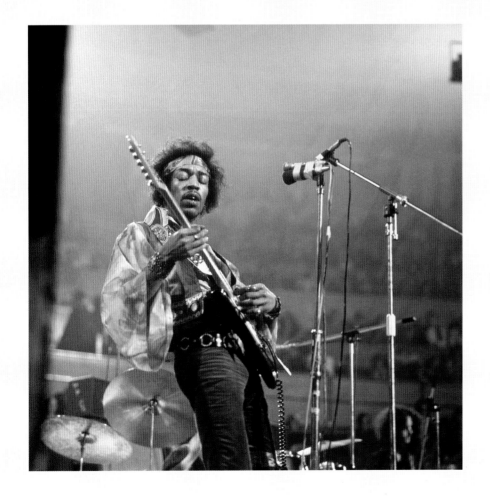

The Royal Albert Hall, London, February 24, 1969.

*The Royal Albert Hall, London,
February 18, 1969.*

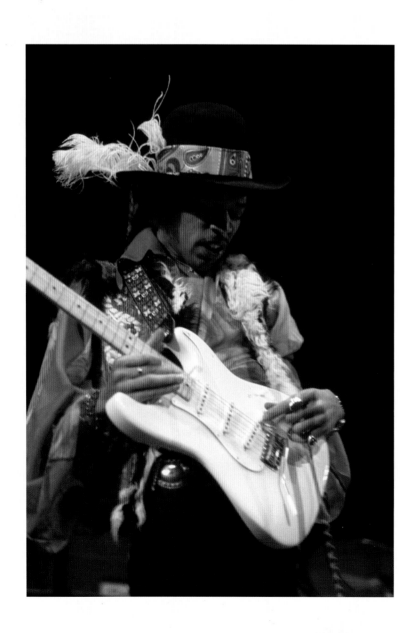

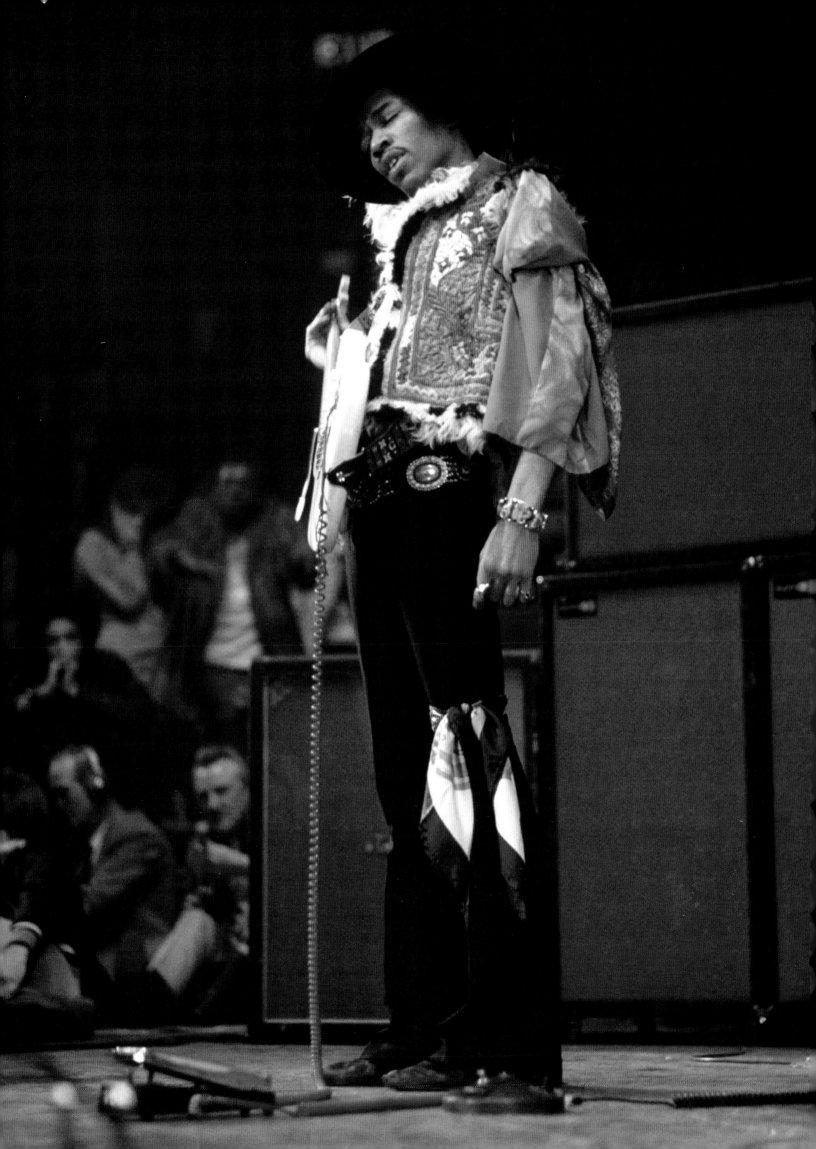

Though Hendrix, Redding, and Mitchell took space from one another throughout the month of March, they reunited again in April for a large-scale US tour, which commenced in North Carolina. Though they still hadn't made any progress on a follow-up to *Electric Ladyland*, their focus, chemistry, and talent onstage were undeniable. The band's performances throughout the tour were forceful and spirited. Hendrix's popularity was such that he even changed the fee structure that had long favored local concert promoters over artists, demanding ninety percent of the receipts as opposed to a smaller guarantee against a percentage of gross revenues that had long been standard. Fans filled sports arenas in cities such as Philadelphia, Oakland, and Los Angeles, eager to see Hendrix perform. "The Experience were huge in America, huge," Redding said. "This started at the end of 1968. We were now playing before 20,000 people." The group's burgeoning popularity was confirmed by their record-breaking crowds, and all three of the group's albums enjoyed strong and steady sales. Songs such as "Purple Haze," that had been virtually ignored by Top 40 radio, enjoyed the fervent support of underground FM radio stations across the country.

TITLE:

" if found lost... please return to Body "
~~_____~~ or West coast Seattle Boy

1. Hey My feet's on fire, Head in the air
Loveing, life and flowing free is
my only care . (Music Break)

I feel fine, Don't mind dying, (cause)
WHEN I do, there's no harm in crying
I'm just a west coast Seattle Boy -

2. Well I ride ~~fome~~ me a stagecoach
up to your rave porch
You Better have some ~~totted~~ Ocean
(Cause) I'm carrying me a torch

Moon life in Spiral light —

1. Moon lite ... Bathe Us in
Silver flight — trips as they
breath of air ... Quick as acid
of life ...
life upon the grasses moist ... only
Mother Moon whispers the final
Command of orgasm ... purpose
of coming together beyond children.
What more keeps Men alive?
GOD? DOG? Mirrors or mirages?
Take me Moon as My Love lies in
Heat under my waiting, for I feel

(Moon lite ect.)
2.
She is real — ... And this is beyond
Heaven Itself so this) I must protect —
for the love of Happiness for my Mate
to make reunion as one, we must
not be late
She is Woman, young, old, wisdom
she holds in her mouth and heart
refreshing as dew oasis
quietly refresh the wanderers and
thanks is heard from thier sighs
of relief of needs thirst, not
knowing the language of the waters
and sands but rejoice as ocean
breaks it's seeds across the barren
Land,

3. Moon lite —

o my Love hold on to me for
once in your world at least
a moment, I am a part of ..
Needing wanting - Drinking
from my woman as the Sun
drinks from the clouds of rain.
a purpose so light as rays,
so deep as the waves —
Waves = ... motion
rythem ...
Africa —
RAYS = Melody.
evolution ... purpose
America
together? +
a song — Marriage of the fruit and (OVER)

4.
frustrations
of the past the Moment of
NOW — ... Tears of Joy ... laughters
of sorrow ... And the Birth of nesesary
Dreams of tomorrow

LONDONDERRY HOTEL
PARK LANE LONDON W1
Telephone 01-493 7292
Telex 263292
Cables Londhotel London W1

Devonshire Downs, Northridge,
California, June 22, 1969.

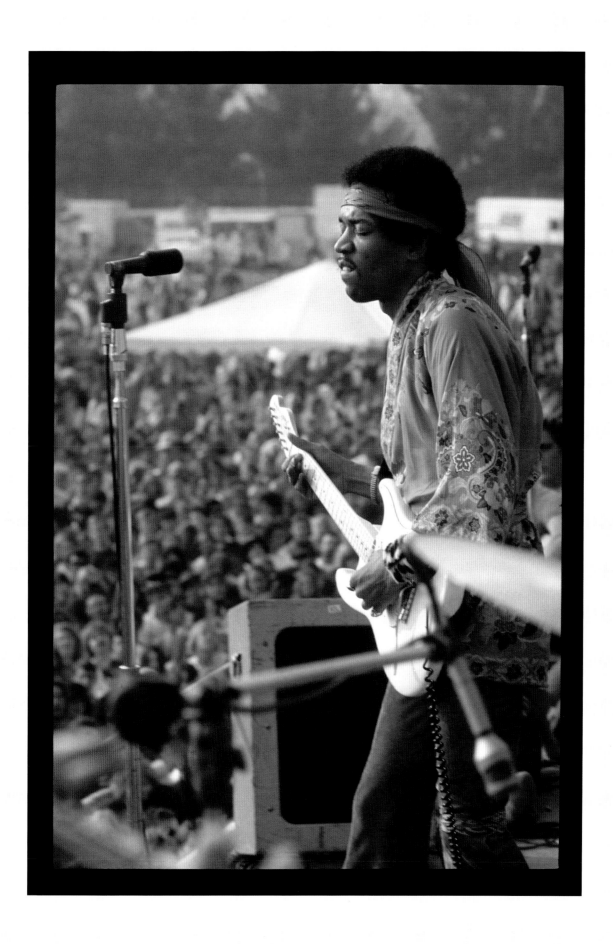

The Experience had reached the pinnacle of their popularity, but the extraordinary pace they had maintained since their inception had worn them down. Jimi sought out a steady, calming influence, and as he was adrift from Chandler, he called on trusted friend and former army mate Billy Cox.

Cox, an active Nashville R & B session musician, had not heard from Jimi since the guitarist's departure for New York some years before. He was also entirely unaware of Hendrix's international success as a rock artist until shortly before Hendrix contacted him. "I found out Jimi had really hit the big time when a friend came over to the house with an album by the Experience," Cox remembered. "He said, 'Look at this. This is your buddy here.' I looked at it and said, 'I don't know that guy.' He had lost a lot of weight, his hair was long, and I said, 'No, that's not the guy that I knew.' My friend said, 'Put the record on.' I put the record on and said, 'That's him! That's him!'"

Some months later, Cox received a message that his old friend was trying to reach him. "The only telephone number Jimi had for me was for Mr. Wright's television repair shop, because neither of us had a phone in the old days and we could get messages there. I was told that someone from Jimi's office had called saying that Jimi wanted to get in touch. He gave me the number and I called him." The two arranged to reunite when the Experience played in Memphis on April 18. "He told me that he wanted me to be his bass player," Cox continued. "He said that things weren't in the order the way he wanted them, and would I come as a friend and help him out. He said he'd take care of me and everything would be okay. I gladly accepted. I went back to Nashville, closed my publishing company, and dropped everything else and left for New York."

While few, if any, of Hendrix's associates understood the significance of his and Cox's backstage meeting, Jimi's behind-the-scenes maneuver signaled his conclusion that the original Experience could no longer function as a cohesive unit. A string of lucrative concert engagements were scheduled through June, yet Hendrix had privately set in motion a new musical direction. "At that point in time," Cox said, "he didn't have an apartment in New York and was staying in a hotel. He had a little amp there and we would work day in, day out with little [rhythm] patterns, trying to put together some good music."

Finishing the Experience tour proved tumultuous, with Hendrix's problems really beginning on May 3 in Toronto when the guitarist was arrested for possession of narcotics. Arriving at the airport from Detroit, custom authorities found a tube described as a crude hashish pipe as well as heroin hidden inside a small Alka-Seltzer bottle in Jimi's bag. Jimi had experimented with numerous illegal substances in recent years, but in this instance, he denied the drugs were his. Nonetheless, Toronto authorities formally charged him. He made bail and completed his performance that evening at the city's Maple Leaf Gardens. Before he could even begin to assess the impact the arrest could have on his life and career, another sold-out concert awaited him in Syracuse. The morning after the concert, Hendrix returned to Toronto and was remanded on bail.

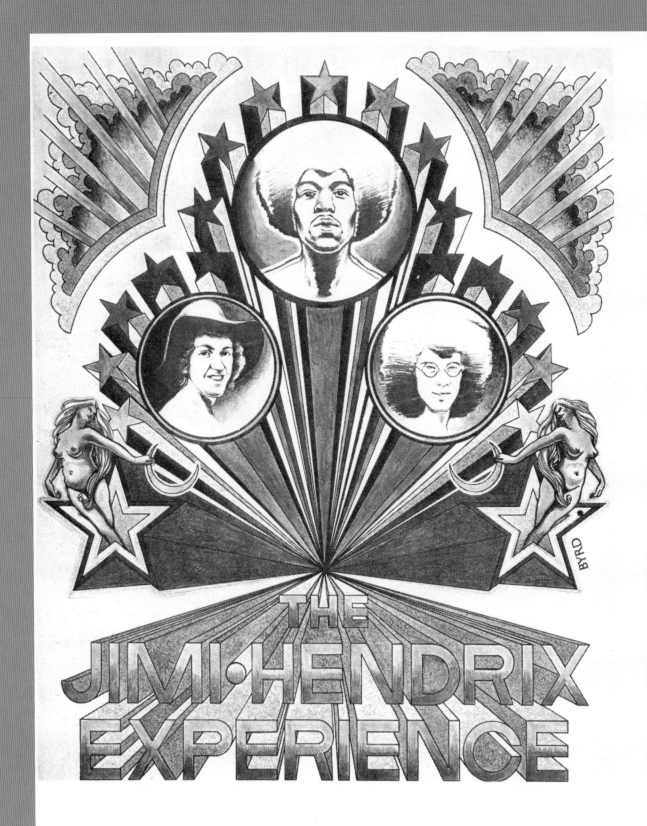

THE JIMI·HENDRIX EXPERIENCE

also **NOEL REDDING**

CORA PROMOTIONS PRESENTS

CHARLESTON CIVIC CENTER

Saturday, May 10 at 8:30 P.M. — 1 Show Only

Tickets $3.50 - $4.50 - $5.50

Tickets on Sale Now at the Civic Center, Galperins, Turners, Sears, Gorbys and Kay Jewelers in Downtown Huntington.

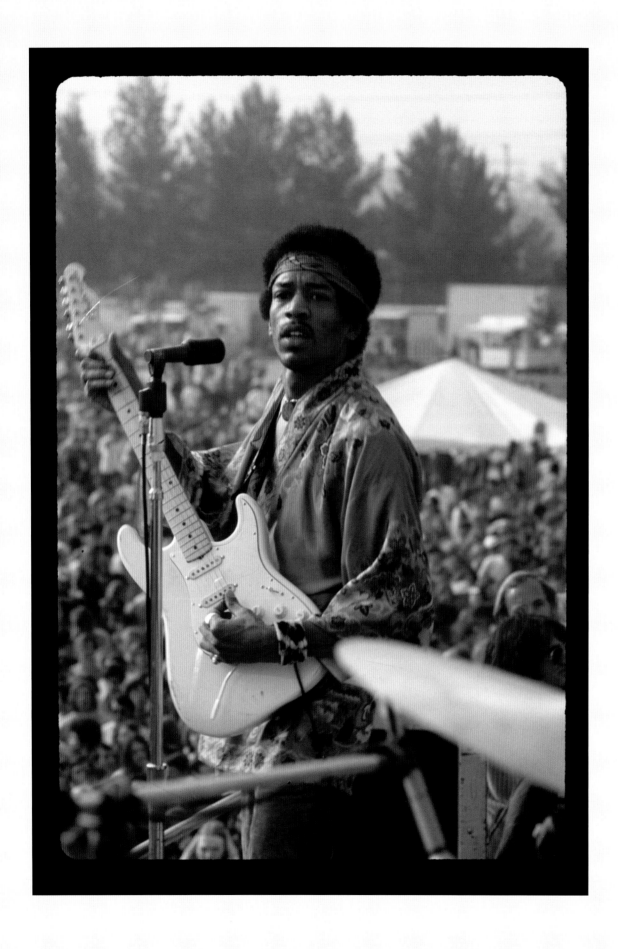

Devonshire Downs, Northridge,
California, June 22, 1969.

A performance at the June 1969 Newport Pop Festival illustrated just how formidable the Experience had become on the concert circuit and also demonstrated the group's and Hendrix's troubles. The group commanded a fee of $100,000 to serve as the three-day festival's headline act. Hendrix not only lent the fledgling hippie music festival credibility, he was the act upon which promoters were certain they could sell tickets. But the volatile backstage conditions at Newport soured his mood. Black Panthers jostled for access to the guitarist, crowding his dressing room. Amid the clamor, one of Hendrix's beverages was reportedly dosed with a hallucinogenic drug. Onstage, the surly nature of the audience—many of them angered by the festival's poor planning and lack of basic facilities—only worsened Hendrix's state. He repeatedly chided them for their rampant heckling and unruly behavior. "We hope we're not playing to a bunch of animals," he remarked sarcastically at the close of "Fire."

Unsurprisingly, the group's performance was uncharacteristically beneath their standards. To his credit, Hendrix redeemed himself by returning on his own two days later to jam with Buddy Miles, Tracy Nelson, Eric Burdon, and others—an impromptu happening cited by many as the brightest moment of the festival.

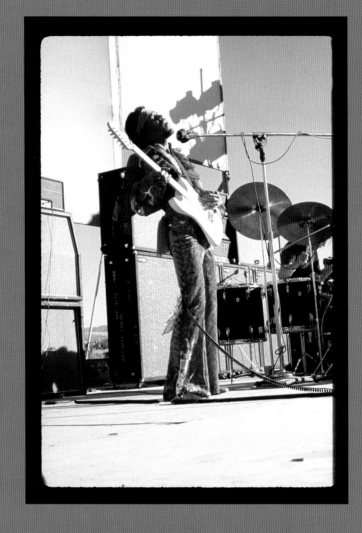

Santa Clara County Fairgrounds,
San Jose, California, May 25, 1969.

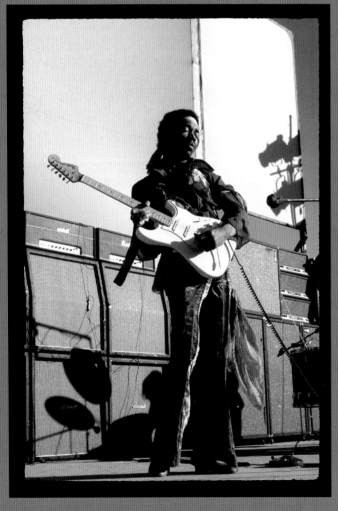

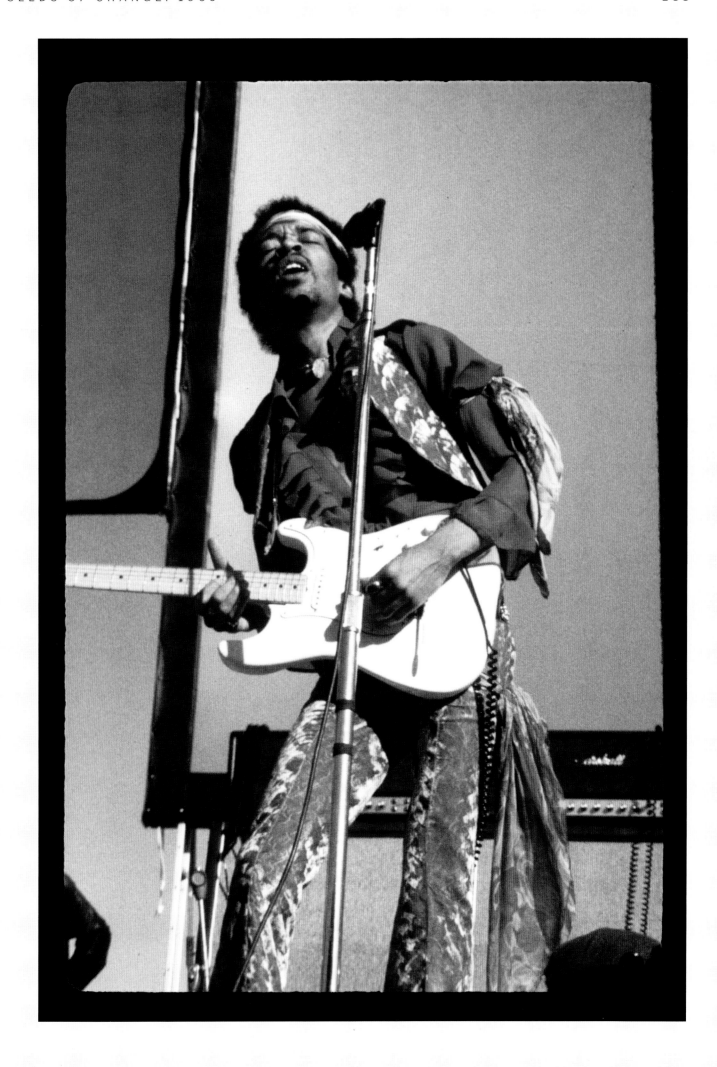

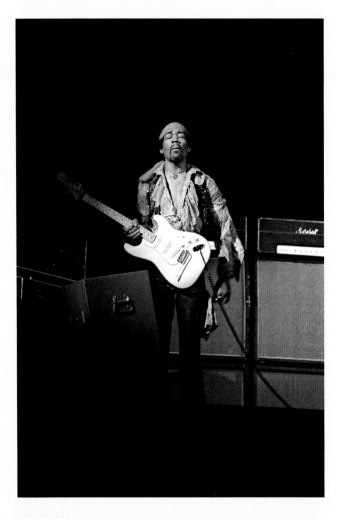
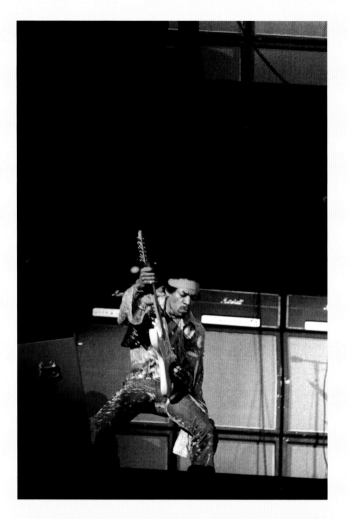
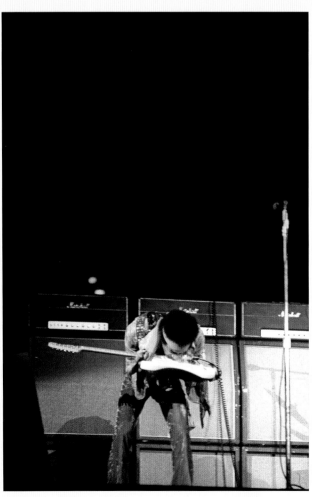
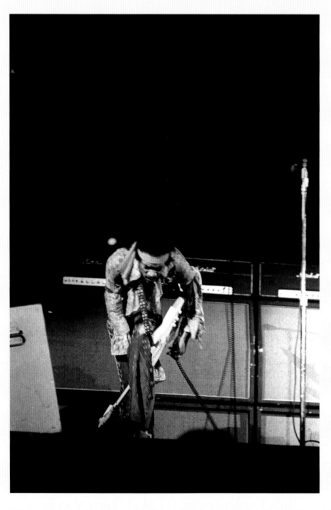

"Songs such as "Purple Haze" that had been virtually ignored by Top 40 radio enjoyed the fervent support of underground FM radio stations across the country."

Seattle Center Coliseum, Seattle, Washington, May 23, 1969.

One final obligation, headlining the Denver Pop Festival, was all that remained before the tumultuous 1969 tour would conclude. "It had been a long tour and we were all very tired," remembered Redding. "Prior to the gig someone in the hotel had said, 'Had you heard that Jimi said something to the press about extending the band?' and I said, 'Well, he didn't tell me.' So that went to my head. Then we played this gig [before] 35,000 people and they all tried to get on stage, which, they wouldn't fit, would they? Then the police started firing tear gas, except the wind was coming our way. So basically we had to get off stage and then these 35,000 people were trying to chase these three blokes, so they put us into this Avis rent-a-truck, locked the back door, there were no lights in it, and all these people start crawling over the truck and the roof is buckling and the guy gets in and drives us back to the hotel and there still was people on top of the truck. We had to go in the back of the hotel because we couldn't get in the front, through the kitchens or something. The next day I got on a plane and I just said I couldn't handle it any longer."

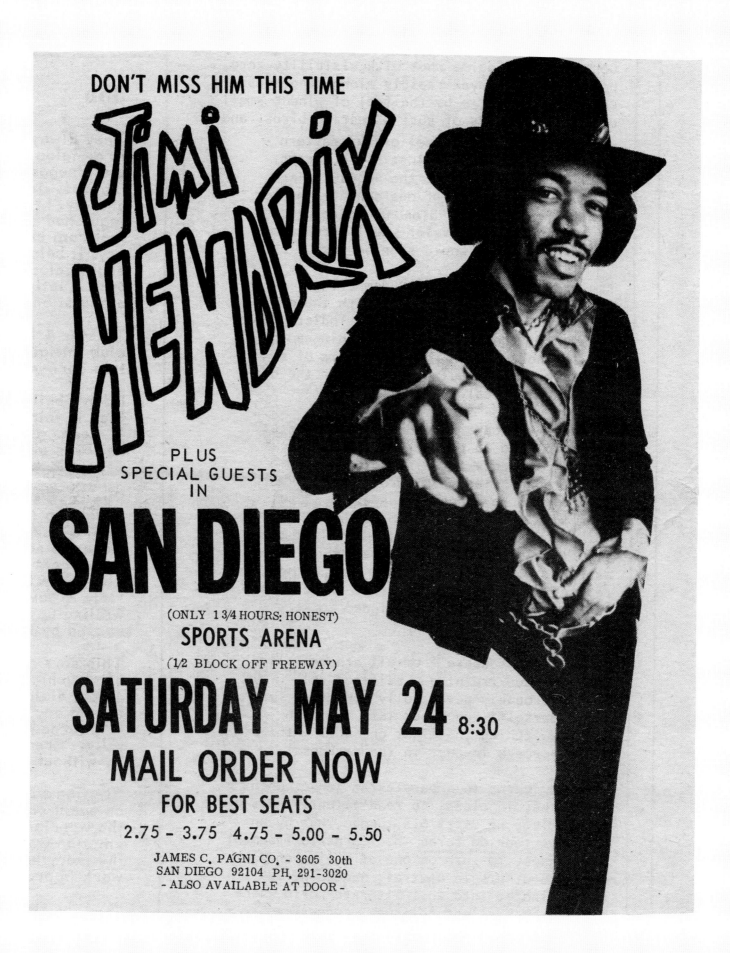

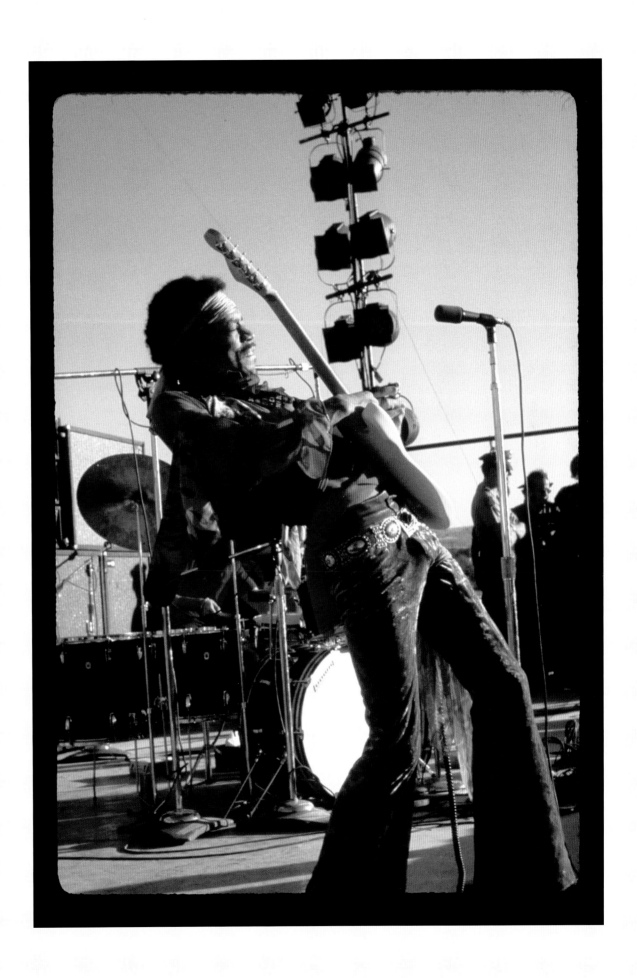

Santa Clara County Fairgrounds,
San Jose, California, May 25, 1969.

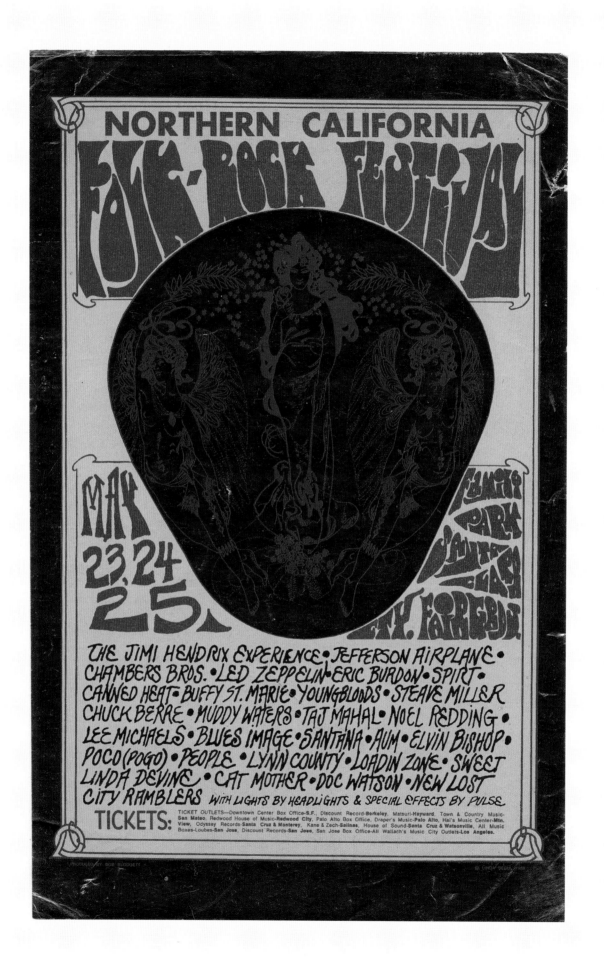

FRIDAY
June 20
SATURDAY
June 21
SUNDAY
June 22

At:
SAN FERNANDO VALLEY STATE COLLEGE

(San Diego Frwy. West on Devonshire St.
Corner of Zelzah Ave.)

TICKET OUTLETS

Devonshire Downs
Valley State College
Wallich's
Mutual
Groove Co. Stores
Free Press Bk. Stores
Judkins, Garden Grove
Long Beach Arena
Sound Spectrum,
　　　(Laguna)

For Ticket Information
Call: (213) 363-8181

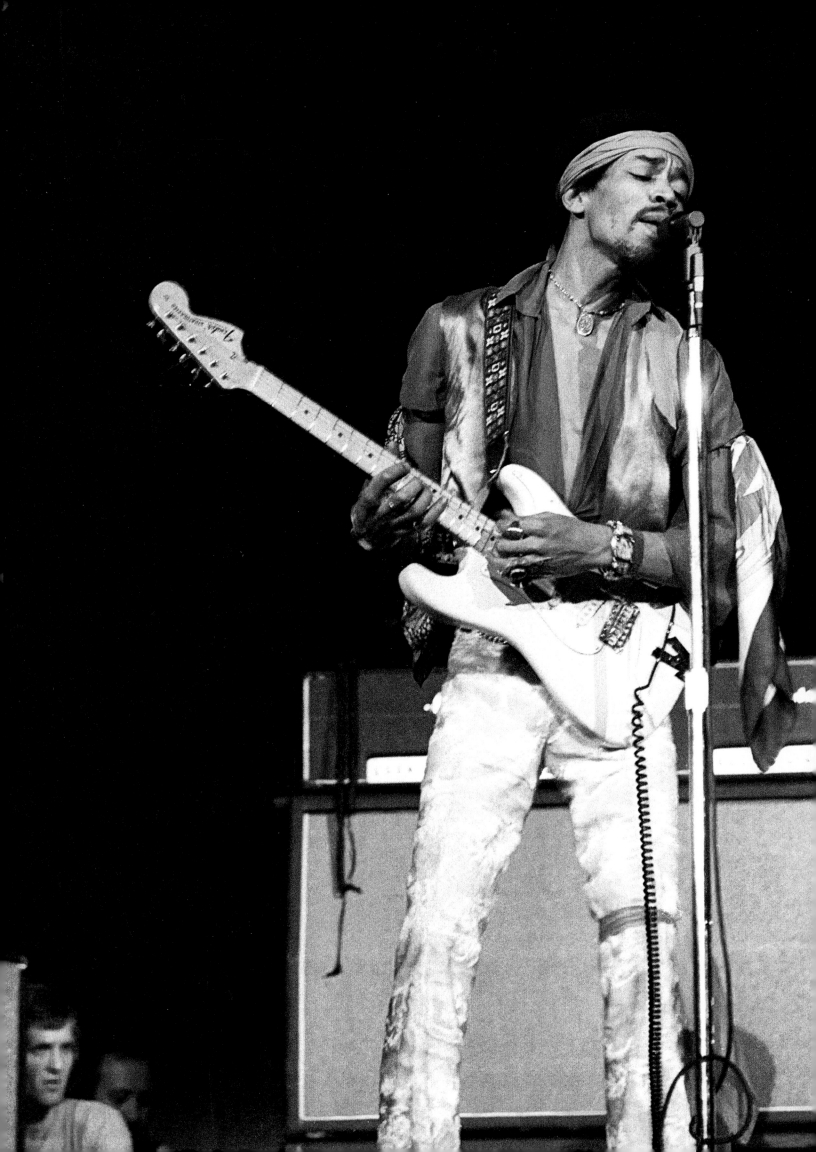

Oakland Coliseum, Oakland
California, April 27, 1969.

Redding elected to leave the group and return to London. There he would reconvene with Fat Mattress and serve full-time as their guitarist. Redding's abrupt departure forced Hendrix to reassess his musical course. He turned to Billy Cox, whose behind-the-scenes work with Jimi since April had confirmed that he could handle the assignment. Hendrix's management never formally confirmed Billy Cox as Redding's replacement, but the guitarist cared little for publicity considerations. A challenging new direction lay ahead, and Cox's dedication and friendship would prove to be an invaluable asset.

Hendrix soon relocated to Shokan, a quiet, upstate New York village near Woodstock, allowing him much-needed time to relax, jam informally with local musicians such as Phillip Wilson from the Paul Butterfield Blues Band, and refine his new material. "Jimi was taking a kind of vacation out in the country, trying to get his act together," Eddie Kramer said. "It was all part of his developmental process, wood shedding if you want to call it that."

Hendrix dedicated much of his time at his rustic summer retreat to developing new material. He was bound to the terms of the 1968 PPX legal settlement and, as a result, owed his next album to Capitol Records. As Jimi struggled to harness riffs and rhythm patterns into finished songs, Cox assumed a valuable role as a sounding board.

Calmed and encouraged by Cox's presence, Jimi reached back again to his Tennessee roots in the form of guitarist Larry Lee, another old friend and veteran of the chitlin' circuit. Where Cox had been actively involved in various Nashville-based music projects prior to joining up with Jimi, Lee had just returned from a stint in Vietnam. "I think I had been home about maybe two weeks," Lee said. "I had just come from the unemployment office when the phone rang and it was Billy. I said, 'Wow!' I haven't heard from any of the old guys. I said, 'Where are you?' He said, 'I'm in New York.' I said, 'What you doing up there?' He said, 'I'm with Jimi.' I said, 'Where is Jimi?' I figured he was gonna say in England somewhere, because he was hot then by the time I got out. He said that he was sitting right there. That kind of scared me man! I spoke to Jimi and he was the same Jimi. I didn't know if he would even remember me as much money as I heard he was making. . . . He said, 'Hey, what you doing? We're gonna try out a few things up here. We'd like for you to come up here and join us.'"

Hendrix had reunited with the two musicians who had supported his early efforts to establish a musical career after his discharge from the army in 1962. Now, as his influence and popularity continued to grow throughout the world, he welcomed the opportunity to reach back to repay a debt of gratitude to old friends who knew all too well how difficult his struggle for acceptance had truly been.

WOOD STOCK

In contrast to the trio format Hendrix had favored with the Experience, Jimi's vision for this new venture was to grow larger in sound and scope. Percussionists Juma Sultan and Jerry Velez were recruited to join Hendrix, Cox, Lee, and Mitchell. Dubbed loosely Gypsy, Sun & Rainbows by Hendrix, it was this expanded ensemble that backed the guitarist during his celebrated Woodstock performance on August 18, 1969.

"I had no idea that Woodstock was what it was," remembered Lee. "Jimi said, 'We got this gig here,' and he just said it casually like he did everything else. . . . As we pulled up, I saw people laying on the ground. I thought they were dead, man, covered with mud. I had never seen nothing like it. It looked like a war zone. There were naked people laying around you know, I had never seen that, and I figured I had been gone too long in Vietnam!"

Apart from Hendrix and Mitchell, veterans of the festival stage, none of the other musicians were prepared for such a massive reception at Woodstock. "As far as my situation went," said Cox, "I came from clubs that seated two or three hundred people at the most, and that three hundred was a lot of people. Two hundred thousand people was something else! I think even Jimi was shook up when they carried our stuff up on the stage and we looked out at that crowd. I looked at Jimi and Jimi looked at me, Mitch looked at us and said, 'God, look at those people. . . .' God bless Blue Nun wine, that's how we made that gig!"

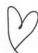

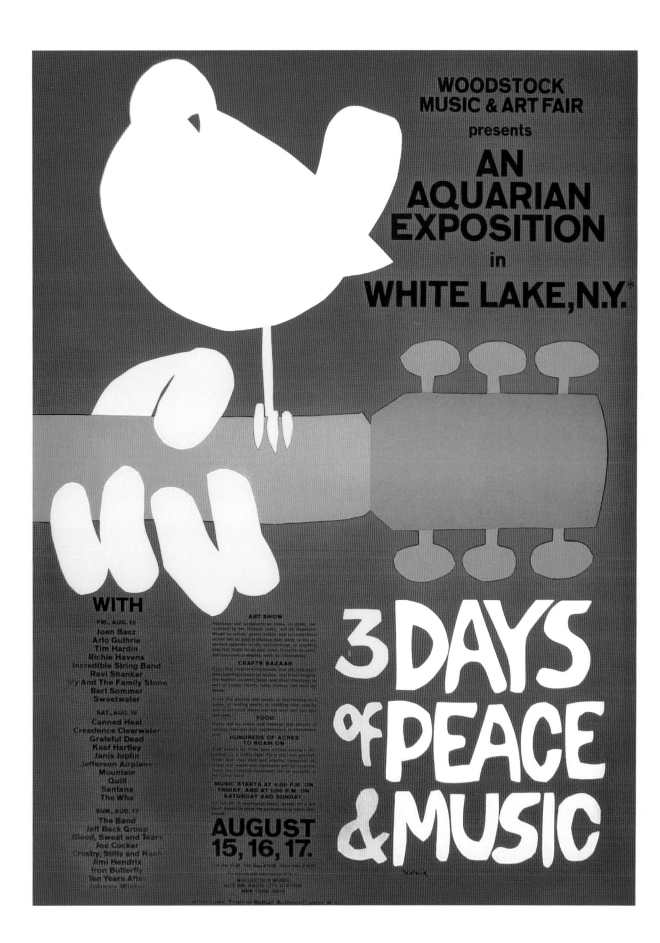

"

AS FOR HIS FEELINGS ABOUT HIS **WOODSTOCK** PERFORMANCE, WHEN DICK CAVETT SUGGESTED TO HENDRIX THAT HE MIGHT GET SOME HATE MAIL BECAUSE OF HIS 'UNORTHDOX' RENDERING OF THE **NATIONAL ANTHEM,** JIMI WAS GENUINELY PERPLEXED. 'THAT'S NOT UNORTHODOX,' HE SAID. **'I THOUGHT IT WAS BEAUTIFUL.'**"

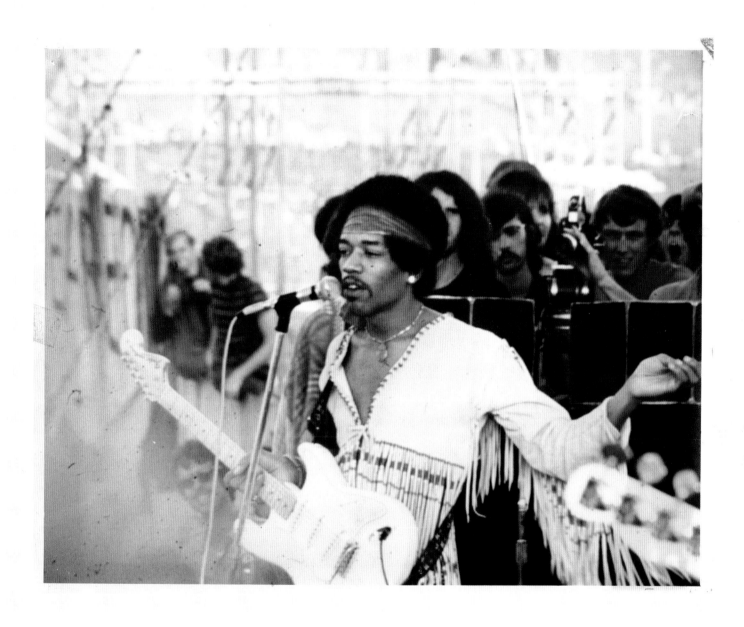

Woodstock Music and Art Fair,
Max Yasgur's farm, Bethel, New York,
August 18, 1969.

Woodstock Music and Art Fair,
Max Yasgur's farm, Bethel, New York,
August 18, 1969.

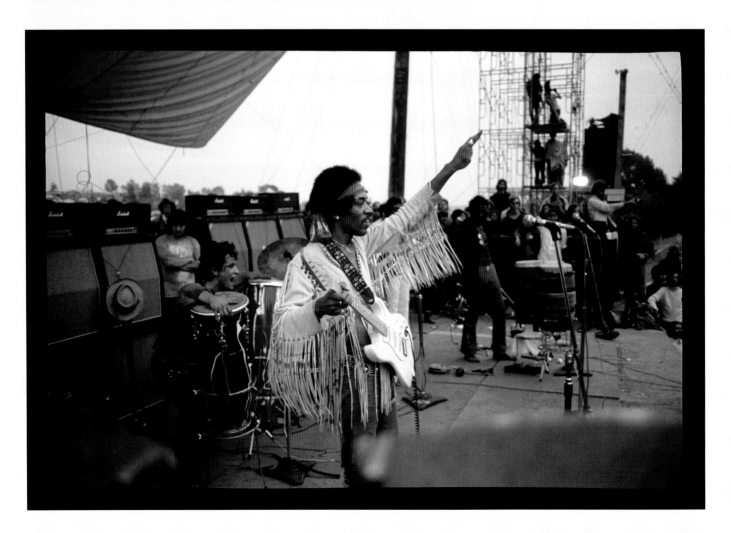

Hendrix was originally scheduled to close the show, but a multitude of production and weather-related delays had compromised the festival from the outset. Promoter Michael Lang gave Jimi and Michael Jeffery the option to perform on Sunday evening at midnight, the time slot he viewed as the pinnacle of the festival, but they declined, maintaining their preference to close the show on Monday morning after the Paul Butterfield Blues Band and Sha Na Na had completed their sets.

This decision to close the festival had a decided impact on how Hendrix approached the performance, allowing the guitarist to take the stage free of any time restrictions. Hendrix greeted the remaining crowd, whose ranks had dwindled from the Saturday peak of nearly three hundred thousand people. From the stage, Hendrix spoke of being tired of the Experience name for the time being and described his new ensemble as Gypsy, Sun & Rainbows, then Band of Gypsys, or anything the audience wanted to call them. Hendrix opened with a sprawling take of "Message to Love," the intensity swelling to a rousing finale.

Experience favorites such as "Fire," "Spanish Castle Magic," and "Foxy Lady" were interspersed with new material such as "Izabella" and "Jam Back at the House." There were an abundance of musical highlights, particularly by Hendrix and Mitchell, but these were counterbalanced by seemingly interminable gaps between songs for instrument tuning, equipment issues, and other logistical problems. Hendrix struggled to fully integrate Lee's rhythm guitar, and the two percussionists seemed extraneous, their contributions all but drowned out by the volume of the group's amplifiers.

Jimi's momentum surged as he moved deeper into his unusually long set that morning. A muscular "Voodoo Child (Slight Return)" kicked off an extraordinary medley nearly thirty minutes in length. Hendrix shifted from the fury of "Voodoo Child (Slight Return)" without pause into his extraordinary interpretation of the "Star-Spangled Banner." With Mitch Mitchell drumming furiously behind him—in order to keep his hands warm, he would later admit—Hendrix turned in a performance so brilliant that, like the burning of his guitar at the Monterey Pop Festival, his rendition of America's anthem would be forever seared into the Hendrix legend, crystallized as the symbol of his incredible talent. "That was incredible," Cox remembered. "We had never practiced that. Jimi just did it. If you listen to it very carefully, you hear me start off with him. Then I said to myself, sit a minute, he is going to another level. Let me just lay out and listen. That's just what I did!"

A charged "Purple Haze" flowed seamlessly into what would become known as "Woodstock Improvisation"—an instrumental tour de force display of Hendrix's unparalleled skill—before concluding with the magnificent "Villanova Junction." Hendrix would return for a rare encore, offering "Hey Joe" for those who remained entranced until the very end.

Despite such brilliant moments, the uneven performance by Gypsy, Sun & Rainbows at Woodstock exposed the weaknesses of Hendrix's big band experiment. "I didn't feel that the band at Woodstock was as tight as it could have been," recalled Eddie Kramer. "I felt that Billy, Jimi, and Mitch were fairly tight together, but all the rest of the guys didn't really fit and it was excessive."

Perhaps the performance was uneven to an insider, but it was Jimi's rendering of the "Star-Spangled Banner" that stood out to the rest of the world. And the artist's role as a leading figure of the burgeoning counterculture movement—however inadvertent—did not escape the notice of the mainstream media. A few months earlier, Dick Cavett had secured an interview, marking Jimi's American television debut. Cavett was genuinely intrigued by Hendrix and sought to share his fascination with a national audience. The resulting interview, as well as a second appearance the month after Woodstock, presented a compelling portrait of a deeper and more complicated artist than most understood. Clearly nervous, Jimi rarely looked directly at Cavett, but he talked openly about how distracting compliments are, how money can sabotage one's sense of self, and how music was something he turned to whenever he was down or depressed.

As for his feelings about his controversial Woodstock performance, when Cavett suggested to Hendrix that he might get some hate mail because of his "unorthodox" rendering of the national anthem, Jimi was genuinely perplexed.

"That's not unorthodox," he said. "I thought it was beautiful."

Hendrix was eager to return to the recording studio to develop the brightest examples of his new music. Yet despite the promise evident in "Izabella," "Machine Gun," and others, he was unable to round his expanded group into form. "I think Jimi realized very soon thereafter that he had better pare this down and refocus his energy," explained Kramer.

Put more bluntly, Jimi's professional life was in turmoil. Mounting demands from Jeffery to resume touring further compounded Jimi's frustration with the failure of his big band experiment. He also had financial pressures to contend with. The guitarist had decided to build his own Greenwich Village recording facility, Electric Lady Studios, on West 8th Street. Though Hendrix and Jeffery were equal partners in the venture, funding for the design and construction were out-of-pocket costs. When work on the studio began in the spring of 1969, the Experience was earning record-setting box office receipts from their US tour. But by late summer, the ongoing construction required additional funds, and Hendrix's personal finances were already restricted because of litigation. Nonetheless, even in the face of this escalating pressure, Hendrix canceled a series of September US concert dates. He felt the band, as presently configured, was just not ready to perform.

By October, with Hendrix's plans still unsettled, Mitch Mitchell returned to England. "Mitch didn't leave the group," explained Cox. "It wasn't like that. I think we all just took a break." Frustrated himself with the situation, Cox also quietly departed. "There was a lot of things going on that I just wasn't happy with and I left," said Cox simply. "Soon after, I received a telephone call from Michael Jeffery . . . and Jimi to come back, so I made some demands and they adhered to those demands and I came back."

Hendrix had come under increasing pressure to deliver the settlement album promised to Capitol Records, yet that new studio album had proved elusive. A live Experience album, drawn from stops along the 1969 tour, had been compiled, but Jimi dismissed it. Cox sympathized with his friend's situation and wanted to help extricate him from this bitterly contested legal nightmare. "In 1965, there weren't a lot of record deals that musicians got in on," Cox said of Jimi's early career. "Jimi was a typical musician, he'd sign a piece of paper as soon as someone came up to him in the hope that maybe it could advance his career." So Cox returned to his friend's side, and another musician, Buddy Miles, did the same. Buddy was an accomplished musician in his own right, and had been a frequent participant in late-night jams with Jimi. Jimi's explorations with Cox and Miles signaled a new chapter in his musical evolution. "Message to Love" and "Power of Soul" were indicative of this exciting transition, incorporating rock, funk, and soul into Jimi's own, entirely original style. "I think Buddy and I were bringing more of Jimi's roots and the R & B scene to the music," Cox said, referencing their time on the chitlin' circuit. "We were just bringing it all back home to him, because we had that camaraderie and that type of music in common."

Woodstock Music and Art Fair, Max Yasgur's farm, Bethel, New York, August 18, 1969.

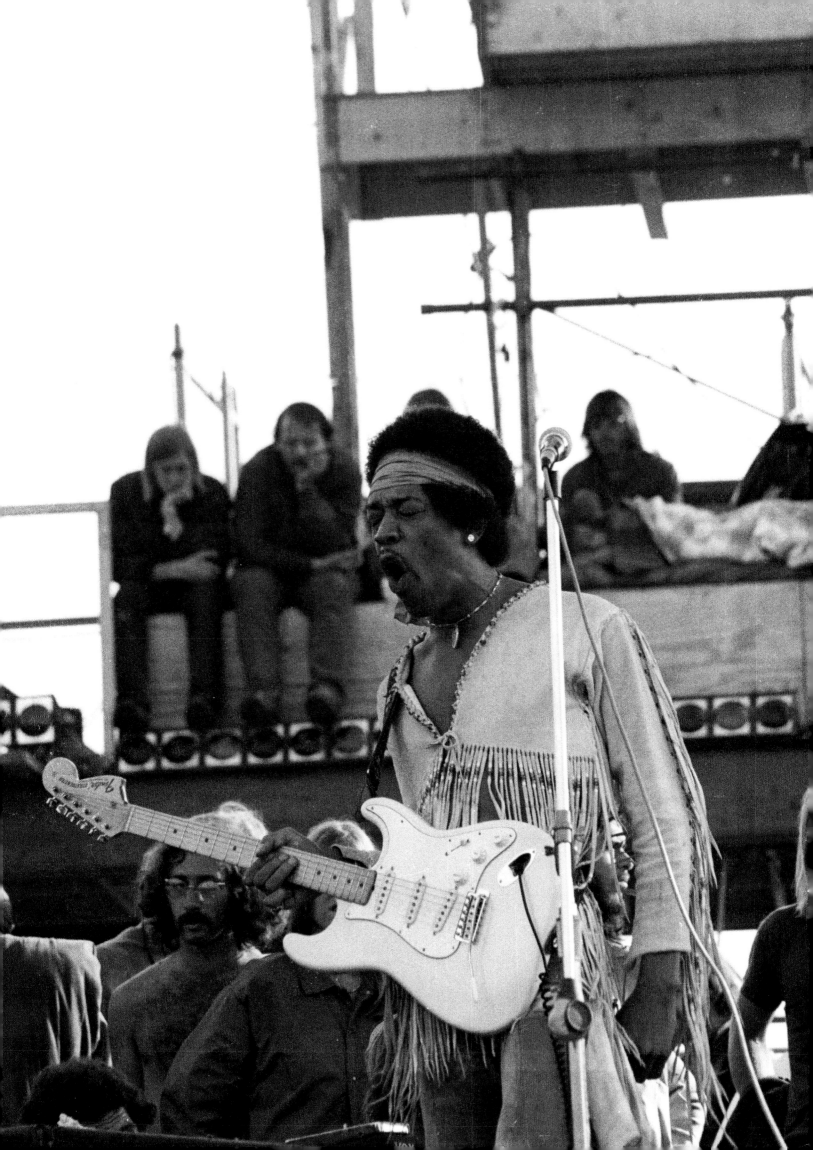

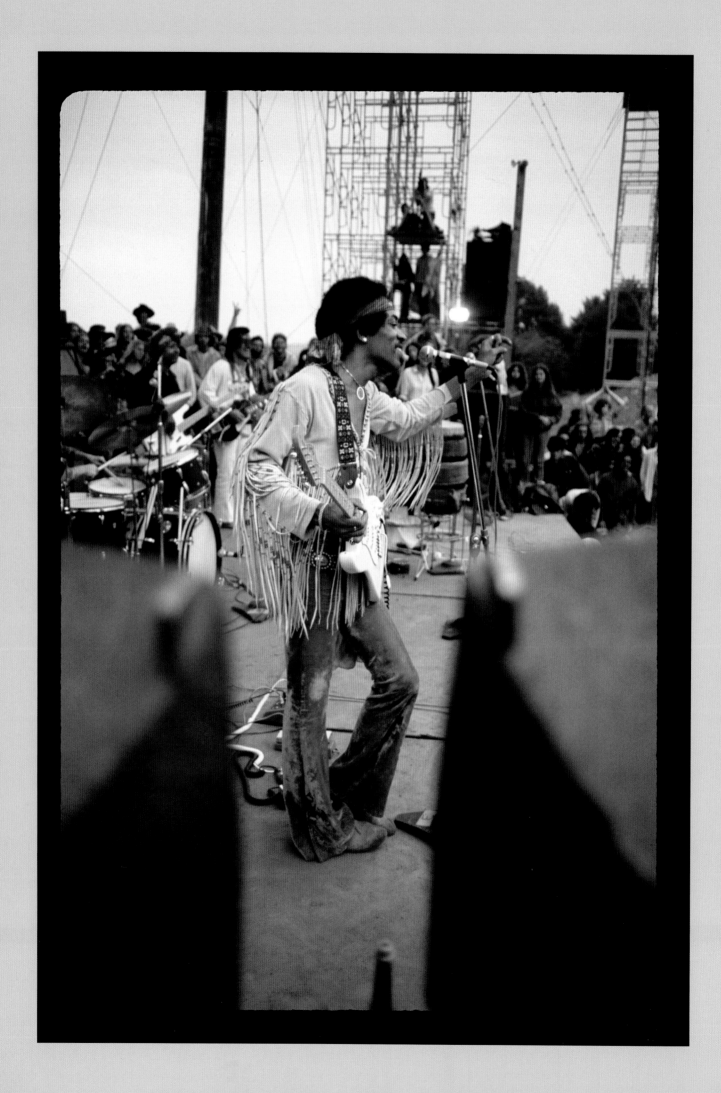

Woodstock Music and Art Fair,
Max Yasgur's farm, Bethel, New York,
August 18, 1969.

The new sounds might have preoccupied Jimi's attention, but the old sounds were still enjoying great popularity; all three Experience albums sold briskly throughout 1969. *Smash Hits*, a compilation of singles and album tracks issued by Reprise in July 1969, also proved enormously successful, providing Hendrix with his fourth consecutive top ten disc. Capitol, recognizing Jimi's enormous appeal, was desperate to get their settlement album as swiftly as possible. Jimi, Cox, and Miles returned to the studio, but as the end of the year drew near, Jimi had yet to craft the album he envisioned.

Hendrix and his Band of Gypsys were booked into the Fillmore East for four performances spread over New Year's Eve and New Year's Day, and all four would be recorded in the hopes they'd produce a workable album. But Hendrix's ability to perform those dates was uncertain. His troubles extended far beyond the continued calls for the long overdue settlement album; he was due in Toronto for the drug possession charges. Left unspoken was the prospect of imprisonment.

When Hendrix arrived in Toronto on December 6 to prepare for the trial, he was once again detained by Canadian customs authorities—this time for an unidentified capsule found in his guitar case. When the court date arrived, Toronto police had yet to classify the capsule's ingredients. In the end, those charges were dropped. Hendrix's trial progressed swiftly, his cause well served by the compelling testimony of former manager and producer Chas Chandler. Hendrix himself was even more convincing. He had eschewed his normal dress at the urging of his management, opting instead for a more conservative look. His frank testimony convinced the jury that while he had previously experimented with drugs, this particular incident did not involve him in any way. On December 10, the jury acquitted Hendrix of all charges. He told reporters that he was "happy as a newborn baby," and immediately returned to New York. The verdict had lifted an enormous burden from the guitarist's shoulders.

With the court case and all of its possible ramifications now behind him, Hendrix redirected his energy toward preparations for the live album recording at the Fillmore East with Cox and Miles. The new trio jammed extensively, rounding Hendrix's rhythm patterns into structured songs. "We decided that we couldn't do any songs that had already been released," said Cox. "We wanted to give them something different. So we went at the project in a joyous, creative posture and ultimately developed the repertoire of the Band of Gypsys."

Though each of the four shows was sold out, few could have anticipated just what the band held in store for the Fillmore East audiences. "We didn't know what to expect from the audience and the audience didn't know what to expect from us," said Cox, "but from the time we hit that first note, they were in awe. You had Jimi Hendrix, a drummer who had been with the Electric Flag and Wilson Pickett, and I was the new kid on the block."

Hendrix led his trio through two scintillating performances on New Year's Eve, peppering his sets with fresh, exciting songs he had never before performed in concert. Plus, none of the eleven songs presented in the seventy-five minute opening performance had yet to grace an Experience album. Hendrix was brimming with enthusiasm, easily blending the likes of "Izabella," "Earth Blues," "Burning Desire," and "Power of Soul" with signature songs such as "Voodoo Child (Slight Return)." At midnight, a recording of Guy Lombardo's "Auld Lang Syne" wafted through the theater, signaling the beginning of both a new year and a new decade. Jimi then surprised the joyous house with his own inspired reading of the holiday staple.

Dawn had broken over Manhattan by the time the group finally left the venue in the early morning hours of January 1, 1970. With the hoopla of the New Year's Eve festivities behind him, Hendrix now centered his attention on the remaining two New Year's Day performances and on realizing a complete live album. Desperate to absolve himself of his bitter legal problems, Hendrix rallied and gave two of the finest performances of his storied career, each centered around "Machine Gun."

Anti-war anthems of the Vietnam era seem like quaint nostalgia in comparison to Hendrix's searing exploration of man's inhumanity to man. Hendrix's brilliant improvisation, set atop a bedrock foundation by Cox and Miles, showcased his remarkable command of the guitar while harking back to his earliest influences. "Jimi was aware of the political situation at the time," Miles said. "He purposely told me what 'Machine Gun' was all about. Beyond that, if you listen to the melody lines of 'Machine Gun,' it was really taken from a style of music called Delta blues. This is royal blues, like how they used to do it in the Deep South."

A rousing encore of "Hey Joe," "Purple Haze," and "Wild Thing" closed out Hendrix's fourth and final Fillmore performance. "After the gigs were finished, Jimi was quite relieved," Cox said. "We felt the concerts went well. Jimi did all of his powerful techniques he could think of.... It was incredible. There were people in the audience with their mouths open."

Two weeks after the concerts, Hendrix gathered with Eddie Kramer to craft *Band of Gypsys*, his souvenir of the group's January 1 Fillmore East performances. Hendrix selected "Who Knows" and "Machine Gun" from the first set, and "Changes," "Power Of Soul," "Message To Love," and "We Gotta Live Together" from the second. The finished album was delivered to Capitol Records, with Hendrix finally free of his outstanding legal obligations.

Michael Jeffery still did not accept the Gypsys as a permanent group. Yet it would be Cox and Miles—not the Experience—who performed with Hendrix at the Winter Festival for Peace in late January. This performance, as it turned out, would be their last. "We went into the dressing room," said Cox, "and it appeared that someone did not want this group to make it. Jimi was staggering. Someone had given him something very bad, so he pulled me and Buddy aside and pointed some fingers. Buddy was really pissed off and at that time Buddy had a temper. Man, it wouldn't quit. However, we [still] went on stage and it was a fiasco."

At some point amid the crush of activity backstage, Hendrix became too stoned to perform—either unknowingly or by design. Buddy Miles claimed that Michael Jeffery, in a deliberate effort to sabotage the group's performance, slipped Hendrix LSD backstage. But no member of Hendrix's management team present at the concert accepted the sabotage story. Jeffery, they cited, had not only agreed to have Hendrix perform, he had invested his own money to have the concert filmed.

The group took the stage shortly after 3 a.m., concluding a lengthy evening of performances and passionate anti-war testimonials from a host of artists including the Rascals, Dave Brubeck, and the cast of *Hair*. Hendrix's appearance lasted only long enough for the guitarist to lurch miserably through "Who Knows" and "Earth Blues" before drawing the performance to a close. "That is what happens when Earth fucks with space, never forget that," offered Hendrix to a mystified audience. He then rose from a seated position off of the drum riser and walked off stage. He did not return.

Backstage, Michael Jeffery fired Buddy Miles, and the Band of Gypsys was officially disbanded. Miles felt that when it came to Jeffery, the drummer had long ago worn out his welcome. "I was hurt when management told me that I was fired," recalled Miles. "I felt rejected. To me it didn't have anything to do with music, it was personal."

Woodstock Music and Art Fair,
Max Yasgur's farm, Bethel, New York,
August 18, 1969.

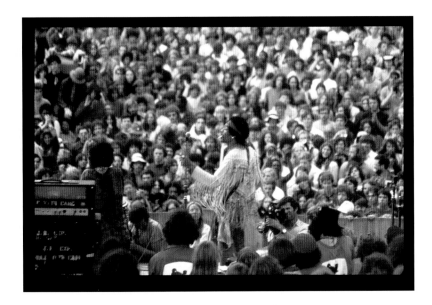

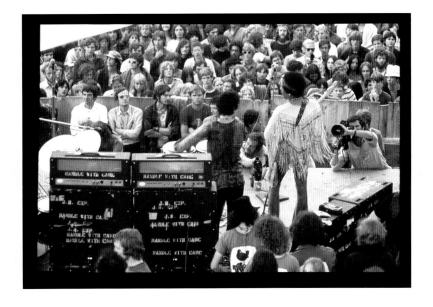

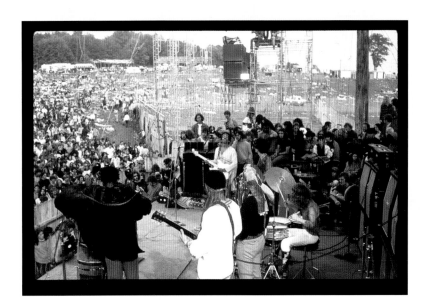

Woodstock Music and Art Fair,
Max Yasgur's farm, Bethel, New York,
August 18, 1969.

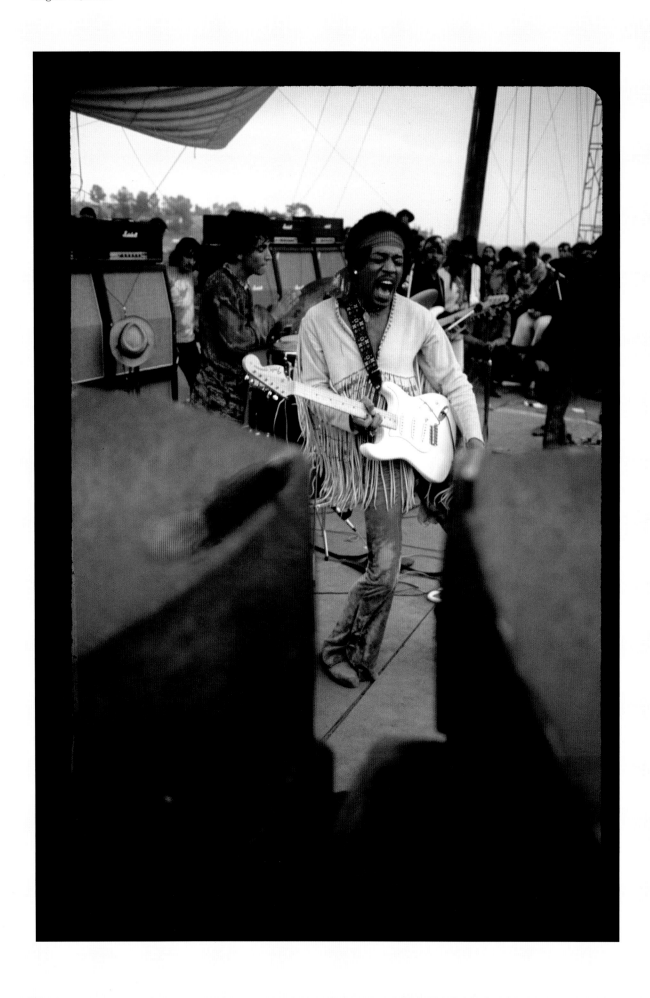

Unfinished Rough Sketch of woodstock fest.

A.1. 500,000 Halos
out shined the mud and → History.
B. We washed and drank in
..... in God's tears of Joy,
And for once ... and for everyone —
The truth WAS not a mystery —

2. Love called to all ... Music is Magic .
As We passed over the walls of Nay
Hand in Hand as we lived and
made Real the dreams of Men —
We came together ... Danced with
the pearls of Rainy weather
Riding the waves of Music and
Space.... Music is Magic ...
magic is life
Love As never Loved Before..
Harmony to Son and Daughter ... man and wife .

500,000 Halos, by Jimi.

Miles, and to a lesser degree Cox, felt that race played a role in Jeffery's opposition to the two replacing the Experience as Jimi's rhythm section. But it wasn't an opinion shared by the majority of Hendrix's long-standing associates, many of whom viewed Jimi's work with the Band of Gypsys solely as a vehicle to help create the PPX settlement album. Mitch Mitchell bristled at any notion that the Experience had been cast aside in favor of the Band of Gypsys. "That's not the way things were," he said. "The only reason they were together was to make that album. During that period of time, the Experience was going through some changes. I was fortunate enough to do some work with Jack Bruce and Larry Coryell. Jimi would come along and see the gigs that I was doing, and we always spoke. We still continued playing, even during those times."

With Miles out of the way, Jeffery was determined to refocus Hendrix's energy, pressuring his talented star to reform the Jimi Hendrix Experience, even reaching out to Noel Redding to return. Jeffery's vision was to reestablish the Jimi Hendrix Experience with a high-profile tour leading directly to the release of Jimi's next studio album. He wanted to put as much distance between the forthcoming *Band of Gypsys* album—a musical collaboration he considered a one-time creative diversion—and the Experience, arguably the most popular rock concert attraction in the world. Moreover, the lucrative tour would generate much-needed capital to finance the continuing construction of Electric Lady Studios.

Hendrix jettisoned the reunion of the original Experience as immediately as it was proposed, reluctant to reform the group with Redding as bassist. Instead, Cox was coaxed to return, partnering with Hendrix and Mitchell in a revised version of the Jimi Hendrix Experience. "I had left it behind, but then I looked up and there again was Mike Jeffery," explained Cox. "He said, please come back. This time, I placed demands. No more Mr. Nice Guy. Everything had to be right, so I went back and soon after that Mitch was back, we were in the studio doing some things, and next thing you know, we were touring under the name of the Jimi Hendrix Experience."

"Dawn had broken over Manhattan by the time the group finally left the venue in the early morning hours of January 1, 1970."

*THIS PAGE and FOLLOWING
Fillmore East, New York, New York,
December 31, 1969.*

BILL GRAHAM PRESENTS IN NEW YORK

JIMI HENDRIX: A BAND OF GYPSYS
JIMI HENDRIX—BUDDY MILES—BILLY COX

THE VOICES OF EAST HARLEM

JOSHUA LIGHT SHOW

December 31, 1969—January 1, 1970

GRATEFUL DEAD

LIGHTHOUSE

Extra Added Attraction:
COLD BLOOD

JOSHUA LIGHT SHOW

January 2-3, 1970

FILLMORE EAST

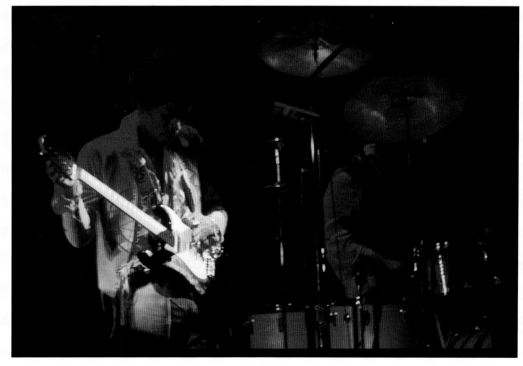

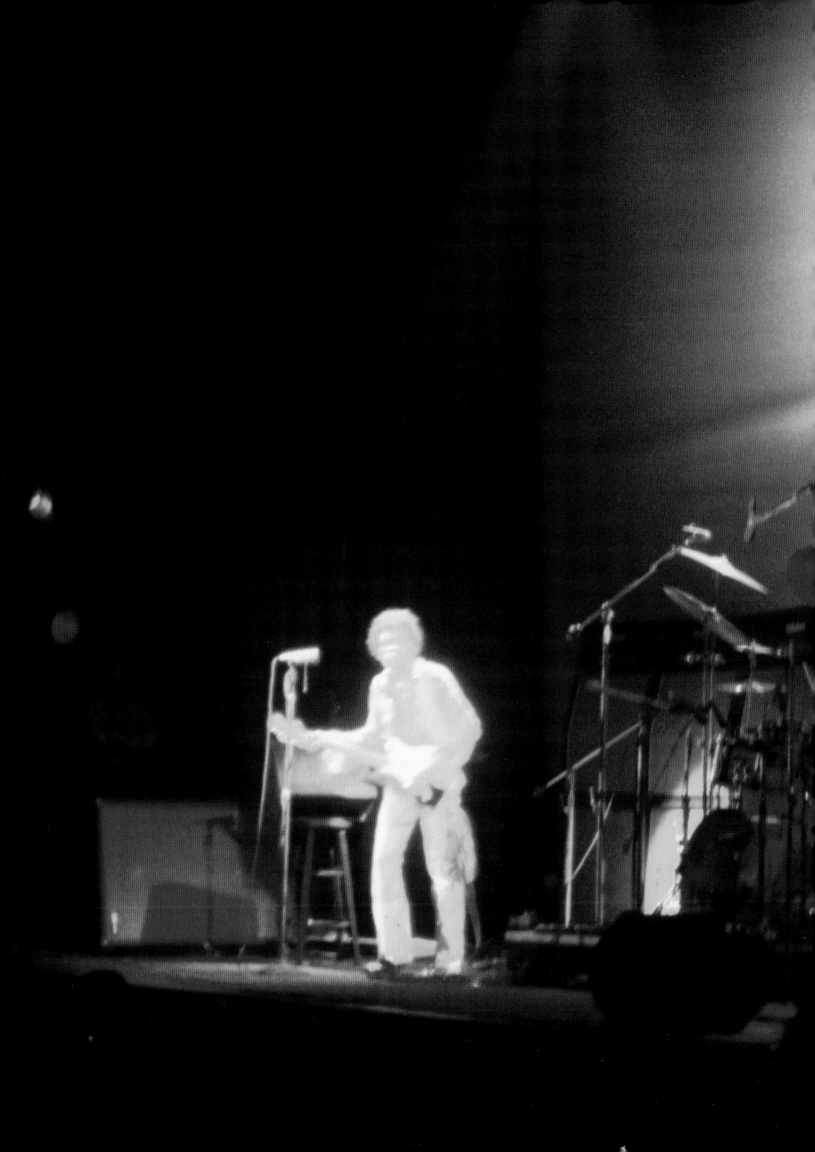

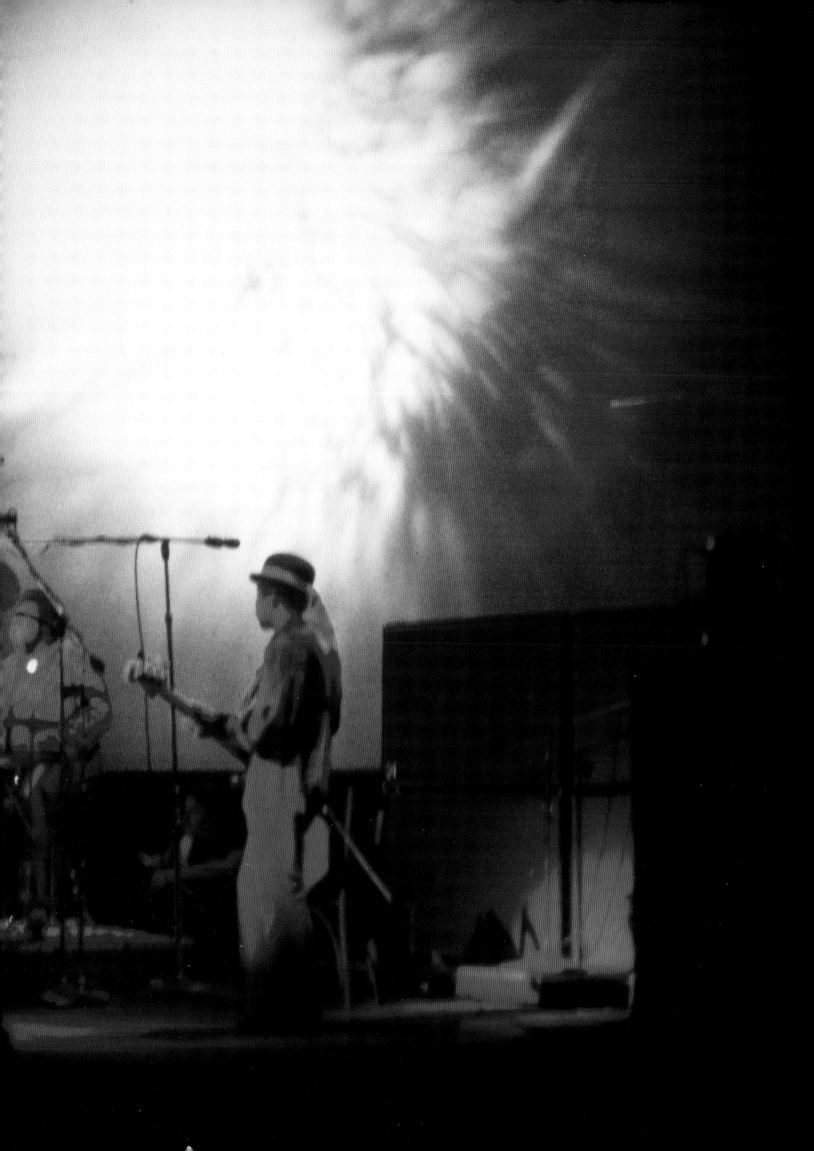

"

HE WAS **VERY POSITIVE** ABOUT **1970**. HE HAD HIS **NEW STUDIO** AND HIS MUSIC WAS COMING TOGETHER."
—EDDIE KRAMER

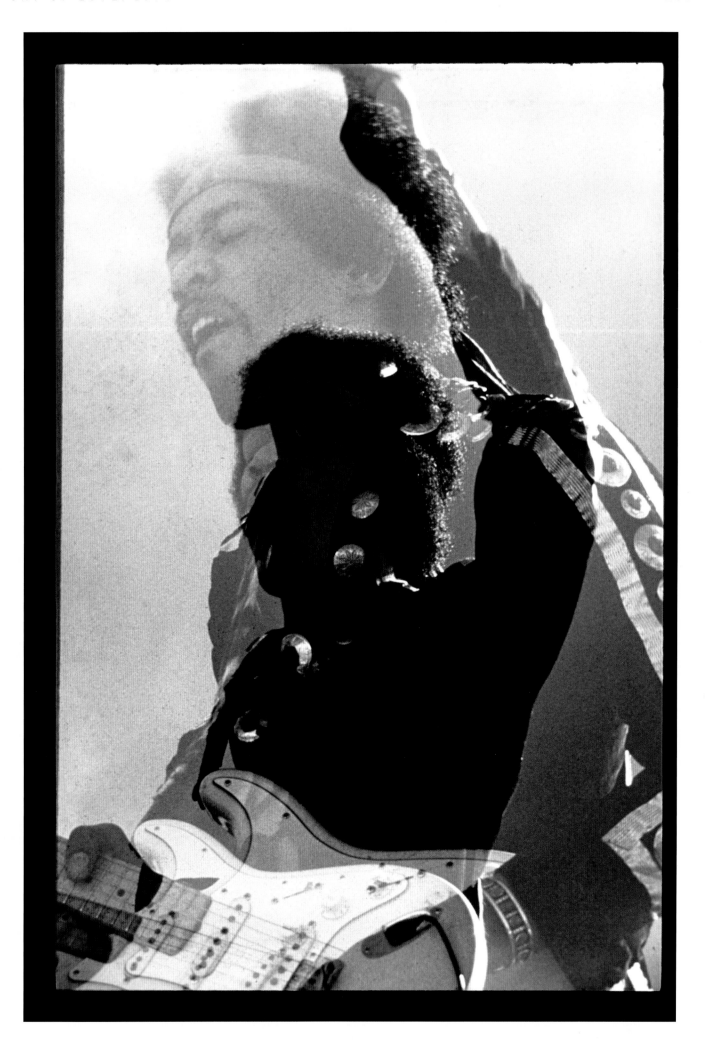

CRY OF LOVE

The theatrical release of the immensely popular *Woodstock* documentary, which prominently featured Jimi's dramatic rendition of "The Star-Spangled Banner," confirmed Hendrix's elite status as a counterculture icon. Hendrix, *Woodstock* director Michael Wadleigh would later say, performed at the festival as if he had taken his own guts and strung them in place of the strings. The film won an Academy Award and became the highest-grossing documentary of all time. In time, Hendrix's extraordinary rendition of the national anthem became synonymous with Woodstock. The film's enormous popularity served Jimi well, fueling interest in his music and further elevating his profile throughout the world. Capitol Records launched a major marketing campaign to trumpet the release of *Band of Gypsys*. Jimi's growing fan base immediately embraced the album, making it one of the most popular records of the year.

As the construction of Electric Lady Studios inched toward completion, Jimi was eager to focus his energies on *First Rays of the New Rising Sun*, the ambitious double studio album he was planning. The studio was a source of tremendous pride, a tangible symbol of his hard work and success. Whereas just four years before, he had scuffled unsuccessfully as an unknown, itinerant sideman, getting by on the shelter and support of various girlfriends and paltry wages, now he had his own studio. Despite its considerable costs and construction delays, Electric Lady would provide Hendrix with a creative home, something that had eluded him throughout his life and career. "He was very positive about 1970," said Kramer. "He had his new studio and his music was coming together."

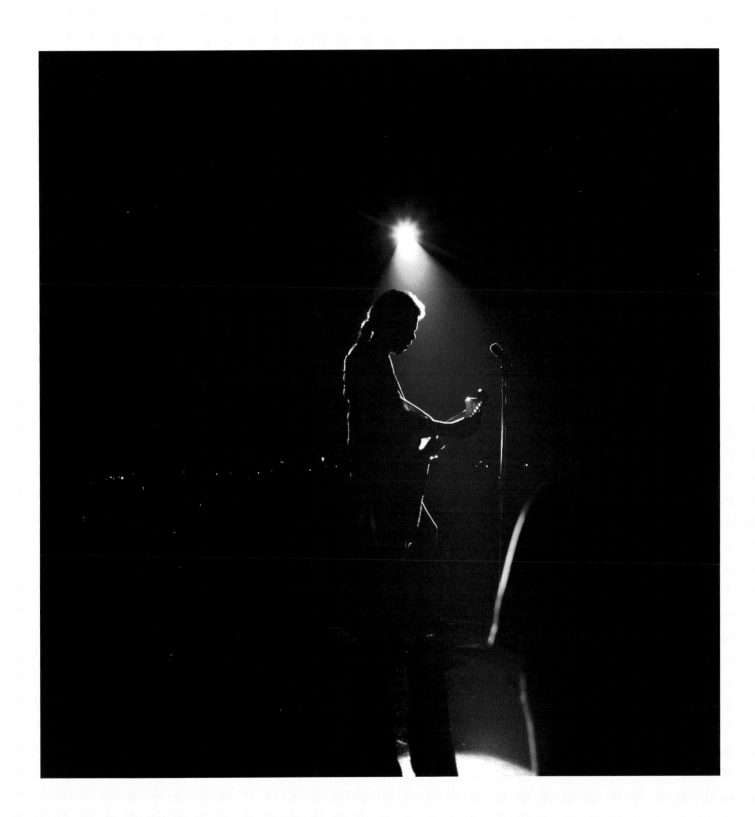

PREVIOUS
Olinda Road Cattle Ranch, Maui,
Hawaii, July 30, 1970.

ABOVE
Middle Georgia Raceway, Byron,
Georgia, July 4, 1970.

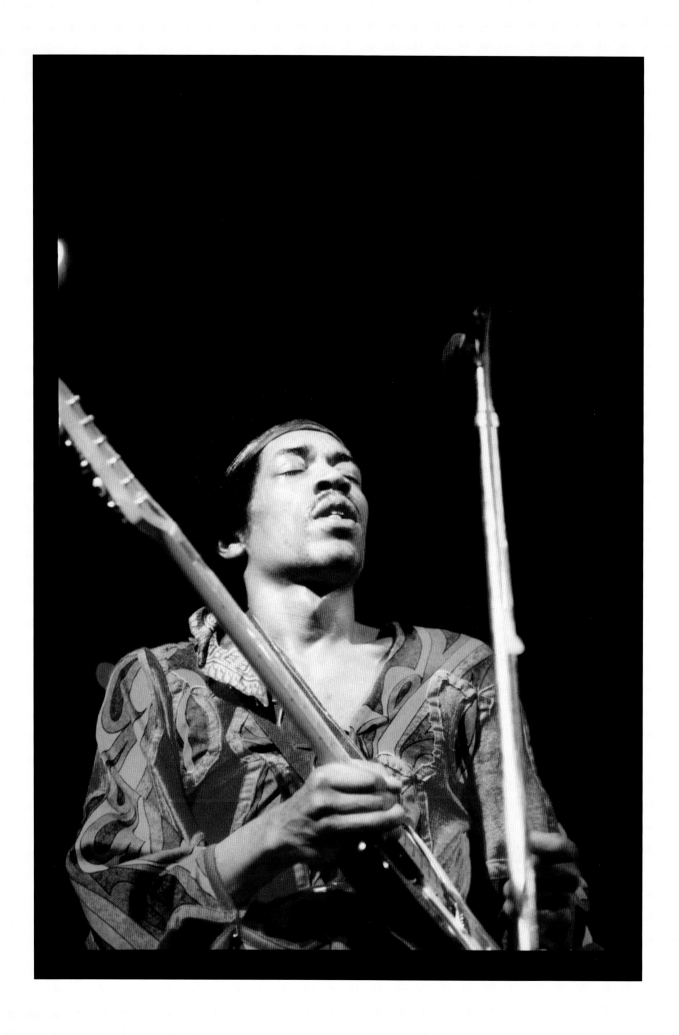

The Experience began a loose string of tour dates with a sold-out show at the Los Angeles Forum on April 25. But, having learned from previous experience, Jimi told Jeffery he would do shows on weekends only, leaving weekdays free for studio recording.

The secure environment of Electric Lady Studios sparked a creative revival within Hendrix. A closed-circuit camera system was installed, and intrusions by unwanted guests and groupies were greatly reduced. "Jimi was really happy," explained Cox. "To us, the studio was a toy. Because it was Jimi's studio, we could go in at eight in the evening and come out the next day at twelve in the afternoon, just creating and having fun musically. This allowed Jimi to keep expenses down, instead of the Record Plant, where it would get expensive if we spent a lot of time in there. I think in Electric Lady we were more productive than any of the other studios we had been to." Hendrix's initial task at the new studio was to reevaluate the mass of song sketches and unfinished masters he had begun at a host of studios through 1969. "Eddie pulled out the tapes and Jimi spent a lot of time doctoring up and trying to improve those tracks we had already recorded," Cox said. "We spent a bunch of time doing this before we started recording new material."

Many of these unfinished songs traced their roots to Jimi's 1969 sessions with Cox and Miles. Essential tracks such as "Room Full of Mirrors," "Ezy Ryder," "Izabella," "Stepping Stone," and "Earth Blues" were among those the guitarist sought to finalize and introduce on the new album.

"He relished being in the studio, going through the tapes, playing with the lighting, and some of the other features that had been built with him in mind," said Kramer. "I actually saw him really laugh and carry on and smile—which I hadn't seen in a while. There was a wonderful feeling of camaraderie. He just enjoyed being in his own space." Jimi's confidence was further bolstered by the quality of new material, such as "Freedom," "Dolly Dagger," and "Night Bird Flying," developed at Electric Lady. "The record was coming together," Kramer said. "One of the most exciting things for me was hearing Jimi's new songs. The material we had collected from the previous year at the Record Plant was laborious, whereas, starting at Electric Lady, we had a chance to cut fresh tracks—and they were very rapidly cut. The record had momentum, and we could see that there was a shape to it. I remember Jimi writing up some of the song titles, saying 'That will make a good Side A. That will make a good Side B. We have enough for a Side D and C.' That was pretty cool, to see all of the effort of the last two years just coming together. You could see the end in sight."

The new Experience was blissfully free of the corrosive tension that had permeated the original band. "The three of them communicated very well," Kramer said. "There was a very good balance of power. Mitch stepped up to the plate and played with more of the funkier feel that Jimi was looking for. He understood the new direction that Jimi wanted to head in. Billy kept it all tied together with his rock solid bass playing." Unlike Redding, who yearned to play guitar and develop his own musical identity, Cox relished his supporting role. His infectious enthusiasm lifted the spirits of both Hendrix and Mitchell. "Those times on the road with Jimi were incredible," said Cox. "That was what I always dreamed about, being able to perform in front of a large audience that appreciated what you did."

The group recast Hendrix's set list, fusing Experience favorites with songs from Band of Gypsys. Hendrix confidently showcased the likes of "Hey Baby (New Rising Sun)," "Ezy Ryder," "Room Full Of Mirrors," and others throughout the 1970 tour. "Songs like 'All Along The Watchtower' may have been old to Jimi and Mitch but they were new to me," explained Cox. "I think adding my flavor to those songs made it refreshing for Mitch and Jimi to play them again. Playing new songs like 'In From The Storm' gave us a chance to take them out of Electric Lady, which was our laboratory, and see what people's reactions would be."

Boston Garden, Boston,
Massachusetts, June 27, 1970.

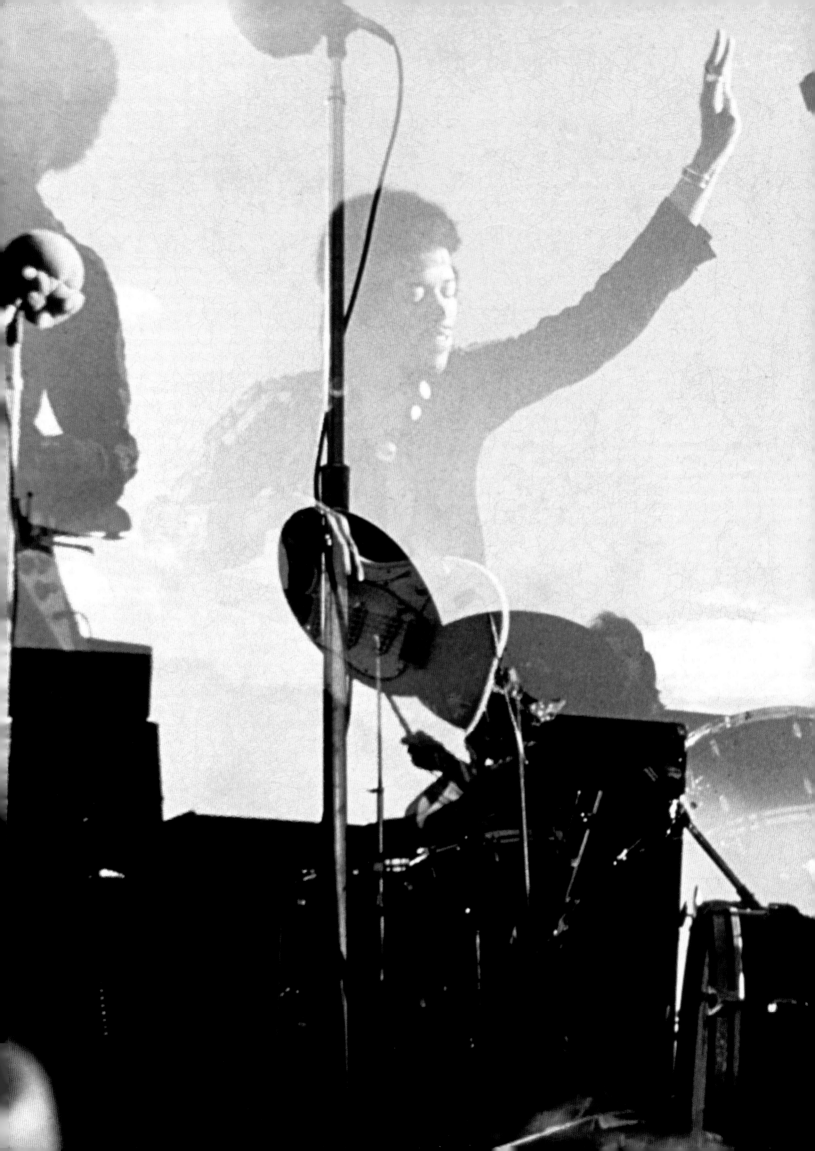

PREVIOUS
Olinda Road Cattle Ranch, Maui,
Hawaii, July 30, 1970.

Throughout the spring and summer, Jimi's tour itinerary was dotted with an eclectic assortment of colleges, sports arenas, and large festivals. In Berkeley, Jimi's two brilliant performances were documented by a film crew dispatched by manager Michael Jeffery. On July 4, he headlined the Atlanta Pop Festival, thrilling an audience in excess of three hundred thousand people. The tour drew to a close later that month, following engagements in San Diego, Honolulu, and Seattle, where Jimi welcomed the opportunity to reconnect with his family again.

Though their face-to-face time together had been brief, Jimi relished the opportunity to bring his entire extended family to see his Seattle show. Though most of the family sat backstage, the noise was too much for Jimi's grandmother, so she and Jimi's aunt sat up in the rafters. At one point during the show, Jimi dedicated "Red House" to his aunt and grandmother because he knew they liked the blues. Janie remembers looking up and seeing her grandma and aunt swaying to the music.

It was pouring down rain during the Seattle show, and Jimi, whose schedule was as taxing as ever, wasn't feeling well after the performance. He spent the night at his family's home, and in the morning when he was due to be picked up, his father told his tour manager, "He can't go today." Al would see to it that he caught a flight to the next engagement in time, but he saw the strain on his son and insisted he stay home to recover.

When Al eventually saw Jimi off at the airport, he said after they'd said goodbye and Jimi was halfway down the jetway, Jimi turned around and came back, and the two men looked at each other a moment before saying goodbye again. "I had a feeling that would be the last time I would see him," Al said.

Seeking rest and relaxation, Hendrix, Cox, Mitchell, and their entourage traveled to Maui, Hawaii, for a three-week retreat. "Jimi rented a house for us and we had some of the best times of our lives," Cox remembered. "We played Ping-Pong and dominoes, watched TV, and were having a good time. That went on for about three days before Michael Jeffery came and got him. He said, 'Look, we want you to be in this movie.' We didn't

see much of Jimi after that. We were relaxing, but he was still working."

Hendrix's hopes for a short vacation were thus superseded by Jeffery's film project, *Rainbow Bridge*. Mitchell described the project as, "This crazy film. . . . Mike and a few other people from the film came up with this idea of literally going through the streets with a truck and a few placards saying, 'Anyone that wants to come, come up to the crater of the sun, to the volcano. We are going to have a concert.' If my memory serves me right, it was like a four-mile hike. Even if you had a car to drive on where it was, you still had one hell of a walk."

The hastily arranged concert proved a logistical disaster. Staged in a meadow on the mountain, the wind howled so fiercely that Jimi's crew was forced to cut foam from the group's instrument cases to serve as microphone wind screens. With no hardwired power available, the group had to share a generator run by the film crew.

Despite the chaotic surroundings, the group relished the opportunity to play in such a relaxed, informal outdoor setting. On that windy hillside in Maui, the group turned in a loose but inspired set before a sparse audience of just a few hundred people. "The main thing was that the band just enjoyed playing," Mitchell remembered. "All of these people turned up and we were having some fun."

When Hendrix returned from Maui, he redoubled his efforts at Electric Lady. While *Band of Gypsys* continued to do well for Capitol, Reprise continued to pressure the guitarist to deliver a new album in time for the profitable Christmas season. Also looming was a commitment to appear at the Isle of Wight festival in Britain and a short string of European concert dates.

As the Isle of Wight grew near, Hendrix felt reluctant to leave Electric Lady Studios; he had made significant recording progress and did not want to resume touring until he had finished the album. "That was very frustrating for him," said Kramer. "Going out on the road interrupted the flow of making records. He knew that he had to make money to pay the bills, but he would rather have stayed in the studio twenty-four hours a day, seven days a week if he could."

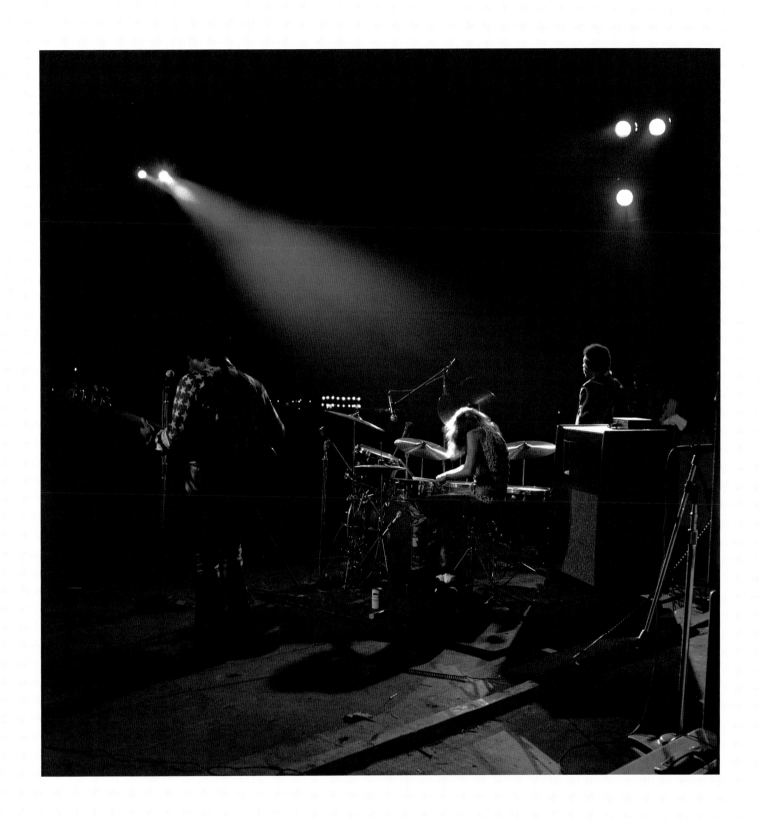

Middle Georgia Raceway, Byron,
Georgia, July 4, 1970.

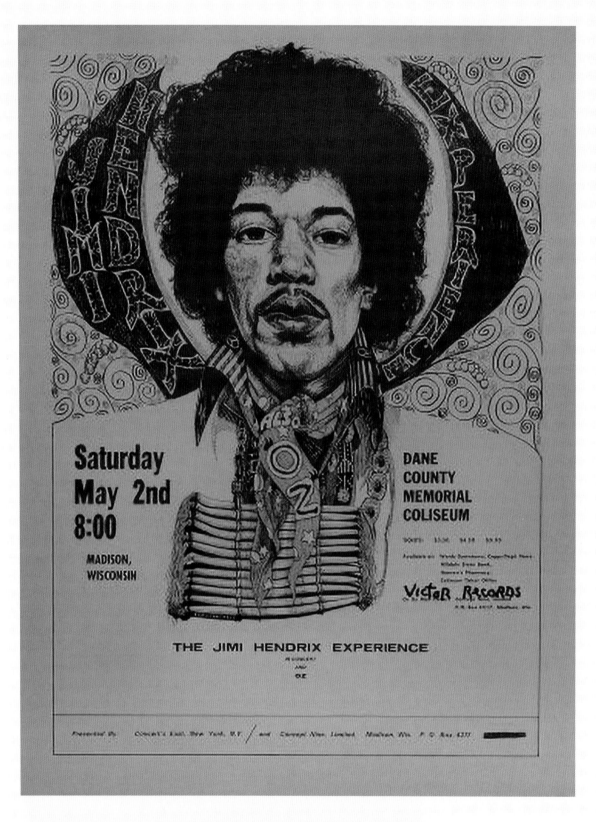

Boston Garden, Boston,
Massachusetts, June 27, 1970.

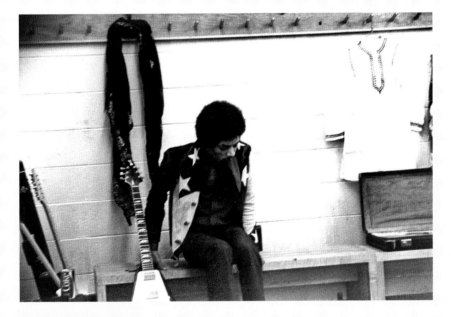

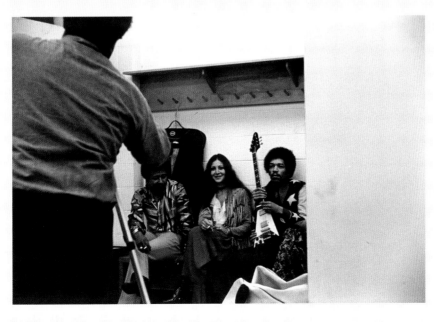

"We knew that Jimi had these commitments coming up," said Cox. "More than anything, he needed rest. He was just plain wore out."

Hendrix spoke with great pride of Electric Lady and what he hoped to accomplish there. "I have done great things with this place," Hendrix stated. "It has the best equipment in the world. We can record anything we like here. There is one thing I hate about studios usually and that is the impersonality of them. They are cold and blank and within a few minutes I lose all drive and inspiration. Electric Lady is different. It has been built with great atmosphere, lighting, seating, and every comfort that makes people think they are recording at home."

Hendrix was present but decidedly low-key at the public opening of Electric Lady Studios on August 26. "We threw a big party for the opening of the studio," Kramer said. "It was to say to the world, hey, Electric Lady is open now, we're running and open for business. Jimi was sitting in a little lounge area where there was a barber's chair. Don't ask me why we had a barber's chair, but I remember him sitting back, away from the crowd, and got the impression that he really didn't want to be there for the party, and then have to get on a plane and go to Europe. We had mixed four songs and they sounded really great. He was thinking, 'Here we go, we are going to interrupt the flow of what we are doing again. Once again, I've got to go to Europe and make some money so we can support the studio, whereas what I really want to do is be in the studio and finish this record.'" Partygoers previewed selections of Jimi's new music and were impressed with the distinctive, subterranean layout of the state-of-the-art facility. Later that same evening, Hendrix quietly slipped away from the party with road manager Eric Barrett and flew to London.

BELOW
Ventura County Fairgrounds, Ventura, California, June 21, 1970.

RIGHT
Fillmore East, New York, New York, January 1, 1970.

"Going out on the road interrupted the flow of making records. He knew that he had to make money to pay the bills, but he would rather have stayed in the studio twenty-four hours a day, seven days a week if he could."

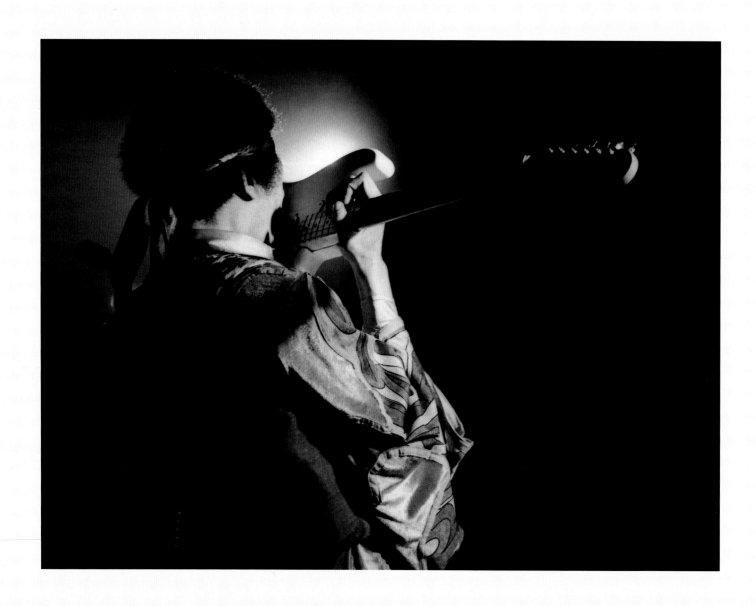

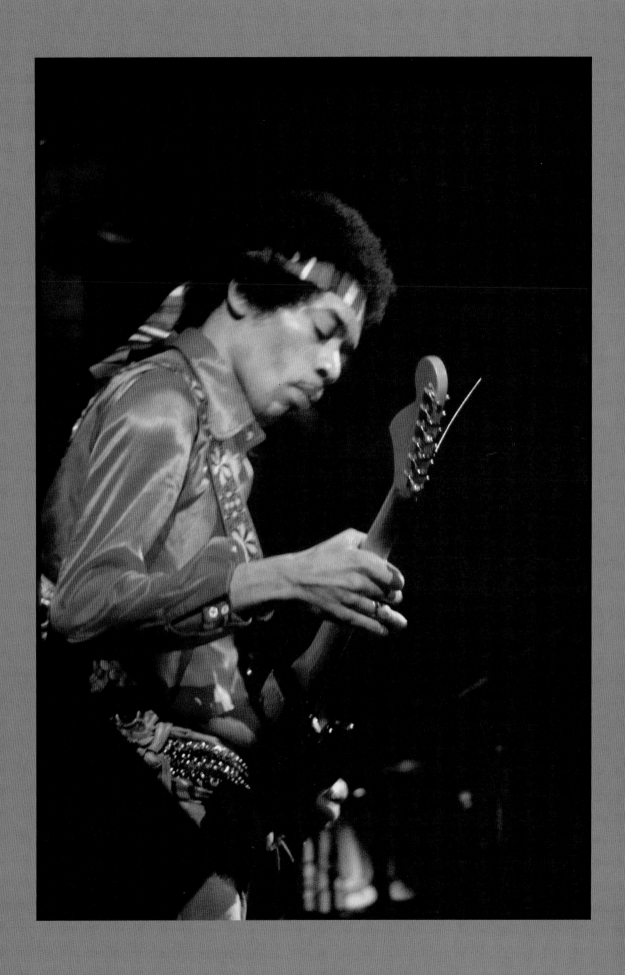

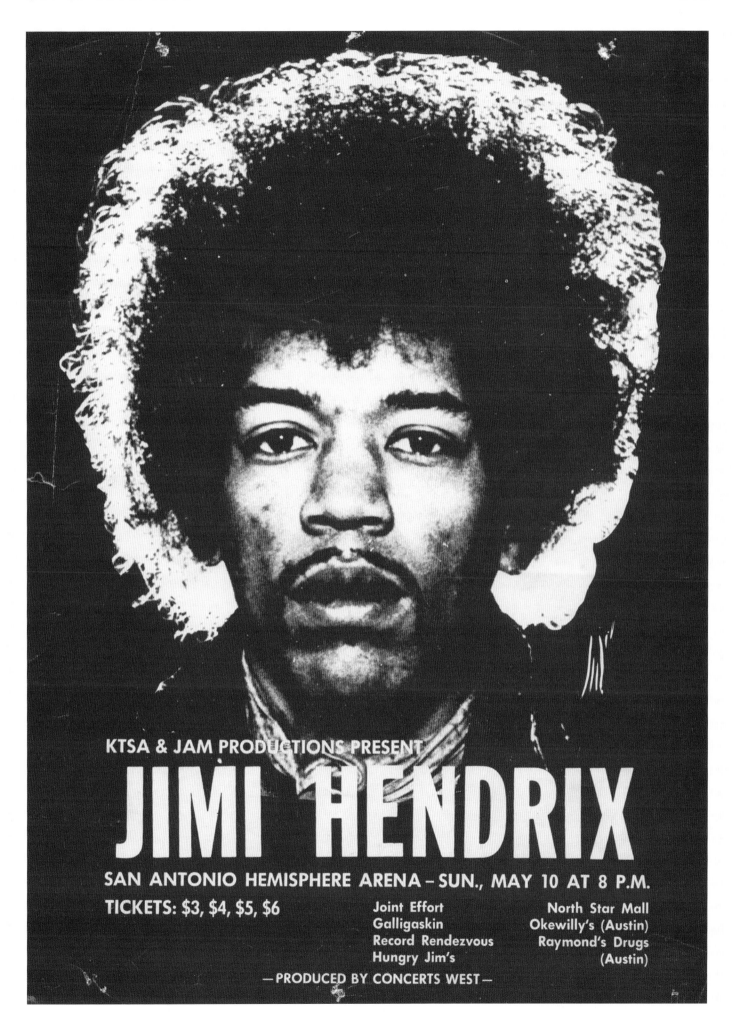

Hendrix's August 30 appearance at the Isle of Wight festival marked his first British concert since the two sold-out February 1969 appearances at London's Royal Albert Hall. He topped an impressive bill that included the Who, the Doors, and Miles Davis. An audience estimated at six hundred thousand—by far the largest the Experience had ever performed for—gathered on this small British vacation island. Hendrix took the stage well into the early morning hours of August 31, somewhat uncertain of how the audience would greet him. "Jimi was quite apprehensive," remembered Cox. "He said, 'I've been gone so long they've forgotten about me.' I said, 'Man, I don't know if they're gonna accept me. Here I am black and I've replaced Noel Redding.'" The Experience need not have worried. "As soon as we hit the stage—before we had even played a note—the crowd started cheering for him," said Cox. "We were on our way after that."

Determined to rally the massive audience, Jimi began with an impromptu medley of "God Save The Queen" and "Sgt. Pepper's Lonely Hearts Club" before launching into a two-hour set that blended old favorites with new songs such as "Dolly Dagger." In both a searing "Red House" and an extended "Machine Gun," Hendrix's vocals were imbued with a sense of clear desperation. Though Jimi was dogged by technical setbacks that hampered his amplifiers, stage monitors, and spirit, he gave the audience a medley of the hits they had called for throughout his set. He closed with a savage rendition of "In from the Storm," furiously bending and squeezing the strings before thanking the crowd, dropping his guitar to the stage and walking off into the darkness.

Following this energetic performance, the group flew directly to Stockholm for another performance that same evening. The trio was exhausted, particularly Cox, who was on the verge of serious illness, and turned in a lackluster performance. Soon Jimi, too, was overcome by exhaustion and illness. In Denmark he struggled through dismal renditions of just three songs before departing.

Though Cox had sailed effortlessly through all of the 1970 US dates, the bassist now struggled to keep going. Eventually, serious health concerns necessitated his return to the States, and his return to the group was uncertain. Following the group's performance on September 6, at the Isle of Fehmarn in Germany, the Experience canceled the remaining tour dates.

Heathrow Airport, London,
August 27, 1970.

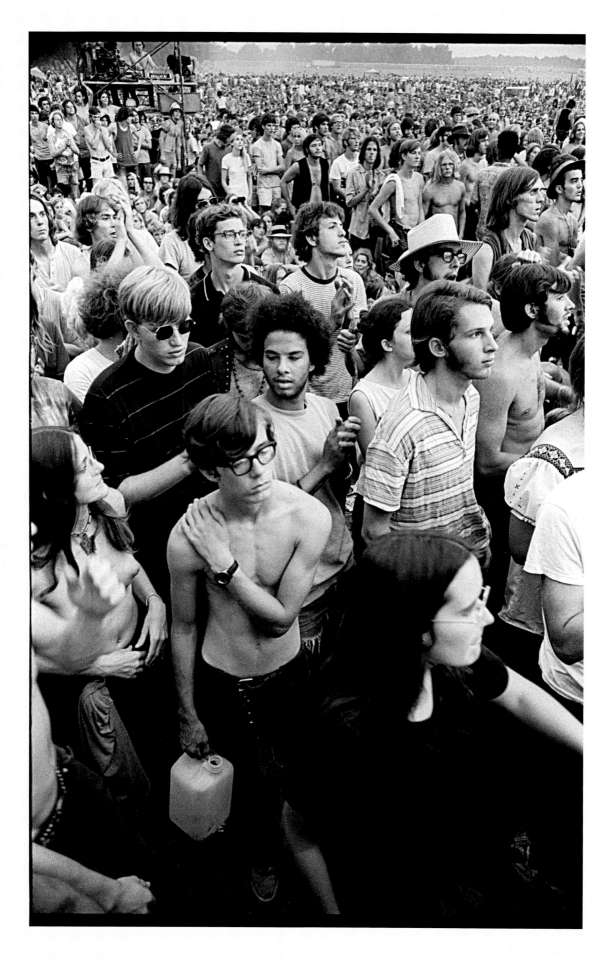

*Middle Georgia Raceway, Byron,
Georgia, July 4, 1970.*

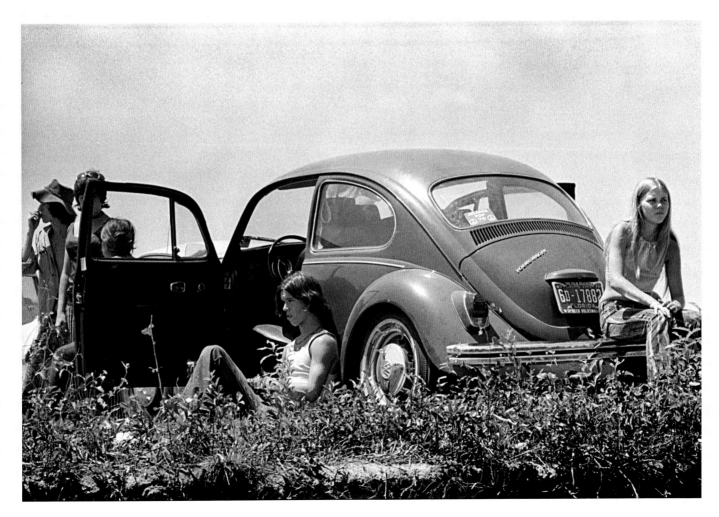

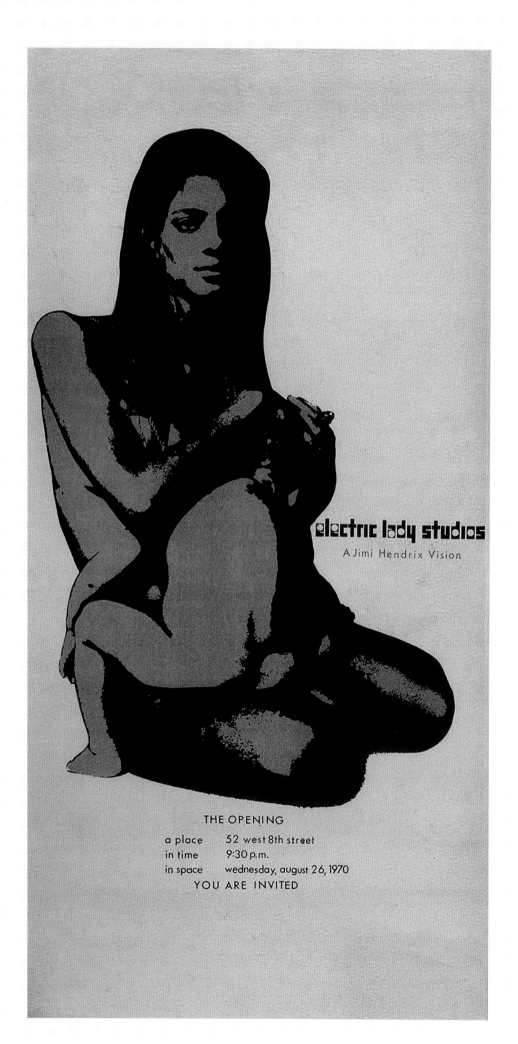

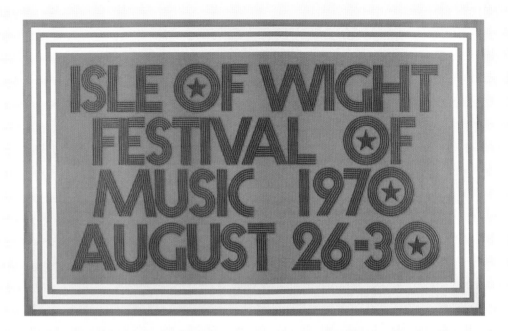

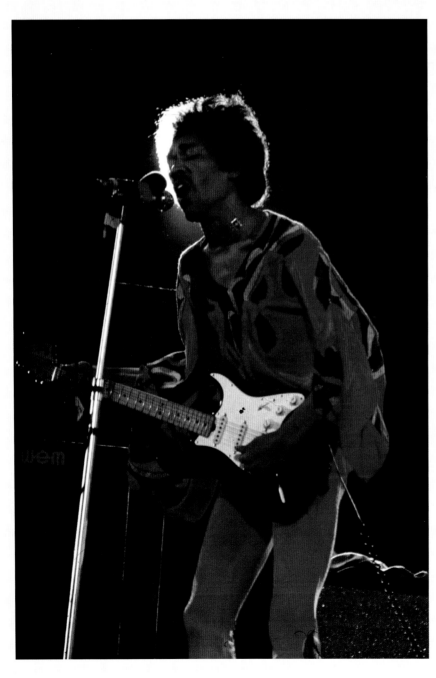

Isle of Wight Festival of Music,
United Kingdom, August 30, 1970.

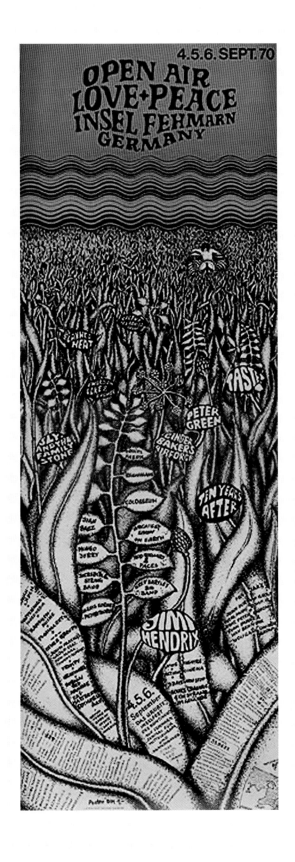

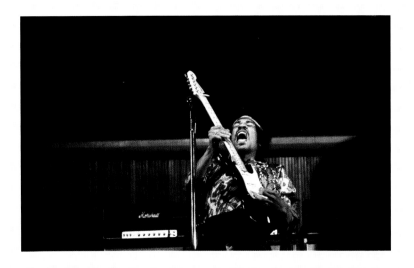

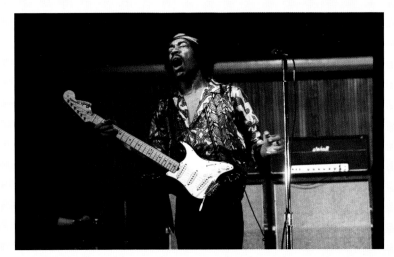

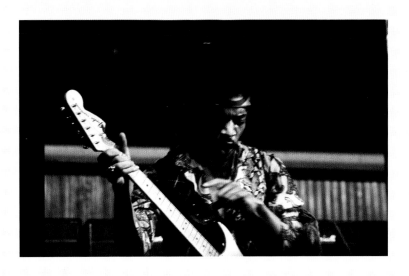

K.B. Hallen, Copenhagen, Denmark,
September 3, 1970.

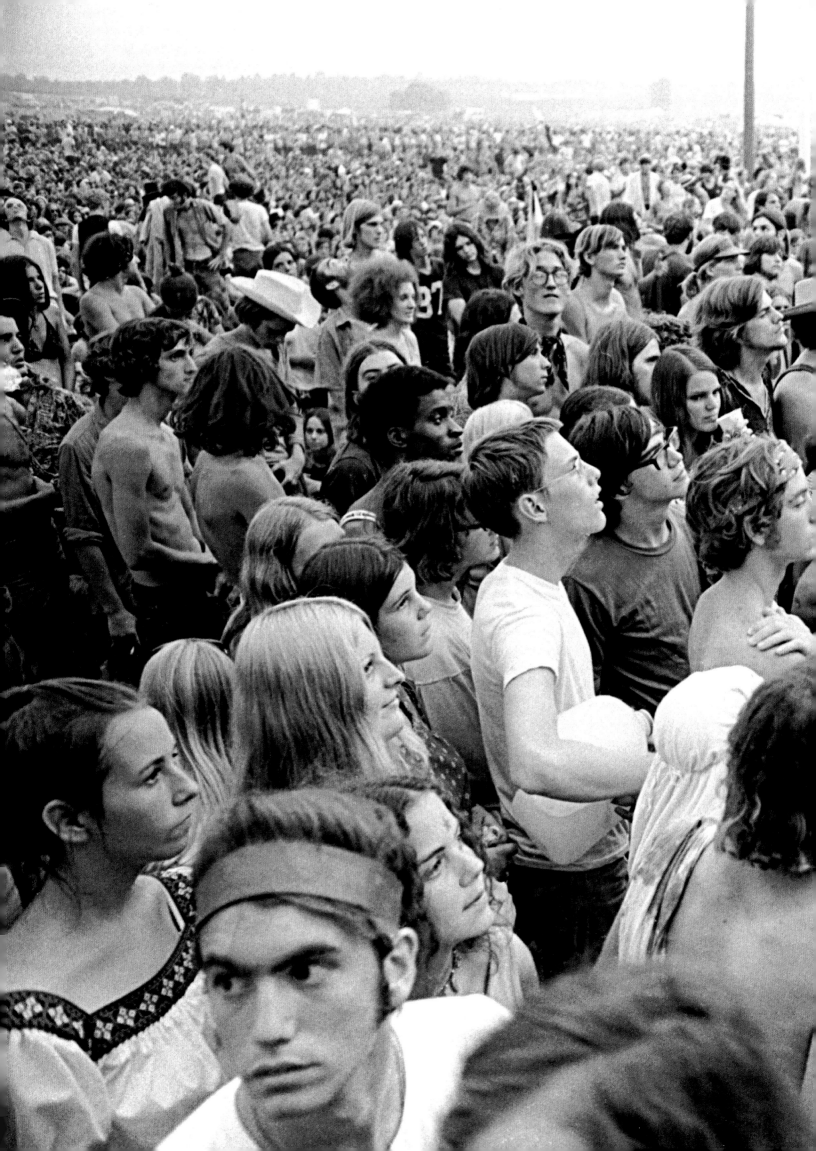

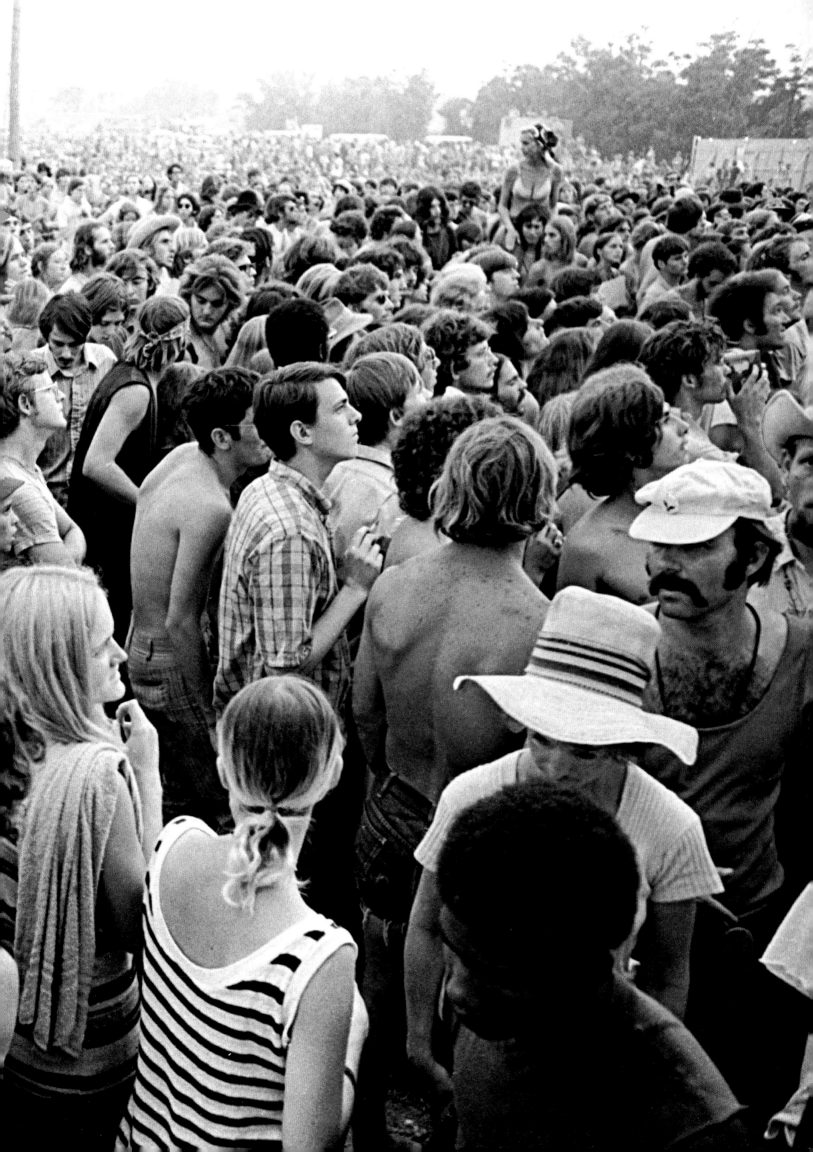

THE LAST DAYS

Jimi remained in London, stuck in limbo as he and Jeffery considered their options. Jeffery argued in favor of drafting an immediate replacement for Cox, suggesting Noel Redding once again, but Hendrix took no action. It was presumed he would return to New York and to his work at Electric Lady. In interviews he granted during this period, Hendrix took stock of his position, speaking frankly of his struggle to further his musical direction. "I've turned full circle," he explained. "I'm back right where I started. I've given this era of music everything, but I still sound the same. My music's the same and I can't think of anything new to add to it in its present state. When the last American tour finished, I just wanted to go away and forget everything. I just wanted to record and see if I could write something. Then I started thinking. Thinking about the future, thinking that this era of music, sparked off by the Beatles, had come to an end. Something new has to come and Jimi Hendrix will be there."

In the days following, Hendrix surprised Chas Chandler with an unexpected visit, where they discussed the possibility of Chandler helping to evaluate the many recordings Jimi had developed over the summer.

"I got a call from Jimi in London," Eddie Kramer, who was in New York at the time at Electric Lady, remembered. "He asked if I could bring all of the tapes over to London. I was surprised. I sensed something was up, but I said, 'Jimi, don't be crazy. We've built this beautiful studio for you. You'll be here on Monday.'

"There was a long, drawn out pause on the line until he said, with a touch of resignation, 'Yeah, you're right. I'll be back on Monday and we'll get it together.' He sounded disappointed that I couldn't or wouldn't bring the tapes over to England. It seemed as if he wanted me to drop everything and come over. . . . It did seem as if he couldn't talk, but I had no idea as to his intentions. I just figured he couldn't wait to get started again."

After his meeting with Chandler, Hendrix dropped by the famous jazz club Ronnie Scott's, hoping to sit in with Eric Burdon and War. To Burdon's road manager Terry McVay, Hendrix seemed somewhat disoriented, and he wouldn't allow the jam session to take place. Hendrix returned the following evening, looking, in McVay's words, "clean and sharp.'" He sat in with the group and enjoyed a spirited interplay with them, particularly their guitarist Howard Scott.

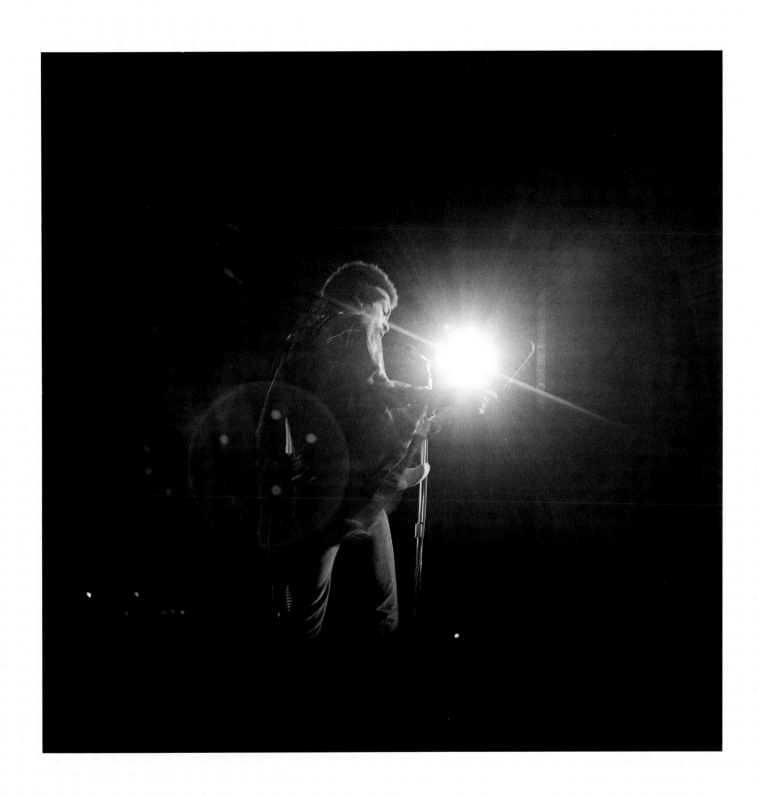

ABOVE and PREVIOUS
Middle Georgia Raceway, Byron,
Georgia, July 4, 1970.

Hendrix spent most of September 17 with Monika Dannemann, a girlfriend from West Germany living on Landsdowne Crescent in London. According to Dannemann, Hendrix spent the day running errands and making business calls. Dannemann's details of that evening's activities are sketchy, but they remain the only first-hand account of Jimi's last hours. "He got up and had something to eat, then I took some photos of him for my work. We met some people at his hotel, where he telephoned New York. He went to the flat of a person we had met and stayed for about one hour. We arrived home at about 8:30 in the evening. [There] I cooked a meal and around 11 p.m. we drank a bottle of wine. I washed my hair and we listened to music. He told me that at 1:45 a.m. he had to go see someone at their flat, they were people he didn't like. I dropped him off in my car and picked him up an hour later. During the time we were apart, we spoke three times on the telephone. Just after 3:00 a.m. we went back to my flat. We talked and I made him two fish sandwiches. At 7:00 a.m., I took a sleeping tablet. I woke at 10:20 and could not sleep anymore. Hendrix was sleeping normally so I went out to get some cigarettes. I came back to see if he was awake and I saw that he was sick, [with] vomit around his mouth and nose." It turned out Hendrix had taken nine of Dannemann's Vesparax sleeping pills. Dannemann summoned an ambulance, and a Notting Hill police sergeant later confirmed the grim details. Hendrix, "had been found by Monika Dannemann at 11:00 a.m. to have been sick in his sleep, lying in a pool of vomit. The ambulance was called at 11:18 a.m. and arrived at 11:27 a.m. I went to St. Mary Abbot Hospital where I saw the lifeless body of Jimi Hendrix at 11:45 a.m."

As with many icons that pass away at the height of their careers, a great amount of speculation and attention has always been focused on the death of Jimi Hendrix. Though no one can truly know his mental state in his final days, it is clear that Hendrix was neither depressed nor suicidal. He was, however, clearly tired, worn down from lifestyle choices and working nonstop since his arrival in London in September 1966.

Jimi's death has at times been attributed to recklessness, and theories of conspiracy and foul play have also been voiced. The facts are that Hendrix ingested sleeping tablets prior to going to bed, and this simple, reckless act brought a remarkable life to a close.

Jimi Hendrix was buried in Seattle on October 1, 1970, where family and friends gathered to mourn the loss of one of the brightest examples of American popular culture. While his untimely death robbed the music world of one its brightest innovators, his incredible legacy, built by legendary concert performances and the albums he issued over the course of just four brief years, continues to influence fans and musicians alike to this day.

Because Jimi's death came before his work at Electric Lady was complete, we can only guess as to his grand visions for *First Rays of the New Rising Sun*. What the songs intended for that album do make clear is that Hendrix had begun a remarkable creative rejuvenation. With full faith in his direction, Hendrix was primed to introduce his audience to a new frontier, where the triumphs of his past would merge freely with his unique blending of rock with rhythm and blues.

His work founding Electric Lady had other, far-reaching effects, as Electric Lady Studios became one of the most popular recording facilities in the world. Artists and groups including Stevie Wonder, David Bowie, the Clash, and countless others recorded landmark music there. Given Hendrix's fertile imagination, we can speculate that the music he would have recorded at Electric Lady, the creative possibilities he would have pursued within its walls as a musician, composer, and producer, are limitless.

Beginning with *Cry of Love* in 1971—the first in a steady stream of posthumous albums—Hendrix's impressive body of music continues to expand, providing new insights and a deeper appreciation and understanding of the man and his music.

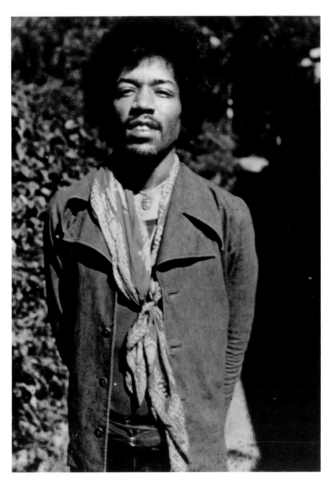

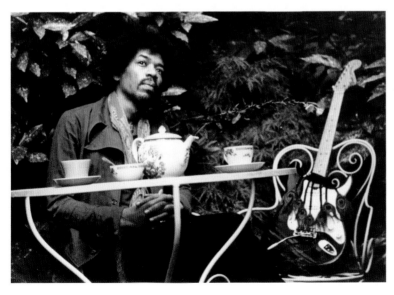

Samarkand Hotel, London,
September 17, 1970.

In 1993, Jimi's surviving relatives, led by his father Al, waged a contentious and expensive legal battle to reclaim the guitarist's work from companies operated and managed by Al's former lawyer, Leo Branton. The Hendrix family prevailed, and in 1995, Al formed Experience Hendrix, the company that now serves Jimi's great legacy.

Hendrix's popularity continues to grow throughout the world. Annual album sales today exceed those the guitarist enjoyed during his lifetime. The demand for new music is so strong that in addition to conventional albums, Experience Hendrix launched Dagger Records, an official, mail-order-only bootleg label. Releases such as *Morning Symphony Ideas* and *Hear My Music* have been dedicated to documenting Hendrix's songwriting approach, presenting demos and song sketches and a compelling window into the development of new music.

The Fender Stratocaster itself is inextricably linked to Hendrix. It is now seen as his symbol, the instrument he used to redraft the possibilities of the electric guitar. The innovative techniques he pioneered are now part of rock guitar's basic vocabulary. Companies have created amplifiers, guitars, and tone control pedals that help replicate Hendrix's unique sound and make it accessible to those young musicians inspired by his command of the instrument. But it is Hendrix's superb compositions that stand as the foundation of his legacy. Countless artists have covered his songs, and his recordings regularly appear in major theatrical films and television programs.

The Jimi Hendrix Experience was inducted into the Rock & Roll Hall of Fame in 1992. In 2000, Experience Hendrix contributed to the creation of a permanent exhibition at the facility's Cleveland, Ohio, location. And in Seattle, the Experience Music Project was inspired by Paul Allen's love of Hendrix. The museum's unique gallery of artifacts and ephemera remain its most popular attraction. In 2005, Jimi Hendrix was inducted into the newly formed UK Music Hall of Fame in London.

Though his career unbelievably lasted only four short years, his legacy shows no sign of fading. Music literally poured out of Jimi Hendrix, and he sought to preserve every note.

LEG

"HE WAS VERY SELF-EFFACING ABOUT HIS MUSIC, BUT THEN WHEN HE PICKED UP THAT GUITAR HE WAS JUST A MONSTER."
— PAUL MCCARTNEY

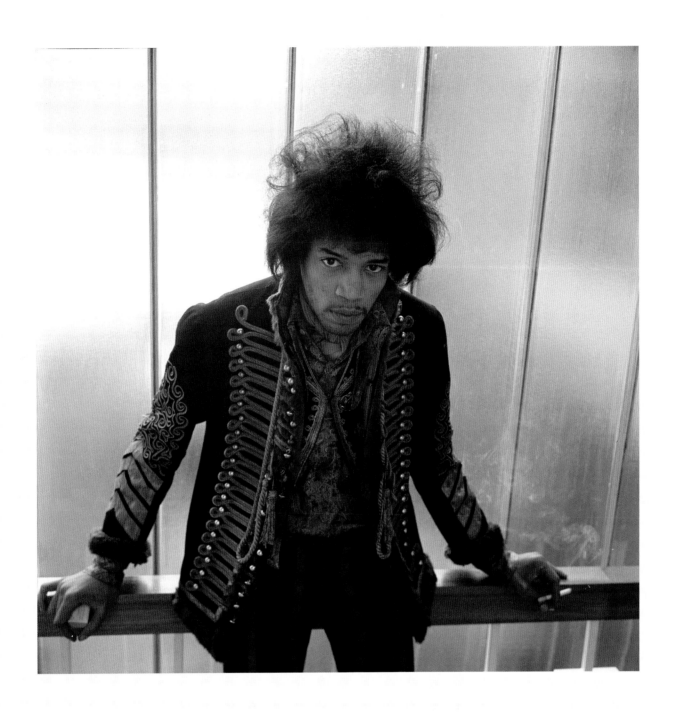

Nottingham, England, April 20, 1967.

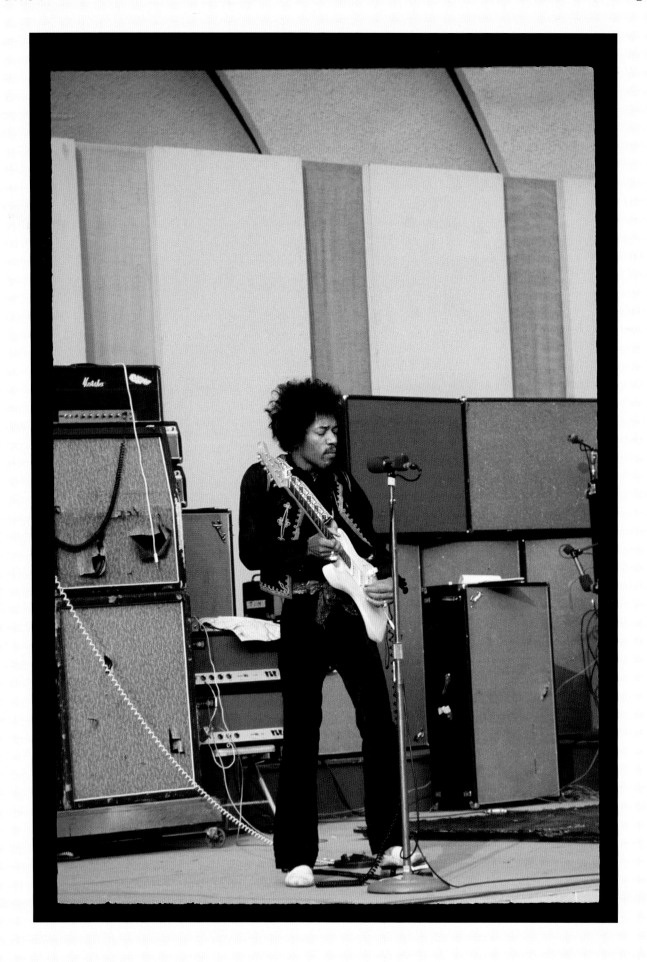

*Afternoon rehearsal, Hollywood
Bowl, Hollywood, California,
September 14, 1968.*

"JIMI HENDRIX IS VERY IMPORTANT. **HE'S MY IDOL.** HE SORT OF **EPITOMIZES**, FROM HIS PRESENTATION ON STAGE, THE WHOLE WORKS OF A **ROCK STAR.** THERE'S NO WAY YOU CAN COMPARE HIM. YOU EITHER HAVE THE **MAGIC** OR YOU DON'T. THERE'S NO WAY YOU CAN WORK UP TO IT. **THERE'S NOBODY WHO CAN TAKE HIS PLACE."**

— FREDDIE **MERCURY**

"IT OVERWHELMED ME, REALLY. HE HAD SUCH TALENT, HE COULD FIND THINGS INSIDE A SONG AND VIGOROUSLY DEVELOP THEM. HE FOUND THINGS THAT OTHER PEOPLE WOULDN'T THINK OF FINDING IN THERE. HE PROBABLY IMPROVED UPON IT BY THE SPACES HE WAS USING. I TOOK LICENSE WITH THE SONG FROM HIS VERSION, ACTUALLY, AND CONTINUE TO DO IT TO THIS DAY." —BOB DYLAN

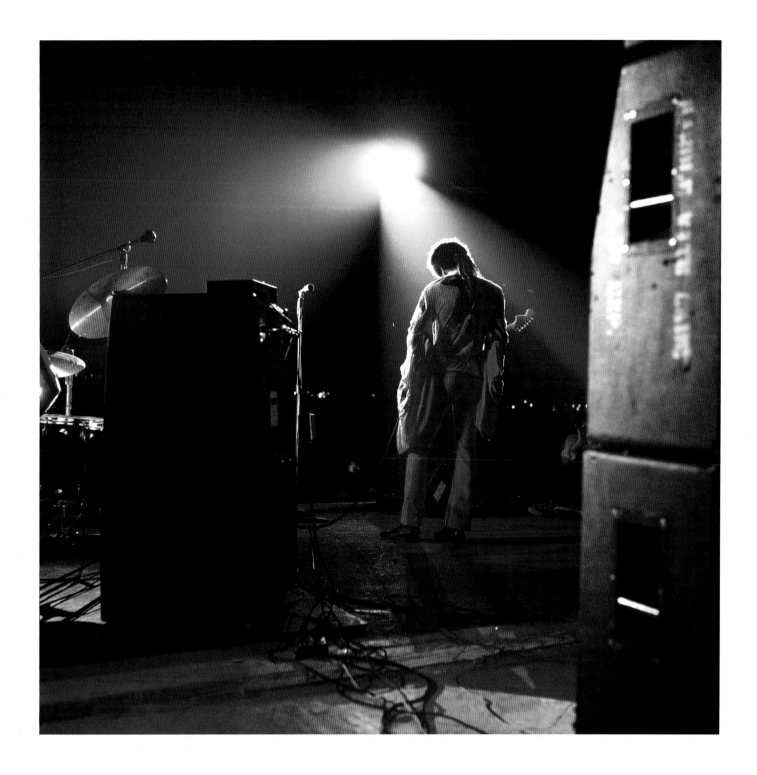

Middle Georgia Raceway, Byron,
Georgia, July 4, 1970.

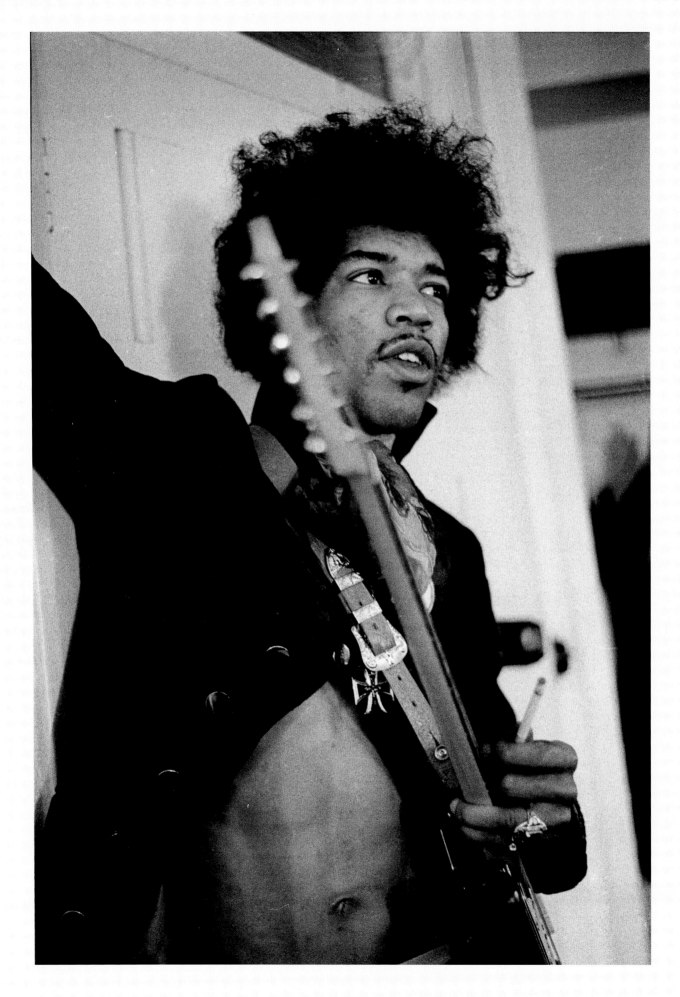

Saville Theatre, London, June 4, 1967.

"JUST BEFORE THIS CAME OUT, I SAW JIMI LIVE AT AN UNDERGROUND CLUB. DOLLYBIRDS IN BIBA CLOTHING WERE PROBABLY EXPECTING A FOLK SINGER BUT HE CAME ON AND **BLEW THE HOUSE DOWN**," BECK REMINISCED ON THE HEADY DAYS OF LONDON IN THE **SWINGING SIXTIES.** "IT SHOOK ALL OF US — ME, ERIC CLAPTON, JIMMY PAGE. HE WAS **SO GOOD**, WE ALL WONDERED WHAT WE WERE GOING TO DO FOR OUR LIVING." —JEFF **BECK**

"HENDRIX WAS A **GENIUS ON FIRE.** PEOPLE HAD THEIR ASSES BLOWN OUT BY **HENDRIX."** —DAVE GROHL

"

JIMI WAS AN ABSOLUTE ORIGINAL. YOU DON'T HEAR THAT KIND OF SOUL TODAY."
—DON HENLEY

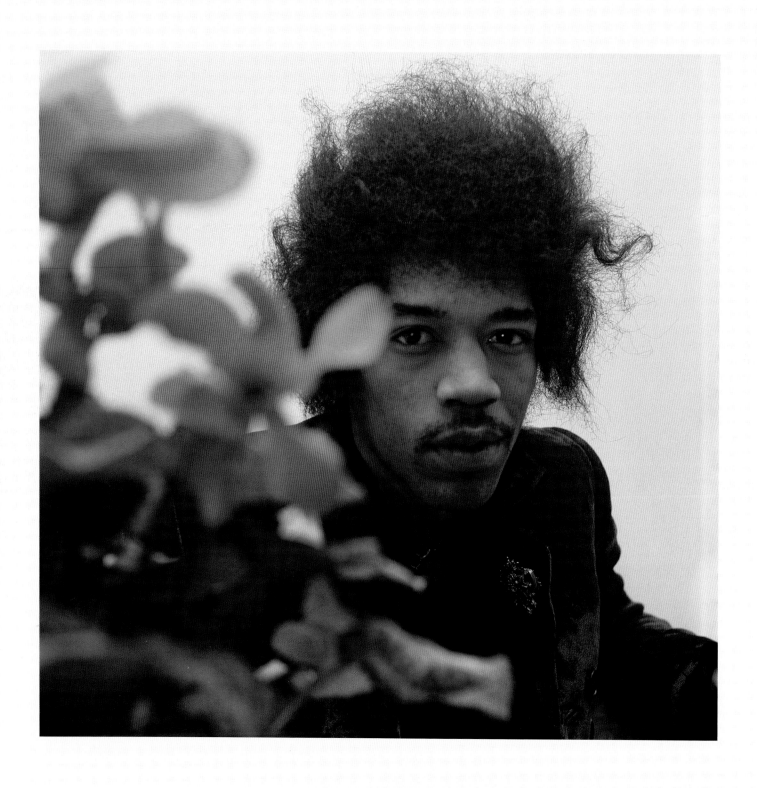

*Jimi's apartment, 43 Upper Berkeley
St., London, November 7, 1967.*

"

HIS **HANDS WERE** CONNECTED TO HIS **SOUL**, YOU KNOW? HIS PLAYING WAS JUST SO EMOTIONAL. YOU COULD FEEL **THE FIRE,** YOU COULD FEEL THE **BLUES."**
—LENNY KRAVITZ

"

THE BEST THING I EVER HEARD WAS IN THE '60S. I HEARD JIMI HENDRIX PLAY 'I CAN HEAR THE GRASS GROW' AFTER A REHEARSAL, AND IT WAS BRILLIANT."
—RON WOOD

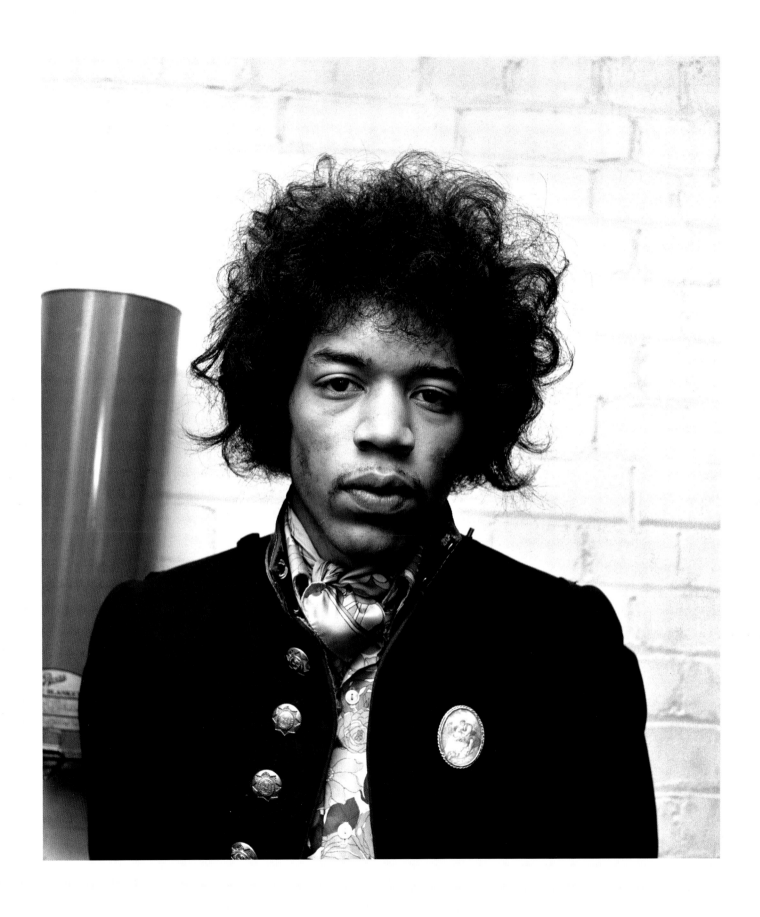

"

THEY'RE CLAIMING THAT
'THE GRUNGE BANDS'
FINALLY PUT SEATTLE
ON THE MAP,
BUT, LIKE, WHAT MAP?
I MEAN, WE HAD
JIMI HENDRIX.
HECK, WHAT MORE DO WE
WANT?" —KURT COBAIN

"WHO I AM AS A GUITARIST IS DEFINED BY MY FAILURE TO BECOME JIMI HENDRIX."
—JOHN MAYER

"I'M A HUGE FAN—
I PLAY THE DVD OF HENDRIX
AT WOODSTOCK TO PUMP ME
UP BEFORE I PERFORM.
WATCHING HIM GO
OUT THERE AT 10
IN THE MORNING IN SHITTY
WEATHER AND CONQUER
THE CROWD
ALWAYS GIVES ME A LITTLE
MORE ADRENALINE."
—DRAKE

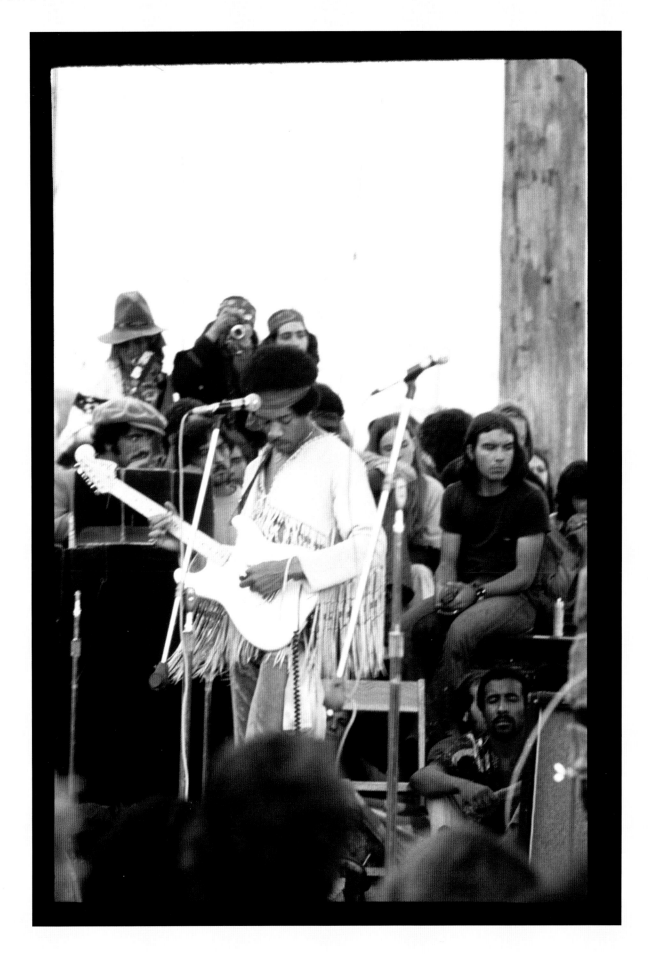

Woodstock Music and Art Fair,
Max Yasgur's farm, Bethel, New York,
August 18, 1969.

"HE PLAYED HIS OWN SHIT, HE DIDN'T PLAY NOBODY ELSE'S STUFF LIKE THEY DO NOW. JIMI WAS ORIGINAL."
—ALBERT COLLINS

"I HAVE THE UTMOST **RESPECT** FOR HIM, HIS MUSIC, WHAT WAS BEHIND HIS MUSIC, **WHAT HE WAS TRYING TO SAY** AND SEEMED TO BE SAYING WITH HIS MUSIC."
—STEVIE **RAY** VAUGHAN

"EVERYBODY ELSE JUST SCREWED IT UP, AND THOUGHT WAILING AWAY IS THE ANSWER. BUT IT AIN'T; YOU'VE GOT TO BE A JIMI TO DO THAT, YOU'VE GOT TO BE ONE OF THE SPECIAL CATS."
— KEITH RICHARDS

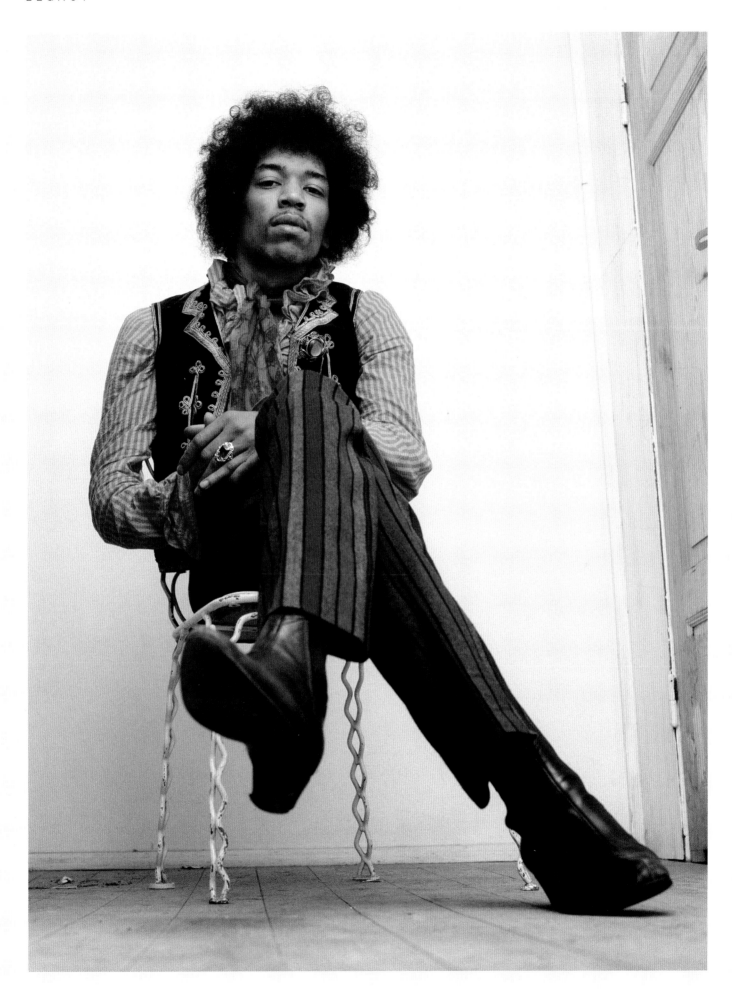

Copenhagen, May 21, 1967.

DISCOGRAPHY

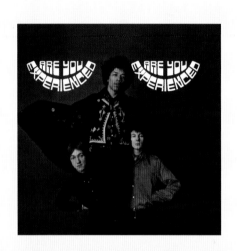
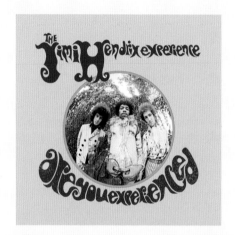
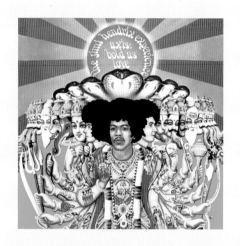

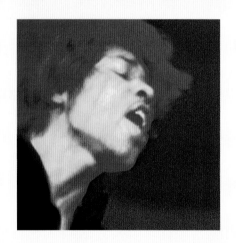
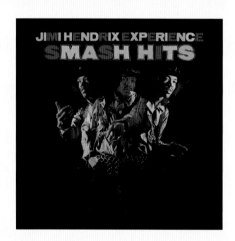
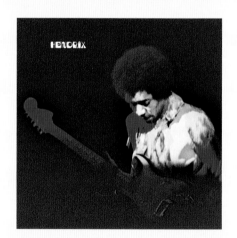

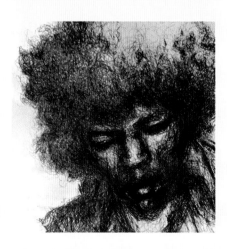

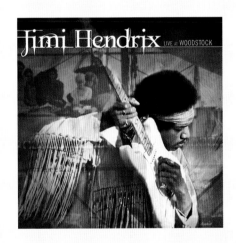

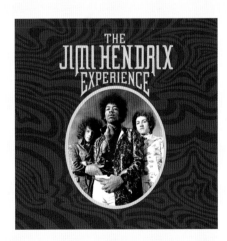

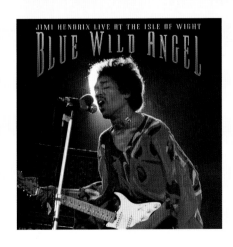

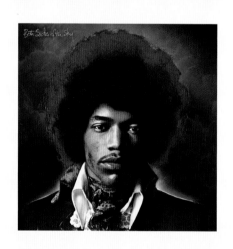
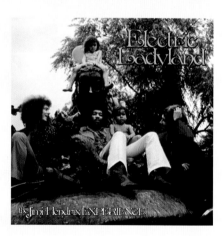

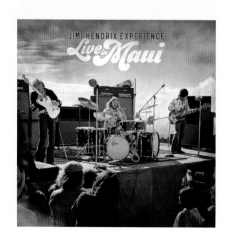

1967–2020

CREDITS

All photographs and artwork within this publication:

Copyright © 2022, Experience Hendrix, L.L.C. All Rights Reserved.

Photographs, artwork and original handwritings are Copyright © Authentic Hendrix, LLC unless otherwise stated.

Cover photo by: Bruce Fleming via Getty Images.

Photos by:

Authentic Hendrix (Pages 36, 41 [Bottom]; 65, 66, 74, 221, 226, 277)

Colin Beard (Page 91)

Jan Blom (Pages 213, 254, 255, 256-257)

Chuck Boyd (Page 96, 125,147,158,159,164 [Row 3-Left], 165,185,199,211,230,231,235,294)

Joseph Cestaro (Page 271)

Brian T. Colvil (Pages 118, 119)

Monika Dannemann (Page 289)

Torben Dragsby (Page 283)

Tony Gale (Pages 71, 73, 77, 78, 83, 85, 97, 103, 105, 108, 120, 121, 128, 142-143, 293, 302)

Ulrich Handl (Pages 79, 80-81)

Wolfgang Heilemann (Pages 94-95, 98-99, 100, 110-111, 122-123, 132, 135, 141 [Top]

Bruce D. Henderson (Page 272)

James "Al" Hendrix Collection (Pages 11, 12, 19, 21, 22, 23, 24-25, 27, 28-29, 33, 35, 39, 40, 41 [Top], 42-43, 47, 50, 53)

Allan Koss (Pages 244, 248, 252)

Bruce Krejcik (Page 238)

Gordon Linden (Page 141 [Bottom])

Jeremy Ross (Page 204, 205)

Jouni Sakki (Page 164 [Row 2-Right], 174-175, 198)

George Shuba (Pages 173, 177, 180, 181, 200-201)

Jonathan Stathakis (Page 243, 251, 309)

Peter Tarnoff (Page 247, 264)

Daniel Tehaney (Page 261, 266-267)

John Veltri (Page 281)

Friedhelm von Estorff (Page 134, 136, 137)

Bernhard R. Wagner (Pages 104, 127)

Chris Walter (Pages 282)

William Warner (Page 164 [Row 1-Both, Row 4-Right]

James White (Pages 163, 164 [Row 2-Left], 170,172)

Jim Wiggins (Pages 263, 269, 287, 297)

Günter Zint (Pages 102, 115)

Additional photographs by:

Ulvis Alberts / MoPOP / Authentic Hendrix, LLC (Page 13)

Bob Baker / Getty Images (Page 106-107)

© Ken Davidoff / Authentic Hendrix, LLC (Page 178)

Henry Diltz / Getty Images (Page 92)

© Sam Feinsilver / Authentic Hendrix, LLC (Pages 278, 279, 284-285)

Bruce Fleming / Getty Images (Page 89)

Allan Herr / MoPOP / Authentic Hendrix, LLC (Page 273)

Roz Kelly / Getty Images (Page 160-161)

King Collection / Avalon / Getty Images (Page 130)

Monitor Picture Library / Avalon / Getty Images (Page 305)

MoPOP permanent collection, © MoPOP (Page 54)

MRPI / Authentic Hendrix, LLC (Pages 149, 150, 151, 154-155, 162, 164 [Row 3-Right, Row 4-Left], 183, 188-189, 206-207)

© Nate Naismith / Authentic Hendrix, LLC (Page 232)

Graham F. Page / MoPOP / Authentic Hendrix, LLC (Page 216, 217)

David Redfern / Getty Images (Pages 4-5, 214, 215)

Photo by Bent Rej (Page 313)

Peter Riches / MoPOP / Authentic Hendrix, LLC (Page 194-195)

Frank Seay / MoPOP / Authentic Hendrix, LLC (Pages 59, 62)

Woodstock Music and Art Fair, 1969 Poster © Arnold Skolnick. Courtesy elizabethmossgalleries.com (Page 243)

John Sullivan / MoPOP / Authentic Hendrix, LLC (Page 298).

JIMI
by Janie Hendrix and John McDermott

Edited by Steve Crist

Art Direction:
Gloria Fowler and Steve Crist

Design and Typography:
Tré Seals / vocaltype.co

Layout / Graphic Production:
Alexandria Martinez

Production: Freesia Blizard

Hendrix Archivist: Steve Pesant

Pre-Press: John Bailey

Copy Editor: Sara DeGonia

ISBN: 978-1-7972-2001-7

Library Of Congress Cataloging–In–
Publication Data Available.

Manufactured in China.

MIX
Paper | Supporting
responsible forestry
FSC™ C136333
www.fsc.org

CHRONICLE CHROMA

CHRONICLE CHROMA is an imprint
of Chronicle Books
Los Angeles, California

Follow us on Instagram
@chroniclechroma

chroniclechroma.com

"

YOU NEVER KNOW WHAT SHAPE CLOUDS ARE GOING TO BE BEFORE YOU SEE THEM."